RON
JEREMY

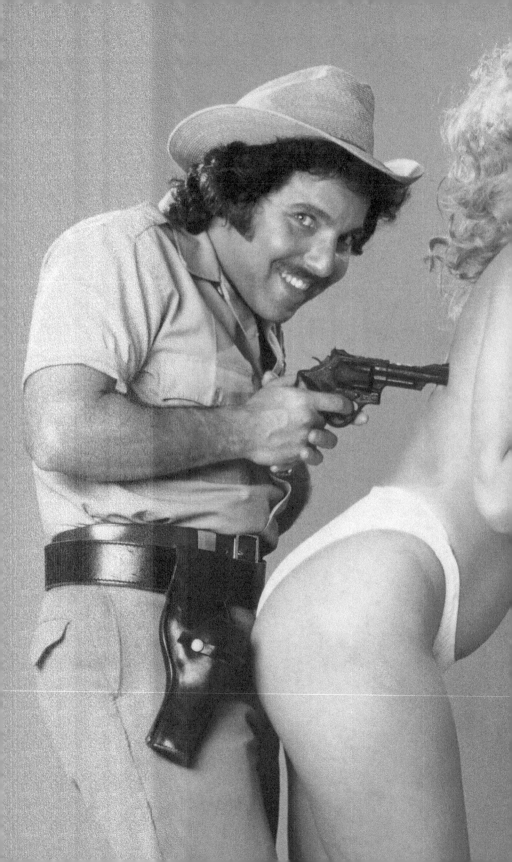

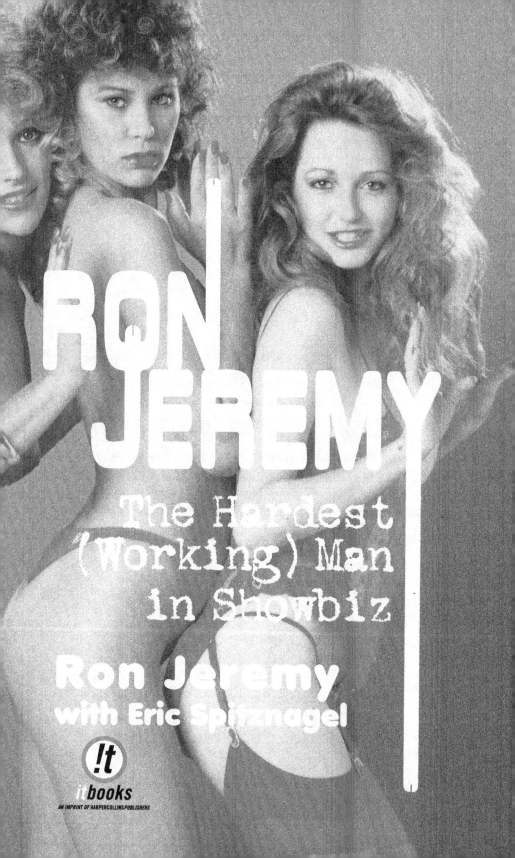

RON JEREMY

The Hardest (Working) Man in Showbiz

Ron Jeremy
with Eric Spitznagel

it books

AN IMPRINT OF HARPERCOLLINS PUBLISHERS

DISCLAIMER

A lot of what you're going to read here involves far-out stories
with celebrities from all walks of life. Some of it may seem wild
and bizarre, but believe it or not, it all happened. I don't lie.
So fasten your seat belts, sit back, and enjoy the ride.

*it***books**

Unless otherwise credited, all photographs courtesy of the author.

Title page photograph courtesy of Collectors/Gourmet Video.

A hardcover edition of this book was published in 2007 by HarperEntertainment,
an imprint of HarperCollins Publishers.

HarperCollins books may be purchased for educational, business, or sales
promotional use. For information please write: Special Markets Department,
HarperCollins Publishers, 10 East 53rd Street, New York, NY 10022.

FIRST HARPER PAPERBACK PUBLISHED 2008.

Designed by Timothy Shaner

Library of Congress Cataloging-in-Publication Data has been applied for.

ISBN: 978-0-06-084083-9

To my role models: daddy Arnold, mommy Sylvia, and cousin Eliott Weiss, whose service and sacrifice during World War II helped make this world a safer place, and allowed me the freedom to choose this career. In addition, I'd like to give a special thanks to Arnold and Sylvia for raising three children who never touched drugs, never smoked a cigarette, barely drink, and have each been through a six-year college master's degree program. Nice work.

The fox
knows many
things, but
the hedgehog knows
one big thing.
—Archilochus

CONTENTS

PROLOGUE

isn't even noon and I've already had sex with fourteen women.

To be fair, it wasn't entirely my doing. A company called Zane Entertainment hired me to star in a new porno flick called *Put It in Reverse, Part 3*. It's a little different than most gang-bang films. Rather than a bunch of guys doing one girl—the typical formula—they pick one lucky stud (in this case, me) to bone over a dozen lovely ladies. I'm not so jaded that I don't feel incredibly fortunate. How often does a guy get to be the center of attention, the "meat" in an all-girl sex sandwich? But it's not nearly as much fun as it sounds.

"You okay, Ronnie?"

I look up to see Chuck Zane staring down at me. Chuck is an old friend, and the producer and founder of Zane Entertainment. He's been in the business almost as long as I have, and with his slicked-back gray hair and the stogie that never seems to leave his mouth, he looks the part of a porn producer. He's always been good to me, which is exactly why I've continued to work with him for well over a decade, starring in such features as *I Love Juicy* and *America's Raunchiest Home Videos*.

I can tell from the concerned look on his face that something's

On the set of This Lady Is a Tramp, *1980. (Courtesy Chuck Vincent/Video-X-Pix)*

wrong. He knows that I'm a dependable performer and that I've never failed him yet. But with everything that can go wrong with a gang bang, today's shoot is making him nervous.

"I'm fine," I tell him. "I'm just taking a break."

I'm sitting by myself in the corner of the room, naked save for a small towel and covered in a syrupy layer of my own sweat. The crew is loading the camera with a new roll of film, so it seemed like a perfect opportunity to sneak away to recover. I've been having sex for well over three hours straight, and it's beginning to take a toll. I'm drinking bottles of water like my life depends on it, and given how dehydrated I am, it just might.

"Are you sure you don't want some Viagra?" Chuck asks me.

"What? Of course not. Does it *look* like I need it?"

"No, no, you're doing great out there," he says. "I was just wondering if maybe you needed a little pick-me-up."

"I told you, I'm fine. And even if I wasn't, I sure as hell wouldn't take any goddamn Viagra."

"Okay, okay, calm down. I just wanted to make sure. We have a case in the back if you change your mind."

"If I see so much as one blue pill, I'm going to flush it down the toilet. I'm serious, Chuck."

He starts to back away. Chuck knows he touched a nerve. "You're a pro, Ronnie," he says, flashing me a toothy smile. "Sorry I doubted you."

I don't know why the very idea of Viagra bugs me so much. I guess it's because I consider it cheating. Most male porn stars today use some form of Viagra or VigRX or ExtenZe, but I'll never touch the stuff. The minute I need a pill to get wood, I'm going to retire from the business. I don't care how old I get. I want my boners to be *au natural*. Maybe I'm being too old school about it, but that's the way I feel.*

* To be fair, however, I have seen VigRx and ExtenZe work for actors I've directed, and I've endorsed these pills on TV. I Just hope *I* never need them.

The girls are lounging in the living room, enjoying their brief break from a hard morning's work. They're like a cross section of every man's fantasy: there are blondes and brunettes, blacks and whites, big titties and tiny titties. What more could you ask for? Am I a lucky bastard or what? I can't believe that I get to have sex with women half my age.

Most of these girls are in their early twenties. Only Angella Faith and Jessica Jewel could pass for porn veterans, and they've only been doing films since the early 1990s. I'm a dinosaur compared to them. I was making porn when most of them were still zygotes. I don't even want to think about it. It's too depressing.

Funny thing is, it's impossible to say how much longer any of them will be around. Very few performers stay in the business for longer than a few years. They come in, make a few hundred films, and then disappear. You almost don't want to remember their names, because they might be gone before you get a chance to work with them again. It's not like it was back in the 1970s, when I was getting my start in adult films. Back then, it *meant* something to be a porn star. Everybody knew your name, and you felt like you were part of an extended family.

A radical, on-the-edge, sexually liberated, hippie-dippie family, that is.

Yeah, I'm one of those. I can wax nostalgic about the old days with the best of them. There was a time when porno was still shot on film, and we had actual budgets and sets and scripts. Nowadays, porn is all about quick turnaround. They'll knock out two or three pornos in just one weekend. Hell, I'll be done with this particular shoot before lunch. Back in the day, that was unheard of.

It's also gotten more complicated. Remember when condoms used to be the last thing you'd see in a porn film? I do. You'd just show up, stick your dick in whatever girl you happened to be booked with, and be on your merry way. Now, condoms are required. Or at least they were. Three porn actresses tested HIV-positive, and the industry went under lockdown. You couldn't so much as look at another actress

without wearing a condom. For this shoot alone, I have to wear a different condom for every girl. That's fourteen girls, dozens of sex acts, and a different condom each time. You do the math. I've already gone through a Dumpster of condoms and we're not even at the halfway mark yet. I've taken rubbers off and on so many times my penis looks like it has windburn.*

Matt Zane, the director and Chuck's son, walks over and sits down next to me. He's a good kid, though, like the women, he's very, very young. He couldn't be more than twenty-two. He joined the family business last year, and he's already become the new face of "Gen-XXX Porn."

"How ya feelin', Ronnie?" he asks, patting me on the back.

"Couldn't be better," I say. "You ready to start rolling again?"

"Any minute now. We just have to get a few more positions and maybe some anal and then we'll be done. Think you can handle that?"

Why does everybody keep asking me that?

"Of course I can handle it," I assure him.

Matt smiles and throws a playful punch at my torso. "You the man," he says, and returns to his crew.

I can understand why everybody is treating me with kid gloves. Even for a young stud, having sex with the equivalent of a small sorority house is no small feat. The Zane family was kind enough to throw a party last night in my honor. Most of the actresses and a few celebrities, like Elijah Blue and Jonathan Davis of the rock band Korn, toasted me and helped get me excited for what promised to be a daring, almost superhuman undertaking. But the moment the clock hit ten P.M., I was shuttled off to bed like a kid before his first day of school.

Funny thing is, there are few things I enjoy as much as morning sex. But on a porn set, all the romance and spontaneity is stripped

* Months later, the condom-only policy was no longer in effect.

away. You can't just roll over and tap your partner on the shoulder. You actually have to *leave* the house, and take the long, bleary-eyed drive to whatever backwoods, out-of-the-way location is being used for the day's shoot. By the time you get there, your morning wood has been replaced with a sagging mushroom, a shadow of your former glory.

And then there are the rehearsals, the waiting, the presex showers to ensure that everybody is squeaky-clean. Even though it might be only six A.M., it doesn't feel like morning sex anymore. You're just another employee, working your shift and counting the hours before lunch.

"Okay, guys, break's over," Matt announces. We all return to the living room, ready for round two.

Angella Faith has her hands on the couch, her cute little butt in the air. I stand behind her and wait for my cue. After mumbling some instructions to one of the lighting guys, Matt turns to me and says, "Let's do this thing."

He yells for action, the camera purrs into life, and I penetrate Angella.

Don't get me wrong, I love making porn films. But sometimes it can get a little monotonous. I mean, you're basically doing the same thing, over and over and over and over again. In and out, in and out, switch positions, in and out, in and out. Who wouldn't get a little bored after a while? Sometimes I let my mind wander, maybe make a mental inventory of the rest of my week.

Let's see, what else do I have lined up for today? Well, after we finish the morning's shoot, I'm going to jump on a plane and fly out to Indiana to host the Ponderosa Nudes-A-Poppin' Festival. After that, I'm off to Buffalo, New York, to shoot a few scenes for a new Troma movie. Next I'll be catching a flight to Los Angeles for a stand-up gig, then back to New York the next morning for a radio interview with Howard Stern, and then back on a plane for the long journey over to New Zealand for the Erotica Expo, where I'll be shooting a porno with some Kiwi women.

And that's just the weekend. Well, okay, a week and a half.

I can't imagine how I'm going to squeeze it all in. At some point I must've thought I could manage. Or maybe it was just wishful thinking. Sometimes I wonder if I'm stretching myself too thin. I mean, seriously, how is it possible for one guy to be in three different states—including the state of despair—and even an entirely different country, in less than an eleven-day period? I must've been out of my mind when I agreed to it. My schedule would be physically impossible even if I somehow found a way to clone myself. Hmm, actually, that's not a half-bad idea. I wonder if I could arrange for that. If they can clone a sheep, surely they could clone one measly little porn star, right?

Why do I keep doing this to myself? Why do I take every last gig that's offered to me? Sometimes it seems as if I'm terrified of not being busy. Like if I sit still for too long, I might cease to exist. I don't think I'm quite that screwed up, but it is curious why I always seem to be moving at such a frantic pace. It's as if I'm trying to cram four lifetimes into one. But I like it that way. I'm not comfortable being idle. I want to keep moving, keep looking for the next project, the next opportunity. I'm always afraid that the phone will stop ringing someday.

When I first told my dad that I wanted to be an actor, he told me, "Remember to have something to fall back on." I may have taken him just a little too literally. I've got so much to fall back on, it's propping me up.

"Ronnie. Hey, Ronnie."

I didn't even realize that Matt is standing right in front of me. "I'm sorry, what?" I mutter in reply. "Are we still shooting?"

"Yes, we're shooting, goddamnit. Come on, Ronnie, pay attention."

Matt asks me to move on to an actress named Temptress, who wants to do missionary. I pull out of Angella and join Temptress on the floor. God, she is so beautiful. What a face on this girl. She's making eye contact with me, which is always dangerous. Nothing makes me pop quicker. I look away and try to think of something else. Dead

animals usually do the trick, but I don't want to take it too far and end up going limp. It'll just give Chuck another reason to start mentioning Viagra again.

I wonder if I turned off my cell phone. I'm expecting a call from Adam Rifkin, my good friend and a very successful director and writer. He always tries to get me mainstream work. He put me in *Detroit Rock City* and *Night at the Golden Eagle* and *The Chase*. He's been promising that he has another project lined up for me. I couldn't be more excited. I always make room for a mainstream gig, especially if it has the potential to be seen by a bigger audience. Adam has been one of the most loyal friends I've ever had.

"I need a little anal," Matt says. "Who signed up for anal?" A few girls raise their hands.

A pretty black girl drops to her knees. She's ready to go, her asshole lubed and stretched out about as far as it'll go. I put just the head of my cock in at first. I don't want to hurt her. Anal is tough even for the seasoned pro.

"Is that okay, honey?" I ask her. "Tell me if that's too much, okay, sweetie?"

"Oh, Jesus Christ, Ron," she says, thrusting her pelvis toward me. "Just ram it in, will you?"

Well, so much for the gentle approach.

It's strange the things that go through your head as you're fucking a girl in the ass. I start to daydream about my life up to this point. I am, according to most men's magazines, the most famous male porn star on the planet. But I also wonder if people know anything else. I've done a lot more than porn. As far as I'm concerned, that's just one line on my résumé. It's a fat line, of course. But I'm also a mainstream actor of sorts. I've been in a lot of Hollywood films, like *The Boondock Saints* and *Orgazmo* and *Meet Wally Sparks* and dozens of others. And when that doesn't pay the bills, I'm a stand-up comic. I've done my act in nightclubs around the world, and rubbed shoulders with comics from Sam Kinison to Rodney Dangerfield. Oh, and don't forget music—I'm a classically trained pianist and violinist. I've

been in more than thirteen music videos, performed with Kid Rock at the L.A. Coliseum and other venues, and even recorded a hit single, "Freak of the Week," which was on the Billboard charts for more than twenty-seven weeks. My name appears on products from T-shirts to greeting cards to rolling papers to hot sauce to skateboards.

That's awfully ambitious of me, I know. Most people would be happy with just one career, but I had to try everything. I'm not sure why that is. I guess it's because I don't want my gravestone to read: HERE LIES RON JEREMY, THE GUY WITH THE BIG DICK. Sure, I'll take that. But if there's room at the bottom, I wouldn't mind if a few of my other credits were mentioned as well. Something that *doesn't* involve my oversized schlong.

"Can we get some more lube over here?" Matt asks.

A stagehand runs over with a tube and I apply fresh lube to the next girl's ass. I put on a fresh condom and move on to Randi, a cute blonde with a set of breasts so perky they'd take out an eye if she wasn't careful.

"Lift a leg for me, would you, Ronnie?" Matt says. "We need a down-under shot."

I know what you're thinking. "Poor, pitiful Ron. He's not happy getting paid to bonk beautiful women for a living. Oh no, that's not good enough for him. What he really wants is to be a *legitimate* actor. Most people would be thrilled to be the most famous male porn actor of all time. But not Ronnie. He wants our *respect*."

Well, you know what? You're wrong. I'm not chasing some elusive and far-fetched dream. I don't have any illusions that I'm going to be the next Brad Pitt. (At least not as long as I keep going back for seconds at the buffet.) I'm just another actor who wants to take his shot. I know that some people—okay, *most* people—will only ever see me as Ron Jeremy, Porn Star. But I don't want to settle for that. It's too easy. I don't want to be on my deathbed someday and think, Well, I could've done more, but I blew it. I never gave myself the chance to see how far I could go. And if I just sit around the apartment all day, waiting for some producer to call me and give me a break, it's never

going to happen. You have to get out there and bust your ass, pound the pavement, work it.

As Abraham Lincoln once said, "Good things come to those who wait, but only the things left by those who hustle." I couldn't agree more. If you wait around for the world's scraps, that's all you'll ever get. But I'm going to hustle for as much as I can. And in the end, if I still get nothing, it was still one hell of a ride. And at least I tried.

"You ready for the pop?" I ask Matt.

"I'm ready if you are," he says.

The girls surround me, sitting on their knees in a semicircle. After almost five hours of fucking, this is the moment of truth. I spray my goo over them, trying to hit as many faces as I can.

"You're missing Tamia," Matt barks at me. "Share the wealth, man. We need total coverage."

"I'm doing what I can here," I yell back at him, furiously beating myself off. "Just make sure you get it all. I'm not doing this again."

After every last ounce of protein has been squeezed out of me, Matt calls it a wrap. The girls and I retreat to the back bathroom for a shower. A half hour later, I finally stumble back to the living room to find my clothes.

As I'm getting dressed, I notice a guy in the corner staring at me. He's young and buff, probably in his early twenties at most. I assume he's somebody's boyfriend, as he's the only guy here who doesn't seem to have an actual job. It's not unusual for boyfriends to loiter around the set to watch the action. The business calls them "suitcase pimps," which isn't the kindest nickname. Most of them are pretty nice guys, and this one seems like no exception.

He eventually wanders over and introduces himself. "I'm a huge fan," he tells me. "I've seen all of your movies."

"Thanks," I say, pulling a shirt over my head. "You're too kind."

"When I heard my lady was going to be screwing Ron Jeremy, I nearly flipped out. You're a legend, man."

"Well, I don't know about that."

"It was an honor just to watch you work. I can't believe you boned fourteen girls. That has to be some kind of record."

He asks for an autograph, and I'm happy to accommodate. After some small talk, he finally musters the courage to ask the question that has clearly been on his mind all morning.

"So how big is it?"

"It?" I ask, though I know full well where this is heading.

"Your penis," he says, looking a little embarrassed.

"Oh, that. It's two inches . . . from the floor!"*

It's my standard joke, but he howls with laughter anyway. I thank him again for his kind words, and gather my things to leave. As I'm walking toward the door, I can hear him repeating my line under his breath, like it's the funniest thing he's ever heard in his life.

"Two inches from the floor," he giggles to himself. "I wouldn't doubt it."

* That line probably comes from Milton "Mr. TV" Berle, also known for having a big one. I'm happy to have met him before he passed away. I've also used another great line attributed to him. Whenever a guy wants to compare penis sizes, I'll say, "I'll just pull out enough to win."

I remember
when the air
was clean and
the sex was dirty.
—George Burns

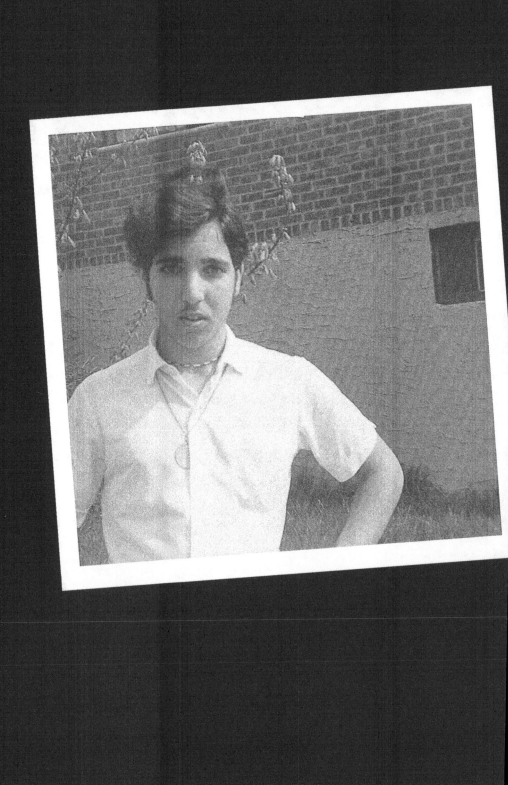

chapter 1
PORTRAIT OF A HEDGEHOG AS A YOUNG MAN

There are two stories involving my birth that may very well tell you everything you need to know about me.

I was born on March 12, 1953, in Bayside, Queens. As my father remembers it, my mother didn't experience much in the way of contraction pains. She just woke him up in the middle of the night, calmly announced that it was time, and had him drive her to the hospital. After the doctors wheeled her into the delivery room, I plopped out less than a half hour later. It was as simple as that. No epidural was necessary. My mother didn't even need to push. I did most of the work. I knew that it was time, and I just . . . came out.

"Oh," she apparently said. "That was it?"

I like to think that I just wanted to cause my mom as little physical discomfort as possible, but my dad has a different theory. "You were in a hurry to get out," he's told me. "You knew you had things to do, and you didn't want to stick around in the womb any longer than was necessary."

The other story took place later that morning, just a few hours after my shotgun delivery. My mother was taken to a private room to rest and recover. Though it was an altogether effortless birth, she was still feeling a little groggy; the doctors had injected her with too much

anesthesia, having anticipated a birth at least slightly longer than a sneeze. But she was conscious enough to overhear a pair of nurses talking in the next room, where they were bathing me and getting a first glance at my unusual physical gifts.

"Good Lord," one of them muttered. "Would you look at that kid's penis?"

"It's pretty big," the other said. "And on a baby, no less."

The nurses giggled nervously. If they had any idea that my mother was listening, they certainly didn't let on.

"Well, he's a very lucky boy," one of them concluded.

And that, as the dramatists like to say, is what you call foreshadowing. Even as an infant, I was an impatient little fucker. And I had a bigger schmeckel than most guys my age and older.

If there's a better indication of the man I was to become, I don't know what it is.

Doing a cartwheel out of my mom's womb was just the beginning. Most of my infancy was spent trying to escape the boring inactivity of babyhood. I just couldn't sit still for it. During the first few months of my life, my parents would put me in a crib and quietly leave the room after I'd fallen asleep. But within a matter of minutes, they'd hear loud thumping sounds, and they'd come in to find me banging my head against the crib, like an irate prison inmate desperate for freedom. On some nights, they'd catch me crawling the crib's walls, literally balancing on the edges, teetering dangerously close to falling off.

At one month, I was already crawling. From what I understand, that's not just unusual, it's a little bit freaky. Most children don't start crawling until between seven and ten months. Me, I couldn't wait that long. My parents were obviously thrilled that I was such a quick learner, but they also couldn't help but wonder, Just where the hell does he think he's going, anyway? No sooner did they place me on

the floor than I started scampering toward the door, as if I thought I was already late for some long overdue appointment.

My youth was almost unreasonably happy. I had parents who loved and supported me, siblings whom I adored and who never failed to be my closest allies, and a neighborhood that was like something out of a Norman Rockwell painting. In Bayside, most of us lived in semidetached, private homes no more than a few feet apart. You could look out of your living room window to see the family next door having dinner. It was like the entire neighborhood lived in the same apartment complex. It may sound like hell if you have a thing for privacy, but for me, it was pure bliss.

My memories of growing up often involve lazy afternoons at the Alley Pond Park, playing stickball and basketball in the street; family trips to Manhattan to visit the museums and zoos; and bike trips over to Springfield Boulevard to have a slice and a Coke for 25 cents at Joe's Pizza. I could roam free without my parents worrying, and enjoy the kind of freedom that most kids today can scarcely imagine. I still look back on it as some of the best days of my life.

But despite my idyllic upbringing, I didn't exactly take life at a leisurely pace. If anything, I was a lightning bolt of energy. I was constantly telling jokes or putting on impromptu shows for the neighbors. I'd dress up in my father's clothing and parade in front of anyone who so much as set foot in our house. I needed to be the center of attention at all times, and I'd do just about anything to ensure that it'd happen.

By the time I started attending Nathaniel Hawthorne Junior High, I was already pegged as the class clown. This delighted my schoolmates, but for the poor saps who were unfortunate enough to be my teachers, it proved endlessly frustrating. It was bad enough that I had the attention span of a gnat, but given my determination to be the most entertaining person in the room, I was the living incarnation of every teacher's worst nightmare.

It should come as no surprise that I was sent to the principal's office on an almost weekly basis. I was there so often that I was soon on a first-name basis with the school secretaries. I was scolded,

threatened with detentions, and told that I was putting my scholastic future in jeopardy. But this only added fuel to the fire, and my class disruptions continued.

Before long, the principal began asking my mother to join us, where the three of us would sit in the office for hours and discuss the "Ron Problem."

"I don't understand," my mom would say. "His grades don't seem to be slipping."

"Oh, they're not," the principal replied. "Ronnie's a very bright boy. It's just . . . he has a tendency to crack jokes."

"And?" My mom said, shooting me an approving look. "What's wrong with that?"

"He's distracting the other students. They can't focus on their schoolwork. We're at a point where the other children in his class are failing."

My mom tried to suppress a grin. "Well," she finally said, "maybe *they're* the ones you should be worrying about."

When we were alone, my mom told me to ease up on the classroom antics. But rather than punish me for my lack of interest in school—bless their hearts, my parents were never ones for discipline—they opted instead to encourage my tendencies toward acting out. If I was so eager to be the center of attention, they reasoned, there was no point in fighting it. At my dad's urging, I made my acting debut at a junior high school talent show, where I performed a song-and-dance skit as the Statue of Liberty.

> *Give me your tired, your poor, your homeless*
> *I'll take a deep breath*
> *And blow them right back to you*
> *Ya little bastard*
> *We don't want them.*
> *We're crowded enough.*

Needless to say, not everybody was amused by my satirically unpatriotic sentiments. But the majority of the crowd screamed with

laughter. It was the first time that I had the undivided attention of a room full of strangers, and I was hooked.

By the time I enrolled in Benjamin Cardozo High School,* the acting bug had wiggled its way deep into my chest and wasn't budging. I took every drama class the school offered, hung out with the theater crowd, and starred in productions like *The Devil and Daniel Webster* and *Oklahoma*. When I wasn't cast in *The King and I*, I managed to persuade Mr. Segal, the director, to let me play piano as the musical accompaniment.**

Though music and theater were my first loves back then, my second love was making money. I was barely in my teens before I decided that I needed a disposable income. By fifteen, with proper working papers, I was gainfully employed as an ice-cream vendor in Cunningham Park. The ice cream was supplied by a local hot-dog stand, and I would walk around the park for hours with my little cart, peddling ice cream to the tourists and making a staggering $1.60 an hour for my efforts. I can still remember the thrill of receiving a check every week. It wasn't much, but to me it was a fortune. And best of all, I had earned it.

But you want to know about the girls, don't you? I'm getting to that. It all started, innocently enough, with a kiss.

Her name was Stephanie, and she lived in the court just down the

* George Tenet, the former head of the CIA and a close friend of George W. Bush, was also a student at Cardozo. We both played soccer, and while I didn't know him that well, we said our hellos. Years later, my cousin (who works for the government) asked me to Xerox a few pages of our yearbook to show his coworkers. It was *implied* that George Tenet himself wanted to see it because he'd lost his copy.

** This production also starred Reginald VelJohnson (another Cardozo student), who became a big Hollywood actor (*Die Hard* and *Family Matters*).

block from me. I think she may have been a member of my family's temple, though I wasn't exactly a practicing Jew at that point. I was smitten by her the moment I laid eyes on her. Not that I ever let on, of course. I was maybe eleven or twelve at the time, and like any self-respecting boy my age, I couldn't possibly fathom that I might actually be attracted to a girl. Still, whenever I had the chance, I would gaze longingly at her and wonder what it might be like to wrap her up in my arms and steal her away.

After months of successfully ignoring her, I stumbled across Stephanie while returning from a street stickball game. It was a perfect opportunity to introduce myself and finally break the ice with this neighborhood hottie, but I was far too shy for that. She beamed at me and said hello, but, big pussy that I was, I just nodded and quickened my pace. The moment I passed her, however, I noticed a group of older kids heading in our direction. They looked tough, like the kind of local bullies who might corner a defenseless kid like me and pelt him with rocks—although this hardly ever happened, except during Halloween trick-or-treating.

Without thinking, I grabbed Stephanie's hand and led her to a nearby shack, a shared space that was used by the local kids to store their bicycles. We tunneled toward the back and hid behind the bikes, waiting for the teens to leave. We weren't really in danger. I was just pretending, and she kind of went along with it.

I didn't like being in such close proximity to a girl, but it was nothing compared to the terror of being stoned by a hotheaded juvie. Given my choices, it seemed like the more reasonable alternative. Stephanie and I huddled together, deep inside our little rickety shelter, and prayed that our (exaggerated) would-be attackers would eventually pass us by.

I tried to focus on the impending doom outside, but all I could think about was the cool breeze of Stephanie's breath on my neck, and her tiny prepubescent body pressed firmly against my skinny chest. She tightened her grip and pulled me closer. When I finally opened my eyes, she was staring directly at me, a big grin on her face.

"Do you wanna?" she asked.

"What?"

"Do you wanna?" she asked again.

I just stared back at her, completely dumbfounded. "Do I wanna *what?*"

She paused for a minute, as if flabbergasted that I was actually making her come out and ask.

"Kiss," she said at last.

"Uh, okay."

And we did.

It was like I'd found religion. We didn't use our tongues—I didn't know that such a thing was possible yet—but both of our mouths were open. It was everything I'd been hoping for and more. It was wet and noisy and rapacious and sloppy and, oh God, I could've done it all day.

But then the bullies went away. And so did Stephanie.

A fter my initiation into the world of the opposite sex, you might expect that I became an overnight horndog. Now that I had tasted the forbidden fruit, I wouldn't very well be able to keep my hands off of girls ever again.

Well, you would be wrong.

Remember, I was still a virgin, and still naïve enough to think that kissing was as good as it got. Which isn't to say that I was completely opposed to the idea of dating. There were one or two girls whom I'd see regularly, and I'd take them out to Digi's or Joe's Pizza for a slice and a soda. With the money I made from my ice-cream business, I could easily afford the 40 cents for a night out on the town. If their tastes were more expensive, I would take them bowling or to the movies or, if I really liked them, out on my yacht.

Well, it wasn't a yacht per se. One of my first major purchases was a tiny lifeboat that I bought for $40. You'd blow it up with a

pump, and it would become a two-man raft. It had plastic paddles, and I would take it out in the bay in Little Neck. I even tried it out in the ocean a few times, but the waves made it a little too rocky for my purposes. The boat became a standard part of my dating routine. I'd take girls out into the bay with a little wine and cheese. We'd take turns paddling, find a secluded spot, and have a picnic, which invariably ended with a makeout session.

Though I enjoyed dating (especially the kissing part), I never became too emotionally attached to any of the girls in my neighborhood. I liked Stephanie a lot, and she was always a blast to hang out with, but that was as far as it went. It never occurred to me that I might actually fall in love with her or anybody else.

Until I met Mandy.

I've had sex with more than four thousand women in my life, but I've been in love with only five of them. I suppose that, given the math, it was bound to happen sooner or later.

Mandy was the first. She was the first to cause me sleepless nights, the first to make me lose my appetite, the first to make me seriously consider monogamy, the first to break my heart, the first to be the one by which all other girls are judged.

And, of course, she was the girl who broke my cherry.

Well, kinda.

Hold on, we'll get to that.

In many ways, Mandy was the polar opposite of what one might expect from a future porn star's soul mate. She wasn't a bleach-blonde, big-titty bimbo. Well, her boobies were nothing to sneeze at. But unlike some of the women I've dated over the years, her breasts didn't inhabit their own area code. She was a diminutive redhead—undeniably hot, but not the kind of girl to whom most guys would've given a second glance. But at least to my eyes, she was absolutely breathtaking.

It wasn't her appearance that really caught my attention. There was

something about her that was more exceptional than any of the other girls I knew in Bayside. Under her tough-as-nails exterior, there was a vulnerability that she only hinted at. With the other girls, they were eager to share everything with me. With Mandy, I had to work to break down her walls and catch a glimpse at the real person underneath. Maybe I just liked the challenge of it, or maybe I was shocked that she trusted me enough to let me see the raw skin beneath her armor.

I was flirting with Mandy from the moment I saw her during recess in junior high, but it took years before she'd let me so much as hold her hand. And then another few years before she let me kiss her. She was always the instigator, and I was only along for the ride. She kept me at a distance at first. We were just friends who "occasionally" fooled around. She didn't seem to want anything more, and I was happy for whatever I could get. I knew enough not to ask her out, as any request for a proper date would only be greeted with laughter. Without saying a word, she made it very clear that *she* was running the show. If we were ever going to become more physically intimate, she would be the one to let me know that the time was right.

On a hot summer day in 1968, the time was right.

When you're a teenager living with your parents, there aren't many ideal conditions for experimenting with sex. You could try doing it at home, in your bedroom, but there's always the danger that you'll get caught. As if having sex for the first time isn't scary enough, you don't need the added tension of having your parents walk in on you. If it was ever going to happen, you had to be creative, and Mandy knew just the spot.

There were abandoned lots next to most of the public schools in Queens. And at one particular school lot, near PS 46 at Sixty-fifth Avenue and Springfield Avenue, there was a rock notable for its remarkable size that we could hide behind. It was about five feet high and roughly eight feet long, just big enough to conceal, oh, I don't know, a couple of sex-crazed teenagers looking for some privacy.

Mandy and I visited the rock often during our courtship. Our first attempt at sex wasn't exactly one for the record books. We never

slowed down long enough to get undressed, so we had to make do with dry humping, though I did manage to cum in my shorts. We tried again a few weeks later, and this time we had the forethought actually to get naked. But even with this obvious advantage, it was only slightly more successful. I say "slightly" because, though I did achieve penetration, I'm not entirely sure if it was *her* that I penetrated. In my haste, I had put the rubber on backward, and the lubricated side was rubbing against my penis. So I basically screwed the rubber. Whether I was actually inside Mandy, well, your guess is as good as mine. It felt like I was, but it's hard to say. I might have just been resting my cock against her pelvis while I fucked the living shit out of a well-lubed condom.

And that was how I lost my virginity. Maybe. Depending on your point of view.

The funny thing is, I thought we were being creative. I thought that we alone had discovered this rock, and we had brilliantly picked it as the ideal setting for a bit of covert nookie. But when I bragged to my friends about our encounter, instead of applauding me for my ingenuity, they said, "You mean the rock over by lot 46? That's where I lost it, too."

"Seriously?" I asked them, stunned and a little hurt.

"Oh, yeah. My older brother told me about it. He's been using it for years. And our dad lost his virginity there, and our grandfather. Everybody goes there."

As it turned out, the lot 46 rock was Grand Central for underage sex in Bayside. It was a miracle that we didn't run into another couple heading there to do the very same thing. That it wasn't covered in used condoms and graffiti boasting of sexual conquests probably attests to the fact that it was, and remains, one of the neighborhood's most revered and closely guarded secrets.

Until today, anyway. Sorry about that, guys.

Not long after our sorta-maybe-kinda sex, Mandy and I stopped seeing each other. We were never technically dating to begin with, so there wasn't much of a relationship to fall apart. I eventually became

involved with a nice Jewish girl from Little Neck named Karen. I'm not sure why I chose her as a steady girlfriend. Maybe it was the convenience—we both went to the same high school and took many of the same classes. Or maybe it was our shared interests—she was an actress, too, and we performed in several plays together. But in the back of my mind, I was still pining for Mandy, though I didn't have the guts to admit it yet.

Karen and I were having sex—*actual* sex, not just fucking a condom—and I soon learned that Mandy had moved on as well. She was seeing a guy named Charlie, who was older than me, better looking, and considerably more experienced. Just the idea of her fucking Charlie was enough to give me nightmares. I could see it all so clearly: Charlie crawling on top of her and pumping his eighteen-year-old penis into her, as she howled with ecstasy and scratched her fingers down his brawny shoulders. Oh God, it was horrible. I'd wake up some mornings in a cold sweat. (It was *later* that I realized that romance made me more jealous than just sex.)

A few months later, Mandy and I started dating again, and we didn't waste a moment making up for lost time. We screwed at every opportunity, regardless of whether it was safe to do so. We screwed in bedrooms, in the backseats of cars, at her family's summer home in upstate New York, on a canoe drifting down the Delaware River—any place where we could find even a few seconds of privacy. I discovered an elementary school in Little Neck where the windows were left unlocked at night. Telling our parents that we were at the movies, we'd sneak out to the school, shimmy through the windows, and then proceed to have sex in every classroom in the building. At one point, we even screwed on a few tables in the cafeteria. Because the school had running water, we were able to take a sponge bath afterward and come home without the telltale "sex funk" that might have otherwise given us away. It was our escape from the outside world, and sometimes we'd just lie for hours on the dirty hallway floors, cuddled together on a blanket and counting the constellations on the insulated ceiling tiles.

But even though I was falling in love with Mandy, on the side, I was still seeing Karen who had proven to be more than a passing fancy. Oh, I know what you're thinking, but it wasn't cheating! Mandy was well aware that I was still screwing around with Karen. In fact, she had her fair share of boy toys, and I was fine with it. Our relationship was becoming serious, but it was by no means exclusive.

At a young age, I was very clear on the distinction between love and sex. Mandy could fuck anybody she wanted, and it never bothered me. She could've gone back to Charlie and his brawny shoulders for all I cared. Because Mandy and I had something more significant than just sex. Sex just for sex's sake doesn't mean anything. What would've made me insane with jealousy is if I ever found out that Mandy was cuddling with somebody. Oh God, the mere thought of it was enough to make my blood boil. Anything that seemed too romantic was off limits, as far as I was concerned. She couldn't take a walk in the park with a guy and hold his hand, and I wasn't crazy about candlelight dinners either. But cuddling was so out of bounds, it wasn't even open for discussion. Cuddling was intimate. No, no, no cuddling! You put the dick in, you take it out, you walk away, end of story. You want to cuddle? Come see me.

I thought we had the perfect arrangement, but apparently Mandy didn't feel the same way. One day, completely out of the blue, she put her foot down.

"I'm going to stop seeing other guys," she told me. "And I want you to stop seeing other girls."

"Okay," I said. I couldn't argue with her. I didn't like the idea of having sex with just one person, but I was too much in love with Mandy to protest.

She gave me a disbelieving look, as if she knew I didn't completely understand. "That means Karen, too," she added.

"O-okay," I said with a gulp. "I'll stop seeing her."

"That's not good enough," she said. "I want you to break up with her."

"Is that really necessary?"

"Yes," she said firmly. "You need to tell her in person. She won't give you up unless you say the words. Do it today."

I was like putty in her hands. What choice did I have?

So I slinked over to Karen's house and told her that it was over between us. It took me a while to find the right words. I didn't want to hurt her, but I didn't know how to break up with her gracefully. She listened silently as I stammered and overexplained, trying to make her understand. She didn't try to change my mind. She knew that she couldn't compete with my feelings for Mandy. It was probably one of the most painful things I'd ever done in my life. I hated every minute of it.

We sat on her bed, and she cried, and I was helpless to do anything to make it better.

It was the first and *only* time that I ever dumped a girl.

I'm not sure why Mandy and I eventually drifted apart. There were a lot of reasons I could point to. For one thing, I graduated early from high school and enrolled in Queens College, where I was hanging out with a very different crowd. But more than that, our lifestyles were becoming increasingly disparate.

A few years into our relationship, I learned that Mandy was taking drugs. Not just pot, but the harder stuff, like LSD. She had started experimenting when she was still dating Charlie, who socialized with Jamaican foreign-exchange students and had access to all the drugs he could handle. I didn't know it at the time, but Mandy was regularly sneaking into the girls' bathroom at our school to do drugs with her friends. It was a world that I couldn't have known less about. I never tried drugs; I never even had an interest in them. I smoked pot a few times during school field trips and didn't care for it. Mandy was a different story. She loved getting high, and I didn't have a clue how to help her.

She visited me occasionally at Queens College, and during the

summers when I worked as a waiter at the Catskills. But her visits became less and less frequent. The last time I saw her, she was at a drug rehabilitation center in New Jersey. I heard from a friend that she kicked the habit and went to college, where she got straight A's, and that she was now working at a lab for a major chemical company. But she never contacted me again. To this day, I still don't know where she is and what she's doing with her life.

I still think about Mandy sometimes, and I remember the shivers that used to shoot down my spine when I looked at her. I know that everybody looks back at their first love with rose-colored glasses. But on some days, it still seems unreal, like something that I just imagined but never really experienced. Sex has never been so innocent for me since. It's odd to think that there was a time when one girl might've been enough to make me happy, when all I wanted was to sit on the cold floor of a dark and abandoned school and count the pretend stars on the ceiling tiles.

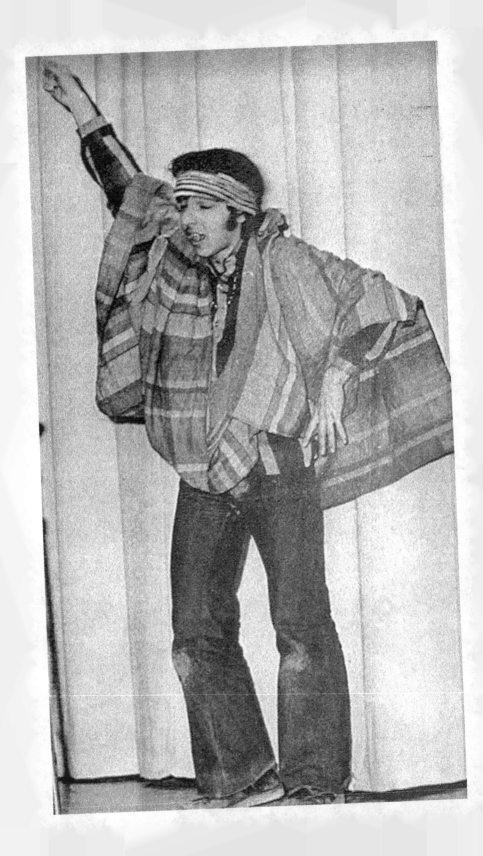

CATSKILLS-A-GO-GO

Ken was giggling so loudly he was about to blow our cover.

"Oh my God," he sniggered. "I can't believe we're actually doing this."

"Will you shut up? They're going to hear us."

Ken and I were hiding behind the desk in his office, peering over it like hunters on the prowl for a cartoon rabbit. We'd been waiting there for almost ten minutes, and there was still no sign of our dates.

"Why are they taking so long?" Ken muttered. "The suspense is killing me."

"They'll be here," I assured him. "Just be patient."

The dates we were awaiting so eagerly were hardly our girl-friends. They were a pair of Borscht Bunnies whom we'd bedded the night before. "Borscht Bunnies" or "Bungalow Bunnies" were terms coined in the Catskills, meaning, "married women who love boinking younger guys."

Allow me to explain.

Every summer, rich couples from Manhattan would drive up to the Catskills for the weekend, wining and dining at the best resorts that money could buy. On Monday, the husbands would return to the

My very first performance as the talking Statue of Liberty.

city (and, one could only assume, to their mistresses) while their wives stayed behind. They were lonely, armed with their husband's credit cards, and ready to play. By "play" I mean, of course, have as much sex as possible with as many hot young boys as possible, which usually meant the resort's staff of easily seduced waiters and busboys.

Well, as luck would have it, on this particular summer in 1975, I just so happened to be a maître d' at one of the poshest resorts in the Catskills: Gasthalter's Paramount Hotel. The moment I spotted these two Borscht Bunnies in the Paramount dining room, flirting and drinking wine, I knew it was going to be a good night.

I called my friend Ken, and we met up with the ladies for a few drinks after my shift. Several cocktails later, we invited them back to our room at the Flagler Hotel. There was just one thing we forgot to mention to them. It wasn't actually the Flagler Hotel anymore. The Flagler had gone out of business years ago. It was now the Crystal Run School for the Mentally Challenged.

A small technicality, really.

Ken and I both worked at Crystal Run. Ken was the in-house psychologist, and I was teaching part time while I finished my master's degree in special education at Queens College.* During the week, I taught Academics of Daily Living to children with learning and emotional disabilities. No, really. I showed them the proper way to brush their teeth. I took them to the local fire station and taught them about fighting fires. I took them on field trips to the bank and gave them each a quarter to open an account. I was actually pretty good at my job. There was a time when I believed it might be what I was destined to do with my life.

Ken and I lived in the staff quarters on the top floor, which had many of the same furnishings from when it had been the Flagler Hotel.

* I finished my thirty-two credits of graduate school to fulfill the master's degree. I never got the actual certificate because I left for the West Coast. But I did get a permanent license to teach in New York State. I did my master's thesis on psychodrama, using role-playing to help discipline children from acting out.

There were elegant rooms, an Olympic-size swimming pool, the works. So anyone visiting might reasonably think that it *was* a hotel.

At three A.M., the building was completely empty, so we had the entire grounds to ourselves. We took a dip in the pool before splitting off into pairs and retiring back to our respective rooms. Though my Borscht Bunny couldn't have been more than forty-five, I'd never been with an older woman before, so it was a novelty to me. It was like having my own personal Mrs. Robinson. And she clearly had some built-up sexual frustration, because she fucked like a caged lion. I was in the prime of my sexual prowess and no slouch in the sack, but this lady literally screwed the living crap out of me.

The next morning, I woke up early and dragged Ken out of bed. By the time the girls opened their bloodshot eyes, we were already dressed and heading for the door. Though Ken assumed that I was just planning a quick getaway, I had something far more devious in mind.

"We want to treat you ladies to breakfast," I announced.

"Really?" they said. "That's so sweet."

"We're just going to run downstairs to get a table," I said with a wink. "This hotel has a great restaurant."

I could feel Ken staring at me. I shot him a look, and he knew in an instant what I was plotting.

"Oh, yeah, right," he said, picking up my lead. "It's right on the ground floor. Really good food. And I think there's a convention in town."

"That's right," I said, somehow managing to hold a straight face. "A doctor's convention or something."

Ken's face was tightening, and I knew he was about to break. I jabbed him in the ribs.

"Okay, see you there?" Ken said, fighting back the tears of laughter.

We ran downstairs as fast as we could, dived behind the desk in Ken's office, and waited for the fireworks.

Ken glanced at his watch and frowned. "We're running out of time," he said. "Breakfast is almost over, and the children will be heading back to class."

I put a finger on his lips and pointed toward the stairs. "Here they come," I whispered.

Our two Borscht Bunnies, still wearing the same clothes from the night before, were making their grand entrance. Their makeup was smeared, they looked a little haggard from a long night of partying and fucking, but otherwise, they were none the worse for wear. We ducked behind the desk and listened as they called out our names, their high heels clicking as they wandered around the lobby. And then we heard them slowly walk toward the dining room.

They probably expected to find a buffet waiting for them, or at least a friendly crowd of doctors, sipping mimosas while making idle chitchat.

Instead, they were about to meet our students.

I know it's not politically correct, but I think mentally challenged children are adorable. They're just so innocent and sweet, and so eager to please. They have such a curiosity about life, and it takes so little to make them happy. Every day is a new discovery for them. From the moment I started teaching at Crystal Run, I fell in love with each and every one of them.

Of course, it probably isn't nearly as cute if you're a hungover and middle-aged woman, and you're staying in what you *think* is a high-class hotel in the Catskills.

When we heard the screams, we immediately jumped up from behind the desk and came running. Our dates were standing in the middle of the dining room, surrounded by a growing throng of mentally challenged kids. The moment they walked in, the children had leapt out of their seats and descended on them. They meant no harm, but they recognized that these ladies were new and they wanted more information.

"Hi," they said, tugging at the women's sleeves. "Who are you?"

"What's your name?"

"Are you our new teacher?"

"You're very pretty. Can I touch your hair?"

The Borscht Bunnies were frozen in their tracks like deer in head-

lights. Their faces had gone pale, and, judging from the glossy look in their eyes, they were in shock. The children had them cornered and were advancing on them like zombies from *Night of the Living Dead.* They were pulling on their clothes, tugging at their hair, trying to hold their hands. The women had absolutely no idea what was happening, but they were fairly sure they didn't like it.

We watched them for a few minutes, just relishing in the beautiful awkwardness of it all. And then we swept in and pulled them away, explaining to the kids that these women were our friends and that they had to leave for an important appointment.

We tried to walk them to their cars, but the Bunnies wanted nothing more to do with us. We had to chase them down the street, pleading with them to let us explain.

"What the *fuck* was that all about?" one of the women screamed at me, nearly spitting she was so angry.

"What?" I smiled, feigning ignorance. "It was a convention, just like we said."

"You said it was a convention of *doctors!*"

"Well . . . there were *some* doctors there."

It took a while, but they eventually smiled and got the joke.

I first started coming up to the Catskills when I was still in high school. I'd spend the summers working as a waiter at any of the high-class hotels, like the Concord and Grossinger's and Green Acres. As I got older and more experienced, I eventually moved up in rank and seniority. I loved the work, but more important, I loved the money. For a young Jewish kid with a limitless supply of energy, the Catskills was like a gold mine.

But I wasn't just a miser looking to line his pockets with cash. Some of that money was actually necessary. When I enrolled in Queens College, I needed something besides good looks to pay my tuition. My parents, though not poor by any means, did not have a

lot of disposable income, especially after my mom was diagnosed with Parkinson's disease and needed expensive surgeries. I didn't want to be a burden on them, so I found a way to be financially self-sufficient.

You could make a small fortune at Grossinger's if you learned how to work the guests. It wasn't enough just to be polite and bring out their meals as quickly as possible. You had to play into their expectations. I learned that from watching the Christian waiters. They'd wear yarmulkes and pretend they were med students, and they'd always get the biggest tips. I, like a fucking idiot, who actually *was* a Jew, didn't wear a yarmulke. I was a reformed Jew, so it never seemed appropriate. And I was too honest with my customers. They asked me what I wanted to do with my life, and I told them that I was pursuing an acting career. Big mistake.

"Oh dear," they'd moan in their thick Jewish accents. "That doesn't seem like a very wise choice. What are you going to do for a living?"

When I figured out that honesty wasn't getting me any tips, I gave myself a full Jewish makeover. I wore yarmulkes. Hell, if I could've gotten away with it, I would've worn a full prayer shawl and shtreimel. And when a customer asked me about my career choices, I would always—*always*—claim to be studying medicine.

"I want to be a *dokter*," I'd say, breaking out the Yiddish. "I want to save people's lives someday."

"What a sweet boy," they'd say, fawning over me like I was their own flesh and blood. "Good for you, son."

Though I was younger than any of the other waiters, I was always the hardest worker. When the Woodstock Music Festival was announced, all of the waiters wanted to attend, and I volunteered to cover their tables for the day. I made $400 in a single weekend, which was a *fortune* for a kid of sixteen. I wasn't a big rock fan at the time, but I was at least curious enough about Woodstock to check it out during my break. I jumped on my dirt bike and rode down the mountain into White Lake, Bethel, where Max Yasgur's farm was. I was there for only maybe a half hour. I saw Grace Slick come out onstage

and shout, "Good morning, people!" And then she and Jefferson Airplane started playing "Volunteers." I listened for a few minutes and then went back to work. Not exactly the quintessential Woodstock experience—there was no LSD or messing around with hippie girls for me—but at least I didn't skip it entirely.*

Just because I was such a stubborn workhorse didn't mean that I avoided fun altogether. Grossinger's had some incredible discotheques and nightclubs, and I always visited them after my shifts, shaking my butt on the dance floor and flirting with the female guests. It was a dangerous game, because, at least in theory, the hotel's clubs were off-limits to employees. Remember the movie *Dirty Dancing?* It was exactly like that, although not as highly choreographed. The staff wasn't allowed to socialize with the guests, and doing so was grounds for dismissal.

But unlike Patrick Swayze's character, I was a little more cunning.

I had very long hair at the time, which was prohibited in the restaurants because of the possibility that a loose strand of hair might fall into the food. But rather than cut it, I bought a nylon skullcap and short-hair wig, which I wore whenever I was waiting tables. After a while, the staff forgot that I actually had long hair under that wig. When I clocked out at night, I'd just have to take off the wig and, *presto*, I was a completely different person. Nobody recognized me. For all they knew, I was just another rich Jewish kid, out for a good time on his parents' dime.

I thought it was the perfect scam, but one day I was caught. And

* Years later, Fred Durst asked me to introduce his band Limp Bizkit at Woodstock '99. With almost a quarter-million people in the audience, it would be my biggest crowd yet. But just before I left for the show, I got a call that Mini-Me was going to introduce the band instead. I was heartbroken. When Dennis Hof heard about it, he had the girls from the Bunny Ranch call and tease me about it. "I can't wait to fuck your brains out," they'd say. "Oh wait, Mini-Me is here. I gotta go!" (click). I later met Mini-Me at a show in Hawaii and told him the story. He loved it and apologized for taking my place. And as a courtesy, he likes to be referred to by his real name, Verne Troyer.

not by my boss or one of my fellow waiters. No, that would've been too easy. I was caught by none other than Mark Etess, the son of the owner and the heir to the Etess-Grossinger family fortune.

I was out on the dance floor, making pretty good time with a young girl who was staying at the hotel, when I saw Etess standing nearby, studying me like he could've sworn he knew me from somewhere but couldn't quite put his finger on it. Thinking fast, I pulled my date toward me and kissed her, hoping it would obscure my face just long enough to distract Etess.

It was too late. Etess recognized me. The jig was up.

"Oh my fucking God!" he screamed. "You're Ron Hyatt!"

"Excuse me?" I said, deepening my voice and assuming a regal pose that I hoped might make me seem like one of the Grossinger's regular clientele. "I think you have me mistaken with somebody else."

"Fuck you, Ronnie. I know it's you!"

I could feel sweat beginning to trickle down my forehead. I was busted! All that remained was for Etess to fire me and send me packing. But he didn't. Instead, he just laughed and hugged me like we were old friends.

"Unbelievable," he said. "That's pure genius, Ronnie! I can't believe you had the balls to pull it off."*

We partied together for most of the night, flirting with girls and dancing until our legs felt like rubber. I was a bit more careful after that, visiting the hotel's clubs only when I was sure that none of the higher-ups might be there. But when the owner's son himself lets you get away with bending the company rules, it's hard not to feel like you're untouchable.**

* He also guessed that I was a Pisces (which I am).

** When Grossinger's went out of business, Mark went to work as Donald Trump's right-hand man. Twenty or so years later, I went to Atlantic City with Sam Kinison, Bill Gazzarri and Mark Saginor (Hugh Hefner's doctor) to see my friend Frank Stallone sing at one of Trump's hotels. I decided to pay Etess a visit. I

The restaurant managers weren't quite so generous with me. They had no sympathy when I'd arrive late for my shift, especially when my puffy eyes and bleary expression made it painfully obvious that I'd spent another all-nighter at the discos.

"You're fucking late!" they'd scream at me. "I know you had a fucking date last night! Any other guy, I'd let it go. But not *you*, Hyatt!"

I probably deserved the abuse. Even for a kid with little use for sleep, I was burning the candle at both ends, working all day and chasing the girls all night. All around me were vacationing women, walking around in their skimpy bikinis, looking for a fling with the first teenage boy with a big penis to walk up and buy them a drink.

Not all of the flirtation between the staff and guests was frowned upon in some of the smaller hotels. When it came to the Borscht Bunnies, sometimes we were expected to "date." Though we couldn't socialize in their nightclubs or discos, there was an unspoken understanding that we were allowed to "take care of the women" if they needed company.

Sometimes it was taken further. Sometimes it *wasn't* an unspoken arrangement. Once our manager sat us down and said, "You're dating this girl."

That was exactly what happened with Connie. Poor, innocent, homely Connie. The hotel was the Paramount, in Parksville.

When we arrived in the morning for our daily chore assignments, we all noticed that a new job had been added to the list. As the manager explained it to us, one of the more affluent guests was visiting the Paramount for the summer. He was staying at the most exclusive, deluxe, superexpensive condo, and he wanted to get his money's worth. He had a daughter named Connie whom he wanted to, as he

talked to an employee at his hotel and said, "When Mark finds out that I'm here, he's going to *die*." The employee's exact words were: "He already has." She told me that Mark had been killed in the highly publicized Trump helicopter crash years earlier. I was stunned. RIP, Mark Etess . . . old friend.

put it, "have a good time." And who better to show her a good time than a nice Jewish waiter who would be closely supervised?

Her name was listed on the bulletin board under chores like vacuuming the carpet and burnishing the silverware. "Date Connie." We couldn't believe what we were reading. This was a *chore*? What was wrong with this girl, anyway?

As it turned out, quite a lot.

Connie was not easy on the eyes. I'm not saying I'm God's gift to women. I'm not saying I'm in great shape right now. I hate to say bad things about anybody, but she was everything unattractive you could imagine in a girl. She had braces and buckteeth and pimples and acne and a high-pitched nasally voice that sounded like fingernails being scratched down a blackboard.

My brother (also a waiter) said, "Great. This hotel has our mind, heart, and soul, and now it wants our *balls*."

In some ways, dating Connie was worse than polishing the silverware or cleaning the bread trays. But when the time came, we accepted our chore assignment gracefully and took Connie out on the town. My friend Randy, however, was not quite so willing to be a date for hire. He called it "taking out the garbage."

"Aw fuck, guys," he moaned. "I don't want to do this. She's a fucking cow. God*damn*it, it's too fucking nasty to think about. I'll trade you vacuuming the dining room."

The next morning, Connie walked into the dining room for breakfast, and I asked about her date with Randy.

She snorted and rolled her eyes. "Oh my *God*," she said in her most nasally voice. "He was an *animal*."

"*What*?"

From every corner of the restaurant, waitstaff and busboys came running. We gathered around the table, pleading with her for more details.

"He kept trying to force his lips into my lap," she said, delighted with the attention. "And then he pulled out his schmeckel and asked me to touch it."

"Did you do it?" we asked, a bit too eagerly.

"Oh *God* no," she shrieked. "It was disgusting."

We couldn't take it anymore. We rolled on the ground in laughter. Here was the only guy on the entire staff who complained about dating Connie, and he was the only one who actually made a move on her.

Needless to say, we teased Randy mercilessly. And he denied it all, of course. He howled about the injustice for weeks, but it was hard to miss the excitement in his eyes when he checked the chore assignments every morning, scanning for Connie's name.

The list of summer chores got a little shorter that day. We still had to empty the trash and vacuum the carpets. But when it came to Connie duty, we knew just the guy who would always be happy to trade.

Will you stop laughing?"

"I'm not laughing!"

"Move your leg over a little bit. You're squishing your balls together."

"Like this?"

"That's great. Now hold that position."

"Wait, wait, give me a minute to suck in my gut."

"You don't have a gut."

"Are you sure? They say the camera adds twenty pounds."

"Relax. You look amazing. Now shut up and smile for me."

The year was 1977, and Alison and I were enjoying a private weekend together to celebrate the end of the summer. Alison was my girlfriend at the time, my first serious relationship since Mandy. She was a Taino, a Spanish Indian from Puerto Rico, and a vision of beauty. We met while working together at the Catskills, and I dated her for almost four years, which was some kind of record for me.

Eventually she would leave me, as all my girlfriends do, claiming that I was incapable of committing to a monogamous relationship.

"You're a lost cause," she would tell me. But at least for that summer, we were very much in love, and unable to imagine life without each other.

We were staying at the Paramount Hotel, which was a rare treat. When business was slow, the owners would allow their staff to live in the empty rooms. Because of our seniority, Alison and I had the pick of the freebies. We always stayed at the Deluxe Building, Room 214. It was our favorite suite because it was usually reserved for honeymooners. It had a king-size bed, a hot tub, anything that a couple of young lovers could possibly want or need. We bought a bottle of champagne and decided to make a romantic weekend of it.

Somewhere along the way, a camera got thrown into the mix.

It started out as a joke. For months, Alison had been teasing me to pose for some naked pictures. She wanted something to look at when she couldn't have the real thing, or at least that was her rationale. I agreed to do it, mostly in jest, never thinking anything would come of it. When she showed up for our weekend rendezvous with a camera, I thought, What the hell? It'll be good for a laugh.

I undressed and lay on the bed, and she began snapping pictures. It was awkward at first. I'm not, by nature, an exhibitionist, and it was a little discomfiting to be so exposed. Alison had seen me naked plenty of times, but never like this. It's impossible not to feel self-conscious when you know that you're making a permanent record of your body, available for anybody to see.

"Is it too hard?" I asked her, motioning to my penis. "I think it's too hard."

"It's not too hard, Ronnie."

"I've never seen erections in any of these magazines. Maybe we should wait until it goes limp."

"You're being ridiculous."

Our impromptu photo shoot had evolved from a silly little game into something more significant. She mentioned, completely off-the-cuff, that we could probably sell the pictures to *Playgirl* magazine and make a small fortune. We both laughed and I said, "Sure, why not?

God knows I haven't had much luck finding as much acting work as I wanted."

It had been a tough year for me. I'd given up teaching to become a full-time actor, but thus far I had only a few off- and off-off-Broadway productions to show for my efforts. I was just another out-of-work actor, living with his father and watching his savings rapidly dwindle away. But maybe getting into a magazine would be just the trick to jump-start some kind of career. The exposure would be invaluable. Granted, my cock would be getting most of the exposure, but it was better than nothing. Desperate times call for desperate measures.

I told Alison my plan, and she agreed that it was brilliant. Motivated by our new sense of purpose, we stayed up until the wee hours, shooting lots of film. The next morning, we went through every last Polaroid and narrowed it down to a select few. We bundled them into a manila envelope and walked down the block to the post office.

"Are you sure you want to do this?" Alison asked. We were holding the envelope together, dangling it over the mailbox as if we were daring ourselves to drop it.

"Yes, I'm sure," I said. She loosened her grip, which only made me clutch tighter. "I think I am."

She laughed. "You don't have to go through with this if you don't want to."

"I'm fine. What's the worst that can happen? The entire world gets to see my tallywhacker. Big deal."

"Okay then," she said.

"Okay."

She glanced at my hand, which was still clinging to the envelope. "You ready?" she asked.

I swallowed hard. "You do it first."

She smiled at me. "We'll do it together."

We counted down, like we were preparing to launch a rocket. And then we both let go.

When the October 1978 issue of *Playgirl* came out, I went to the nearest newsstand and bought two dozen copies. The salesman looked at me like I was some kind of pervert. He probably thought that I was gay, and very, very lonely. I considered explaining, but I was in too good a mood to be bothered. I almost wish that I had added a jar of baby oil to the stack, just to spook the poor guy a little more.

As you've probably guessed, my pictures had made it into *Playgirl*! I had hoped they might call me in for a professional photo shoot, but instead, they used the untouched pictures for a new section called the Boy Next Door. They sent me a couple hundred bucks, and that was the end of it. It would've been nice to be on the cover—that honor went to John Ritter, the lucky bastard—but I was happy just to be in the magazine.*

Now that my face (and the rest of me) was finally in print, I sat back and waited for the calls from producers to come pouring in. And just as I had hoped, they did. But they weren't from producers. And worst of all, they weren't calling *me*.

"Ronnie," my grandmother told me one morning over breakfast. "Some sissy called for you last night."

I nearly spat out my eggs. "I'm sorry, *what?*"

"A sissy boy called and asked if you'd be willing to meet him at the gas station downtown. Does that make any sense to you?"

"Uh . . ."

"I assume it was one of your drama friends. He sounded like a sweet fellow, though he was breathing awfully heavy. I'm guessing he has asthma."

It didn't take a huge leap of logic to figure out what had happened. Because I lived with my parents, I didn't have my own phone number. But my grandmother, Rose Hyatt, did. She lived down-

* Years later, I appeared in the magazine a few more times.

stairs in our house and was listed in the phone directory under "R. Hyatt." Anybody who had seen my pictures in *Playgirl*, where I was credited as "Ron Hyatt from Bayside, Queens," would surely think that "R. Hyatt," also residing in Bayside, must be the same person.

But when they called, expecting to talk to a young stud with a big cock, they ended up getting a very annoyed elderly woman who was in no mood to be pestered by, as she called them, "sissies."

"A lady called for you," she told me the next day. "She asked me to tell you that you're very handsome, and she loves your body. Ronnie, what in the world is she talking about? Do you know this woman?"

"Oh, yeah, sure," I lied.

"Well, when you talk to her, tell her that it's not in very good taste to call a complete stranger and tell her intimate details about her grandson's physique. It's just . . . it's inappropriate."

We expected the calls to stop after a while, but it only got worse. Rose even moved out of the house because she couldn't take it anymore, and it took a month before we could get her number changed. My dad was furious, and, of course, he blamed me.

"Listen, Ron," he said. "I don't have a problem with your getting into this naked, crazy business. But if you use the family name again, I'll kill you."

"Don't worry," I assured him. "I'm done with it. No more nude photos, no more magazine layouts. I'm going to stick to serious acting from now on."

And I meant it, too. Little did I realize that my idea of "serious acting" was very different from what was in store for me next.

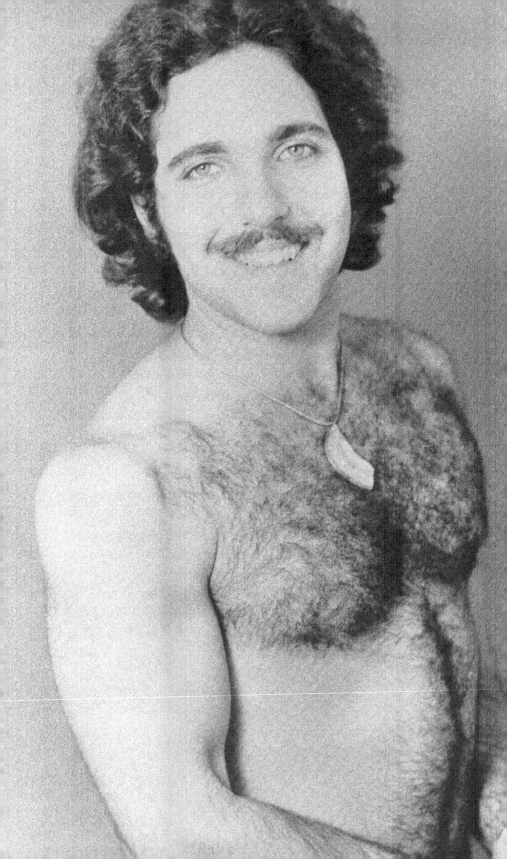

LIONS AND TIGRESSES AND BEARS, OH MY!

"You must be Ron Hyatt."

"Ron *Jeremy*," I corrected him with a nervous smile.

"Ah yes, of course." The production assistant scribbled on his call sheet.

"I'm using my middle name," I told him. "My dad, you see. He doesn't want me . . . It's a long story. I—"

"Yes, that's fine," he said, cutting me off. "I'll make sure the director knows." He opened the door to the house and pointed inside. "Right this way."

I was already having second thoughts. When the producers gave me the address for today's shoot, I had expected it to be a studio warehouse, or at least something that passed for a proper movie set. Instead, it was at a town house in lower Manhattan, which had been loaned to the producers just for the weekend. It all seemed too amateurish, like a student film that was operating on a limited or nonexistent budget. I wondered if it was too late to make a break for it.

I began to relax as the PA led me inside. The living room was filled with boom mics and cameras. Electricians were mounting lights, gaffers were running equipment, the director was barking orders at his crew. At least it *looked* like a real movie.

One of my first professional photographs.

I walked in just in time to watch the first scene in progress. Samantha Fox, the film's lead and star attraction, was sitting on the floor, chatting with her male costar. I'd never met her before, but I was well aware that she was one of the biggest names in the business. I thought about introducing myself, but I didn't want to interrupt. And it seemed a little weird just to walk up to a completely naked woman and say hello.

The director called for action, and Samantha began furiously sucking on her partner's cock. The crew and I watched silently, though they seemed more bored by the proceedings than I was. She gave it a few more strokes before looking up at the camera.

"When I have a lovely piece of flesh like this in front of me, I just fall apart," she said. "Most guys don't know it, but all women are tigresses. You should feel my cunt right now. It's open and wet."

She returned to her task, gulping down the guy's shaft as if she thought it might contain some magical elixir. Just the idea that I would soon be on the receiving end of this human vacuum cleaner was enough to give me a woodie.

"Not every gal is as direct as I am when it comes to hard cocks," she continued. "That doesn't mean they love stiff pricks any less. Sexually, they're tigresses, too. They just use a different approach. Some set their traps in the thorny jungles of social acceptability."

I felt a tug at my shoulder, and I turned to see another PA motioning toward the stairs. I followed him up to the second floor and into a back bedroom. Inside, there were five men standing around, talking among themselves and looking just as nervous as I felt. Sitting on the bed was a beautiful woman with long blonde hair and not a stitch of clothing.

The PA cleared his throat, and I managed to avert my gaze, at least momentarily, from the naked girl.

"Hello, Ron," he said. "I just wanted to take a moment to welcome you to our set. I understand this is your first shoot."

I shook his hand and tried to focus on keeping my balance. I had the sudden sensation that I might pass out at any moment.

"We've seen you in *Playgirl*, and we know you're a college-educated boy, and, from what we can gather, you have a nice, big dick."

"Uh, thanks," I said, swallowing hard.

"Hopefully you'll have fun today. As you saw, Samantha is in the middle of a scene right now, but we'll probably be ready for you in another fifteen minutes or so. In the meantime, feel free to enjoy Christie here."

He pointed toward the naked blonde girl. She smiled at me, and I gave her a wave. "Christie is our fluffer for today," he said. "And she'll be getting you hard so you're ready when the time comes."

"Sounds great," I said. I glanced over at the other guys, who didn't seem to have any intention of leaving. "So, uh, do we do it here or is there anyplace more private that we could . . . ?"

"There are four bedrooms on this floor. Feel free to use any of them."

"Good to know," I said.

"If you have any questions, please don't hesitate to ask."

"Is there a script?"

"Excuse me?" he said, already turning to leave.

"A script. I haven't learned my lines yet, and I was wondering if I could take a look at the script."

His expression turned suddenly dour, almost apologetic. "Yeah, about that. You're not going to have a lot of dialogue today."

"Okay, that's fine. But if I could just—"

"Actually, you don't have *any* dialogue."

"No dialogue?"

"No, sorry."

"Just sex," I said, the color leaving my face.

"That's right." He gave me an encouraging pat on the back. "Don't worry, you'll be fine."

As he walked away, the panic returned. My every justification for doing this movie had just evaporated. I had managed to convince myself that it still qualified as acting. But without any actual dialogue,

everything had changed. I was just another piece of meat, fucking on-screen for the amusement of some lonely raincoaters in Times Square. All of my training in Stanislavsky and Bertolt Brecht suddenly seemed like one big fat waste of time.

"You okay, sweetie?"

I looked up and saw the fluff girl smiling at me reassuringly. "Yeah," I said. "It's nothing. I'm just—"

"It's okay, I get it." She took my hand and led me out of the room. "Don't you worry, I'm going to make sure you have a nice, big erection."

Actually, that wasn't what was worrying me at all. But when in Rome . . .

Fluffers are one of the most time-honored traditions of adult films, and also one of the most misunderstood.

Simply put, a fluffer is a woman hired to get the male performers hard, usually by blowing them. They work off camera, away from the action, and don't actually appear in the movie. It may sound easy enough, but it's one of the trickier jobs on a porn set. For one thing, they have the daunting task of bringing a penis from limp to erect, which is especially difficult when you're dealing with a bunch of nervous guys trying to learn their lines while they wait for their cue. On top of that, the fluffer has to get a guy erect, but not *too* erect. If a fluffer gets a guy so riled up that he walks on the set and explodes within a few minutes, or worse still, cums backstage, away from the cameras, she'll get reprimanded. It's a thankless profession, with none of the stardom or accolades of the featured actresses and at half (or less) of the pay.

Probably the biggest misconception about fluffers is that they are used on every porn set. Fluffers were first employed back in the early 1970s, during the days of 8mm loop shoots. Cameras rolled almost continually because of the small budgets and minimal supply of film.

There was no money for reshoots, so everything had to be perfect in the first take. A series of loops would be shot in one sitting, with each scene happening back to back without any downtime. Guys literally had to walk onto the set and be ready to go. There was no time to sit around and wait while the actors jerked themselves into a hard-on. Fluffers weren't a luxury, they were a necessity.

By the time I got into the business, budgets had gotten bigger and fluffers weren't always required. They were still used occasionally, mostly at the request of the actress. Annette Haven, for instance, was famous for demanding fluff girls on her sets. I saw her on a few sets, most famously in *Co-Ed Fever*. She was worried about smearing her makeup, so she made sure there were always fluffers available to "do the preparation work" and deliver slobbery blow jobs on her costars before she went to work on them. That way, she would still look pristine when the cameras started rolling. There have been actresses since who misused the fluffer principle, letting their fluffers do almost everything and coming in only at the last possible second. I even saw a few of them ask for fluffers in between takes, while the camera angle was being changed or a lighting gel was replaced. The fluffers would jump in and continue blowing the guys while the actress would sneak away for a smoke. If you ask me, it was weird. If you're so opposed to having sex, why the hell are you in porn anyway? Eventually fluffers were phased out completely, and by the early 1980s, guys had to get themselves hard on their own time, and the actresses, whether they liked it or not, had to get their hands (and the rest of them) balls deep into the nookie.

In recent years, fluffers have made a comeback, no pun intended (well, maybe a little). With the popularity of gang-bang films, like the *World's Biggest Gangbang* series starring Houston, Annabel Chong, and Jasmin St. Claire (all of which I emceed, by the way), fluffers became a requirement again. When you're dealing with multiple partners, anywhere between fifty to five hundred guys, most of them amateurs, somebody has to help them get hard. The exhausted star, who has to take occasional breaks to ice down her vagina, can't pos-

sibly attend to all of them. So fluffers became a booming business. But unlike the fluffers of the past, the modern-day fluffer would be seen on camera alongside the featured players. In technical terms, it wasn't strictly fluffing, it was part of the production. But the same rules applied: get the guys hard, but not hard enough to pop.

Without fluffers, the studs of today turn to religion. You'll see them in some corner of the room, jerking their cocks and saying, "Oh God, let me get a hard-on. Oh God, I don't want to be embarrassed by failing in front of all these people." I assume that if the Lord above hears these prayers, He's probably saying, "*What?* You want me to do what? Help you get hard so you can commit sodomy?* I'm busy right now. I've got things to do. Try downstairs. That's *his* department."

People sometimes ask me if I miss the era of fluffers. Hell *yeah* I miss them. What could be better than showing up on a set expecting to fuck one girl and finding out that you get to mess around with *two*? It was twice the fun for the same paycheck.

The fluff girl had been blowing me for several minutes before I recognized her.

"Holy shit!" I said, nearly falling over backward. "You're Misty Winters!"

She looked up at me, my cock still tonsil-deep in her throat. "That's me," she said, or muffled words to that effect.

I wouldn't say that I was starstruck. She wasn't exactly in the same league as a major mainstream celebrity. But at least in the porn world, she was about as close to the top as you could get. She had appeared in *Debbie Does Dallas*, one of the biggest adult movies of

* Which, by the way, is against the law in parts of Virginia and Oklahoma. Which is kinda funny, if you think about it. Commit sodomy in these states and they'll throw you in jail, where you'll get . . . sodomized!

all time. When she was introduced to me as Christie Ford, I hadn't made the connection.

A lot of thoughts went through my head after realizing that my penis was in the mouth of a quasi-famous actress. The most prominent being, Why would the costar of a classic of erotica be fluffing guys off camera for chump change? Was she just in the neighborhood and decided to do the director (and actors) a favor? Was she such a fan of giving blow jobs that she'd jump at any opportunity, even if it meant she wouldn't command the same salary as a featured actress? I might've asked her some of these questions, but it's difficult to initiate a conversation when, as I mentioned already, your penis is in the mouth of a quasi-famous actress.

Just as I was really beginning to enjoy myself, I heard a knock on the door.

"Okay, Ronnie," a voice from outside yelled. "We're ready for you."

I pulled out of the fluffer and threw open the door. A PA escorted me downstairs, where Samantha and the rest of the crew were waiting for me. I just stood on the sidelines, not sure what was expected of me.

"Okay, Ron," the director said, breaking the silence, "whenever you're ready."

"Should I . . . ?" I motioned toward Samantha.

Samantha slapped the floor next to her. "Take a seat over here, cowboy."

I wandered over and sat gingerly next to her. I was like a schoolkid on his first day of school. I squinted into the bright lights, waiting for some kind of direction. I had no idea what to do next. Should I touch her? Wait for her to touch me first? I looked at Samantha and managed a feeble smile. She laughed at my tentativeness and shoved me to the ground.

"Don't worry, kid," she said. "I promise I'll be gentle."

She grabbed my boner and gave it a few strokes. It was more of a friendly hello than anything overtly sexual. But as soon as the cameras began rolling, her mouth dived onto it and began sucking like a

category 5 hurricane. It felt amazing, but my attention kept drifting over to the crew members, who were hovering over us on all sides. It was impossible to concentrate with so many eyes on me, and within a matter of minutes, my erection had disappeared.

"I'm sorry, I'm sorry!"

"It's okay," Samantha said, letting my flaccid penis fall out of her mouth.

"This doesn't usually happen, I swear."

"How can we help?" the director asked. If he was annoyed by my inability to perform, he wasn't letting on. He voice was calm and encouraging. "Do you want to go see the fluffer again, or would—?"

I jumped up and ran toward the stairs like somebody was chasing me. "Yes, thanks, that'd be great," I said, all but pushing a cameraman out of the way.

When I got upstairs, Christie was already working on the next guy. He looked up at me with panic in his eyes, probably assuming that it was his turn to perform.

"Listen, I hate to be a bother," I said, "but do you mind if I borrow her for a minute?"

"Excuse me?" he said.

I pulled Christie to her feet and dragged her out of the room. "Just five minutes and then I swear, she's all yours."

We found an empty bedroom and Christie started blowing me again. But it wasn't working this time. I kept thinking about all the cameramen and gaffers and grips and makeup people downstairs, waiting for me and expecting me to come waltzing in with an erection that could cut glass. I needed something a little more intense to put me in the right mind-set.

"Can I ask a favor?" I said to Christie. "Would you be offended if I ate you out a little?"

"Sure," she said with a shrug, "knock yourself out."

I know this may surprise you, but I've always preferred giving head to receiving it. There's nothing I enjoy more than being face-deep in a woman's snatch. And though this may sound like bragging,

I'm very good at it. Maybe it's because I like to eat. Vagina, lasagna, whatever.

It was working. My penis was beginning to show signs of life. Just to be on the safe side, I stood up and rubbed it against her pussy. I didn't insert it, just rubbed the tip against her lips. That was another technique of mine, which I'd been using since my teens. There was a time when girls called me Ron "Just the Tip" Jeremy. It's not as penetrating as actual sex, and I've found that it's the perfect way to get a girl nice and wet, because you're rubbing the clitoris under the hood.

Sometimes, when I was about to have actual sex (often anal), a girl would say, "I don't know if this will work," or "You're too big."

"How big is your boyfriend?" I'd ask.

"Six inches."

"Fine. I'll only put in four."

It worked every time. And the excitement of just being in the vicinity of a vagina was usually enough to make me hornier than a dog in heat.

Though my erection was as stiff as could be expected, I wanted to be sure. No point in returning to the set only to go limp again. Perhaps something a bit more adventurous would ensure that my boner stayed at attention.

"Do you mind if we screw?" I asked Christie. "Just a stroke or two?"

"Sure," she said, with enough enthusiasm to let me know that she wasn't just being polite.

"Want to just ride me?"

"Sure," she said. She threw me to the bed and jumped on top of me, slipping my cock inside her without the slightest hesitation.

It was at that exact moment that a PA came barging into the room. "Are you about ready here?"

"Almost," I muttered.

It took him a minute to realize what was happening. "What the hell? Are you out of your mind?"

"Don't worry," I told him. "I know what I'm doing."

He stifled a laugh. "Y'know, Samantha is more than happy to fuck you. You didn't need to save it for the fluffer."

Christie, a consummate professional, could feel that I was coming dangerously close to cumming and promptly jumped off of me. I stood up, shoved the PA out of the way, and bolted toward the door.

I tumbled down the stairs, screaming at the top of my lungs, my massive boner waving in the air like a pendulum.

"Roll! Roll! Roll! Roll the cameras! Roll the cameras!!"

I saw my first porno film in 1969, when I was just sixteen years old.

Actually, I'm not sure if it counted. The only reason it could've been called porn at all was because it had the word *pornography* in the title. It was called *Pornography in Denmark*, a documentary about the first country to legalize adult films. By today's standards, it wasn't even scandalous enough to shock the typical PBS viewer. But when my dad announced that he was taking me to the American premiere at the Mayfair Theater in Fresh Meadows, Queens, I was so excited that I couldn't sleep for a week. All I could think was, "I'm going to see a movie about boobies. Boobies, boobies, boobies. What god did I please?"

As it turned out, boobies in Denmark were hard to come by, even in a documentary *about* boobies. There were plenty of ancient-looking sexologists talking about boobies. But when it came to actually *showing* us boobies, they were apparently in short supply.

Things slightly improved during the summer of 1972, when *Deep Throat* opened in New York. I was nineteen at the time, and less interested in seeing other people have sex than doing it myself. But with all the media hullabaloo surrounding the film, I was at least curious enough to check it out. I went with a date to the Mayfair,

which probably wasn't the best of ideas. This was no *Pornography in Denmark*. *Deep Throat* featured lots of explicit hard-core sex with very little left to the imagination, which isn't exactly the sort of thing you want to watch with a prudish date. Luckily, the rest of the movie was pretty goofy, so we made the most of an awkward situation by mocking the terrible acting and sloppy production values.

Though I wasn't very impressed with *Deep Throat* as a porno, I wasn't so jaded that I couldn't appreciate Linda Lovelace's fellatio skills. Her technique was, if nothing else, unique. She didn't take the entire shaft in one gulp. She'd break a blow job down into stages. She'd take a penis into her throat almost to the point where it hit her epiglottis, and then she'd pause for a moment before sucking the rest of it down. It was as if she was deciding just how much she'd need to expand her throat to fit the rest of it inside. She'd make a cute little grunting noise—an "unngh" sound—and then boom, the penis would be gone, right down to the balls.

Harry Reems, Lovelace's costar, wasn't exactly small in the cock department. How she got all of him inside without his dick popping out the back of her head was a miracle. I was just in awe. It wasn't until years later that I learned a trick that Little Oral Annie used to do. Before a blow-job scene, she would cover her gums with butter or margarine. Apparently the lubrication made it easier for a cock to slide naturally inside and keep right on going.

A few years later, I saw the sequel, *Deep Throat 2*, in the Catskills. There was a drive-in movie down on Route 42 that showed adult movies exclusively, so I went with some of my teaching friends from Crystal Run. It was horrible. There wasn't any actual sex in it. It barely passed for soft core. My friends and I were outraged and left halfway through. I found out later that Arrow, the company that produced the original *Deep Throat*, was being investigated by the FBI, so they decided to make two different versions of the sequel: one an X-rated version and the other a softer, less-explicit R-rated version. The X-rated reels were stolen from the lab, so the company had no

choice but to release the R-rated version. It flopped, of course, because who wants to see *Deep Throat* without any deep throating?*

I went to see a few other adult films when I lived in the Catskills, mostly at the insistence of my friends. I didn't find them particularly erotic, and I sure as hell wasn't going to jerk off to any of them. For the record, I've never jerked off to porn. When I was a kid, I occasionally masturbated to *Gilligan's Island* and *I Dream of Jeannie*. I still prefer Mary Ann to Ginger. But jerking to porn just seemed too obvious.

It never crossed my mind that a career in adult films might be something I'd want to pursue. The actors weren't really actors, after all. They were just stunt people who could handle some dialogue. They were movable body parts hired to reenact fantasies. I wanted to be a *thespian*, performing great plays on Broadway or starring in major motion pictures. I wanted to be appreciated for something other than the size of my penis, or my ability to fuck in front of a camera. No, I thought, the very idea is preposterous. Not even worth considering.

It's funny how quickly your entire outlook can change.

In 1978, not long after my *Playgirl* spread, an acting friend arranged for me to meet Jim Sandberg, a New York–based director who'd made a name for himself with low-budget B movies. I was beside myself with excitement. It was my first contact with a legitimate film-maker, and I was ready to take whatever role he offered.

"I hate to break this to you," Jim told me when I called. "I don't really make B movies anymore. I'm mostly doing X-rated stuff these days."

* Years later, I directed *Deep Throat, Parts 4, 5,* and 6 for Arrow Films. I had the girls try the Little Oral Annie technique, and it *worked!*

My heart sank. "Oh, well that's—"

"Have you ever thought about doing an adult film?" he asked.

"Not really," I said, being totally honest.

"We could use a guy like you. I've seen some of your theater credits, and I'm very impressed. You studied with Dr. Stephen Macht and Joel Zwick* of La MaMa, isn't that right?"

"Yeah."

"I also saw you in a production of *Salome*. That was probably the best interpretation of King Herod I've ever seen."

"Thanks." I was blown away. He seemed to know more about my theater career than most of my closest friends.

"And, of course, I had to sneak a peek at you in *Playgirl*. Not bad at all. If you don't mind my saying, you have an extraordinary penis."

I had no clue how to respond to that.

He offered me a small part on his latest film, *All About Gloria Leonard*, based on the memoirs of the female publisher of *High Society* magazine.

"No," I said, a bit too quickly. "No, I think I'll pass."

"Okay," he said, unable to hide his disappointment. "Well, if you ever change your mind, feel free to call me. I'm sure I can find something for you."

I spent the rest of the week telling myself that I'd made the right decision. But all around me was mounting evidence that I had made a mistake. Since the mainstream success of *Deep Throat*, adult films had achieved a legitimacy that would've been unthinkable just years earlier. Porn directors were no longer stringing together unrelated sex scenes with flimsy or nonexistent story lines; they were creating actual plots with compelling characters. Gone was the silly hamming of *Deep Throat*. The new breed of adult actors performed, in some ways, with the intensity and commitment of a trained Broadway player.

* Joel went on to direct *My Big Fat Greek Wedding*.

Even more surprising was the crossover potential. In the days of porn loops and stag films during the 1960s, there was a clear line between adult and mainstream actors. But thanks to the growing popularity of porn, it was beginning to change. Georgina Spelvin, who starred in the original Broadway production of *The Pajama Game*, took a break from theater to appear in *The Devil in Miss Jones*, and it only *helped* her career. Marilyn Chambers, who became an overnight sensation in the porn classic *Behind the Green Door*, was cast as the lead in the David Cronenberg film *Rabid*, and nobody in Hollywood questioned whether the public would buy a porno actress in a nonsexual role.

The floodgates had opened, and porn was no longer a shameful profession dominated by drug addicts and filth mongers. It could be a very real stepping-stone into the mainstream, and it seemed as if I was the only actor in New York who hadn't figured it out yet.*

But I wasn't ready just yet to jump blindly into the porn trade. Before I made such a monumental, life-altering decision, I needed to talk to my dad.

He listened silently as I explained it all to him. I told him that I wasn't looking to stay in adult films forever. It would just be a temporary thing, just long enough to get a few film credits under my belt. I told him about the director I'd spoken to, Jim Sandberg, who was widely considered to be one of the best foreign-sex-film directors of all time. I wasn't putting myself in the hands of some hack smut peddler, I told him. This guy was a genius. A respected filmmaker who could feasibly help my acting career.

"Well," my dad said after a long and thoughtful pause, "I guess, if you think it sounds like a good idea, you know more than me."

"Really?" I hadn't expected it to be so easy.

"You've been in *Playgirl*, so people have already seen you nude."

* Of course, you wouldn't see porn stars in movies meant for a children's audience, or in most TV commercials.

"That's exactly what I thought!"

"At least you're performing in front of a camera—and there's some story line to it, and you're doing some acting. If you *really* think this is a wise choice, you have my permission. But I do hope you go on to better things."

I hugged him so hard, I nearly broke his neck. "Just one thing," he said, his face buried in my chest.

"Anything."

"If you use the name Hyatt, I'll kill you."

I could only imagine that, somewhere downstairs, my grandmother was thinking exactly the same thing.

Do you want me to cum now?"

The entire crew was staring at me, as if I had just sprouted wings and a tail. I wondered if I was being too presumptuous. Maybe I should just shut up and do as I was told. I didn't want to be branded as difficult before I'd even finished my first scene.

"Uh, yeah," the director, Jim Sandberg, said. "You think you can?"

I didn't just think I could, I *knew* I could. Cumming had never been a problem for me. Once I have an erection, I could time my orgasms literally down to the second. I could stall for hours or pop within seconds, depending on my mood. In my social life, this was nothing more than a mildly amusing trick. But, as it turned out, on the set of a porno film, it was a valuable and rare commodity.

"Sure," I said. "Just tell me when you need it."

The director and crew shook their heads in amazement. "Wow," a gaffer muttered under his breath. "This guy is good."

"Can you do it in one minute?" Jim asked.

"Yeah, no problem." I glanced at my watch. "One minute and counting."

Samantha laughed, which didn't exactly help matters. Any

contraction in her vagina was enough to make me cum ahead of schedule. But I managed to cling to what remained of my willpower and continue the scene.

Samantha was riding on top of me, grinding onto my cock with violent thrusts. Normally, this is a dangerous position for me; it's when I have the least amount of control. When a guy is on top or doing doggy, he can control his strokes, slowing down or speeding up as needed to keep from exploding. But when the girl is on top, she has complete control. If she decided that she's going to pound away at you at lightning speed, there's not a damn thing you can do to stop her.

To make this work and cum on command, I would have to draw on some juju magic.

I was fighting an uphill battle, especially considering that I was working with a sexual hellcat like Samantha. She wouldn't just fuck you, she'd rip you to shreds. She had incredible control of her pussy muscles. I didn't think it was possible for an orifice to have such powerful suction. It was like putting your penis into the circulation pump of a swimming pool, but without the nuisance of spinning blades.

"Okay, let's get the pop shot, please," Jim announced.

Thank God, I thought. It's about fucking time.

The set went eerily quiet as they awaited my orgasm. I pulled out of Samantha, and she jerked me off as I popped into the air. And let me tell you, I came *gallons*. The sperm came blasting out of me in a torrent, like somebody had replaced my penis with a hose and turned it up full blast.

Samantha continued to jerk my penis, squeezing out every last drop, then turned to the camera to deliver her final line: "Did you see that juice?" she asked. "Tigresses always get their milk."

It was all I could do to keep from laughing. "Tigresses always get their milk?" Who *wrote* this stuff?

Jim called for the cameras to cut, and the entire crew burst into applause. I wasn't sure if they were applauding me or Samantha, but I felt a surge of pride nonetheless.

"Holy shit, kid," Samantha said with a wicked grin. "Where'd all that sperm come from?"

I smiled back at her, and with a completely straight face, I said, "Chicken soup."

That's right, chicken soup. When I was growing up, chicken soup was a medical necessity in our house. My grandmother used to call it "Jewish penicillin." Whatever is ailing you, chicken soup will take care of it. I ate so much chicken soup during my youth that it was practically coming out of my ears. If chicken soup could cure any number of diseases, well, it was only logical that it could have other benefits, like increased semen production.

Of course, I didn't really believe that. I knew it was bullshit. But it was less embarrassing than the truth.

The real reason that I came so hard was that I held back. When I learned that I had the job, I didn't have sex for a week. I wanted to make a good first impression, and cumming like Niagara Falls seemed like the best way to do that.

"Chicken soup?" Jim asked. "Seriously?"

It was too late to change my story now. "Yeah," I said. "A bowl of chicken soup two hours before sex. Works every time."

Little did I know that I had inadvertently started one of the biggest insider myths in the New York porn world. Word spread quickly around the set, and by the time I returned upstairs to get dressed, two of the actors had already sent out PAs to get chicken soup.

"Thanks for the tip," one of them told me.

Years later, chicken soup would become a common sight on porn sets. I'd show up for a shoot and find cans littering the dressing room. Even Samantha Fox's boyfriend, porn actor Bobby Astyr, bought into the folklore. Whenever I'd see him, he'd invariably have a few bowls of soup heating nearby.

"Oh yeah," he'd explain. "It makes you cum like a volcano. Chicken soup is very good for you."

"Well, sure," I'd say. "But not for *sperm*!"

When I left the set, I went straight over to my sister Susie's apart-

ment; she lived just a few blocks away. I burst inside and screamed, "I did it!"

"Oh my God," Susie squealed. "You really went through with it?"

"I did! It was amazing! I popped and everything!"

Susie took a step away. "Okay, I probably didn't need that last bit of information. But thanks for sharing."

In just a few weeks, my feature-film debut was out in theaters. It was called *Tigresses . . . and Other Maneaters*, and I was one of the first in line to see it. I'd be lying if I didn't admit to being a little disappointed. When they finally got to my scene, it took me a minute to recognize myself. You couldn't even see my face! I was just a headless torso, and the top half of me was completely out of the frame.

"What the hell?" I grumbled, unaware that I was speaking out loud. "I spent an hour in makeup, and they didn't even shoot my goddamn *face!*"

"Will you keep it down?" a man sitting nearby yelled at me.

I mumbled an apology and eased back into my seat. A part of me wanted to turn to him and say, "Listen, jerk, you see that huge pecker up there on the screen, shooting off like a fireworks show made entirely of viscous fluids? That's *me*, asshole."

But I didn't.

I just sat there and watched myself in action, dreaming about the day when my face wouldn't get second billing to my cock.

"Ron 'The Hedgehog' Jeremy. I think that has a nice ring to it."

chapter 4
A STAR IS PORN

I knew I was in trouble when it started to snow.

I'd been cast in a movie called *Olympic Fever*, which was being shot in the mountains of Southern California. It was my first trip to the West Coast, and I'd tried to pack accordingly. I brought a few pairs of shorts and linen shirts, everything I needed for the eighty-degree weather. What's more, I had opted against renting a car, assuming I could get around just as easily with a motorcycle. Back in New York, a bike was my main mode of transportation. I owned a Honda Hawk that I used to commute between Queens and the city. During the winter months, it could be a major pain in the ass, especially when the roads were icy. But here in the Sunshine State, I thought, it was the perfect environment for motorcycle travel. Nothing but sun and warm weather. It was going to be glorious.

But I had been seriously misled about just how goddamn tropical this state was.

When I walked off the plane at the L.A. airport, the weather was pleasant, almost humid. So I jumped on my bike wearing the skimpiest outfit I owned and headed up to Lake Arrowhead. It's a two-and-a-half-hour journey north of Los Angeles, up in the canyons near

Victory shot. 1980. (Photograph by Len Tavares)

San Bernardino. I wasn't thrilled about driving through unfamiliar mountains, but I had the luxury of taking my time, because I wasn't needed on the set until later that afternoon. I planned on taking a long, leisurely trip, enjoying the views, and soaking up the rays of my first April day in California.

When it started to snow, I thought it must be some kind of sick joke. The snow turned into hail, and then just as quickly became a blinding blizzard. Before long, I wondered if I was going to die.

Up until that day, it had been a great couple of years for me. I'd worked steadily since *Tigresses*, making an average of six films per month. And best of all, I was even given *speaking* roles, where my face was seen about as often as my penis. I appeared in high-profile movies like *Mystique, Object of Desire, Blonde in Black Silk, The Good Girls of Godiva High, Pink Champagne*, and *Women in Love*, to name just a few. But it was a film called *Sizzle* that put me on the map. At long last, I was really able to *act*, showing off my comedic abilities with a goofy southern accent that was played more for laughs than authenticity.

It was because of *Sizzle* that I had caught the eye of Phil M., the director responsible for one of the most lauded big-budget pornos of the late 1970s, called *Lust at First Bite*. It starred all the major names in adult movies: John Holmes, Seka, Serena, and Jamie Gillis. I'd seen the movie when it opened in New York, and I was floored by it. It was by far the funniest comedy I'd ever seen in porn. Some of the dialogue was so smart you forgot that you were watching a skin flick. And what's more, it featured some kinky scenes, from sex with vampires to mental patients with delusions of prepubescence. Gillis, who played Dracula, had anal sex with at least two of his female costars. I couldn't believe what Phil had gotten away with for that time period, and I wanted to work with him. When he offered me a role in his second big feature, and free airfare to California for the shoot, I didn't have to think twice.

Not that I needed it, but he gave me an advance copy of the script for *Olympic Fever*. I read it on the plane, and laughed like an idiot

during the entire trip. It involved the U.S. Olympic swim team and a young swimmer with a protein deficiency that could be cured only by giving blow jobs. I was cast as a Russian spy, who, along with my partner (played by Seka) plotted to sabotage the swim team and stop them from winning gold at the summer games. We were basically doing versions of Boris Badenov and Natasha Fatale, only with less-believable Russian accents.

The snow was coming down in such thick sheets, I had no idea where the road ended and the cliff began. I could very well have plummeted to my death at any moment. And to add to my anxiety, the bitter cold had almost brought on the first stages of hypothermia. With nothing but a lightweight T-shirt and shorts to protect me from the elements, I was shivering so violently that I could barely steer my bike. There were icicles on my mustache. I fully expected to die of frostbite.

At long last, I saw the campgrounds in the distance. To re-create an Olympic training camp, the director had found an abandoned Boy Scout camp in the middle of the woods. I'd never been happier to see civilization, though I had a surge of panic when it occurred to me that there might not be running water or heat at this place. It was, after all, a fucking barracks.

I staggered toward the nearest bunkhouse and knocked weakly on the door.

"Good Lord! What happened to you?"

I almost collapsed into Bill Margold's arms. He was an actor and cowriter on *Olympic Fever*, and large enough to drag my limp body inside. By the expression on his face, I thought it might already be too late for me.

"You drove a *motorcycle* up here?"

"I didn't know," I whimpered. "It's California in the spring. What happened to the expression 'sunny California'?"

"Ron, we're up in the mountains. It's cold."

"Well, I didn't fucking know that," I shouted at him with my last burst of energy.

He took me into a back bathroom and pointed toward the

shower. With what little strength I had left, I stumbled out of my clothes. "I have someone here who might be able to warm you up," Margold said. He called over Connie Peterson, a beautiful blonde actress who'd been rehearsing with him before I arrived.

"Oh, you poor baby," Connie said, giving me a sad look like I was a sick puppy. She stepped into the shower with me, turned on the hot water, and soaped down my ice-covered body. When my body temperature finally returned to something resembling normal, she asked if I wanted to fuck.

Well, sure, I thought. After a near-death experience, nothing makes you feel alive again like having sex in the shower with some big-boobed woman. Even if it was just a sympathy screw, I was happy for whatever I could get. I didn't climax. I knew I had to save it for my scene with Seka later that day. But it was enough to get my blood circulating again, which is all I really needed.

When I walked out of the shower, feeling refreshed and rejuvenated, Margold was waiting for me, along with Seka and a few of the other actors. He took one look at me and burst into laughter.

"What's so goddamn funny?" I asked him.

"Will you look at this guy," he said to the others. "He's all pink and furry, like a little hedgehog."

"Oh, fuck you," I snapped.

"You look like one of those animals in *The Wind and the Willows*."

The entire room was laughing, so I ran back into the bathroom to check my reflection in the mirror. He was right, the combination of extreme cold and heat had given my skin a pink hue. And the hairs on my body were standing on end, which did sort of resemble the furry bristles of a rodent. Although hedgehogs *are* kinda cute.

Margold was standing right behind me, enjoying the view. "You are a hedgehog, my friend," he said with a smirk. "A walking, talking hedgehog."

"Will you please shut the hell up?"

"Ron 'The Hedgehog' Jeremy. I think it has a nice ring to it."

"You're an asshole," I told him.

I could only pray that the nickname wouldn't stick. That's the kind of thing that could haunt a guy for the rest of his life.

I never wanted to be a porn star. But once the wheels were in motion, I became insatiable. It wasn't enough just to do one or two films, I had to do *everything*. When there weren't any jobs for me in New York, I'd jump on a plane to L.A. or San Francisco or anywhere that I was booked for an adult production. I didn't care where it was happening or what the film was about, I wanted to be a part of it.

It was a large part of why I became so famous in the porn world so quickly. I worked more than most because I was willing to do the legwork. At the time, porn actors tended to live either on the East Coast or the West Coast, and they didn't travel unless it was absolutely necessary. If a movie was being shot in their neighborhood, they'd do it. If not, well, they'd just wait until one was. But I didn't have that kind of patience. I wanted to stay busy. I wanted to work. And if that meant leaving one set at midnight and driving to LAX to catch a red-eye to New York for another movie the next morning, I'd do it.

Although it wasn't the career I'd hoped for, I was still a working actor. I studied my scripts and tried every day to give the best performance I could. Except for the "having sex on camera" part, I was living the life that I had always dreamed about.

Granted, there were days when it wasn't much fun. There was one shoot* in Majorca, Spain, that promised to be a paid vacation. And for the first few days, that was exactly what it was. The sky was crystal clear, the water was blue; it was paradise on earth. But on the last day, I was scheduled to do a scene on an eighty-foot yacht.

* For a movie starring Cicciolina, a popular porn star from Italy and a member of the Italian Parliament, believe it or not.

Because of my tendency to get seasick, I took a Bonine pill before boarding, just to be on the safe side. Nobody else in the cast or crew bothered to take anything, and after just a few hours out at sea, they all became deathly ill.

Not just a little queasy, mind you. They were puking in buckets, puking over the sides, puking in anything that so much as looked like a container. It was disgusting, and not exactly conducive for a morning of hot hard-core action.

But the show must go on, and, despite the fact that she had been throwing up all day, Caroline (the actress I was scheduled to work with) refused to cancel the shoot. She arrived on the ship's deck right on time, slipped out of her clothes, and gamely tried her best to perform. When your leading lady has a green complexion and her "come hither" eyes are really saying "I may hurl chunks at any moment," it's not the sort of thing that puts me in a sexy mood.

We tried to make the best of a rotten situation. We obviously couldn't do any positions where her face could be seen, primarily because of all the vomit coming out of her mouth. So we decided to stick to doggy-style. That way, she could remain perched near the ship's edge, where she was free to throw up to her heart's content.

But even with our careful choreography, I still couldn't bring myself to do it. It just didn't seem right. I stood behind her with my hard-on, watching the poor girl puke her guts out, all while her ass was aimed toward me, waiting for me to enter her.

I'm a gentleman. When a girl is puking, I like to hold her hair, not fuck her silly. Call me old-fashioned, but that's how I feel.

"Ron, just do it," she assured me. "I'll be fine."

I did the best I could, under the circumstances. If you've never had the chance to fuck a woman while she's vomiting over the side of a ship, I wouldn't recommend it. It's about the furthest thing from erotic that you could ever experience.

It was all eventually fixed in editing. Back on shore, Caroline recovered from her seasickness, and the director got a few "reaction shots" of her face faking an orgasm, with the ocean and the sky in

the background. In the finished movie, nobody would ever know that the woman who appeared to be moaning and groaning with ecstasy was, when the camera wasn't on her face, puking like a Roman at a vomitorium. It's all part of the magic of moviemaking, but I still can't watch the scene without grimacing.*

Those were the bad days.

On the good days, however, it was hard to believe that I was actually being paid to do this for a living. I remember being flown to Maui for a *Hustler* photo shoot in 1980. It was me and a female model named Danica. They took us by helicopter to a secluded beach, where a shipwrecked boat could be seen in the distance. They put me in a tuxedo and her in a cocktail dress, and we'd sip champagne on the beach and then eventually simulate sex. But on our first day, the photographer, James Baez, looked at the sky and said, "The sun isn't quite right today. Let's try again tomorrow." So we'd all take the day off and go Jet Skiing. Althea Flynt, Larry's wife, came along and paid all the expenses.**

The next morning, Baez looked at the sky again and it was still no good. "Okay," I said, "let's do some sailing." Althea came along again and, you guessed it, paid for everything.

This went on for days. Every day that we didn't shoot, we'd end up snorkeling or lounging on the beach or taking a catamaran out to the ocean. Every night we had huge lobster dinners. (It was then that I realized that food tastes so much better when someone else is paying for it.) I was spoiled rotten. I was the only one I knew who actually came *back* from work with a tan. I didn't need a vacation. Hell, my *job* was a vacation.***

* Both Caroline and Mario Salieri, the director, thanked me for a job well done.

** I was good friends with Althea, and when I saw Courtney Love at Larry Flynt's wedding, I got a chance to tell her what a great job she did portraying Althea in *The People vs. Larry Flynt*.

*** By the way, this shoot was one of the first *Hustler* centerfolds to feature a man *and* a woman. And to this very day, I have always appreciated the fine treatment *Hustler* and the Flynt family have always given me.

The best part of my travels was when producers would fly me to Los Angeles. I made the most of my visits, using every free moment to advance my career. When I wasn't on a porn set, I'd be driving my motorcycle around Hollywood, dropping off head shots with agents, hustling my way into TV auditions, trying to get my foot in the door of the mainstream.

Joel Zwick, my old movement teacher at Queens College, got me an audition with Bobby Hoffman at Paramount. He was directing episodes of *Laverne & Shirley*, and he briefly considered casting me as Laverne's fireman boyfriend. I ended up losing the job because I was too short. Another Queens College alum, producer Mark Rothman, helped me get an audition for *Happy Days*, for a guest stint as "Satan's nephew." It was just one episode, but it was still a very big deal. *Happy Days* was responsible for a lot of spin-offs. Robin Williams played Mork on *Happy Days*, and the network gave him his own show. Jimmy Brogan played an angel and got his own show called *Out of the Blue*. I would've given anything for that kind of opportunity. I had stars in my eyes. I would've dropped porn in a heartbeat. But I think they gave the part to some comic named Richard Levin. He never got a spin-off, but it was small consolation.

Some mornings, it wasn't worth getting out of bed. Jesus, I'd think, who does a porn star have to blow to get a break in this town?

Even with all my travels, I still called Queens home. I never bothered to get an apartment in New York. It would've been pointless because I was hardly in the city for longer than a day or two. And besides, when I did return to the East Coast, I wanted to spend time with my family. Particularly my mother, who had Parkinson's disease. Though I tried not to think about it, I knew that she was getting sicker and would probably not be around for much longer.

During the late 1970s, she underwent experimental cryogenic sur-

gery. It's a process where damaged tissue in the brain is removed by freezing it with liquid nitrogen. The doctors told us that freezing the tissue rather than cutting it would cause less bleeding. Cryosurgery had been successful in removing tonsils, hemorrhoids, and cataracts, and they were hopeful that it might work on Parkinson's.

The first few surgeries were successful, and we began to think that she just might pull through. But subsequent surgeries made her condition only worse. And it was by no means an easy procedure. It caused her such excruciating pain that, even under anesthesia, she'd often faint right there on the operating table.* She told me that the pain was worse than childbirth. I tried to keep her spirits up and remain optimistic, but she was too smart not to realize that she was running out of time.

She managed to live many more years, but it was difficult for her, because she had always been an independent woman. In many ways, she may have been one of the country's very first feminists. Long before I was born, she scared the pants off the family by enlisting in the army during the 1940s. She wanted to fight in World War II, which was not something that women at the time were expected to do, especially since she was a Queens College graduate. She served as a lieutenant in the Overseas Special Services, the direct precursor to the CIA. She was a translator and cryptographer, helping to decipher German codes. Her missions were so dangerous that she was given cyanide capsules in case she was ever captured.**

My father had his theories about how she developed Parkinson's. He thought that she might've been a casualty of war. While flying over Germany, she was frequently shot at by enemy planes, and

* They have since discontinued this type of surgery for Parkinson's.

** Almost everybody in my family served in the U.S. military. My father was a sergeant, fighting in the Philippines and designing and building radar towers. (He was a scientist even back then.) All of my uncles fought in World War II, and all of my great uncles and grandfathers fought in World War I.

the damage caused the cabins to lose oxygen. Her brain may have suffered because of the lack of oxygen, which feasibly could have resulted in her becoming ill. But I knew in my heart that even if she had advance knowledge of what would happen to her, it wouldn't have stopped her from going to war. She was a stubborn woman with enough courage to sustain an entire army.

When she became too sick to fend for herself, I would come home to help my brother, sister, and dad take care of her. She had just been hired as a proofreader for Random House, and she refused to give up her job despite her condition. Even if she wasn't able to use her body, she still found ways to keep her mind active. Random House would send her manuscripts, and she'd proofread them from her bed and send them back. But before long, she was too sick even to lift a manuscript without assistance. I tried reading to her, but it made her feel belittled and helpless.*

She died in a Bronx hospital in 1979, a year after I entered the porn business. I never got the chance to ask her what she thought of my career choice, but my dad insists that she would have supported me. A part of me knows that he's right. She used to say that I danced to the beat of a different drummer.

During one of my last summers in the Catskills, she and my father came up to visit and to watch me hang gliding over the mountains. The disease had already taken its toll on her body, and she was barely able to walk unassisted. My girlfriend, Alison, was with us, and she was so sweet to my mother. As I was gliding over them, Alison lifted her head and pointed toward me.

* Many, many years later at the St. James Hotel in Los Angeles, I spoke with Janet Reno, the former attorney general, about the current state of Parkinson's. Ms. Reno said she appreciated my mother's participation in the now-defunct cryogenic surgery, as it paved the way for more successful types of treatment. I also told her that my dad predicted twenty years ago that the real cure would be found through stem-cell research.

Hang gliding in the Catskills, mid-1970s.

"There's your son," she said helpfully. "That's Ronnie up there."

My mom had just finished her first round of cryosurgery, and she'd been in a medicated stupor for most of the day. She hadn't said so much as a word to anybody. But the moment she saw me, a smile crept over her face.

"Nobody really understands my Ronnie," she said with a sigh.

She was right. And I hope that wherever she is, she's still one of the few women in the world who does.

For as long as I can remember, I've had a paralyzing fear of death. I know that I'm going to die someday—hell, we *all* are—but the very idea of it is usually enough to give me nightmares. It may have something to do with watching my mom die, but I've had this anxiety long before she got sick. It just scares me to think that one day I'll cease to exist, and there isn't a damn thing I can do to stop it.

Over the years, I've found a way to overcome this existential terror. And it's all thanks to a distant cousin whom I never met.

His name was Eliott Weiss, and he died a war hero during World War II. Like most Jews at the time, he wasn't allowed to be an officer because of his faith. So he lied and told the army that he was a Christian. He never actually converted, but he wore a cross and professed to believe in Jesus. Though it was an obvious ruse, it worked, and he was promoted to lieutenant and sent to fight in the Battle of the Bulge as an airman, where he was shot down by a German sniper while trying to rescue his fellow soldiers. He was buried in Brussels under a cross. Later my aunts had his body exhumed and brought back to the States, to be buried under the Star of David, because, despite what his superiors believed, he was still a Jew.

He was posthumously awarded the Purple Heart and the Airman's Medal of Honor. I still have the airman certificate, dated March 24, 1945, which goes word for word like this:

He lived to bear his country's arms. He died to save its honor. He was a soldier and he knew a soldier's duty. His sacrifice will help to keep aglow the flaming torch that lights our lives, that millions yet unborn may know the priceless joy of liberty. And we who pay him homage, and revere his memory, in solemn pride rededicate ourselves a complete fulfillment of the task for which he so gallantly has placed his life upon the altar of man's freedom.

Every time I read those words, I get choked up. The tears just come streaming down my face. And it reminds me that I have no right to be so afraid of dying. "How *dare* you?" I tell myself. "Who the fuck do you think you are? You've had such a phenomenal life. These guys sacrificed everything, and most of them were killed when they were still kids. They didn't get to experience *half* of what you did. So get over yourself."

I don't know if I believe in reincarnation, but if it's true, I'm pretty sure that I was once a soldier. I can't watch World War II footage or even a war movie without breaking down. And while most of my family did, I never served even a day in the military. I managed to escape the Vietnam draft because it was a war that I didn't feel was necessary, so I missed my chance to experience war firsthand. But I still feel a connection with the men who fought and often lost their lives in combat. I've wondered if there might be some spiritual explanation for why I have so much empathy for them.

What better way to be reincarnated than as a porn star? As Henry Miller once wrote, "Sex is one of the nine reasons for reincarnation. The other eight are unimportant." So maybe there's a dead soldier, or soldiers, inside me, making up for lost time. It makes a certain kind of sense. Think about it: if you went to heaven and God gave you a choice of how you could be reincarnated, who would *you* pick?

"Well, you can be a scientist or a teacher or a porn star or a—"

"Wait, back up. What was that last one again?"

"Uh, porn star?"

"Yeah, that's the one. Sign me up for that."

Shortly after my mom passed away, I flew back to Los Angeles to be a contestant on *Wheel of Fortune*. It wasn't the big break I'd been hoping for, but at least I would be on TV. And I needed something to distract me from the heartbreak of losing my mom.

For obvious reasons, I competed under the name Ron Hyatt, not Ron Jeremy. I'm sure that Chuck Woolery, the host, wouldn't have been amused to learn that his family-friendly show had been infiltrated by a porn star. I did well. I came in second and won a bunch of gifts, including a trip to Mazatlan, Mexico, and graphite tennis rackets. I even made a dumb joke. When Chuck Woolery told me that I'd won a $20 gift certificate to a Beverly Hills clothing store, I said, "Twenty dollars in Beverly Hills? That won't even pay for parking."

As it turned out, I never got to enjoy my hard-won free trip to Mexico. Hours before I was going to get on a plane, I got a call from Bob Vosse, a photographer for *Club* and other mags. He asked if I was interested in doing a photo layout with Marilyn Chambers for a new book called *Marilyn Chambers' Love Positions*. I nearly crapped in my pants. This wasn't just another job; it was a chance to work with a legend, the star of *Behind the Green Door* and the *Resurrection of Eve*. I was in awe of Chambers, and not just because of her incredible body and scorching sexual prowess. She had a business savvy about her career, which was a rarity among actors in the adult industry. She was smart enough to negotiate a contract with producers that gave her a percentage of the gross from her films. With the profits from *Green Door* alone, she probably made more than a few million in two years.

I told Vosse yes. I'd do it. To hell with Mexico. I could eat tacos in the sun any day. But how often does a guy get to cozy up to a bona fide porn icon?

I showed up at Vosse's studio the next day, and it was like I was a newbie all over again. I had butterflies in my stomach, and when Marilyn waltzed into the room, naked as the day she was born, I nearly blacked out.

The shoot was soft-core, meaning that there wasn't any actual penetration. We were just supposed to *simulate* sex. But the moment I crawled onto the bed with Marilyn, I got a whopping boner that wouldn't go away.

Vosse stopped and gave me a disapproving scowl. "Ronnie," he said, "what the hell is that?" He pointed at my engorged knob. "You know this is soft-core. We're not supposed to see it."

"Okay," I said. "Give me a minute." I closed my eyes and tried to concentrate. I thought about dead puppies, car crashes, open-heart surgeries, my grandmother—anything to discourage my boner. But it refused to wilt.

It was ironic, really. I'd been on countless porn sets where I was expected to have a raging hard-on. Some days I was in the mood, and some days I had to fake it and beat the little bastard into submission. But the *one* time I didn't need a boner was exactly when it decided to pop out of its shell and get stiffer than a two-by-four.

"Oh come on, Ron," Vosse yelled at me. "Hide it behind her leg or something."

"I'll try," I told him.

"We can't shoot anything until you get that thing out of the way."

"I'm doing what I can."

"I have an idea," Marilyn said. We both turned to her. She had a mischievous grin on her face. "You can hide it right here."

Boom, right in her vagina.

She slipped it inside so casually I almost didn't realize what was happening. But when she started thrusting against me, my jaw very nearly dropped to the floor. I was *screwing Marilyn Chambers*! Me, a punk kid from Queens, a relative nobody in the industry. I couldn't believe it. The world must've turned on its axis. There was no other reasonable explanation for my good fortune.

Vosse frowned at us, but then just shrugged and began snapping pictures. "Fine," he said. "Works for me."

I'm not sure how long we were fucking before I heard a door swing open and heavy footsteps heading toward us. I was having too much fun to care, but out of the corner of my eye I could see a

huge figure standing near Vosse. I turned and saw Chuck Traynor, Marilyn's husband and manager, glaring at us from the sidelines.

I thought that I was going to have a heart attack.

I'd never met Traynor before, but I knew his reputation. He was Linda Lovelace's former husband, and the man responsible for orchestrating her porn career. Lovelace had just published a book called *Ordeal*, in which she claimed that Traynor had beaten her and held a gun to her head during the making of *Deep Throat*. I heard from very reliable sources that Linda was lying. She was just resentful about how quickly her star had fizzled. After *Deep Throat*, the one-time queen of porn quickly lost the spotlight to more ambitious and talented starlets like Marilyn Chambers. So Lovelace concocted an outlandish story about kidnappings and beatings, which perfectly played into the antiporn fanaticism of some of the feminists and religious zealots. The media ate it up. But none of it was true.

I think.

Long before *Deep Throat*, Traynor cast Lovelace in a series of 8mm stag films. This was in New York, I think, around 1971. The films were mostly nasty stuff. One was called *Piss Orgy*, which involved Lovelace getting peed on. There was also *The Fist* and *The Foot*, in which Lovelace masturbated with the respective body parts. But the most infamous was a bestiality loop called *Dogarama* or *Dog Fucker*.

I've never seen the film, but I heard about it from Eric Edwards, an actor who performed with Lovelace in most of the loops and claimed that he held the dog while Lovelace had sex with it. From what I understand, Lovelace sucked the dog's dick and then got fucked—literally—doggy-style. The dog's name was Norman.

I'd just like to reiterate that I've never been a witness to anything like this. I've never seen it, never been a part of it, and never would be. I know that it happens. I saw ads for bestiality movies in Times Square during the late 1970s. But I've never had any interest in that sort of thing. I've always been able to love animals in a different way.

But Lovelace wasn't so strict with herself when it came to human-on-dog sexual relationships. Or, if she is to be believed, Traynor wasn't. She claimed that Traynor forced her to do it, that he promised to kill her if she didn't have sex with a canine on film. I don't buy any of that story.*

This was all I could think about as I was lying on the bed in Vosse's studio, my dick plunging in and out of Chuck Traynor's wife while he watched just a few feet away.

I didn't really expect him to get angry. He'd been married to Marilyn Chambers for almost five years, and she seemed far too smart to stay with a guy who was abusive to her. But still, he cast an imposing figure. And even if you didn't believe all of the wild stories about him, it was still a little distressing to be caught in the act of screwing his wife, especially considering that it wasn't what he or Marilyn had hired me to do.

I remained perfectly still, waiting for some kind of reaction from Traynor. He was clearly surprised, but if he was angry with us, he wasn't letting on. And then, after the silence had become almost deafening, he began to laugh.

"Well," he said, winking at us, "I guess we can't really call this soft core anymore, can we?"

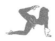

I didn't meet Chuck Traynor again until years later. He invited me to a dinner party at his house up in the hills of Las Vegas, where he and his new wife, Bo, were operating a horse stable and shooting range. (He and Marilyn had divorced, but they remained business partners and good

* However, Linda backed down a little on her claims that Traynor beat her and made physical threats. When she modeled for a *Legs* magazine centerfold shortly before her death, she recounted many of the stories to my friend Diane Hanson, who was in charge of the shoot and told me about it. She told Diane that some of the antipornographic feminists used her for their agenda. And she actually felt a little exploited by *them*.

friends.) I brought a girlfriend with me, partly because I wanted the company and partly because Traynor still made me a little nervous. I loved and trusted the guy, but still, it never hurts to have a pretty girl around.

Traynor cooked us a lovely steak dinner, and afterward we sat in his living room, sipping on cocktails and chatting about the business. It was just a friendly get-together, and I didn't expect anything more to come of it. But just as it was getting late and I thought about calling it a night, Bo turned to Traynor and asked, "Would you mind if I fucked Ron?"

He smiled and gave her an approving pat on the knee. "Sure," he said. "Go ahead. Have some fun."

She walked over to me, took my hand, and pulled me down to the carpet with her. I was not one to refuse free nookie, but it was weird nonetheless to be screwing Traynor's wife in his own home, right in front of him, after he had just cooked me a delicious steak dinner.

As Bo and I were screwing, my girlfriend joined Traynor on the couch and tried to return the favor by blowing him. But as skilled as she was in the oral arts, he politely declined her advances. He was more interested in watching Bo and me have sex than in doing anything himself.

After a few minutes of riding my cock like she was drilling for oil, Bo looked back up at Traynor and asked him, "Chuck, could Ron put it in my ass?"

"Sure, baby," he said, like she had asked for nothing more bizarre than to freshen up her drink.

So I changed positions, knelt on the floor, and began fucking her ass.* I was having the time of my life, all the while shooting sympathetic glances at my date. I couldn't help but feel badly for her. She was stuck on the couch, watching the two of us go at it without getting to enjoy any of the action. But we were in Traynor's house, and, as his guests, we both felt obligated to follow his rules.

* Less than a year later, Bo and I recreated that scene in front of a video camera, to be used in a Mark Carriere movie for Leisure Time Entertainment.

When we had cum and cleaned up, we thanked Traynor for a lovely evening and said our good nights. As we were leaving, I nearly tripped over a dog sleeping near the door. It was an elderly German shepherd (I think) that appeared to be at least ten years old. I squatted down to pet him, and as I was rubbing his stomach, a horrible thought occurred to me.

"Is this, uh . . . ?" I could barely get the words out. "Is this your dog?"

"No," Traynor said with an evil sneer. "It is now, but it belonged to Linda."

"Linda as in Linda Lovelace?"

"That's the one."

I just stared at him. Was he really telling me what I thought he was telling me?

"It's not . . . ?" I asked. My face had gone white.

"It sure is," he said. "That, my friend, is Linda Lovelace's son."

Chuck had a sick sense of humor. But in all actuality, it *was* the grandchild of the dog Linda slept with for the porn loops. Strange but true.

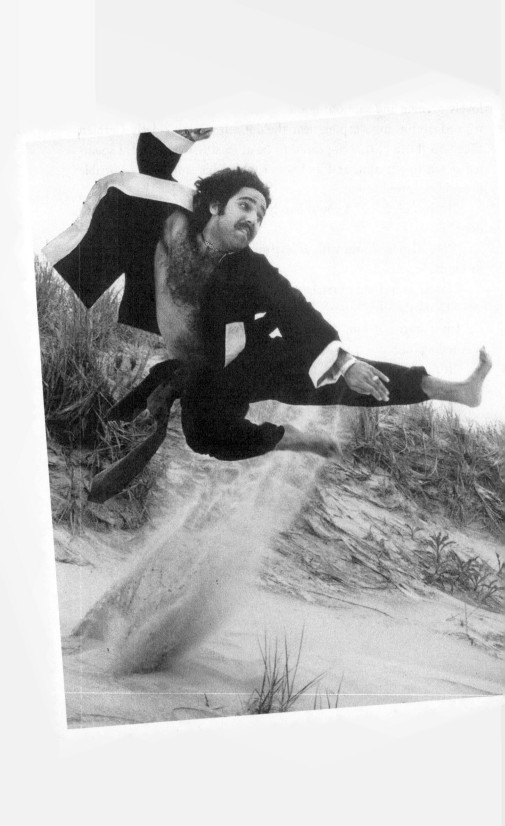

chapter 5

THE HUMAN OUROBOROS

"Can you really suck your own cock?"

It's not the kind of thing you expect to be asked by a pretty young woman just minutes after meeting her. But among porn actors, who were likely to be seeing one anothers' genitals before they had uttered so much as a hello, I suppose the normal rules of social decorum don't apply.

The year was 1980, and I'd just arrived on the set of *Co-Ed Fever*, which was being shot at a luxurious mansion just north of San Francisco. Even by Hollywood standards, it was a major production. We had a ridiculously large budget, a director who'd been plucked from the mainstream, and the most famous names in the business, like Vanessa Del Rio, Jamie Gillis, and John Leslie. But the producer, Harold Lime, had a thing for fresh faces. So for every legitimate star in attendance, there were at least three young beauties just getting their start in adult films.

And every one of them, it seemed, already knew about me, the kid from New York.

"I'm sorry?" I asked my buxom interrogator. "What did you say again?"

I earned a brown belt in Kung Fu—here I am jumping off sand.

"I heard that you could give yourself head," she repeated. "Is that for real?"

I raised an eyebrow. "Where'd you hear that?" It was a rhetorical question. I knew damn well where she'd heard it. I'd started the rumor myself. I should've known that it'd be only a matter of time before it came back to bite me in the ass.

"Is that a yes or no?" She was persistent, I'd give her that.

"Maybe," I said coyly.

She wasn't going to get an answer out of me quite so easily. We continued to stare at each other, our eyes locked in a meaningful gaze, like a flirtatious Mexican standoff. I could've just come out and told her what she was clearly dying to know, but I wanted to toy with her a bit longer.

"Can I see?" she finally asked, lowering her voice to a whisper.

I looked around the room to make sure that nobody was listening. "Okay, fine," I said. "But not here. Let's go someplace private."

I led her into the bathroom.

Let's back up:

Eleven years earlier, I was just another teenage boy with a very large penis and no idea what he could do with it.

I didn't always know that my dick was on the larger side. I assumed that I was a little larger than average, give or take an inch or two. I didn't have much basis for comparison, save for occasionally showering with other guys after gym class at school. And then the black dudes seemed to have the advantage. It wasn't until I started dating that I realized the size of my schlong might be in any way big.

Mandy was the first to tell me. Well, she didn't really volunteer the information. I had to finagle it out of her. Not long after we began seeing each other seriously for the second time, I was in her bedroom while she was talking on the phone with one of her girlfriends. In the

middle of their conversation, Mandy covered her mouth with a hand to keep me from overhearing. Normally I had no interest in her girly chats, but the secrecy had piqued my curiosity.

"What were you whispering?" I asked after she'd hung up.

"None of your business," she said, her face going beet red.

"Come on," I prodded. "You can tell me."

"I really shouldn't."

"Yes, you can. What were you whispering?"

She hesitated. "Promise you won't get mad?"

"I won't get mad."

She smiled feebly. "I told her that we were dating again and that I was glad because I loved your big dick."

It took me a minute for this to sink in. "Excuse me?"

"You've got a big dick, Ronnie. Don't act like you don't know."

I didn't. "It's really big?"

She laughed, though I wasn't trying to be funny. "Are you kidding me?" she said. "It's like Godzilla's penis. Trust me, Ron, it's very, very big."

I had her repeat it a few more dozen times, just for good measure. A guy can never hear a thing like that enough.

I was on top of the world. I had a big dick, and a girlfriend who was willing to go on the record saying as much. Who could ask for anything more? Little did I know, however, that this valuable bit of information was only the beginning. In just a short while, my entire world was going to change.

During the summer of 1968, I went to the Ten Mile River Boy Scout Camp in upstate New York. It was a camp for urban kids, and it was exactly what I needed to burn off some steam. For an entire month, I did nothing but canoe and ride horses and swim with my friends. Sex was the last thing on my mind.

But one morning, when I was alone in the cabin getting dressed for a hike, I made a startling discovery as I leaned over to tie the laces of my boots.

I could kiss it.

I didn't actually kiss it, of course. I just touched my lips against the crotch of my pants. But I knew exactly what it meant. If I was naked, I could have . . . well, you know. I sat there for a minute, marveling at my newfound ability. I had never tried anything like this before, but it was remarkably easy. I just leaned forward and my mouth was buried in my own lap. Could every guy do this? I wondered. Was there something wrong with me? Was this dangerous for the back, even?

I immediately ran to the nearest pay phone and called my dad. I explained everything to him. He listened intently until I finished, and then took a moment to collect his thoughts.

"Is anybody in the room with you right now?" he asked.

"No, I'm alone."

"Well," he continued. "I suggest that you don't tell anybody else you can do this. They might think it's a bit strange."

"Should I be worried?" I asked, my voice cracking from the panic.

"No, no, no," he said calmly. "It's not bad at all. It's just . . . well, a little unusual. It's not something everybody can do."

"Would they want to?"

"How do you mean?"

"If everybody could do it, would they want to?"

He paused and considered the most prudent way to answer me. "It's not something most guys think about," he lied. "You don't want to kiss your own penis, do you?"

"Not really," I said. "It's kinda gross."

"Exactly. And when you turn eighteen, there'll be plenty of girls who'll want to kiss it for you. So if I were you, I wouldn't give it a second thought."

And I didn't. At least not for another decade. And even then, I should've taken my dad's advice and shut my big, fat mouth.

ven before I showed up for the *Co-Ed Fever* shoot, I knew that the mansion in San Jose that we were using as our set was a piece of sexual history. During the 1970s, it was a popular spot for swingers' parties, hosting more casual sex than most homes see in a lifetime. It had also been used for several adult productions over the years, most famously Marilyn Chambers's classic of erotica, *Insatiable*.

It's no surprise why so many porn producers picked it as a location. It had over forty bedrooms, horse stables, a private courtyard where you could enjoy outdoor sex without being leered at by noisy neighbors, and even its own indoor bowling alley. The bowling alley was probably the most notorious attraction, thanks to the now legendary scene in *Insatiable* where Marilyn violated herself with a bowling pin. I'd heard rumors that Sammy Davis Jr.—yes, the same Sammy Davis Jr. of the Rat Pack—was a producer for *Insatiable* and may have even stopped by the mansion during the filming. The tales were possibly exaggerated, but it was hard not to wander through the mansion and imagine that you could still hear Sammy's crooning.

It may have been the perfect location for a porn film, but it was an even better setting for casual, unscripted encounters. Like, say, taking a porn starlet into a back bathroom and demonstrating the finer points of self-fellatio.

I was leaning against the sink, my pants around my ankles, looking disapprovingly at my flaccid penis. I made a few halfhearted attempts to reach it with my mouth, but never quite made contact, always missing the mark by inches.

"It's kinda difficult to do this when I'm limp," I said with a groan.

The actress looked at me with an impatient expression. "But you could do it if you had an erection, right?"

"Well, sure," I said, making a few last futile lunges before giving up. "I'm sorry, I don't know what to tell you. I'm not really turned on by the idea of my own mouth. The little fellow doesn't want to come out to play. I guess I won't be able to show you after all."

It was, of course, bullshit.

I could easily kiss my penis in any state, whether I had a raging hard-on or if it was just peeking out of its shell. I could've just squeezed the base and pulled it up to my lips. But it didn't *look* that impressive. It was much more visually pleasing (at least to the ladies) if I was actually sucking on something with some girth.

We stood there together in silence, both waiting for the other to suggest what was becoming obvious.

"Well," she said, moving closer to me, "can I do anything to help?"

I smiled at her with a devious twinkle in my eye. "Well, sure," I said. "You could pose for me or something."

"Would that get you excited enough?" she asked softly, letting her finger slide down my chest.

"It might," I said. "Or, I don't know, maybe if you touched it."

"Yeah?" Her breathing had quickened, and she was already loosening the straps of her flimsy lingerie. She grabbed my cock with both hands and began to jerk it.

"Or," I said, pretending that I didn't know exactly where this was heading, "you could kiss it a little. Just enough to get it hard."

"And then you'll kiss it, too, right?" she asked, dropping to her knees.

"Oh sure," I said. "No problem."

You might not believe this, but the ruse had never been my idea. That honor belongs to Veronica Hart.

A year earlier, I met her at a party in New York. She was new to the business, and we were going to be working together soon in a movie called *Fascination*. For some reason I mentioned to her that I could give myself head. Veronica insisted on seeing it, and I brought her to the bathroom for a private show.

I dropped my pants and started kissing on it while my dick was soft. Veronica watched me for a few minutes and then, without any

provocation on my part, crawled to the floor and began sucking it with me. We alternated between her sucking it and me kissing it, and then did it together. It was a first for me, and it remains the only time I've ever received and given myself a blow job simultaneously.

To be fair, it wasn't really Veronica's suggestion to use my self-fellatio skills as a regular seduction technique. But she did plant the idea in my head.

As I left the bathroom on the *Co-Ed Fever* set, having just completed another class in self-fellatio 101, my newest student, John Leslie, was standing there smiling at me with his famous leer.

Leslie was one of my heroes. He had been in the adult industry many years longer than me, and he was very respected both sexually and as an actor. He was like a cross between a sophisticated gentleman and a nasty old man, and he played both sides of his personality to perfection. He was most infamous for something he called the "Rat Look," a sneer that was so charged with sexuality it'd wet a girl's panties within seconds.

He was giving me the "Rat Look" when he caught me outside the bathroom. But this time, it wasn't meant as a sexual advance.

"You son of a bitch," he snarled at me. "I can't believe it."

"What?" I said, giving the actress a quick peck on the cheek and sending her on her way.

"I've watched you take a few women in and out of that bathroom. What the hell are you doing in there?"

"Nothing," I lied. "We're just . . . talking."

"Don't bullshit a bullshitter," he sniggered. "I heard about this trick you've been pulling. Can you seriously kiss your own dick?"

"I guess. Why? You want to see it?"

He howled with laughter. "Fuck you, Jeremy!"

He put an arm around me and gave my forehead a soft noogie. "You are a genius, my friend. It's the perfect seduction technique. My hat goes off to you."

"It's not like I'm doing it on purpose," I explained. "They *asked* to see it."

"Of course, of course," he said, giving me a knowing wink. "Y'know, Ron, one of these days, you've got to do that in a movie."

"Yeah," I said sardonically, "because *that's* what guys want to see when they watch a porn flick. Some hairy dude polishing his own knob."

"Trust me," he said. "This talent of yours is going to make you very, very famous someday."

Leslie didn't know the half of it.

he first time that I kissed myself on camera was for a film called *Inside Seka*. I played a factory boss named Burt Morris who discovers one of his workers messing around with Seka in the company stockroom. I watch the two of them go at it before trying to get myself invited into a threeway.

"I get an erection every time I look at you, you know that?" I told Seka. "How about playing a Hoover on my ding-dong here, huh?" (Great dialogue.)

Seka turned to me with a scowl and said, "Why don't you suck yourself off?"

Dejected, I wander back to my office while Seka blows a growing number of working stiffs. As I'm beating myself off, it occurs to me that Seka might've had the right idea.

"Maybe she has a point," I said, admiring my erection. "Hmm. I'll tell you, this looks so good, maybe I should eat it myself." And then I do.

Okay, before we go on, I'd like to set the record straight. This is the only film in which I have ever—and I mean *ever*—had an erection while doing this. And even then, I only popped into the air. I did not, and have not, and would not, and would never pop a load of my cum into my own face or mouth.

Are we clear on that?

I didn't even want to blow myself with an erection, but the direc-

tor insisted on it. So I asked for a fluffer, which was the only way I was gonna get hard enough for a porn-worthy scene. An actress named Barbara Burns volunteered to come to the set to help me out. She and her husband, Mike Feline, had been close friends of mine for years. They had turned me on to swinging and Plato's Retreat (we'll get to that later). So Barbara was more than happy to lend a helping hand, not to mention a helping mouth and a helping pussy.

In between takes, Barbara and I would be having sex, doing whatever it took to get me hard for the scene. She was an amazing lover who never failed to get me hot and bothered. When the cameras started rolling, she stepped away and I had to continue blowing myself without any assistance. I'd go limp almost immediately, and the cameras were stopped while Barbara went to work getting me hard again. I had fun fucking Barbara, but the rest of it was just a chore. It was difficult and probably the least erotic experience I'd ever had on a porn set.

Very few people believe me when I tell them I don't enjoy blowing myself, but it's true. Conventional wisdom has it that self-fellatio is every guy's dream. As George Carlin once observed, "If I could reach, I'd never leave the house." And sure, it sounds like a good idea in theory. But when you're actually *doing* it, unless you're gay or bisexual, it can be a profoundly disturbing experience. A part of me is thinking, Hey, you've got a nice set of lips on your dick. That feels pretty good. But the other half is screaming, Ron, there's a fucking dick in your mouth! Get it out! Get it out!!

Anyway, this back-and-forth with Barbara and me went on for one half an hour. She'd suck it for a while, then I'd suck it, then she'd suck it, and eventually we had enough footage for a proper scene. When the director was ready to shoot the cumshot, he asked if I might consider popping in my own face.

"Are you crazy?" I boomed. "It's not gonna happen."

"Come on," he goaded me. "It'll be hot."

"Nope. Not a prayer. Don't even think about it."

I wasn't thrilled about giving him any kind of pop shot, but I

finally agreed to shoot it into the air, aimed squarely *away* from my face. We had to time it down to the last second. I wasn't going to reach orgasm with my own mouth, so Barbara got me to the point of nearly exploding and then leapt out of the frame while I jerked myself off, making it appear that I had blown myself to completion.

"Never again," I told myself. "Never again."

"Never again," however, soon turned into "just one more time."

Chuck Vincent, a brilliant porn director who gave me my first starring role in *Fascination*, asked me to kiss my dick in a film called *This Lady Is a Tramp*. It was for a scene involving a traveling circus of sex freaks. He had already cast an actress named Veri Knotty who could tie her pussy lips into a knot. I agreed because Chuck was a friend and I wouldn't be the only sexual oddity on display.

But never again, I said.

Until *Lips*. It was a Swedish erotica film, and the script had a funny scene that had been written just for me. I played a pervert, watching two girls have sex from an outside balcony. They catch me in the act of kissing myself and invite me inside for a threeway. It was just used as a joke, and I had to kiss myself only for a few quick seconds.

But that's it, I told myself. You're done. No more blowing or kissing yourself on camera.

Until *The Devil in Miss Jones, Part 2*. I had to do that one. In it, I was a lost soul damned to the bowels of hell, where I was forced to lick the tip of my cock for all eternity. And it was a prosthetic forked tongue, so it wasn't even mine. (Good rationalization, huh?)

But that's where it ended. I was through being porn's sideshow attraction. I vowed that, from that day forward, I would never perform self-fellatio, or kiss it, or lick it, or even stare too closely at it ever again.

Except for *Sulka's Wedding*.

And *Consenting Adults*.

And *Cosmopolitan Girls*.

And *Olympic Fever*.

But that was it. I was done. I was officially retired as a self-fellator. If they wanted to see Ron Jeremy kiss himself, they'd have to imagine it.

Absolutely.

Seriously . . .

The funny thing is, I wasn't even the first porn actor to display this talent for the cameras. That achievement belongs to Ken Turner, a seven-foot-tall blond giant who played a sadistic pervert in the 1976 kink film *Femmes De Sade*. There was also a gay actor named Dr. Infinity who performed self-fellatio in several stag films during the 1970s. And more recently, Al Eingang devoted his entire career to the art of sucking his own penis, putting out films like *The Young Man from Nantucket* and *Blown Alone*. All of these actors deserve at least a little of the spotlight.

I know that I'm almost solely to blame for creating my own mythos. I haven't exactly turned down many opportunities to demonstrate my abilities, and it's had a weird way of catching up with me, usually in inopportune moments. Once I was invited to be a guest with Seka on Tom Snyder's TV talk show. It was a debate on pornography, and both Seka and I surprised everyone with our well-spoken arguments.

"You really are a fascinating and intelligent young man," Snyder told me during a commercial break.

But later, seemingly out of the blue, he turned against me.

"Oh, Ron," Snyder said with a frown, "is it true that you kissed your own penis in a movie?"

"Where'd you hear that?" I asked miserably.

He shook his head like a disapproving parent. "I was even starting to like you."

"You still can," I said, but I knew that any respect he'd had for me was long gone.

Despite the occasional humiliations, I still thrived on the notoriety that came with my self-made image. I had a standard set of jokes that I told at every opportunity, whether doing stand-up comedy at strip clubs or giving radio or TV interviews or even before kissing my cock in a porn movie.

"I make sure to wear a rubber before I do it," I'd say, "'cause I don't know where he's been."

Or "Before I do it, I take myself out to dinner."

Or "I gave myself a wrong phone number so that I don't call me anymore."

John Holmes, who had a much larger penis than mine, once asked me how to do it. Lucky for him, I have a foolproof technique that will work for just about anybody. And it doesn't involve removing a rib or having costly penile enlargement surgery.

Begin in a standing position, tilting your body slightly at the waist, with each hand on a hip bone and your head facing your penis. In yoga, this position is called the "Crouching Penis." Roll forward from your hips, pushing your head toward your toes and allowing the weight of your upper body to stretch your back. Exhale and hold for twenty seconds. Now pull back and repeat, pushing from your hips while keeping your spine in its natural arched position. When you've stretched as far forward as you can, have somebody jump on your back, snapping your spinal cord like an old piece of candy. When you get out of the hospital, you should be able to do it.

I'm kidding, of course.
I'm just having fun with you.

The truth is, there is no technique. It helps to have a huge dick, but John Holmes had a horse cock and he couldn't come close. It helps to have a short torso and a flexible spine, but that won't mean a thing if you're hung like a peanut.

What can I tell you? It's a genetic crapshoot.

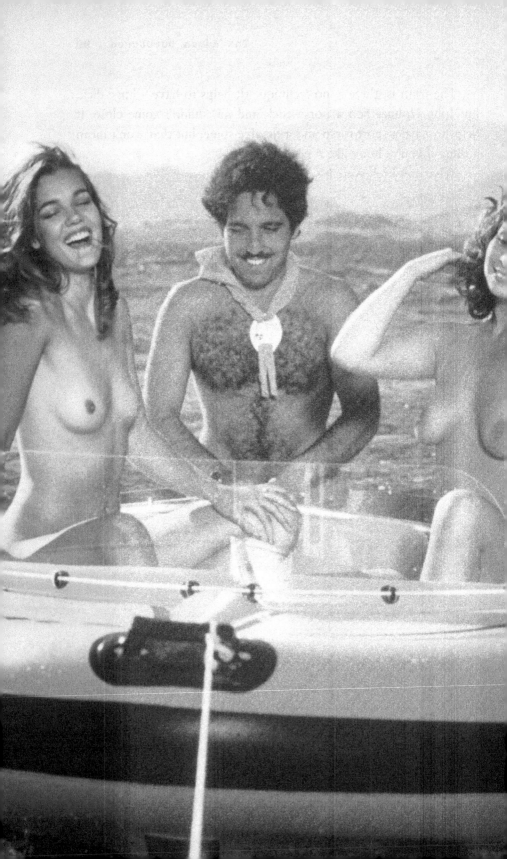

SWINGING
IN THE RAIN

There's an opening montage in a film called *Fascination*—my first starring role (as a nerd named Ernie Gordon) and still my proudest moment in porn. In it, I'm seen wandering through New York, gazing at the lights and sounds of the city at night. But it's not the New York that's usually romanticized in movies. It's the New York that was personified, at least during the late 1970s and early '80s, by Times Square, the one-time epicenter of sleaze. There are the triple-X theaters and strip clubs and massage parlors and porn palaces . . . and hookers plying their trade along Eighth Avenue. Everywhere I look, there's sex for sale, and I'm drinking it all in with a grateful smile that seems to say, I'm the luckiest boy in the whole wide world.

That five-minute montage perfectly encapsulates my experiences in New York City as a young porn actor.

It was on the set of that movie where I first met Mike Feline and Barbara Burns. Mike, a burly hulk of a man with a wispy mustache, played my father, while Barbara, a slender and exotic-looking brunette, had a brief cameo as a nightclub dancer. We became fast friends on the set, and I learned that they were a happily married couple and lifelong swingers.

Filming Bad Girls. *(Courtesy Collectors/Gourmet Video)*

They invited me to join them during their nightly escapades through New York's bustling swingers' scene. I had already been getting my fair share of sex, but this was a whole new world to me. I'd heard rumors about the "anything-goes" sex clubs and partner-swapping key parties that were a mainstay of Manhattan nightlife, but I'd never been brave enough to venture out and explore them on my own. I hadn't even set foot inside Show World, the infamous sex emporium where many of my porn colleagues performed live sex shows every night. When it came to the city's nightlife, I was a novice, but I was eager to learn. And Mike and Barbara were more than happy to show me the ropes.

It was like a buffet of sex. There was enough available flesh for everybody to enjoy. On some nights, it was like a hectic race to see and do everything. We'd start at the legendary Le Trapeze, move on to the S&M-friendly Hellfire Club, and end up at the "Barnyard" in Brooklyn, a private swinging party hosted by a two-hundred-fifty-pound lesbian. Though I relished every new discovery, nothing could quite compare to the glorious debauchery I would find at Plato's Retreat.

From the moment I walked into the doors of Plato's, I knew that I was home. It was a swingers' club straight from the smuttiest edges of my imagination. Located in the basement of the Ansonia Hotel on the Upper West Side, it had once been known as the Continental Baths, an all-gay bathhouse that launched a young Bette Midler's singing career. But in the late 1970s, it was devoted to heterosexual swinging, boldly promising a return to "the glory of ancient Rome."

Inside, it was like a sexual rumpus room, a playground for frisky adults. It housed a disco, several saunas and Jacuzzis, a swimming pool with waterfalls, and dozens of private and public rooms where sex was not just permitted but encouraged. Although clothing was optional, nudity was the norm, and it was unusual to meet somebody in anything more than a towel and a smile. On any given night, you could have sex with as many partners as you could handle or, if you felt in a more voyeuristic mood, just sit on a couch and watch the action. With more than six hundred couples visiting every night, the odds were definitely in your favor.

I became a regular at Plato's, stopping by at least a few nights a week and often staying until the wee hours of the morning. Almost always I'd bring a date, and once in a while I'd go alone, but I always ended up sleeping with somebody—sometimes a few somebodys. It was easy, especially when you were a recognized porn star with a famously large penis.

On one night, a married man approached me and asked if I'd be willing to have sex with his wife.

"It's her birthday," he explained, "and I want to get her something special."

It may have sounded like a filthy proposition, but it was actually quite beautiful. As I had sex with her, the husband sat next to us and held her hand. He was as excited as I was, but for very different reasons. He was just enjoying her pleasure, thrilled at her every orgasmic shudder. His penis was on the small side, and I was going places that he couldn't begin to reach. Jealousy wasn't a factor for them. They knew that I wasn't a threat to their marital vows. I was nothing more than a prop, a human dildo for their sexual play. She didn't even make eye contact with me while we were doing it. She just gazed at her husband, and if you could've seen the look on their faces, filled with so much gratitude and mutual appreciation and unmitigated love, it would've broken your heart, as corny as that sounds.

The minute we were finished, they both thanked me and disappeared. I saw them later in another room, just sitting together on a couch and cuddling. It was probably one of the most romantic things I'd ever seen in this environment, and it made me understand for the first time how swinging and marriage could coexist. If it truly is a mutual experience, and a couple is able to distinguish between sex and love, swinging can actually bring two people closer together rather than (as so many critics are quick to claim) tear them apart.

The couple told me that they'd been married for twenty years. It wouldn't surprise me in the least if they were still together.

And then, of course, I had sex at Plato's that had nothing whatsoever to do with love or intimacy. It was just nasty, lewd fucking

between two anonymous strangers for no other purpose than feeling another person's naughty bits. So in a lot of ways, Plato's was the best of both worlds.

I eventually met up with Larry Levenson, Plato's founder and owner. We instantly took a liking to each other. I admired him because he was the self-proclaimed King of Swing, and he admired me because I was an up-and-coming porn star. Larry liked telling people, "I knew Ron back when he was just some young skinny kid with a big dick."

Larry was like a big teddy bear. He wasn't the most gorgeous guy, but women flocked to him. I don't know if it was his kindness (he was the most gentle man I've ever known) or his generosity (he threw cash around like it was peanuts), but I never saw him without a girl on his arm. He didn't have a large penis by any means, but everybody who slept with him said he was a decent lover. Like me, he loved to give a woman head. Loved it more than anything else. That alone was enough to make him very popular.

I never had to pay the $30 cover charge when Larry was around. In fact, he usually allowed me to enter the club without a girl, which was unheard of. Single men were not normally welcome because it offset the odds. If Plato's was filled with hundreds of guys and just a few women, it cut down the chances of anyone scoring. But Larry liked me, and he knew I wouldn't try to make a move on any of the girls unless I was invited.

Actually, I was usually more interested in the buffet than the sex. There was always an amazing smorgasbord available for the guests, piled high with salads and meats, raviolis and pastas. I stuffed my fat fucking face. I spent more time with my face buried in a plate than in a vagina. Larry knew I was a gentleman with the women but not with the buffet. He didn't mind, because most of the food went to waste at the end of the night. I credit a lot of my weight gain to Plato's Retreat. You can see it in my movies. During the early 1980s, I gradually got fatter and fatter. I might still be thin today if it wasn't for Larry and his goddamn bottomless trough of food.

Larry taught me a lot about the swinging lifestyle. I learned about the etiquette of attending a club like Plato's, which was more complicated than most people realize. For instance, he told me about "Tickets." When a guy shows up with a date who has no intention of screwing around, she's called a "Ticket." She's not going to be a part of any fair trade with another couple. She's just there to hang out and suck up coffee and doughnuts, while the guy is trying to fuck everything that moves. It's the equivalent of showing up single.

Having more girls than guys is always preferable at a swing club. When there are too many guys looking to fuck around, and their dates are just having food or sitting by the pool, it messes with the gentle balance of the swing dynamic. There were a few nights a month at Plato's when single men were allowed. I'd be having sex with a girl and I'd feel a finger tapping on my shoulder. I'd look over and there'd be five guys staring at me, asking, "You almost done with her?"

It was right out of George Romero's *Night of the Living Dead*. The minute somebody started having sex, these zombielike guys would come out of the woodwork, their arms outstretched, muttering, "Pussy . . . pussy . . . we want pussy."

If you intend on participating, always bring a partner to share. If you bring a wife or a girlfriend and she's not interested in having sex, then there is a chance you're not going to have sex either. You can just watch together; that's fine. But if you want to join in, be prepared to make a free and even trade, unless the other couple doesn't mind your date just watching.

Swinging Etiquette RULE #1

This rule can occasionally be amended, but only by invitation. A gang bang, for instance, is a perfect example. There are women who'll book appointments for swing events, like at a lifestyle's convention in

Las Vegas or Reno. Women have asked their husbands to walk around and hand out their room number. "My wife wants to take on ten guys tonight." In that case, it's okay. Swingers' etiquette is put to the side when a girl is specifically looking for a large group of single guys.

There are also cases when only one person in a couple wants to have sex while the other watches, but this has to be an agreed-upon arrangement *before* any swinging exchange begins. You can't lead somebody on with a certain expectation and then change the rules midway through. I saw many couples use this scam, and I even fell for it myself once.

They were a young husband-and-wife team that had been swinging at Plato's for several months. They invited my date and me to join them in a back room, and we jumped at the chance for a predinner screw. We split into partners, and I started eating out his wife while he did the same to my date. Within just a few seconds, however, he went right for the beans. He didn't even pause long enough for a blow job. He just went straight for the insertion. I liked to take my time and really enjoy foreplay before letting my dick stampede toward the vagina, but apparently this guy was in a hurry.

I should've known that something wasn't right. It was all a bit too rushed, but I just told myself that some guys are a little more impatient than others. When I finally lifted my head and started crawling up toward her, ready to bring Mr. Happy in for a landing, she pushed me away.

"No," she said. "No sex."

"Excuse me?" I said.

"I'm not into that. You can eat me out a little more if you want, but I don't want to fuck."

"But you said you were full, one hundred percent swingers," I said.

"I'm sorry if we gave you the wrong impression."

I looked over at my date, who was being pounded by the wife's husband like a haywire jackhammer, then back at this woman. "You're kidding, right?"

"Sorry," she said, smiling sheepishly.

At that exact moment, her husband pulled out, yanked off his condom, and came all over my date's breasts.

I stood up and tapped my date on the shoulder. "Uh, honey, we have to go."

"What's the problem?" the guy asked, annoyed by the interruption.

"You know damn well what the problem is," I told him, leading my date away. "I'm on first base while you're running to home plate."

I went straight to Larry and told him everything. He had received complaints from other couples already, but this was the icing on the cake. He took the couple aside and explained that they were no longer welcome at Plato's.

"Now hold on," the guy growled at Larry. "It's not what you think."

"I'm sorry, guys," he said coolly as he escorted them to the exit. "It's just not fair to the other guests."

Always be up front with your swinging partners. If you're willing to go only so far, let them know in advance.

Swinging Etiquette RULE #2

I'm not a voracious sexual beast. I don't expect every girl to put out for me. But fair is fair. I don't like being lied to. Nobody does. Honesty is a virtue, especially in swinging. If you just want to get eaten out and your boyfriend or husband wants to screw, I (or my lady friend) may be fine with that. But I need to know ahead of time. Maybe I won't care. There's a chance that I've been having sex all night and I'm exhausted, but I'd still like my girl to get some good

beefing. I may just say, "If she's happy, go ahead and fuck her brains out." But you'll never know unless you ask.

Swingers' etiquette is not filled with hard-and-fast rules. There are always exceptions. But you have to be open and sincere about what you expect, or somebody is going to end up feeling taken advantage of.

(I'm just here to help, folks. . . .)

Plato's was by no means restricted to anonymous swingers. As the club's fame grew, it attracted celebrities from coast to coast. On any given night, you might end up mingling with Sammy Davis Jr. or Richard Dreyfuss. He'd visit Plato's once in a while, and though he never had sex on the premises (at least not that I saw), he did a bit of watching.*

But the biggest stars, or at least the most *fawned*-over stars, were usually the porn actors. This was, after all, the holy sanctorum of sex. We were the high priests and priestesses of smut, and we were worshiped within the walls of Plato's like living gods. The porn elite came to Plato's in droves, and on some nights, there were more porn actors in attendance than actual swingers. You might see Sharon Mitchell chatting with *Screw* magazine publisher Al Goldstein, or Herschel Savage and Laurie Smith having sex in the pool, or Amber Lynn showing off her new lingerie to Freddie Lincoln and Luc Wylder. It was a who's-who of adult films, and I was happy just to be invited to the party.

I wasn't easily starstruck, but there were occasions when even I felt like a fan. Such was the case with Jamie Gillis.

* I heard rumors that Dreyfuss talked with Larry about doing a movie about Plato's. Apparently, Dreyfuss was considering playing Larry in the film. (It never happened, of course.)

I'd always admired Jamie Gillis. He could somehow bring himself to do anything sexual and make it believable, regardless of how nasty or degrading or downright disturbing it might be. Those of us who knew him called him a trisexual. He would try anything. He could fuck a pound of calves' liver and keep a boner. He was into T&A, S&M, B&D, IUD, IOU . . . anything with three letters.

During one night at Plato's, I heard that Jamie was in the building. I decided it was time to say hello. I'd just been cast in a movie called *Dracula Exotica*, in which Jamie himself would be starring in the title role. I searched around the club but couldn't find him anywhere. But I did find a female admirer who was eager for a quick roll in the hay. If only to calm my jitters about the upcoming *Dracula* shoot, I took her up on her offer.

A few hours later, I retreated to the bathroom to wash my dick in the sink. All good Jewish boys wash their dicks after they have sex. It's not just hygienic, it's one of the reasons I've stayed healthy all of these years.

You think I'm kidding? You *do* know whose autobiography you're reading, don't you? I practically have a PhD in sexual diseases. In fact, this seems as good an excuse as any for . . .

SEX
Advice from
DR. RON JEREMY

Part 1:
SEXUAL HYGIENE

Okay, class, please take out your No. 2 pencils.

Let's face it, sex isn't always safe. And if you're like me and have sex once in a while with multiple partners, without always using condoms, sex can be dangerous. But there are a few precautions you can take to better protect yourself from being inflicted with any number of annoying and potentially life-threatening STDs.

First of all, use a condom. If you're a stubborn bastard

and don't want to use condoms, there's another way that you can at least cut down on your chances of getting infected. Here's my step-by-step guide to keeping your penis clean and relatively disease-free.*

1. After having sex, jerk your cock as hard as you can. No, smart-ass, you're not trying to get another erection (at least not yet). You're trying to squeeze out any germs that might've crawled up into your urethra. Give it a whack with your hand a few times, and jerk it like you're trying to rip the little bugger off. What you're basically doing is milking out any possible germs. Take a look at the hole to see if anything's coming out. If it's clear you're a-okay. I hate to break it to you, ladies, but this technique is just for the fellas. You can beat and pound on your labia all you want, and all you'll get is one sore pussy.

2. Now stick it in the sink—or if you're a prude, the shower—and wash it with hot water and liquid soap. Give it a few more slaps, just to be on the safe side. Don't go easy on it. Give that one-eyed snake a thorough scrubbing until it's squeaky clean.

3. Finish by taking a pee. This'll flush out anything that might be left up there. We have an advantage over women because our urethra is the passageway for both semen and urine. Peeing after sex flushes out the passageway. Women don't have it quite so easy. It's still a good idea for women to pee after sex anyway, because it'll cut down on the chances of urinary tract infections.

* Keep in mind, however, that this method is not foolproof. The best way to completely protect yourself is by using condoms. My technique is by no means a guarantee that you won't contract an STD-again, the only way to do that is with a condom. Get it?

And that's it. It sounds deceptively simple, I know, but it works. Obviously, this isn't going to protect you from everything. You're not going to avoid catching HIV with a little dick slapping and sudsy water. But for many of the sexually transmitted diseases, this will help keep you relatively clean and safe.

I assume that most of you don't believe me, but I'm living proof that my postsex ritual works. I've been in the adult business for more than twenty-five years and have had sex with a few thousand women, many without condoms, and I haven't caught a thing. I've only had an STD once in my life. It was gonorrhea, and I got it from a girlfriend back in college, long before I started my porn career. I've been on porn sets where everybody in the cast came down with an infection except me, and I may have been the only one who bothered to scrub the hell out of his junk after scenes.

When you're in the business of having sex for a living, you need to do your homework when it comes to STDs. And I know about many of them . . . Gardenella, chlamydia, trichomonas, vaginitis, condyloma. There's some scary stuff out there, just waiting to set up camp on your genitals. Whenever I go for my regular health checkups, I always ask the doctor, "If you're going to tell me I have an STD, at least make it something that sounds good, like condylomata acuminata." Have you ever heard of that? Called "condyloma" for short, it's grapelike clusters that accumulate on your genitals. It's about as nasty as it gets, but the name sounds like a symphony!

I'm telling you, if I ever get a disease, *that's* the one I want.* How much fun would it be to tell a girl, "Would you like some condylomata acuminata?" Who'd say no to that? It almost seems like an exotic cheese.

So trust me on this, folks. After you finish bumping and grinding, make a beeline for the bathroom and follow my dick-cleansing routine to the letter. Spend just a little time washing your man meat

* I am kidding, of course. I don't really want an STD.

today, and you cut down the odds of enduring unnecessary painful urination tomorrow.

Now, where was I?

Ah yes, Jamie Gillis.

So I was in the bathroom at Plato's, washing my dick in the sink. I heard the door swing open and in walked Jamie Gillis, naked as the day he was born. He sauntered over to the sink next to me and plopped his penis under the faucet. If he recognized me, he didn't let on. He turned on the sink and, just as I was doing, began silently washing his dick with soap and water.

It's not every day that you get to stand side by side with another actor, both of you washing your genitals after a long night of fucking. What do you say in a situation like that? How do you break the ice when a man you admire is right next to you, scrubbing the gook off of his pecker with a concentration usually reserved for open-heart surgery?

It was, if nothing else, awkward.

As we stood there, washing our dicks and saying nothing to each other, I thought to myself, This is absurd. Just say hello. I turned my head slowly, trying not to be too obvious. And just as I opened my mouth, I caught a glimpse of his penis.

It was brown.

And red.

And yellow and white.

I couldn't believe my eyes. His dick was streaked with so many colors. It looked like a rainbow. What, I thought, has this guy been doing? How many orifices has he been in tonight? I could understand the brown and red. He had probably had sex with a woman who was menstruating, and then went straight to fucking somebody in the ass. But how to explain the yellow? Had somebody peed on him? And the white—was it sperm? My mind boggled.

I didn't want to stare, but what choice did I have? It was remark-

able. His dick was like a canvas that had been turned into a Pollack painting. The splashes of color almost seemed to be part of a deliberate design. If you gazed long enough, you could start to see shapes and patterns.

I don't know how long I stared at it, marveling at its intricacies, before I realized that Jamie was looking at me. My eyes drifted up, and there was Jamie, watching me watch him. His face had no expression. If he was offended or amused, I couldn't tell. Neither of us said a word. It was so eerily quiet you could've heard a needle drop.

After what felt like an eternity, he turned his attention back to his dick, scrubbing it casually as if he hadn't just been leered at by another adult male. I took the hint and returned to my own cleaning ritual, acting as if nothing had happened.

As I was drying myself off with a paper towel, I could hear him walking behind me, heading toward the exit. My muscles tightened, and I wondered if it was too late to say anything. And then, just as I was about to turn around to introduce myself, I felt him step up right behind me and put his lips just inches away from one ear.

"Pigs," he whispered, "aren't they?"*

And that was how I met Jamie Gillis.

Swingers are a stubborn breed. You can call them sinners, and they'll just turn up the sin a few notches. You can take away the parties, and they'll find someplace else to play. You can even throw them in jail for zoning violations, and they'll still find a way to get some nookie.

In 1981, Larry Levenson was convicted of tax evasion and sentenced to forty months in a state penitentiary. He was sent to Allen-

* I never quite understood his attitude toward women. But despite how he sometimes treated them, women loved Jamie. He was even the longtime boyfriend of the famous *New York Times* food critic Gayle Green.

wood Prison in central Pennsylvania, about one hundred seventy-five miles away from his beloved Plato's Retreat. For a lifelong swinger like Larry, it was the worst fate imaginable.

"All I want is women and pizza," he told me. "And this goddamn prison doesn't have either."

When Larry became eligible for conjugal visits, I decided that the time was right to give him exactly what he was craving.

And I didn't mean pizza.

I found a girl named Katie, a sometime porn star and regular at Plato's. She arrived on the scene long after Larry had been shipped to prison, but she was well aware of his reputation within swinging circles and had read about him in magazine articles. When I offered to arrange a prison rendezvous with Larry, she jumped at the chance.

It wasn't the first time that I'd set Larry up with a girl. Just a few years earlier, Larry had made a wager with *Screw* magazine publisher Al Goldstein that he could ejaculate eighteen times in just twenty-four hours. It was a tall order, even for somebody with Larry's sexual appetites. Larry asked me to supply the "talent," and I immediately asked Patrice Trudeau, one of the best cocksuckers in adult films. Because of all the media surrounding the event, she agreed.

Larry's eighteen-pop-shot challenge was a huge event, taking place at Plato's during one very long day and night. All the major players in porn were there to witness it, and a few, like *Penthouse* publisher Bob Guccione, even contributed to the pot. At the end, there was almost $10,000 riding against Larry. He later claimed that I was almost solely responsible for helping him win. Although he had a lot of volunteers, Patrice single-handedly brought him to at least five or six climaxes.*

Setting up Larry's conjugal visit wasn't nearly as exciting. There were no cameras or cheering crowds or financial stakes on the line.

* And just for the record, his eighteenth pop shot was on a photo of Al Goldstein's face.

But it meant more to me somehow, because this time it was personal.

Goldstein rented a limo and we took Katie on the long journey into Pennsylvania. We rented a hotel room in downtown Allenwood (Larry was permitted to travel only a few miles from the prison) and brought Larry over for his surprise.

Katie didn't waste a minute. Before Larry knew what was happening, she dragged him into the bathroom, locked the door, and yanked off his pants.

"I've always wanted to meet you," she told him. And then she proceeded to fuck his brains out in the bathtub.

Larry made his triumphant return to the new Plato's (a bigger space in midtown) in 1985, with a homecoming parade through the streets of New York. Larry, decked out in a leopard-skin cape and crown, emerged from a convertible limo to greet more than five hundred of his screaming patrons and supporters.

"The King is back!" the crowd cheered. "Long live the King!"

But the victory was short-lived. Just seven months later, on New Year's Eve, Larry and I arrived at Plato's and discovered that the front doors had been chained and padlocked. We didn't need to be told what had happened. The city had been threatening to shut down Plato's for months. Mayor Ed Koch had closed down many of the gay bathhouses and sex clubs like the Ramrod and Anvil, citing new state laws designed to combat the spread of AIDS. When gay-rights groups protested, claiming that they were being unfairly targeted, Koch needed to pick on a heterosexual sex club to appear unbiased.

Larry took one look at the police barricades and cried.

"This is it," he sobbed. "It's over. We're finished."

"Don't say that," I said, trying to comfort him. "We can fight this."

"No," he said, shaking his head, "it's too late."

He explained that the city's timing had been strategic. Larry was planning a huge New Year's Eve party at Plato's, and thousands were expected to attend. At $100 a couple, it would generate enough profit

to keep Plato's in business. Rent for a big building in midtown Manhattan is astronomical. By padlocking Plato's, the city had crippled him financially. Even if he fought and won, he didn't have the money to keep Plato's afloat.

We sat in my car for most of the night and just stared at the Plato's entrance. We watched as throngs of would-be patrons came and went, shaking the doors vainly, some angrily kicking at the barricades before slinking away. Before long, we were alone again. Nobody else was coming. It was like watching a friend die right in front of you.

"It's going to be okay," I said to Larry, trying to reassure him. "We're not going to let these fuckers stop us from enjoying New Year's. I know a few parties we can go to."

Larry just sighed. He looked defeated, like he would have been perfectly happy just to die right there and then.

"I suppose," he said.

"Trust me, it'll be great. We'll stay up till dawn and have so much nookie, you won't even think about Plato's."

He turned to me and raised an eyebrow. "Will Patrice Trudeau be there?"

We laughed until tears came to our eyes, our voices the only sound on the otherwise empty New York street.

Par

The penis is
mightier than
the sword.
—Mark Twain

With Danica Ray in one of the first
male-and-female centerfolds
in Hustler magazine.

Even as a young kid I was always ready for the camera.

Photograph of bearer

Sylvia Koral

1.

1. My mother was a spy during World War II. These are her identification papers.
2. My father, Arnold, fighting in the Philippine jungle during World War II.
3. My cousin Eliot Weiss won the Purple Heart and the Airman's Citation of Honor for his heroics during the Battle of the Bulge.

Description of bearer

Height 5 *feet* 2½ *inches.*
Hair BROWN
Eyes HAZEL
Distinguishing marks or features
X X X
X X X
X X X
Place of birth BROOKLYN, N.Y.
Date of birth MAY 26, 1921
Occupation NEWSPAPERWOMAN
X X X
X X X

Sylvia Koral
Signature of bearer

This passport is not valid unless signed by the person to whom it has been issued.

3

2.

3.

CITATION OF HONOR

UNITED STATES ARMY AIR FORCES

Flight Officer Elliott B. Weiss

WHO GAVE HIS LIFE IN THE PERFORMANCE OF HIS

March 24, 1945

HE LIVED TO BEAR HIS COUNTRY'S ARMS. HE DIED TO SAVE
A SOLDIER . . . AND HE KNEW A SOLDIER'S DUTY. HIS SACRI
KEEP AGLOW THE FLAMING TORCH THAT LIGHTS OUR LIV
YET UNBORN MAY KNOW THE PRICELESS JOY OF LIBERTY.
HOMAGE, AND REVERE HIS MEMORY, IN SOLEMN PRIDE RE
A COMPLETE FULFILLMENT OF THE TASK FOR WHICH
PLACED HIS LIFE UPON THE ALTAR OF MAN'S FREEDOM.

THE UNITED STATES OF AMER

TO ALL WHO SHALL SEE THESE PRESENTS, GREETING
THIS IS TO CERTIFY THAT
THE PRESIDENT OF THE UNITED STATES OF AMERICA
PURSUANT TO AUTHORITY VESTED IN HIM BY CONGRESS
HAS AWARDED THE

PURPLE HEART

ESTABLISHED BY GENERAL GEORGE WASHINGTON
AT NEWBURGH, NEW YORK, AUGUST 7, 1782
TO
Flight Officer Elliott B. Weiss, A.S.No. O-132080,
FOR MILITARY MERIT AND FOR WOUNDS RECEIVED
IN ACTION
resulting in his death March 24, 1945.
GIVEN UNDER MY HAND IN THE CITY OF WASHINGTON
THIS 7th DAY OF August
1945

4. With one of my first girlfriends. **5.** June 1971, with another early girlfriend. **6.** On the beach in Miami, Florida. **7.** One of my earliest publicity shots, when I was still known as Ron Hyatt.

4.

5.

6.

7.

RON HYATT

(212) ▬▬▬

1.

2.

1. A great publicity shot
that Hollywood Video used.
2. Teaching two girls how
to canoe down the Delaware
River. I earned a Boy Scout
Merit Badge for it and I still
go canoeing every summer.
3. This layout, which I did
in 1980, was a period piece.
4. John Holmes acting as
my gay lover. 5. Some early
porn flicks had elaborate
costumes—here I am in
character for *Pink Lagoon*
(a Gourmet Collectors film),
shot in Hawaii.

3.

4.

5.

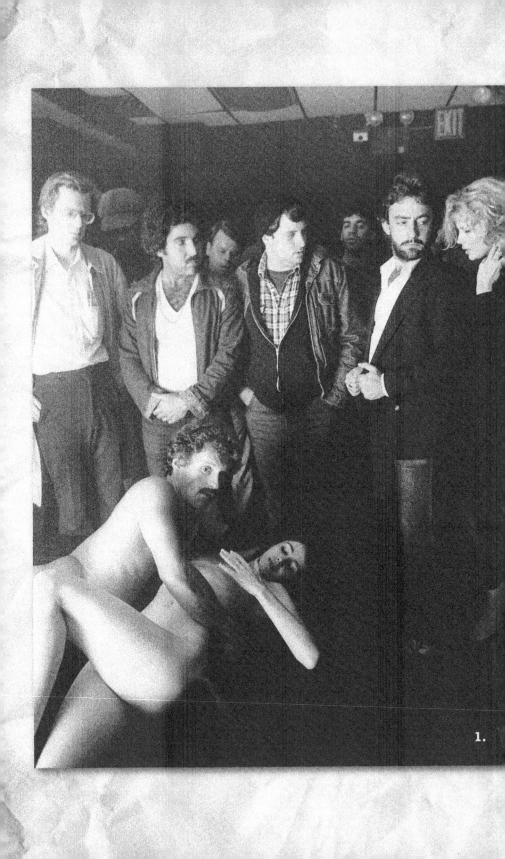

1.

1. By 1984 I was considered very knowledgeable in the world of adult film, so Adrian Lyne asked me to be a consultant on the film *9½ Weeks*. Kim Basinger is on the right. **2.** With director Adrian Lyne at the wrap party for *9½ Weeks*. (Photograph © Peter Merl) **3.** With a young Jim Carrey and Freddy Asparagus at the Comedy Store in L.A. **4.** Sam Kinison was a good friend of mine. We always had a blast. **5.** I like to think that I can transform myself into almost any character, and here I am on the set of *Caged Fury* with James Hong.

1. With Adam Rifkin on the set of *Bone Chillers*, which ABC-TV played on Saturday mornings. I played Blister Face. **2.** In character for Adam Rifkin and Steve Bing's *Without Charlie*. **3.** As Mussolini in a XXX World War II parody. **4.** In costume on a Mark Carriere-produced XXX film. **5.** I admit it, I love to eat! (*Courtesy "Dirty Bob" Krotts*)

5.

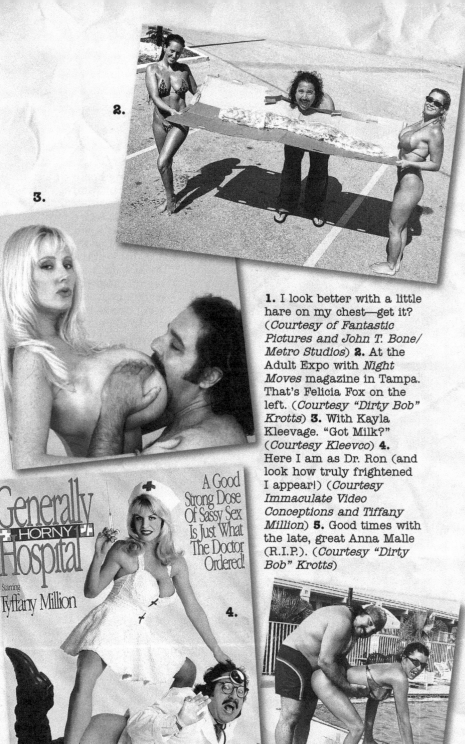

1. I look better with a little hare on my chest—get it? (*Courtesy of Fantastic Pictures and John T. Bone/ Metro Studios*) **2.** At the Adult Expo with *Night Moves* magazine in Tampa. That's Felicia Fox on the left. (*Courtesy "Dirty Bob" Krotts*) **3.** With Kayla Kleevage. "Got Milk?" (*Courtesy Kleevco*) **4.** Here I am as Dr. Ron (and look how truly frightened I appear!) (*Courtesy Immaculate Video Conceptions and Tiffany Million*) **5.** Good times with the late, great Anna Malle (R.I.P.). (*Courtesy "Dirty Bob" Krotts*)

Generally
+ HORNY +
Hospital

Starring
Tiffany Million

A Good Strong Dose Of Sassy Sex Is Just What The Doctor Ordered!

Distributed Exclusively by In·X·Cess Productions • 818.786.5399 • 800.576.7623 • fax 818.786.4082

1. Getting lipstick on my dipstick in Tampa, Florida. (Courtesy "Dirty Bob" Krotts) **2.** I love foreplay because it gives the girls goose bumps if you do it right. It starts with goose bumps and within ten minutes you have an eight-man, interracial, anal, dwarf, bukkake, cream-pie gangbang. (*Courtesy Klinger Video Entertainment*)

1.

2.

3.

5.

6.

4.

3. I was once honored by PETA as an ambassador of goodwill, and here I am consulting with some of the experts. Two dolphins double-teamed me for an aquatic kiss. **4.** Another expert—a female walrus. . . . Hey, I've done worse! **5.** Cherry the Tortoise, my pet (as seen on *The Surreal Life*). **6.** Yes, that's a rat. A hairless one, named Fetus. Howie Mandel had her before me. He called her Chemo. **7.** With a baby lamb from a British TV show called *The Farm*. She was born ill and I helped nurse her back to health. She kissed me on the nose as thank-you.

7.

1. In 2002, Adult Video News proclaimed me the Top Porn Star of All Time. (*Courtesy Adult Video News*) **2.** In 2003 I joined the cast of *The Surreal Life* (first on the WB and later on VH1), with Traci Bingham, Vanilla Ice, Tammy Faye Messner, Trishelle Cannatella, and Erik Estrada. (*© WB/Brett Panelli*)

Here are some of my more recent publicity shots. I can be whatever you want me to be. Ladies, please have a seat on this page so I can brag that you all sat on my face. . . . **3.** Ron Jeremy—Suave and Debonair? (*Courtesy Metro Studios*) **4.** Ron Jeremy—Hustler and Sportsman? (*Courtesy Metro Studios*) **5.** Ron Jeremy—Refined and Sophisticated? Ladies, a toast: "Here's to you . . . on my schmekel!" (*Courtesy Metro Studios*) **6.** Ron Jeremy—Friendly Neighborhood Porn Star!

APPEARING LIVE!
RON JEREMY!

THURSDAY, JUNE 9th
6-9pm
SECRETS ADULT SUPER STORE
1818 West San Carlos Ave.
San Jose, CA, 95128

FRIDAY, JUNE 10th
Noon-3pm
BIG AL'S ADULT SUPER STORE
556 Broadway
San Francisco, CA, 94113

FRIDAY, JUNE 10th
6-9pm
SECRETS ADULT BOUTIQUE
525 Contra Costa Blvd.
Pleasant Hill, CA, 94523

FREE AUTOGRAPHS!
PHOTOS!

COME MEET THE MOST POPULAR PORN STAR IN THE WORLD!

I love public speaking and try to do as much of it as possible. Check your local newspaper—I may be coming to a town near you!

chapter 7

DAYS OF PORN AND ROSES

"Ron Jeremy, you fucking son of a bitch!"

John Holmes pushed through the crowd waiting for my autograph and stormed over to me. We were both appearing at the Consumer Electronic Show in Las Vegas, promoting our latest movies and meeting with the fans. I was signing for Dave and Svetlana at Collector's Video, and John had his own booth with *Swedish Erotica* on the other end of the convention hall. I hadn't had a free moment yet to stop by to say hello. But he was apparently in a hurry to see me, and judging by the throbbing veins on his neck, he was out for blood.

"Johnny Boy," I said warmly, reaching over to give him a hug.

He pushed me away and held up a copy of *Playgirl*, shaking it in front of my face.*

"What the hell is this piece of shit?" he demanded.

"I think it's a nudie mag," I said. "What's your point?"

He flipped through the pages until he found the article that had incited his temper tantrum. He held up the magazine and pointed to

* It was the one featuring Burt Reynolds on the cover.

(Photograph courtesy Hustler *magazine)*

a photo layout. It was a picture of me, looking skinny and attractive. In big, splashy letters over my head, it read: RON JEREMY: PORN STAR OF THE '80s!

"Star of the '80s?" Holmes screamed in mock outrage. "Are you fucking kidding me?"

"Hey, I didn't write it," I said with a shrug.

He threw the magazine to the ground and spit on it. "Why should I even bother making movies?" he roared. "What difference does it make? You're the only one people want to see!"

I laughed and said, "You know that's not true."

His eyes widened, and his ears almost began to smoke. "Well, that's what the magazine says," he hollered. "Consider me officially retired! I'll just be your bitch!"

He turned to the crowd and put his arm around me, letting his wrist go limp in an imitation of a gay lover.

"From this day forward," he announced, "I am Ron Jeremy's bitch!"

After photographers snapped a few pictures, we laughed and gave each other a hug. I'm still not sure if anybody in the crowd knew that he was joking.

"Seriously, though," he whispered into my ear, "congratulations."

"No hard feelings?" I whispered back.

He just looked at me with a sinister smile. "You'll always be *my* bitch, Jeremy. Don't ever forget that."

By the mid-1980s, I was already becoming one of those nostalgic old farts, reminiscing about the glory days and moaning about how everything was better back when I was a kid.

During the first five years of my porn career, the adult industry had more legitimacy. A movie was an event, from the production to the opening night. There were scripts and elaborate sets and full

crews, and we'd sometimes spend entire weeks on a single shoot. That may sound laughable, but compared with the cookie-cutter pornos of today, which are shot on an average of one a day, taking a whole week to shoot just one film was preposterous.

The producers of those early adult films spared no expense, green-lighting budgets that would impress even most Hollywood B-rated movies. In *Blonde Goddess*, I played a Red Baron, and we shot my scenes with an authentic World War I fighting plane. On *Bad Girls II*, we left a path of destruction in our wake. Cars crashed into gas stations, bulldozers stormed over fences, glass storefronts shattered almost constantly. We even drove a police car over a cliff. All of those effects made for an amazing finished product, one that you could feasibly enjoy even *without* the sex.

But the real thrill of making a porno film was attending the opening night screenings. Because adult movies were still being shown at theaters, we had lavish premiere parties. At a typical opening at the Pussycat Theater in Hollywood, there would be roaming searchlights and live bands and paparazzi. All the actors would arrive in limos, decked out in tuxedos and ball gowns. When you walked down the red carpet and saw the lines of cheering fans and flashing camera bulbs, you felt like a star.

Even more extravagant were the award ceremonies—our version of the Oscars—hosted every year in Los Angeles by the Adult Film Association of America (AFAA). It was a carnival atmosphere, with each star trying to outdo the next with the most outlandish entrances. Juliet "Aunt Peg" Anderson once entered the theater riding an elephant. In 1980, to promote the film *Urban Cowgirls*, the actresses showed up on horse-drawn stagecoaches. Al Goldstein was famous for making the biggest spectacle. He would come out onto the stage dressed as a gladiator and riding a chariot, or lowered from a giant crane while in a Superman costume. The awards themselves—a plaster of Paris statue of a naked woman holding a spear, called "The Erotica"—were usually the cheapest part of the entire evening. But

you didn't come for the awards, you came for the *show*. And the houses were always packed, sometimes attracting famous guests like director Francis Ford Coppola and producer Robert Evans.

When you worked in porn during those days, you were instantly part of a community, with all the kinship and feelings of belonging that went along with it. It was a small, close-knit group. We all knew one another's names, watched one another's films, and the odds were good that we'd have sex with one another eventually. You couldn't be an outsider in porn because we were *all* outsiders, and we supported and rooted for one another like family.

John Holmes and I were always very friendly. Our introduction— on the set of a film called *WPINK-TV*—was even captured on-screen. After one of his sex scenes, I walked over to shake John's hand and ended up noticing how sticky it was. It wasn't the most pleasant way to start a friendship, but, given our chosen professions, it was probably the best I could have expected.

Whenever I ran into John at a film premiere or public event, we would go out of our way to tease each other. He liked to call me "Little Dick" (he had about two inches on me).

"John, I'm already hitting bottom," I'd tell him. "Where else are you gonna go?"

"That's okay, Little Dick," he'd say, patting my cheek. "I'm sure you make the most with what you have. Hey, pleasing a woman isn't everything."

"What, are you entering the uterus or something? That's not sex, John. It's a Pap smear."

"Little Dick" and "Pap Smear" became our regular pet names for each other. Anytime we saw each other, John would yell out, "Hey, Little Dick," and I'd yell back, "Hey, Pap Smear!"

During the Consumer Electronic Shows in Vegas, we'd spend half our days just trying to harass each other. We'd pass notes back and forth between our booths, with little messages like, "Will you move your cock? People are trying to leave the parking lot." I had sex with

his wife, Laurie Rose, in a porno called *Personal Touch*, several years before she met John. I used to tease him about it, sending him notes that read, "Love your wife. I had her first."

I lost touch with John after he went to jail in 1982 for allegedly orchestrating the Wonderland Murders. I was sad but not altogether surprised. At around the same time, I began hearing stories that John was a police informant, ratting on his friends in the porn business to save his own ass. I knew that he was into drugs and involved with bad people.

In 1984, I was asked to interview actors on the red carpet for the Pussycat Theater's premiere of *Girls on Fire*, a new adult film starring John Holmes and Ginger Lynn. It was one of the most aggressively promoted films of the year. There were billboards all over New York and Los Angeles.

I was told that John Holmes might be at the premiere. He had been released from prison just weeks earlier and was keeping a low profile, so nobody knew for sure if he would show up. There were also rumors that John might immortalize himself in cement for the occasion. Inspired by the celebrity handprints outside Mann's Chinese Theater, the owners of Hollywood's Pussycat Theater had created their own version of the Walk of Fame. The theater's entrance was covered with handprints of porn's biggest names: Linda Lovelace, Marilyn Chambers, Harry Reems. But for a star like John Holmes, his hand hardly seemed like the appropriate limb to commemorate his legacy accurately.

I arrived at the Pussycat on the night of the *Girls on Fire* premiere. Vince Miranda, the theater's owner and manager, took me aside and said, "We have a problem."

Usually, when I did interviews at movie openings, I was given a microphone that was attached to some kind of recording device. All of my interviews were filmed and then screened before the feature, and sometimes used again in the videotape release. But Vince didn't have all of the equipment. He had a microphone, but nothing to plug

it into. And his careless assistant had found a camera but failed to get any film.

"Think you can fake it?" he asked.

"You want me to just interview people without getting it on film?" I said.

"Well, there'll be a camera on you. But it'll be empty. We don't want to offend anybody, so just pretend that we're actually getting it on tape, okay?"

It wasn't as pointless as it sounded. A porn premiere always attracted the media, from local newscasts to national shows like *Speak Up America* and *Current Affair*. And whenever their reporters saw me interviewing somebody, they'd come running over and aim their cameras at me. They wanted to find out what I was saying and who I was talking to. There'd be ten microphones shoved in my face, so it didn't matter anymore if my microphone was live. My role was mostly as media bait, an excuse to get the theater and the movie's title on the nightly news.

Later that night the stars began to arrive, and I took my place on the red carpet. John Holmes pulled up with his entourage, and he walked straight over to greet me.

"Little Dick," John exclaimed. "Long time no see!"

He gave me a hug, and I could feel a lump on his back, which felt suspiciously like a concealed firearm.

"What's that?" I whispered to him.

He glanced at the reporters that were already beginning to descend on us. "Don't say anything," he muttered.

"Please tell me that's not a gun."

"You don't understand, Ron," he said, his voice tinged with real panic. "There are people after me." He was referring to his involvement in the Wonderland Murders.

I looked over at Bill Amerson, John's manager and best friend, and he also had a conspicuous bulge in his jacket.

We were already surrounded by camera crews and enough microphones to catch even the most hushed whispers. So I went on with the

interview. I introduced him to an up-and-coming young comic named Sam Kinison, and then led him over to the wet concrete, where he made imprints of his hands.

"Is there anything else you want to put in there?" I teased him. "Come on! Dip it in! We all know you want to."

He laughed and declined the penis dip, and we actually managed to have a pretty good interview. It wasn't always easy with John. We had an understanding that it was all in good fun, but at times he'd take my ribbing too seriously. I made a few jokes about his recent legal troubles that made his expression turn suddenly aggressive.

"Are you trying to embarrass me?" he hissed.

"What?" I said, backing away. "No, no, John, I'm trying to be funny. That's what I do."

He studied my face, trying to figure out if I could be trusted. "I'm in no mood for this, Ron. If you think I'm a moron, just come right out and tell me."

The last thing I wanted to do was offend a man with a gun strapped to his back. "No, no, Johnny, you've got it all wrong. You've got a big penis, I crack jokes—that's how this works."

Eventually the TV camera crews moved on, but John continued with the interview. He told me about his upcoming movies and his marriage to Laurie Rose. Everybody had moved inside for the screening, and we were the only two people still on the street, having a conversation in front of a camera that only one of us knew didn't have film in it.

"John, John," I finally said, cutting him off. "This is all great, but nobody's going to know what you're saying now that the media's gone."

He looked at me quizzically. "What do you mean?"

"The camera," I said. "It's . . . it doesn't work."

His head snapped toward the cameraman, who had already retreated inside the theater. He plucked the microphone out of my hand and examined it.

"I suppose this is fake, too?" he asked.

"No, it's real," I said. "But it's not connected to anything."

He yanked at the cord, trying to determine where it led. "There's something on the other end of this."

"Well," I said, "let's find out together."

We followed the cord inside, pulling on it like Sherpas scaling a mountainside. We crept through the lobby, into the back of the Pussycat, finally coming to the end of the cord at Vince's office, where it was tied securely to a doorknob.

"There you have it," I said. "For the last half hour, you've been talking to a doorknob."

"Well," he laughed, letting the microphone's useless cord drop to the floor. "I guess it's what I deserve for calling you Little Dick."

John Holmes and some other porn stars indulged in drugs on occasion.* A young porn stud with connections could have access to an endless supply of pot, booze, crystal meth, amphetamines, methamphetamines, uppers, downers—a veritable pharmacological potpourri. It was all available for the taking, and I wasn't interested in any of it.

It's not like I was sitting at home every night, watching TV and going to bed before nine P.M. I never missed a party. I went to nightclubs and discos, rubbing shoulders with celebrities, rock stars, and the type of people your mother used to warn you about. But I wasn't the guy in the bathroom, plunging his face into a small mountain of coke until he couldn't remember his own name. I was the guy upstairs, having sex with the drug dealer's wife (with the dealer's permission, of course).

Sex was in no short supply during the 1980s. With AIDS still considered a mostly gay disease, casual sex reigned supreme, and you couldn't shake a stick without finding somebody ready to jump on top of you to take a quick ride. And you didn't need to go to some-

* But I probably saw more drugs on mainstream sets.

place like Plato's where sex was the main attraction. You could go to Studio 54 and have sex in the coat-check room.* You could swing by the Hellfire Club and have sex before you even left the parking lot. And if nothing else was available, you'd just need to find out where the porn actors were socializing. Wherever they went, there were certain to be plenty of willing sex partners to go around.

Porn stars always had the best parties. Mark "Ten and a Half Inches" Stevens, of *Devil in Miss Jones* fame, would host parties every other weekend in New York, attracting all the biggest names in porn. I never appeared in a film with him, but he once asked me to play a priest in his mock wedding at a disco called Magique,** when he married his one-time porn costar Jill Munroe. Stevens's most legendary parties happened on Valentine's Day, held at Magique. The place was packed with porn stars like Serena, Vanessa Del Rio, Seka, Samantha Fox, and Jamie Gillis. They'd show up in leather outfits or black lingerie or sometimes nothing at all. We danced beneath strobe lights and, of course, had sex in every available room, private or otherwise.

Los Angeles was a nonstop sex smorgasbord as well, especially if you knew where to go. A few times in the 1980s, the Playboy Mansion was a hotspot for porn gatherings, when Hugh Hefner hosted the after parties for the AFAA Awards. Al Goldstein and I were in charge of the guest list. Hef's only stipulation was that he wanted more actors and actresses than executives. He didn't want the mansion filled with producers, distributors, and exhibitors. He wanted sexy women. So that's what we got him.

Although the entire six-acre mansion would be overtaken by frolicking porn stars, most of us preferred to stay in the grotto, if only because that was where the real action took place. It was a synthetic

* Coincidentally, I had a speaking part in the film *54*, starring Mike Myers. And, yes, my scene took place in the coat-check room.

** Years later, it became Rodney Dangerfield's comedy club.

cave that you could enter through a waterfall. Once inside, there were Jacuzzis, cushioned loveseats, and a lagoon-shaped swimming pool that was kept warm year-round for skinny-dipping.

On one memorable evening, I brought a porn star named Mai Lin to the grotto. All of the naked flesh must have put her in a frisky mood, because she announced that she wanted to have a gang bang. No surprise, there were plenty of volunteers, and she ended up having sex with a dozen guys in just under an hour.

After she finished off almost every guy in the grotto, she looked over at me. She cozied up to me in the Jacuzzi and tried to sit on my lap. I picked her up and carried her over to the Jacuzzi's jets.

"That should do it," I said. "It's like a douche."

I had her sit there for so long, I think she cleaned her tonsils. When I was confident that there wasn't a drop of man juice left, we had sex in the Jacuzzi.

Hefner himself would occasionally join us in the grotto. Whenever he showed up, he always brought a few Playmates with him. During one visit, a sexy lady (who might have been a Playmate) swam over to me in the pool and began giving me head. This went on for a while, and then I noticed that Hefner was standing behind her. It was like being in the presence of greatness. He wasn't just another run-of-the-mill porn publisher. Hefner was a legend, the grand pooh-bah of the sexual revolution.

He was massaging her shoulders and rubbing against her. When the lady realized that Hefner was behind her, she turned around and began hugging him. I watched them for a few minutes and then thought, Hey, what happened here? I thought we had something going. Hefner and the woman were fondling each other, and I was all but forgotten.

I'm not one to interrupt a master like Hefner when he was in the middle of enjoying a sexy model, but I was feeling a little ignored. I decided to give her a friendly reminder that I was still there, and I still had a massive erection that needed some attention. I stood up and began slapping my penis against the girl, just a few light bops on the back of her shoulder, kind of in a humorous way.

Everybody in the grotto was watching us and laughing, and even the girl was giggling, reaching behind and jerking my penis with a few good strokes. If Hefner was aware of what we were doing, he didn't appear to be bothered by it.

Without so much as a nod in my direction, Hefner took the lady by the arm and led her out of the pool. I followed them, just hovering in the distance, hoping that Hef might ask me to join them. I wasn't looking for a handout. I could've brought a girl to join in. I would've made it worthwhile. But he didn't even look at me. He just escorted the lady out of the grotto, taking her straight to his bedroom.

I stood there and watched them go, my erection waving in the breeze like it was saying good-bye. Anthony Spinelli, a renowned porn director, was standing next to me, and he could see the disappointment in my face.

"So you thought he was going to invite you up to his bedroom, too, didn't you?" he asked.

"Well," I said, "I was kinda hoping. It would've been nice. I mean, I was fooling around with her, too."

He laughed and shook his head, amazed that I had not yet figured out what was so obvious to everybody else.

"Oh, Ronnie," he said. "He threw you a bone."

It wasn't all parties and gang bangs. I was still one of the busiest actors in porn, performing in more movies than there were hours in the day. And as if my schedule wasn't hectic enough, I was even starting to dabble in directing. My directorial debut, *The Casting Couch* (which starred me in the title role), was a huge hit. Later on, a producer named Mark Carriere hired me to direct for his company, Leisure Time Entertainment. Mark appreciated me because I was able to deliver what we called "one-day wonders." I could direct a film in a single afternoon, bring it in under budget, and provide him with enough scorching scenes to use and reuse in countless other compilation videos.

But my first love was still acting, and it allowed me to express myself creatively in ways that directing didn't. I had my favorite film-makers, like Hal Freeman, who always cast me in his popular *Caught from Behind* movies. They were usually campy and goofy, and they allowed me to show off my comedic skills, especially when he let me play the perennial lead role of Dr. Proctor.

In September 1983, I took my motorcycle out to Rancho Palos Verdes, a southern suburb of Los Angeles, to appear in Hal's latest sequel in the *Caught from Behind* series. But as I pulled around the corner to Hal's house, the streets were lined with police cars.

I kept right on driving. I didn't even slow down long enough to get a better look. Out of the corner of my eyes, I could see actresses being led outside in handcuffs. If they saw me speeding past, they were kind enough not to say anything.

I went straight to a gas station and called Hal at his home. I didn't really expect him to pick up. For all I knew, he was in the back of a police car, being hauled off to jail. When I heard his voice, I contemplated hanging up, just in case the phones had been tapped. But I needed answers, and that overrode any sense of self-preservation.

"What the hell is going on?" I asked him.

"So you saw?" he said. "I was going to call you, but I assumed you were already on your way over."

"There are cop cars everywhere. Did something happen? Is everybody okay?"

It never crossed my mind that the cops were there for anything having to do with the porn shoot. John Holmes and the Wonderland Murders were still fresh in my mind, and I was terrified that something similar had happened to Hal.

"They busted us for pandering."

"What? What does that mean?"

"It's part of some new antipimping law. I don't know, my lawyers are looking into it. But it seems serious."

"We're not pimps," I said. "This is ridiculous. Since when does making a movie mean that you're involved in prostitution?"

"Since today, I guess." Hal sighed, and I could tell by his voice that a part of him was more afraid than he was letting on. "The times are changing, my friend."

And so they were. More than any of us realized. The ground under our feet was shifting, and it was only a matter of time before it gave way entirely.

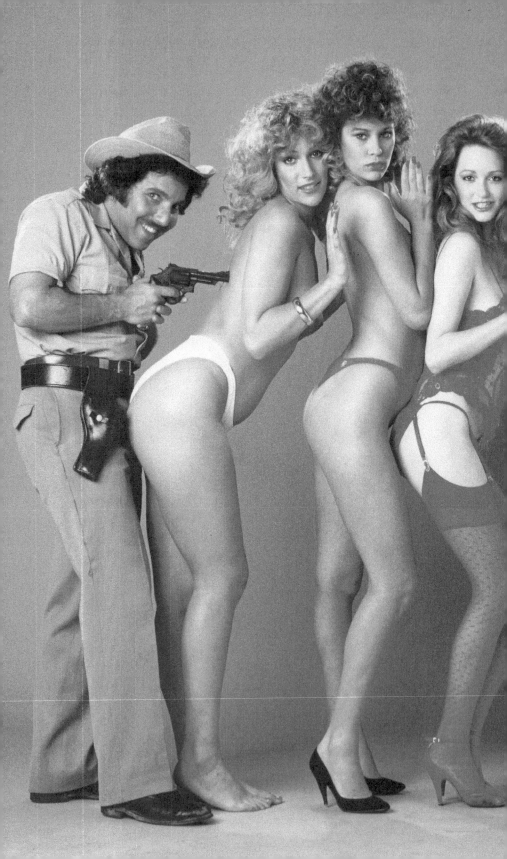

OF VICE AND MEN

"Was it really necessary to break down the door?"

There were sixteen police officers in the living room of my rented house in Laurel Canyon. Which is odd, given that the so-called "criminals" they were there to arrest, which included my entire cast and crew, totaled no more than five people, including me.

Detective Como glanced down at the door that his officers had ripped from its hinges. "Sorry about that," he said with a half smile.

"Y'know, we would have opened it for you. All you had to do was *knock*."

Como just shrugged. "What can I tell you?"

"You do realize that I'm going to have to pay for that, don't you? That's coming out of my salary."

Como's eyes narrowed as he studied me. "If I were you," he said, "I'd be worried about something besides the door."

I was directing a film called *Fade to Black*. We were almost finished for the day when the cops came storming in, literally kicking down the door and causing such a ruckus that it was like a small hurricane had singled out our house for destruction.

There were so many voices yelling at us to freeze we weren't quite

Promotional photo for Bad Girls II. *(Courtesy Collectors/Gourmet Video)*

sure who we should be listening to. Were we supposed to freeze for the eight cops standing in front of us, the six cops behind us, or the cops who were still filing into the room? The actors looked at me, hoping I might have a better idea. I just rolled my eyes and lifted my arms halfheartedly into the air.

"Could you maybe tell your boys to put down their guns?" I asked. Most of the cops yelling freeze were heavily armed. It wouldn't have made much sense otherwise. Needless to say, they had us pretty well covered.

Como nodded, and the cops immediately holstered their guns. "My apologies," he said. "It was our understanding that there were firearms on the premises."

"Hey, the only gun here is in my pants."

It was a smart-ass remark, and not the sort of thing you probably want to say when your living room is filled with police officers, but I was feeling cocky. I had done nothing wrong. I was shooting a porn film. So what? As far as I knew, that wasn't against the law.

I tried not to think about Hal Freeman. It'd been almost three years since his arrest, and although he had not yet served jail time, it was starting to look grim.

It had all started with David Roberti, a Democratic state senator who created an antipimping law in 1982 to crack down on the city's streetwalkers. The law required a minimum three-year sentence for anyone convicted of "pandering," which was just a fancy legal term for selling sex for money. This gave the Los Angeles district attorney an idea. The new law, he reasoned, could be used to target porn. If selling sex for money was illegal, it could be argued that pornographers—who paid actors to have sex—were also guilty of pandering. The city hoped that by criminalizing the industry they could force it out of L.A. completely and make it somebody else's problem.

But before they could scare the industry into packing up shop and skipping town, they needed to show that they were serious. And that meant making an example of somebody.

Hal Freeman was the first filmmaker to get busted. He was charged with five counts of pandering—one for each of the female

performers in his film. Nobody really understood why the men weren't charged, but that's L.A. logic for you. When the case went to trial at the Van Nuys Superior Court, Freeman was found guilty on all counts. The judge refused to give him the mandatory three-year sentence, calling it "cruel and unusual punishment." Instead, he was sentenced to ninety days in jail and a $10,000 fine. Freeman's lawyers took the case to the California Court of Appeals and lost again. There was talk that Freeman might take it all the way to the California Supreme Court, but very few people expected his case to be accepted. Or if it was, that he would win.

Since then, several other porn productions had been raided, and mine was just the latest. I probably should have been more scared than I was. But because Hal hadn't given up, I didn't see any reason why I should either.

I watched from the couch as officers interviewed my actors—all *two* of them—asking about their involvement in the film and taking down names and phone numbers. The actress was already in tears, and God knows what she was telling him. The other officers were searching the house, collecting whatever money they could find and confiscating the camera equipment.

Como was standing in the corner, talking with another vice detective named Navarro. They were whispering something, pausing every so often to shoot a derisive glance in my direction. Well, I thought, if these two were in charge of the sting operation, I might as well be friendly and introduce myself. Know thy enemy and all that.

I wandered over and asked if I could help with their investigation. They could confiscate everything and ask as many questions as they wanted; I wasn't going to admit to doing anything wrong.

"Will you be making any arrests today?" I asked, trying to sound indifferent and casual.

"Not today," Navarro said. "We're just taking names."

I looked over at the six officers interviewing my actors. "So how many cops does it take to write down some names, anyway?" I asked.

Como smirked. "Very funny," he said.

I pointed to a gaggle of officers who were standing in the living room, watching a baseball game on TV. "And what about them? Are they here on 'official business,' too? Or is there just no cable down at the station?"

Navarro was not amused. "Why don't you just back off and let us do our jobs?"

"Sure, fine, don't mind me. You obviously know what you're doing. If you need any snacks or something, just let me know."

One of the officers who had actually been searching the house walked over with a handful of papers. Como leafed through the stack, which contained my production notes and copies of the script. It wasn't anything you wouldn't find on any movie set.

"If you'd let me know what you're looking for, I could probably save you some time," I offered.

Como ignored me and continued thumbing through the papers. He raised an eyebrow and held up a dog-eared notebook. "What's this?" he asked.

Fuck!

It was my address book. My most cherished possession. The phone numbers of everybody I knew in the world were somewhere in that book. Granted, most of the numbers were written in an indecipherable scrawl, so it was doubtful that Como would be able to make much sense of it. He'd need an expert in cryptography to decode my handwriting. But still, if I lost that address book, I would be in serious trouble. It was the only copy in existence, and some of those phone numbers weren't replaceable. I couldn't function without it.

"That's nothing," I said, trying to snatch it away from him. "Just some notes. Nothing you'd be interested in."

My crew, treacherous bastards that they were, began snickering. Como turned to them with an inquisitive look. "What's so funny?" he asked.

"He doesn't want to lose his phone book," the cameraman remarked.

Como grinned widely at me. "Oh, he'll lose it all right."

My calm and cool demeanor had evaporated. I pleaded for Como not to take it. I'd tell him anything he wanted to know, just as long as he didn't confiscate my address book. For the love of God, not *that*. It was too much. It was inhumane. He might as well have told his officers to pull out their weapons and riddle me with bullets.

Despite Navarro's protests, Como allowed me to copy down a few numbers before they took it away. It was still heartbreaking, but it was better than being left destitute.

"I think that about covers it," Como said as the officers carted away boxes of evidence. "We'll probably call you tomorrow and have you come down to make a statement. Do me a favor and don't leave town. I don't want to chase you all over California."

"Don't worry," I told him. "I'll be there."*

Stuart Goldfarb, my lawyer, accompanied me to the police station the next morning. They filed formal charges and put me in a jail cell until my lawyer could post bail. Como didn't bother to frisk me.

"There's no point," Como said. "I know from our informants that you don't touch drugs. Congratulations."

I should have guessed. Somebody had squealed on us. "You wouldn't want to give me a name, would you?" I asked.

Como just smiled.

"Nice try."

After I was out, the wheels of justice moved slowly. I appeared in court for a few preliminary hearings, which were mostly for me to hear the charges and make a "not guilty" plea. Nobody seemed to be in any big hurry to try the case. Even the assistant district attorney might have known it was ridiculous. When the judge scolded her for arriving late to a hearing, she muttered under her breath, "I was working on a *real* case."**

* A famous mainstream director was on the set, and was allowed to leave. You'll learn more about this later.

** The judge didn't hear her, but my lawyer did. "If this goes to trial," he told me, "I'll use that line against her."

I wanted to get back to business as usual, but my lawyer advised me against it. "Just lay low for a while," he said.

"I have to make a living," I told him. "I can't just stop making movies altogether."

"Well, if you have to, at least do it outside of L.A. These guys are keeping a close eye on you. I'm sure there won't be a problem if you shoot a film out of town."

"Did they tell you that?" I asked.

My lawyer nodded. "They implied that."

Hello, Ron. Nice to see you again."

Como and Navarro were standing at the door. At least they were courteous enough to knock this time.

I was in San Diego, shooting a film called *Star 88*. It had been less than a month since my last arrest, and I'd been extra-secretive about my production plans. I stopped using the phone, all of the actors had been cast in person, and nobody was told about the location until the last possible moment. I even found a set that was a hundred miles south of Los Angeles. I had taken precautions. I was careful. This shouldn't be happening.

"You must be kidding," I said as Como and Navarro strolled inside. "This isn't your jurisdiction. You can't be here. You have no authority."

"Oh, we're not here to arrest you," Como said.

"Then what's going on? You just here to watch?"

Como motioned toward the door. "We're with him."

A San Diego vice cop named Detective Hardman shoved past me, waving his badge like he thought he might emit tear gas. "Everybody get on the ground," he bellowed.

I glared at Como. "We're just advising," he said. "Don't mind us."

A small army of police officers marched inside and began putting cuffs on some of my actors. Detective Hardman waited until the entire cast and crew was out of sight before turning to me.

"Hey, Jeremy," he said, as he slapped a pair of handcuffs on my wrists, "loved you on *Geraldo*."

So he had seen it. I was afraid of that. It was all starting to make sense.

A few months earlier, long before my first arrest in Los Angeles, I had taped an episode of Geraldo Rivera's talk show. It was for a segment called "Porn Stars and Their Families." Along with actors like Hyapatia Lee and Nina Hartley, we discussed what our families thought about our chosen profession. I thought it went pretty well. My sister Susie agreed to be interviewed on air, though only in silhouette and under the fake name "Lynn." She had the best one-liner of the entire show. When Geraldo asked her if she still thought of me as her little brother, she said, "No, I couldn't say it *exactly* that way, now could I?"

After Como and Navarro came bursting down my door in Laurel Canyon, I vowed to my lawyer not to do any more national television. It would've been stupid. As my lawyer reminded me, "If you're too much of a public figure, it's just going to provoke the cops. They'll go out of their way to embarrass you. It's like you're throwing down the gauntlet."

But the episode of *Geraldo*, which I had completely forgotten about, had been broadcast that very morning. Como and Navarro must have seen it, and Detective Hardman obviously had. It must've seemed as if I was flaunting my porn career in their faces, and they were going to make damn sure I knew that they didn't appreciate it.

"You sure gave Geraldo a run for his money," Hardman sneered. "It was damn fine TV. You're a funny guy, Jeremy. And you looked good." He patted my stomach. "Not as heavy as you are in real life."

I tried not to make direct eye contact with him. "Can we just get this over with, please?"

Hardman circled me like a vulture honing in on its prey. "Don't expect any favors from me. I'm not gonna be nice to you like they are in L.A. The L.A. cops might like you, but I *don't*."

Hardman was just a few inches from my face, so close that I could feel his hot spit splattering on my cheek. I saw Como standing behind him, whistling nonchalantly. He may not have expected Hardman to get so rough with me, but he was powerless to do anything to stop him.

Hardman grilled me for information. Who was I working for? Who was paying for the shoot? Did the name Mark Carriere mean anything to me? Mark was, of course, my boss, and just as Hardman had guessed, the movie was being funded by Leisure Time Entertainment. But I wasn't about to tell him that.

"Oh, come on, Jeremy," Hardman growled. "We know that you're sending your tapes to Indiana. We stopped the FedEx truck, for Pete's sake. We know that Mark Carriere lives there. We don't want you; we want *him*. Just admit that he's paying your bills, and this will all go away."

"Mark has nothing to do with this," I said. "I always give him first look at my films and allow him the chance to distribute them, but this is *my* movie."

"Goddamnit, Jeremy, why are you protecting this guy? He's a fucking scumbag."

Hardman's accusations got only more preposterous. He started asking if I had connections to organized crime. "What's the mob paying you to direct these movies?" he demanded.

"The mob?" I said incredulously. "Who said I was working for the mob?"

"Are you a part of the Peraino Family?"

"Hell no!"

Hardman looked like he wanted to drag me into a back room and work me over. "How about the Gambinos?" he asked. "Or the House of Milan?"

"Nope, sorry," I said. "I've never dealt with them."

"I'm in no mood for this. You're going to give me some answers, or we're going to make your life very, very difficult."

I shot him a deadpan expression. "This," I said, in my best Hyman Roth impression, "is the business we have chosen."

It was true, of course. I wasn't working for the mafia. I knew that they were at least tangentially involved with porn films, and I heard rumors that some of our investors had shady pasts. But I never met them, never associated with them in any way. I wasn't involved in that end of it. I made the films, shipped them out to Mark, and somehow they got into video stores or theaters. If there were men in fedoras and pinstripe suits having basement meetings, plotting the best way to transport porn across state lines, I never witnessed it.

Not that I was totally unfamiliar with the mob. But it wasn't because of porn. Believe it or not, two generations ago, my family had a mafia connection. My great-uncle worked with both Frank Costello and Bugsy Siegel. He changed his name from Ben Greengrass* to Ben Caruso and got involved with the mafia during the 1930s. My dad has told me some pretty interesting stories. When he was just a kid, Ben would take him up to the Catskills for the weekend, where he met with other gangsters to discuss, well, whatever it is that gangsters talk about when they're alone. A black limousine would show up at my dad's house and whisk him and possibly some other cousins away to the countryside. It looked less conspicuous if they had young children and families with them. They wanted to appear like just another family enjoying a harmless picnic in the Catskills.**

* Our family is distantly related to Barney Greengrass, the sturgeon king of the Upper West Side New York City deli. We're also related to Ken Greengrass, former manager for Julius LaRosa, Florence Henderson, and Steve Lawrence and Eydie Gorme.

** These kinds of meetings were portrayed in the film *Analyze That*.

My great-uncle Ben was known as a rumrunner or bootlegger for Frank Costello, and they used my grandmother's basement to store rum. My dad claims that they may have dealt in drugs as well, but my grandmother denied it.

"Just rum," she'd say firmly when I asked. "Never drugs."

"That's not what I heard," my father would say with a laugh.

My grandmother would shush him. "Arnold," she'd snap, "you shouldn't be saying these things."

"Oh Mom, he's long dead. It doesn't matter anymore. Those connections are long gone."

Another time, my father, sister, and I were watching *The Godfather Part II* on TV. When we got to the scene where Al Pacino's character attends a meeting of mafia leaders in Cuba (they were plotting to open gambling resorts in Havana), my dad went into a back room and brought out some marraccas, which Uncle Ben had brought back for him from Cuba. As it turns out, Ben had been at the very same meetings portrayed in the film!

Not all of the stories about him involved bootlegging and gangsters. He was also a Jew, and fiercely proud of his heritage. He owned a restaurant in New York called McCarthy's Steak House, and one night he heard an Irish sergeant making anti-Semitic remarks. Ben had just lost his nephew Elliot, who died a hero at the Battle of the Bulge during World War II. He loved Elliot, as everybody in the family did, and it killed him to hear this sergeant insulting Jews, claiming that they weren't worthy of being called soldiers. Ben got so upset that he dragged the guy outside and beat the snot out of him. And as he did it, he said, "This is for my nephew."

So no, I didn't have any *direct* mob connections, at least not when it came to porn. But if Detective Hardman had asked me if I had any *family* involved in the mafia, I could have told him stories for days.

Detective Don Smith led me out to the back porch for a private talk. He had somehow convinced Hardman to take off the handcuffs, which was a nice gesture. Smith was a very sweet guy, and, unlike Hardman, he almost treated me like a buddy.

Smith took a pack of cigarettes out of his pocket and offered one to me.

"No thanks," I said. "I don't smoke."

Smith nodded. "That's right," he said. "I knew that."

It was scary how much these vice cops knew about me. And not just things that were relevant to the porn business. They knew little details. *Irrelevant* details. They knew what I spent my money on, and the friends with whom I hung out. It's amazing how often they spoke to the CRI (confidential reliable informant). We later learned that John Holmes was a paid police CRI. No wonder his shoots were never busted.

"Things are going to get much worse before they get better," Smith said. "Why don't you just cooperate, and we can all go home?"

"I haven't done anything wrong," I told him. "What exactly are you expecting me to confess to? Do you really think I'm mixed up in the mob?"

"No," he said softly. "I don't think you are."

"That fucking guy in there—Detective Hardman, or whoever the hell he is—he's an idiot. You are aware of that, aren't you? He's wasting everybody's time."

Smith sighed. He stared at his feet, pondering his words carefully. "Ron," he said, "why are you bothering with this crazy business anyway?"

"What are you talking about?"

"You've done a few TV shows and mainstream movies. I saw you in *52 Pick-Up*. Why do you keep doing porn? Just retire and be done with it. You always wanted to do real films. I can't think of a better excuse to make the leap. And besides, you've got plenty of money."

I almost did a double take with that last remark. "How do you know that?" I asked him ominously. "You've checked my tax returns?"

His smile was all the answer I needed. He patted my back. "It's a good thing you're a straight shooter," he said. "The last thing you need on your record is tax evasion."

When the L.A. "advisers" left, Detective Hardman threw my ass in jail. I didn't tell them anything. They could rattle off my tax records until they were blue in the face, but I wasn't a rat, and I never would be. Besides, how bad could jail be? You had four walls, a free meal, and your own bed. It was like getting a hotel room for the night, all expenses paid. My lawyer would take care of this. And as soon as Mark heard that I'd thrown myself on a bomb for him, he'd wire my bail money without blinking an eye.

"They set your bail at seventy thousand dollars," Mark told me on the phone.

"What? That's got to be some kind of mistake."

"No. I talked to the D.A. myself. He isn't budging. It's your second offense. You were already out on bail for the L.A. job. Can you just ride it out for a bit while I try to get a bail reduction?"

"I'd rather not," I told him. They'd put me in the sex offender's cell. I'd spent the last hour surrounded by rapists and child molesters. There was one guy who was doing yoga on the toilet seat while jerking off. And as if that wasn't bad enough, one of them had recognized me.

"Aren't you Ron Jeremy?" he'd asked.

"You mean the fat guy with the mustache?" I'd said, disguising my voice. "Nope, not me. It's funny, though. I've been told that I look like him."

They'd been glaring at me with distrust ever since. When the warden finally came to give me my one phone call, the other inmates were starting to figure out that I was probably lying. The masturbating yoga guy was reciting lines of dialogue from my own movies back at me. If I went back in there, I might be surrounded by a pound of beef and a bucket of balls. (As it was, I was afraid to pee in front of them, so I held it in for hours.)

"Okay, okay, settle down," Mark said. "I'll make some calls and see what I can do."

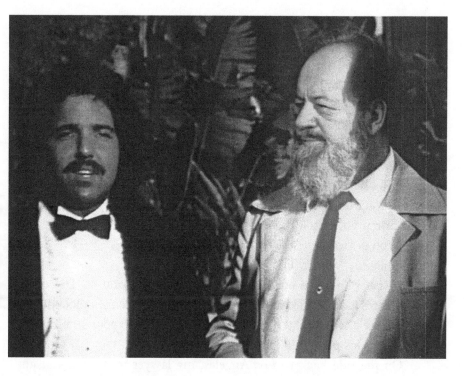

With Ralph "Papa" Thorson.

Luckily, the warden had come to the conclusion on his own that I didn't belong with the sex offenders and transferred me to a different cell. When I was introduced to my new cell mates—nothing more threatening than drunks and petty thieves—I almost wanted to kiss them.

"Hey, aren't you Ron Jeremy?" a friendly looking boozehound asked.

"Yes, I am!" I declared.

I signed autographs and told stories for most of the night. I was so happy to be around people who weren't jerking off in front of me, I would've given them my home phone number had they asked.

The next morning, Mark and I devised a way to get me released without the $70,000 collateral. I called in a favor with Ralph "Papa" Thorson, an old friend and world-famous bounty hunter. He was

legendary in Los Angeles. Steve McQueen had played him in a 1980 movie called *The Hunter*. His word was enough to get me a free pass. Papa talked to the two bondsmen assigned to me, Dan Majors and Mark Herman, and assured them that I wouldn't be a problem.

"Don't worry about Ron," he said. "If he runs, I'll catch him."

As soon as I was out, I found a pay phone and called the sergeant at the San Diego Police Department. I wasn't about to leave town without my driver's license and passport. And if my address book was gathering dust in some police locker, I wanted that, too.

"I don't understand," he said. "Aren't you still in jail?"

"Sorry, no," I told him.

"You posted bail?"

I paused. "Something like that."

I wish I could've been there to see the expression on Detective Hardman's face. He probably thought that he'd have me in lockdown for at least a week, where it would've been easier to get me to rat on Mark. But his plan didn't work.

On the ride back to Los Angeles, my lawyer told me about an article he'd just read in the *San Diego Tribune*. I forget the exact wording, but it was something to the effect of: "After the recent arrest of porn star Ron Jeremy, police are confident that the crime rate in San Diego will drop considerably."

"Yeah," I joked with my lawyer, "it's a good thing I'm leaving town, because if I stayed even one more day, I might knock over another gas station."

"To say nothing of all those carjackings." My lawyer laughed.

It was by no means over for me. With the two counts of pandering in Los Angeles and the ten counts against me in San Diego, I had a long legal road ahead. But for the moment, it was enough just to be free and miles away from the nearest vice cop.

Back in L.A., I met with Mark Herman (one of my bondsmen) at Canter's Deli on Fairfax, just to show my face and thank him again for bonding me out on Papa's word. As soon as I walked into the door, he jumped up and hugged me.

"Oh, thank *God!*" he said.

It seems that Papa, knowing that I'm always late for my appointments, *and,* he being somewhat of a practical joker, had called Mark and told him (as a joke) that I'd just purchased a one-way ticket to Brazil. Mark assumed that I was already on my way to the LAX airport and he'd never see me again. My bail would have cost him $63,000. So when he saw me smiling back at him, he was so happy that he offered to pay for lunch.

When a bondsman is paying *you,* you know that everything is going to be okay.

chapter 9

HOW TO TALK DIRTY AND MAKE PEOPLE LAUGH

"Ladies and gentlemen, please join me in giving a warm welcome to Ron Hyatt *the Maniac*!"

I threw open the curtains and came bounding out onto the small stage at the Good Times Nightclub.* I was dressed in my usual stand-up uniform, an oversize tuxedo jacket that fit me like a potato sack. Without waiting for the applause to die down, I grabbed the microphone and launched into my routine.

"Hello, everybody, I'm Ron. And I am living proof that *anybody* can get laid."

I wasn't exactly the evening's headline attraction. But then again, during the comedy boom of the 1980s, you didn't need to be. Most of New York's hottest comedy clubs hosted open-mike nights, where any hopeful could get onstage and take his shot at comedy stardom.

"I used to be so lonely, I wouldn't get dick let alone pussy. Unlike you guys, I've seen my ass on a wide screen. I could go to the West Village and the gay guys would look at me and say, 'Sorry, we're not *that* gay.'"

* A great club run by Lonnie Hanover, now the manager of Scores in New York.

Sam Kinison and me at the Comedy Store.

Okay, so maybe my act still needed some work. But even if I didn't always get the biggest laughs, it was still a thrill to be on an actual stage, holding a microphone rather than my penis, having an audience pay attention to what I was saying rather than fast-forwarding to the pop shot.

At first, I used my real name, Ron Hyatt, because I didn't want to be automatically associated with my more famous alter ego. But a year or two later, I decided to start using Ron Jeremy. It was a bigger draw, and, let's face it, a comic without an audience is nothing.

"I have a tattoo on my dick of a bigger dick. My dick is so big, my dick has its own dick. And my dick's dick is *still* bigger than your dick."

Well, as the old aphorism goes, "Write what you know." If dick jokes worked for Richard Pryor and Robin Williams, they'd work for me.

I walked over to a piano that sat next to the stage. "You've all heard of 'Moon Over Miami'?" I asked the crowd. "Well, here's a little ditty I call 'My Moon Over the Keys'." I squatted over the piano's keyboard and lowered my ass onto it, pounding out a few off-key notes.

The audience always laughed at that bit. Whether they were laughing because they found it genuinely funny or because they couldn't believe what I was doing, I never really knew.

It didn't matter to me. As long as they were laughing.

I know my brand of comedy hasn't always gotten me accolades. If you saw my documentary, *The Legend of Ron Jeremy*, you probably remember Al "Grampa Munster" Lewis's rant about my stand-up ambitions. I'm not sure if he was kidding, but he certainly slammed my comic skills.

I don't think my act is quite as bad as that, but I do admit to having a fondness for cornball groaners and one-liners. I'm more likely to make jokes about backstage blow jobs and gigantic prop condoms than world politics and literature.

My tastes in comedy shouldn't come as a surprise, especially given my upbringing. Remember, I came of age in the Catskills during the late 1960s and early '70s, in the last heady days of the Borscht Belt comedy renaissance. There were more than two hundred hotels in the Catskills, and every last one of them had nightly entertainment, often featuring some of the best up-and-coming and established comedians in the business. When I wasn't waiting tables (or, as the case may be, trying to get laid), I was sneaking into shows, watching comics like Henny Youngman, Buddy Hackett, and Shecky Greene ply their trade.

These were comics who invented the word *shtick*. They didn't shy away from a mother-in-law joke, or an ethnic gag, or even pulling out a seltzer bottle if the mood struck them. They wore big bow ties and plaid jackets, used lines like "Take my wife, please," and frequently employed a well-timed cymbal crash to announce a gag's payoff. They told puns that wouldn't just make you groan, they'd give you a stomach cramp. It was corny, it was campy, and, sure, it was a little bit stupid. But I loved it.

For a smart-ass kid like myself, who had spent his entire formative years as the "class clown," being in this environment put stars in my eyes. I saw the Catskills as a possible launching pad to the big time. It wasn't such a far-fetched dream. Sid Caesar had waited tables at the Catskills before getting his break. If it could happen to him, it could happen to me.

So I took any stand-up gig I could get. I performed and emceed at open mikes all over town, from the Stag-and-Doe Restaurant to Bum and Kel's Bar to the Paramount Hotel. But when I left the comforts of the Catskills for the big, bad city of Manhattan, my timing couldn't have been less perfect. The broad, goofy shtick that I had watched and studied and tried to emulate in the Catskills was being eschewed in favor of a rougher, more urban style of humor. It was no longer enough to come out and crack wise about mothers-in-law and Jews. Your act had to have *substance*. You had to rail against the status quo and hypocrisy. You had to be wry and ironic and subtle. You had to be the coolest person in the room, not just the funniest.

It didn't fare well for a kid whose signature gag involved impersonating water fountains.

I became a tireless performer, never missing a chance to do an open mike, whether it was the Comic Strip or the Improv, Good Times or Catch a Rising Star. Because porn producers were paying for my airfare, I was appearing at clubs and on cruise ships from coast to coast. I was also introducing rock stars, raves, and spring-break festivities. By the mid-1980s, I was one of the busiest stage performers around, even if my name never appeared on the marquee.

I didn't always need stage time as an excuse to visit the clubs. When I was in Los Angeles, the Comedy Store was like a second home to me. During some weeks, I'd be there every night, just to check out the shows and watch the pros in action.

I occasionally joined a small clique of comics that included Freddy Asparagus, Carl LaBove, Andrew Dice Clay, and Jim Carrey. After Comedy Store shows, we'd get together at a twenty-four-hour diner on the Sunset Strip called Ben Franks. I'd often pick up the tab, as I was the only one at the time with a regular paycheck. We'd squeeze into our favorite booth and make jokes all night, sometimes not stumbling out until the next morning.

Jim Carrey was one of my favorites. He was probably the most successful of the group, having starred in a short-lived TV series in 1984 called *Duck Factory*,* but he was still a relative unknown in the world of comedy. He was a master of impersonations, and during our late-night dinners, we'd pimp him out to perform some of his best characters. We'd each give him a situation, like "Jack Nicholson at the DMV" or "Elvis Presley after a nuclear war," and he would launch into an inspired routine, nailing the impersonation perfectly.

But when it came time for me to offer up a suggestion, for example: "So what would John Wayne do if he was audited by the IRS?" Jim's face would turn suddenly sour, and he'd stare at me with mock

* Coincidentally, the show also starred Jack Gilford, whom my dad knew as a kid.

contempt. "He wouldn't do much of anything," he'd say. "He'd probably just collect his receipts and bring them to his accountant. Jesus, Ron, why would you ask something like that?"

Jim would perform his impersonations for anybody at the slightest provocation, but the moment I piped in with an idea, he would look at me like I'd just suggested a comedic dead end. "Ronnie, you know damn well he wouldn't say anything." His deadpan reaction was priceless, and sometimes funnier than the impersonations themselves.

We spent most of our time laughing over little inside jokes like this. Another popular bit involved Freddy Asparagus and something we called "The Ferret." We once overheard him hitting on a girl at the Comedy Store, who was regaling him with tales of her pet ferrets. Freddy was, as you might imagine, bored out of his mind, but he pretended to be captivated. He even asked her about the color of its cage and what kinds of food she would feed it. We were amazed that he was able to keep the façade going for so long, and none of us believed that he'd be able to hold out long enough to get into her pants. But after listening to her rattle on about ferrets for most of the night, she finally ran out of steam and invited him back to her place, I think.

From that point on, we began to refer to any extremely boring conversation with a woman for the sake of getting lucky later as "Ferrets." It didn't necessarily need to involve a ferret, naturally. It could be any kind of dialogue where you just pretended to care about what a woman was saying. She could be showing you baby pictures or recalling her high school experiences, and you would have to respond as if you were fascinated by every word. "Wow, you really lived in Toledo? That's incredible. Tell me more." If you didn't seem interested, she'd talk to someone else, and if the lucky bastard was patient enough, he might actually *get* lucky.

When we'd see a hot girl at the Comedy Store, or even while sitting at Ben Franks, we'd try to determine just how many Ferrets were required to get lucky.

"I'm guessing she's a one-hour Ferret. What do you think?"

"Are you kidding me? She's wearing granny glasses. A brainy

chick like that is a three-hour Ferret minimum." (By the way, in all fairness, I'm sure many women put up with boring man dialogue on a regular basis. They'd probably call it football dialogue, or car mechanics dialogue.)

Robin Williams would occasionally join us at Ben Franks, although he was already a huge star and would attract large crowds wherever he went. Though every comic wanted to be his best buddy, he genuinely seemed to get a kick out of me. When he was interviewed by Ed Bradley at the Comedy Store for a *60 Minutes* segment, he went out of his way to introduce me. "This is my friend Ron Jeremy," he said, posing with me for the cameras. "We call him the Human Tripod." I was later cut out of the *60 Minutes* piece, but it was enough that Robin didn't think twice about the plug.

We would often tease each other about our respective careers. When he appeared in a movie called *Moscow on the Hudson*, I accused him of stealing my Russian accent from the porno *Olympic Fever*. Robin never denied it.

"You got me, Ron," he said. "Thank God you did that movie. I never could have learned how to speak Russian without it."*

Though I was always popular in comedy circles, there was one comic who went out of his way to befriend me. When he walked up to me at a comedy club's bar and introduced himself, he was just another stand-up, trying to make his name on the Comedy Store stage.

"You must be Ron Jeremy," he said with a giddy smile.

"That's me," I said, giving him the once-over. "And you would be?"

"The name's Sam Kinison,"** he said, grabbing my hand and shaking it. "I have the funny feeling that you and I are gonna become friends." ⎯⎯⎯⎯⎯

* As months went on, I introduced Robin to Al Goldstein, Althea Flynt, and my sister, Sue. Robin gave Sue and her husband free tickets to his show in Atlantic City, months later, VIP all the way.

** We were both friends with Lenny Schultz, the Catskills comic best known for his "Bionic Chicken" routine on *Rowan & Martin's Laugh-In*.

I feel bad for those of you who never got to see Sam Kinison perform. His records and CDs are still around to give you some idea of what you missed, but none of it compares with the live show. It's difficult to describe to the uninitiated. It was like watching a volcano erupt, drenching an unsuspecting town in hot lava. It happened that slowly, often without warning. Sam would begin his act by just pacing across the stage, clutching his microphone but saying nothing, until the audience began to grow restless. And then, out of nowhere, came that decibel-splitting, eardrum-shattering scream.

His screams were equal parts fury and pain, outrage and heartache. Unlike many of the shock comics of his era, who lashed out at anyone and everyone with a sense of smug superiority, Sam never came across (at least to me) like a bully. If he was angry, it was because he was sincerely hurt that the world wasn't a better place. His screams were not born out of arrogance but frustration. While a comic like Andrew Dice Clay might make sexual jokes about women in general, Kinison saved his venom specifically for the women who had broken his heart. And he did it in a way that made you feel a part of the experience, like he was a pastor leading his congregation, helping you banish those dark demons that could be exorcized only with a good, long, primal scream.

Sam and I had some great conversations over the years. In particular, he enjoyed discussing my porn career.

"Do you remember that film *A Girl's Best Friend?*" he asked me once. "There was the scene where you're balling the maid in the kitchen while eating chicken legs."

"Yeah, I remember it," I said, a little embarrassed.

"You start listing off your favorite foods while you're fucking her. You're muttering, 'Apples, plums, olives, flour.' And then when you cum, you're screaming, 'Foood! Fooood!' Oh man, Ronnie, I laughed so hard, I forgot to jerk off.

"And who could forget your timeless role as Sheriff Slater in *Bad Girls II*?" he snickered. "You're fucking those three girls in the jail cell. Come to think of it, you were eating chicken in that scene, too. Y'know, Ronnie, it's starting to make sense why you've gained so much weight. Have you ever done a sex scene that didn't involve food?"

I once brought Jamie Gillis to Sam's Fourth of July barbecue. Sam enjoyed asking him questions and, as he did so often with me, repeating back his favorite lines from Jamie's films.

It was impossible to resist Sam's enthusiasm for all things porno. When he asked to visit the sets, I couldn't very well tell him no. In some cases, I even concocted a reason for him to be there, such as when I was cast in a movie called *Stiff Competition*, billed as "The Super Bowl of Suck-Offs." The movie's grand finale featured a blow-job contest in a wrestling ring, and hundreds of extras were needed for the crowd scenes. Sam brought a few of his comic friends, and during breaks in the shoot, they were easily coaxed into doing impromptu stand-up for the exhausted extras, to help the morale of the crowd. Though Sam's face never appeared on-screen in the edited film, you could clearly see the back of his head, which delighted Sam to no end.

While Sam was renting Robin Williams's house in the Hollywood Hills, he let me borrow his temporary digs to shoot a film. Though we tried to be inconspicuous, we learned later that we might've given Robin's neighbor an unexpected gift. One of my actresses was given the wrong address, and after driving around the neighborhood for hours, she took a wild guess and walked up to the house next door. Now, I won't swear to this, but I'm pretty sure that when she knocked at the door, she was greeted by a very surprised David Hasselhoff (long before his *Baywatch* days).*

"Is this where the porno is being shot?" she asked.

* I asked Mr. Hasselhoff about this story, many, many years later, at the Playboy mansion, Summer 2006. Believe it or not, he verified it.

Hasselhoff looked at the drop-dead gorgeous woman standing before him, thought about it, and then said, "Well, I guess it is now."

Sam was always a loyal friend. When he skyrocketed to fame, he would bring me along during his concert tours, paying for my hotel rooms and giving me backstage access to all of his shows. Nothing really changed between us, other than that it was now *Sam* who was buying dinners and attracting hordes of autograph seekers. I also became friends with his brother Bill, his "Outlaws of Comedy," his various girlfriends at the time, and Rick Jones, his bodyguard.

Sam would occasionally share the spotlight with me. I made a cameo in his music video for *Under My Thumb*.* And when the Fox Network asked him to host a New Year's Eve special, he promised me a small part. In return, I provided ten female porn stars for the show. I arrived for the pretaping and waited around all day, watching as Sam filmed segment after segment. I was worried that he might forget me entirely. But at long last, Sam finally called me to the stage for our prescripted routine.

"So, what are your New Year's resolutions, Ron?" he asked.

"Oh, I guess I want to be like you," I said. "I just want to be a part of family entertainment."

It was a funny little skit, and though I had only a few minutes of screen time, I knew it would be worth it. But as we performed several takes for the camera, I began to suspect that something wasn't right. Crew members were already starting to wrap for the day. I could hear loud crashes behind me as set pieces were dismantled and carted away. The director wasn't even paying attention to us, noisily conversing with his PAs and gaffers. It wasn't the hushed atmosphere

* In a strange coincidence, actor Corey Feldman was originally hired to be in the video, as the defendant in a court case (Sam was his lawyer). But Corey was having his own problems with the law and couldn't make it to the shoot. His role eventually went to David Faustino from *Married with Children*. The video starred Ozzy Osborne and Dweezil Zappa.

that one usually finds on a professional shoot. And that's when I figured it out.

"There isn't any film in the camera, is there?" I asked.

Sam shrieked with laughter. "Of course there is. What are you talking about?"

I peered at the camera's blinking red light. It appeared to be rolling, but I couldn't be sure. I had used the same trick once on John Holmes.

"You're a fucking liar," I accused him. "That camera is empty!"

Sam dropped to the floor and clutched at his sides. "You are such a paranoid freak." He laughed. "Do you really think I'd do that to you?"

We continued with the skit, but I knew in my heart that none of it was being shot on film. And sure enough, when the New Year's Eve special premiered, our scene was nowhere to be found.

I was upset, but it didn't stop me from finding work for Sam. It wasn't always easy. I got him a speaking part in the film *Lords of Magick*, but he lost it when he blew off his first meeting with the director.* Fred Asparagus got the part instead. Sometimes, though, it actually worked. I recommended him for a role in *Savage Dawn*, and he was perfectly cast as a born-again Christian barber who gets his throat slit after singing "Amazing Grace" to a rogue biker (played by Bill Forsythe).

By the late 1980s, Sam's comedy career was bigger than ever. United Artists offered him a starring role in a movie called *Atuk*, about an Eskimo who travels to New York City. Sam promised roles to several of his comedy friends. He was going to try to find me something as well. But just weeks before the shoot was to begin, the project crumbled.

Sam didn't care for the *Atuk* script and decided to rewrite it. I visited him at the Mayflower Hotel in L.A., where he and his writing

* At Sam's funeral, Carl LaBove delivered one of the funniest lines I've ever heard about Sam's chronic lateness and "no-show" reputation. "Well," Carl said to the huge crowd, "this night is like all the rest. I'm going to introduce Sam, and he's not going to show up."

partner pulled all-nighters to finish a new draft. When he submitted their revisions to United Artists, they balked and told him that they would be using the original script.

"I told them if they didn't give me a little more creative control, I'd just walk through it," he explained to me later. "I'd give a lousy performance on purpose."

"So what happened?" I asked.

"They pulled the plug."*

I told him that it might be a bad idea to clash with a major Hollywood studio and a man like Michael Ovitz. And sure enough, United Artists filed a lawsuit against Sam, and he and his manager, Elliot Abbot, parted ways. But he didn't care.

"I'm not going to give my fans a crappy movie," he said. "If it means I go back to sleeping on floors, that's fine. You can just buy me dinners like you used to."

Even if I didn't always agree with his career decisions, I still joined him occasionally during his *Leader of the Banned* concert tour. I even introduced him to my former porn cohort, Seka. They dated for a while, and when he hosted *Saturday Night Live*, Sam gave her a nice bit in a skit with Dana Carvey (the Church Lady).** His eventual fallout with Seka was particularly brutal. (Supposedly, it had to do with Billy Idol.) Sam told me that during their breakup, he said to her, "If I ever want to see your face again, I'll rent a tape."

On April 10, 1992, I was at the Comedy Store hanging out with Jim Carrey and some of the other comics when we heard the horrifying news of Sam's death. Earlier that day, Sam had been on his way to a stand-up gig in Laughlin when he was hit by a drunk driver in the Nevada desert. Sam had often predicted that he would die young.

* The film would also have starred a very young and still unknown actor named Ben Affleck.

** My sister and I watched the entire show from the greenroom with John Travolta, who happened to be hanging out at the live show.

He told me that he just wanted to see the new millennium, and make it past January 1, 2000. I had always suspected that if Sam did meet with an early demise, it would involve a car crash.*

How did I know? Because I was involved in one of those crashes.**

Six years or so before the accident that would take his life, I was driving with Sam through New Jersey, on our way to Manhattan. Sam was planning to perform at Catch a Rising Star with Robin Williams. It was a rainy night, and Sam was driving erratically and far too fast for my comfort, but it was nothing I hadn't experienced before.

We were talking about religion and death, with Sam arguing the pro-God agenda. He had been a Pentecostal evangelist long before getting into comedy, and he still held firmly to his beliefs.

"I *think* I believe in Him," I said. "I *think* I speak to Him. I just wish I had more proof."

"What does proof have to do with anything?" he said. "It's not about needing proof, it's about having a gut feeling that the universe isn't random, that there's some spiritual architect responsible for it."

The rain was starting to come down in sheets, but Sam refused to slow down. He continued speaking to me, but I was too terrified to talk back. The road was just a blur, and I was convinced that he would lose control of the car before long.

And sure enough, as Sam tried to negotiate a corner, he skidded off the highway and down into an embankment. We flipped over and came crashing into a tree, shattering the windows and demolishing the car. We sat there for a moment, upside down, too dazed to do anything else, and I wondered if we might be dead.

"Are you okay?" Sam finally asked me.

"I think so," I said. "How about you?"

* Sam had been responsible for many car accidents, to which he openly admitted. It's ironic that the one time he was totally innocent, the accident cost him his life.

** Just for the record, this story has been told and retold by Bill Kinison (Sam's brother) and Carl LaBove (Sam's best friend and frequent opening act).

We crawled out of the windows and staggered to our feet. Sam laughed as I gathered the pages of my phone book off the car's ceiling. We picked glass out of our clothes and hair, and checked our bodies for broken bones or blood, but there was nothing. The car was totaled, but somehow we had survived without so much as a scratch.

We walked toward the highway in the rain, neither of us saying a word. If I was thinking clearly, I might have yelled at Sam, chastising him for nearly killing us. It was a miracle that we both weren't mangled corpses. But I didn't have the energy to get into a screaming fit. I was just thankful to be alive and walking upright.

"So Ronnie," he said, "do you believe in God now?"

His face was drenched with rainwater, and he was laughing like some mad prophet who had just shared a life lesson.

"You really go out of your way to prove a point," I said.*

A few days later, upon hearing this story, Bill (Sam's brother) and Carl LaBove sat me down, looked me in the eye and said, "It wasn't Sam proving the point."

Comedians always seem to use me as a punch line for some of their jokes. Eddie Murphy did a great routine about me on HBO, as I mentioned earlier, which came very close to being included in his 1987 concert movie *Raw*. "It's okay if Ron Jeremy sucks his own dick," Eddie observed. "As long as he doesn't cum in his own face or fuck himself in the ass with his own dick. 'Cause that would *definitely* be gay."

Sarah Silverman had a hilarious bit that she's used in her stand-up

* Years later, when telling a story about a different accident that happened years later during an interview on Tom Leykis's radio show, he claimed that I was the one driving the car, just to bust my balls. Al Goldstein and John Clark (Lynn Redgrave's husband at the time), who were also guests on the show, believed Sam's version and started insulting my driving abilities. Sam thought this was hilarious, but just for the record, I was *not* driving, and the only passenger was CC DeVille of Poison.

and on talk shows like *Late Night with Conan O'Brien* and *It's Garry Shandling's Show*. She noticed that whenever she saw me masturbating in a porno, I would always be lifting a pinky in the air. "I realized why that is," she said. "It's because he's a classy guy."

Dave Chappelle brought me on his Comedy Central show to do a skit about the Internet. He's having a fantasy where he imagines that the Web is an actual place, a physical location that anybody can visit. He's walking through cyberspace, and he bumps into me.

"Are you sure you don't wanna see me have sex?" I ask him. "I do a great doggy-style."

"Yeah, I know, Ron," he says. "I got my stroke from you. Thank you, Obi-Wan!"

Drew Carey once referenced me in a routine about Brad Pitt. He'd heard rumors that Pitt has a large penis, which struck him as very unfair. God, he said, shouldn't just pass out the large cocks to anybody. "If you're attractive, you shouldn't have a big penis, too," he reasoned. "It should be one or the other. Look at Ron Jeremy. Now *that's* fair."

Yeah, it was kinda mean, but I don't mind being insulted as long as it's funny. And insulting or not, it brings a performer like me closer into the world of pop-culture status.

I'd run into Pauly Shore occasionally at the Comedy Store (his mother, Mitzi Shore, was the owner), and sometimes I would introduce him to porn starlets. If we both had free time, we'd take them back to his place, where we might get lucky (or not). He called it "pizza delivery." When Pauly would hear that I might be stopping by the club, he'd say, "Ron's bringing pizza!"*

Some comics, like Jim Norton, were bold enough to join me for sexual escapades and then tell the world about it. Jim was at a hotel in Vegas for a stand-up performance, and, after his set, he walked into

* Pauly was always a good guy. He mentioned me on his comedy album *Pink Diggly Diggly*. "Sam Kinison was my comedy mentor," he said, "but Ron Jeremy was my sex mentor." (Plus, he had me do a joke on that album as well.)

a room and stumbled upon me having sex with one of the girls. He watched me fuck her for a while, and the girl and I eventually coaxed him into joining us for a threeway.*

He bragged about it later on Colin Quinn's *Tough Crowd*. "I was cock-struck," he told Colin. "Ron says to me, 'I think she needs something in her mouth.' And I'm like, 'I have to do this.' It's almost like the Pope saying, 'Look, I'm doing Mass, could you help?'"

While we were doing it, I tried to mess around with Jim and make him laugh. He was getting a blow job while I fucked her from behind, and I could tell that it wasn't entirely comfortable for him. He wasn't accustomed to having sex while another guy was in the room, much less a guy who was joining in. So every once in a while, I would give the girl an extra deep stroke, really pounding my cock into her, causing her entire body to lurch forward. The propulsion was enough to make her deep-throat him.

After we finished, Jim took me aside and said, "That was so weird. I never thought that another man could have so much control over my sex life."

I also became friends with a brilliant comic named Rodney Dangerfield. Rodney reminded me of the best comedians from the Catskills, delivering one-liners that were so corny and goofy you just had to laugh. Whenever he walked onstage, you knew that you were in the presence of a true master.

Though I met Rodney several times during the 1980s, we were little more than passing acquaintances. But then he asked me to make a guest appearance in his 1989 HBO special, *Opening Night at Rodney's Place*. I was featured in the show's opening skit, where Rodney auditions for a role in a porno movie. The director is less than impressed by Rodney's physical endowment, and I'm called into the room to show him what a "real" porn star should have in his pants. Rodney takes one look at my penis and says, "All men are created equal? What *bullshit!*"

During a visit to Las Vegas, I took him to the Adult Awards,

* Dennis Hof, the owner of the Bunny Ranch, was there as well.

which he enjoyed; but the after parties were not nearly as exciting as he'd hoped. I still remember walking into an Adult Video News (AVN) after party with Rodney. There were at least a hundred guys in the place and not a single female porn star in sight. He took one look at the crowd, turned to me, and said, "Hey, I love your party, Ron. There are ten guys for every guy."

He also asked to sit in on some of my porn sets. Now hold on, I know what you're thinking. He wasn't there to gawk at all the naked women and watch strangers having sex. He was doing research for a new comedy script he was writing, loosely based on the adult film industry. It was a soft-core movie, but there were a few explicit scenes that required actresses who weren't averse to nudity. He never actually made the film, but he was serious enough about it to meet with Jim South at World Modeling, the top porn agency in L.A. They arranged for a casting call, and Jim asked me just how much skin Rodney was expecting to see.

We decided to pull a practical joke on him. When he walked into the office, there was a roomful of naked girls waiting to meet him. Rodney loved that. He had a great sense of humor.

Rodney was not what you'd call a bashful man. He loved naked women, and he had an affinity for loose-fitting outfits that left very little to the imagination.

During one summer, I visited Rodney in Las Vegas to catch his act at the MGM Grand. I brought along Mark Carriere, president of Leisure Time Entertainment, who was a big fan of Rodney's and wanted to meet him. So I took Mark and his girlfriend to Rodney's hotel room to say hello. Rodney greeted us at the door wearing nothing but a bathrobe. Normally, this wouldn't have been cause for alarm, but the bathrobe was tied loosely around his waist. You could barely notice, but his balls were hanging out.

Rodney posed for photographs with Mark and his girlfriend, and I feel a little guilty about admitting this, but I lowered the camera on purpose to get Rodney's balls into the frame. If he saw me doing it, he either didn't know what was happening or didn't care. Two weeks later, I went

to Mark's house in Brentwood to show him the Vegas photos. And sure enough, in one photo, we had a clear shot of Rodney's balls.

"Those *can't* be his balls," Mark insisted. He took a magnifying glass to the photos and examined them more closely. But there was no denying it. Those hairy satchels barely drooping from Rodney's robe were exactly what they appeared to be.

"Jesus Christ," Mark muttered. "I thought *we* were exhibitionists."

Rodney was a good guy, right until the end. He used me in two of his movies, *Meet Wally Sparks* and *Back by Midnight*, and always treated me like a professional and not just a porn star oddity. In his autobiography, he said very kind things about me, complimenting my sense of humor (as well as a few other things).

At Dangerfield's funeral, I ran into Jim Carrey. I hadn't seen him since he became superfamous, and the first thing he said was, "Hey, Ron, John Wayne wouldn't say much of anything!"

After Johnny Carson's funeral at Dan Tana's, I ran into Jerry Seinfeld. He still remembered me from my years on the open-mike circuit in New York. In fact, he made a mention of my old "My Moon Over the Keys" routine, playing the piano with my ass cheeks.

I couldn't believe he remembered that.*

There are some critics who might question the logic of combining comedy and pornography. Is that really what porn consumers are looking for, anyway? Is it possible to laugh and jerk off at the same time? And even if it is, would you even *want* to?

I may not be the best person to answer these questions. I haven't

* For me to list all the additional routines where comics have mentioned me on TV, or in their acts would take another chapter, so here's a partial list of the comics themselves: Dave Chapelle, Jay Leno, Pauly Shore, Sam Kinison, Greg Kinnear, Jimmy Kimmel, Adam Carolla, Bob Saget, Rodney Dangerfield, Bobby Slayton, Carlos Mencia, Robin Williams, Conan O'Brien, Penn Jillette, Arsenio Hall, and Jim Norton.

watched a porno that I'm not in since I was a teenager, and even then I wasn't jerking off to them. So I don't know if there's anything appealing about comedic porn. But I do know this: I've made over seventeen hundred adult films, and the majority of them were comedies. So *somebody* is buying these things and, one can only assume, watching them.

So I guess that makes me something of an expert in the field of porn comedy. And because I'm such a generous guy, I'm going to share some of my secrets with you. So find a seat, put on your mortarboard, and get ready for an educational segment that I like to call . . . I'm a fatty funny fucker, and what's *your name?*

Lesson #1:
THE ONE-LINER

This is probably the most important element of any successful porn comedy. Let's face it, most porn is not, by definition, very funny. Porn is about the sex, not the punch lines, so directors are more interested in shooting scenes that are more inherently sexy than hilarious.

But just because you may not find yourself in a scenario rife with comedic possibilities doesn't mean that you can't show off your wit. You just need to know where to find your moment to shine. It could be where you least expect it, like in the middle of an otherwise scorching oral sex scene, or while probing the anal cavity of your female costar. These are prime opportunities to lighten the mood with a well-placed one-liner.

Remember, you're not trying to distract from the action. You're just throwing out a small comedy nugget to keep the audience on its toes. For instance, say you're giving a girl head. Take a moment to gaze into your partner's cooter and say something goofy and off-the-cuff, like, "Honey, I'm not saying you have a big vagina, but there's a small man up in there, waving a lantern and saying, 'Go back, go back! It's not safe!'" It may not be funny, but it'll catch your audience by surprise. And surprise, as any comedian will tell you, is the root of all comedy.

Don't be afraid to bring a little satire to your routine. Some of

my best one-liners can be found in Hal Freeman's still classic *Caught from Behind* series. I played Dr. Proctor, who ran the appropriately named Sphincter Clinic. In *Caught from Behind 4*, I was using a telescope to look at the stars just as Keli Richards stepped in front of it. With a clear view of her ass, I said, "You know, on a clear night, I can see Uranus."

Like any health-conscious proctologist, Dr. Proctor would wear a rubber glove during his examinations. But while diddling a girl, the gloves would often switch hands without warning, just to see if the audience is paying attention.

In some films, I even wore jewelry over the gloves, like a watch or bracelet. I'd be fingering a girl and suddenly the watch would disappear. I'd just look at the camera and go, "Oh shit. That was a Rolex." Or while eating out a girl, I might place a map of the Grand Canyon next to her, pausing every so often to check it for directions. It's what we in the comedy trade call a "sight gag." It doesn't need to be explained. You either notice it or you don't.*

Another excellent opportunity for one-liners is during your pop shot. You could waste your orgasm with a lot of grimacing and shuddering, but any run-of-the-mill porn stud worth his salt could do that. Instead, delight the viewer with an improvised quip. In *Carnal Possessions*, a 1988 *Beetlejuice* parody, I delivered my funniest pop shot, announcing, "My little semen are about to proudly burst forth, proclaiming, 'I am, I exist, I am here, I matter! I read Descartes!'" Lessons in existentialism or French philosophy might not be what your typical porn enthusiast wants to hear while watching a guy ejaculate, but it's nothing if not unexpected. The element of surprise is one of the most effective tools of the would-be porn comedian. My favorite line, however, is "While diamonds are a girl's best friend, here comes a pearl necklace you're never going to forget. UGGH!"

* Once, when pulling off the glove, one finger at a time, Hal inserted a fart noise for a blooper tape. Very funny.

Lesson #2:
THE FUNNY PORN TITLE

Did you know that the original title for *Deep Throat* was *The Doctor Makes a House Call*? Sometimes a porn film is only as memorable as its title, and with thousands of films competing for your attention every month, it helps to have a title that not only catches your eye but also makes you laugh.

But what makes a porn title *really* funny? It's an art form, and not just any hack writer can come up with a truly inspired title. You need the perfect combination of sexual suggestion and comic premise, erotic allusion and double entendre, making the casual porn consumer think, Wow, that's hot and Wow, that's fucking funny, often simultaneously.

There's no magic formula for creating a porn title that's guaranteed to get a laugh and a hard-on from your viewer. But, as with anything, practice makes perfect. For your further studies, I've collected some of the most hilarious porn titles from my illustrious career, arranged by category.

PUNS

Anals of History
Dick-tation
Incocknito
Innocent Bi-Standers
Udderly Fantastic

POLITICAL

Nude World Order
All American Girls in Heat
Oral Majority
Girls of the Third Reich

PROFESSIONS

Once Upon a Secretary
Samurai Dick

Mistress Hiney, the Beverly Hills Butt Broker
Cheerleader Nurses

BOOBIES
Bodacious Ta Ta's
Big Boob Bonanza
Attack of the Monster Mammaries
Dixie Dynamite and the All-Star Tit Queens

FULL-FIGURED WOMEN
2000 Lbs of Love
This Little Piggy Went to Porno
Let Me Tell Ya 'Bout Fat Chicks
Bad Mama Jama and the Fat Ladies of the Evening
Fatliners

HOLIDAY-THEMED
All I Want for Christmas Is a Gang Bang
Jingle Balls
Gang Bang Under the Mistletoe
Santa Is Coming All Over Town

A RHETORICAL QUESTION
What Did You Say Your Name Was?
What's a Nice Girl Like You Doing in an Anal Movie?
What's the Lesbian Doing in My Pirate Movie?
You Want to Fuck Me Where?

Lesson #3:
PARODYING THE MAINSTREAM

I know you've all played this game before. Take the title of a main-stream movie and tweak it until it becomes a porno. *Forrest Gump* becomes *Forrest Hump*. *Romancing the Stone* becomes *Romancing the Bone*. If you're new to the ol' "porno parody switcheroo," here's

a small sampling of some of my most popular porn parodies and the mainstream movies and TV shows that inspired them.

Mainstream Movie	**Porn Parody**
Against All Odds	Against All Bods
All in the Family	Ball in the Family
Bridges of Madison County	Bridges of Anal County
Driving Miss Daisy	Drivin' Miss Daisy Crazy
Dirty Rotten Scoundrels	Filthy Sleazy Scoundrels
The Flintstones	The Flintbones
For Your Eyes Only	For Your Thighs Only
Frankenstein	Frankenpenis
General Hospital	Generally Horny Hospital
Guess Who's Coming to Dinner	Guess Who Came at Dinner?
Home Alone	Bone Alone
I Know What You Did Last Summer	I Know Who You Did Last Summer
I Dream of Jeannie	I Ream a Genie
Jailhouse Rock	Jailhouse Cock
Mutiny on the Bounty	Mutiny on the Booty
Robin Hood	Throbbin' Hood
Same Time, Next Year	Same Time Every Year
Terms of Endearment	Terms of Endowment
What's Love Got to Do with It	What's Butt Got to Do with It
The Wizard of Oz	The Wizard of Ahh's
Young Frankenstein	Hung Wankerstein

But cooking up a title is only half the battle. Now you've got to make a movie that lives up to your parody without getting you and your financers slapped with a costly lawsuit. Here's where it gets tricky.

It's a little-known fact that most adult filmmakers are sued not for the content of their movies but for the box covers. Take a porno like *Indiana Joan and the Temple of Poon*. The cover was a blatant rip-off of the wildly successful Steven Spielberg movie *Indiana Jones and the Temple of Doom*, right down to the flame letters. Amblin

Entertainment or Universal (whatever) didn't appreciate having its creative property used to sell a porno flick, and they promptly had their lawyers file a cease-and-desist order. The same thing happened to the producers of *Splatman*, who were sued by DC Comics not because of the porno's plot, but because the poster art was designed to look like a *Batman* comic. A porno comedy romp called *Whorios* was sued by Nabisco because the filmmakers modeled their box cover after a box of Oreos. Nabisco didn't object to actual boxes of Oreos being used as props in the movie itself. They just didn't take kindly to their corporate logo being mimicked for a porno's cover art.*

When I directed a porn parody called *E3: Extra Testicle*, I never got so much as a phone call from Spielberg Productions. Our alien looked absolutely nothing like Spielberg's cute extraterrestrial. And our box cover and poster looked completely different. It was just a bunch of gorgeous girls and a spaceship. The title's lettering was different, and there was nothing to indicate that it might in any way be related to Spielberg's sci-fi classic, other than that both films had the letter *E* in the title. You can get away with almost any parody as long as you practice just a little subtlety on the VHS or DVD box cover.

Oh, and then you have to write a porno that's actually funny but not *so* funny that it distracts from the sex. It took me almost thirty years to get the formula right, and I'm still learning every day.

And while I'm not an entertainment or copyright lawyer, I have reported these events as they happened.

* Anabolic Video used Harley-Davidson motorcycles in one of their movies. It wasn't a problem. But when the Harley logo was crystal clear on the box cover, the motorcycle company made Anabolic Video change the cover.

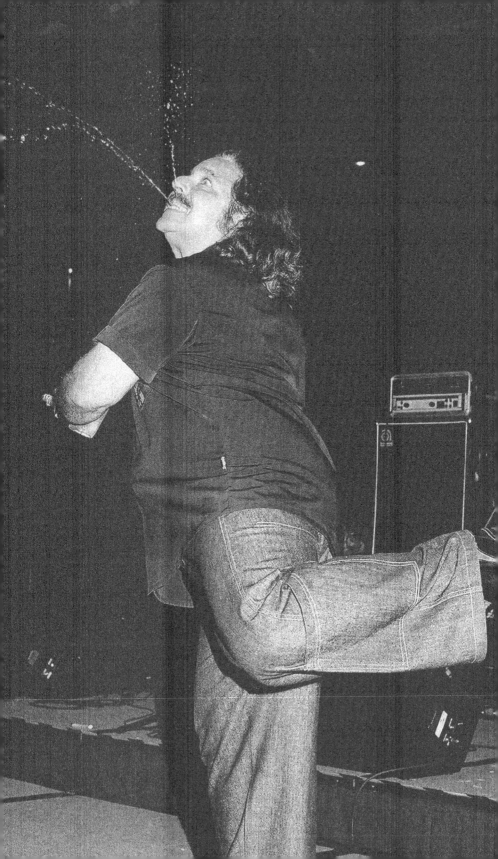

chapter 10

I FOUGHT THE LAW (AND THE LAW LOST!)

I was having nightmares about vice cops on Jet Skis.

After my first two arrests in 1988, I was not taking any more chances. Mark Carriere and I decided that it just wasn't worth the risk to shoot in California, at least not while my pandering cases were still pending. So we moved all future porn productions to Nevada. Though prostitution was legal in some of the state, shooting adult movies was not. But still, given the alternative, it seemed like the safest bet.

We found the perfect location in Lake Mead, a beautiful shoreline community just thirty miles north of Las Vegas. It was secluded, it was small, and it was the last place on Earth that anybody expected to find a porn actor. I rented a houseboat and took the cast and crew to the most deserted corner of Lake Mead. We'd dock at an isolated beachfront and camp out for as long as it took to finish the movies.

During the summer, it could be breathtakingly beautiful. We'd swim, have sex on the beach, take a break for a cookout, start a campfire, have sex under the stars, and then wake up the next day and do it all over again. We had every right to feel comfortable again. The nearest civilization was miles away. Even hikers didn't travel out to such remote corners of the lake. We were safe.

Hamming it up onstage—impersonating Rome's Trevi fountain. (Courtesy "Dirty Bob" Krotts)

But I was still paranoid. Once you've been busted twice and spent time behind bars, it's difficult ever to feel truly at ease again. For months afterward, I jumped every time I heard a knock at the door, even if I wasn't shooting a porno at the time. I couldn't forget that feeling, that glimmer of fear just before I heard them yell "Police!"

At Lake Mead, I was having a few bad dreams. I dreamed that I was having sex on the beach, and in the distance I could see Como and Navarro Jet Skiing toward me. They'd both be in bathing suits, waving at me and flashing their badges.

"Jeremy!" they'd yell out. "How's it going? Didn't think we'd find you, did you?"*

It never failed to wake me up with a start. I knew it was just a silly dream, but it seemed so real. And worst of all, so *plausible*.

I soon found out just how plausible.

At the same time we were shooting at Lake Mead, there was a police convention taking place at the Tropicana Hotel in Las Vegas. I was good friends with a lounge act called Taylor and Taylor, who were booked to perform at the convention, and they told me later about a conversation they'd overheard between two off-duty cops.

"You'll never guess where that porn guy Ron Jeremy is shooting," one cop said.

"Where?" his partner asked.

"Lake Mead," he responded. "Jeremy probably thinks he's getting away with it, too."

That was enough for me. We canceled all of our upcoming shoots in Lake Mead. Mark found another location, at a rented home on the outskirts of Vegas, but I was still nervous. If the police tracked us to Lake Mead, surely they could find us if we moved just a few miles away. I convinced Mark that it would make more sense to find someplace so inaccessible and out of the way that the vice cops wouldn't even consider following us.

* Years later, my lawyer Stu Goldfarb told this dream to officer Como, and both had a good laugh.

Someplace like Hawaii.

Mark didn't go for that idea. Instead, another porn company, Cinderella, hired me to shoot a few films in Hawaii.* The cops were well aware of our plans, though we never had a clue. And it wasn't just Como and Navarro who were on our tail this time. The FBI was now involved, because I had made a fatal miscalculation.

Shooting porn in California may have broken the state pandering law (we're saying it didn't) but by traveling to Hawaii we may have inadvertently violated the Mann Act, which forbids transporting actors across U.S. state borders for the purposes of prostitution (if porn is considered prostitution). The Mann Act was serious stuff. It's basically white slavery. And worst of all, it has long legs. It has tentacles. They can bust everybody involved in a production: the cast, the crew, even the makeup person. Nobody is safe from the Mann Act. When I learned about it later, I had my lawyer look into it. "Theoretically," he said, "even shooting in Las Vegas could have been a Mann Act violation, and you've already done that. It's a stretch, but you could get busted."

Oh, *great.* All we're doing is making adult movies. We're not criminals.

Neither the FBI nor Como and Navarro busted us in Hawaii. They were just watching us from afar and collecting evidence. They had us in their sights from the moment we walked off the plane in Hawaii. One of them was brazen enough to make contact with me without blowing his cover. I was signing autographs for fans at the airport, and I was approached by a beefy guy in a Hawaiian shirt. He asked for an autograph and even posed for a picture with me. Years later, I learned that he was an undercover FBI agent posing as a baggage handler. To this very day, that picture still sits in his office at FBI headquarters. I'm not kidding.

Even without the knowledge that vice cops and FBI agents were

* The films were called *Hawaii Vice, Parts 1–8*, starring Kascha and François Papillon.

around every corner, we went to great lengths to be as inconspicuous as possible. Or at least I thought we did. Before taking a bus out to the beach for the day's shoot, we needed supplies. I knew that I was the most recognizable person in our crew, so there was no way I could walk into a public place without setting off alarm bells. So I asked Ray Victory, one of my actors, to go in my wake. I gave him a grocery list and a wad of money, and I sent him off to the nearest store.

No sooner had he left than Charlie Diamond, my assistant director, asked me just what the hell I was thinking.

"You *are* trying not to be noticed, isn't that right?"

"Well, sure," I said. "That's why I sent Ray."

"Ray," he repeated. "The big, supermuscular black guy with the bulge in his pants."

Aw hell!

It was too late to stop him. And by the time Ray returned to the bus, a small crowd had already gathered in the store's parking lot. They were all staring at Ray, who was casually walking toward our bus in clear sight, dressed in nothing but a tiny Speedo, his huge cock almost bursting from its seams.

The cast and crew were laughing their asses off. "I can't even imagine what they thought," Charlie said. "It's not every day that a nearly naked black man walks into a grocery store and buys twenty-five douches and sixteen enemas. Oh, and lest we forget, enough jars of Vaseline and K-Y jelly to lube a small army. If they didn't know that a porn production's in town, they sure as hell know now."

Ray walked inside and dropped the bags on the bus floor. "Damn," he said. "That was weird."

"Ray," I groaned, covering my face with both hands. "Why the hell didn't you go in there with pants?"

He glanced down at his shorts. Both of his testicles had broken free from the Speedo's fragile fabric and were dangling in the air like two medicine balls.

"Whoops," he said, not bothering to conceal himself.

Mark still wanted me to shoot a few more films for him, so he convinced me to return to Nevada. At least in Vegas, black men with gigantic testicles weren't uncommon enough to stall traffic.

Mark still had a lease with a house outside of town, so we used it for a few shoots while we looked for someplace more convenient and a little less obvious. It was more or less the same arrangement as Lake Mead. We'd buy groceries and retreat to the house for a weekend, being as self-sufficient as possible so we didn't attract too much attention, not coming out until we had at least a few films in the can.

But during one of our visits, we pulled into the driveway and noticed that there were some unfamiliar cars parked nearby. I immediately suspected the worst, assuming that Como or Navarro must be waiting for us, ready to bust us the moment we walked inside.

I snuck around the side and peeked through an open window. There were women cleaning the kitchen, and the strong odor of ammonium was unmistakable. Well, I thought, this can't be right. Mark wouldn't have been stupid enough to hire a maid on the very weekend we were scheduled to shoot a film.

We drove to the nearest phone booth, and I called Mark in Indiana, explaining that the house appeared to be occupied by a rogue cleaning service.

"That doesn't make sense," he said.

"You're damn right it doesn't," I barked at him. "Please tell me you paid the rent on this place."

I waited while he checked his records. "Aw hell," he said. "You're right. We didn't renew the lease."

"God*damn*it, Mark!"

"My secretary forgot to remind me. Wow, buddy, I'm sorry about that."

Mark was a multimillionaire, and one of the richest men in adult films. But he was too busy when it came to keeping track of his own bookkeeping.

"So what do you expect me to do?" I asked him.

"What do you mean?"

"I have a crew with me, Mark. I have actors and cameras and everything. How the hell am I supposed to shoot a goddamn film if I don't have a goddamn set?"

"I've got an idea," he said. "Look to your left. What do you see?"

"Nothing." We were in the middle of the Nevada desert, somewhere between Lake Mead and Las Vegas. There was nothing around us for as far as the eye could see.

"Okay," he continued. "Now look to your right. What do you see?"

"More goddamn desert."

"Look behind you," he said. "What do you see?"

"Desert, you fucking idiot. What are you getting at?"

"That's it!" he declared. "Shoot a desert movie!"

If he was standing in front of me, I would have strangled him with my last ounce of strength.

"Where are the actors gonna pee?"

"Ronnie, just work it out. You've never let me down before. I've gotta go now, good-bye."

The phone went dead. There was nothing to be done. I was stranded with a van full of anxious actors and miles of white sand between us and the nearest town. But at least I had a lot of charged batteries and power packs. And I am, if nothing else, a professional. I wasn't about to give up without a fight. We had no script for this scenario, and just a few hours of daylight left. But as Benjamin Disraeli once said, desperation can be as powerful an inspiration as genius. So with just a camera and some ballsy improvisation, we made our film. We made a film about people stranded in a desert, because that was what we knew. A group of girls run out of gas, some guys come walking by, and they all have sex. It was brilliant in its simplicity.

We had so much fun that we decided to camp out in the desert and make another film. Why make one desert movie when you can

make *two*? It was easy enough; we just changed the scenario and shot the entire thing again. Instead of girls being stranded and getting saved by the guys, the guys were now looking to buy land and build homes in the desert and the girls were real estate agents. It still resulted in hot sex in the desert, so who cared about the setup?

I did a lot of these "one-day wonders" for Mark. It was probably my most inspired period as a porn filmmaker. I was forced to be creative because I didn't have the budget or resources to make an "epic" motion picture. I was just shooting with whatever we had at our disposal and making the most of it. And once the wheels were in motion, I could just sit back and relax and, if I was so inclined, take a short nap.

It's true; I do have a reputation for falling asleep on my sets. But this is just a sign that a movie is in good shape. When a scene is going badly, I have to be on the sidelines, whispering advice to my actors. But when everything is exactly the way I like it, I can sneak away and start snoring. I guess this is the fundamental difference between me and a real director like Martin Scorsese. If he's doing his job right, he should be exhausted by the end of the day. If I'm doing my job right, I should wake up well rested and ready for the long drive home.

Some of my actors have taken advantage of my tendency to fall asleep during a shoot. On more than a few occasions, I've woken up with my nails painted pink,* or some obscene word written in lipstick on my forehead. Some of them have even taken pictures of me with an actor's penis dangling dangerously close to my mouth. One of the hazards of the trade, I suppose.

John Stallion, Mark Carriere's brother-in-law, was the smartest prankster of all. When I fell asleep, he'd get a porn star with the biggest, blackest penis—somebody like Ray Victory or F. M. Bradley—to come over and place his penis right next to my nose. Then he'd yell

* Thanks to Bunny Bleu. I liked how my nails looked so much that I decided to leave them like that for two weeks.

out, "Ron!! Hey, Ron!!" I'd wake up and they'd snap a Polaroid before I realized what was happening. Because my eyes were wide open in the picture, I didn't have an alibi. I couldn't claim to have been asleep.

Anyway, over a period of two months, shooting weekends only, we made more than fifteen desert movies in the time it usually takes to shoot one mainstream B movie. At one point, I got the crazy notion that we should make a science-fiction movie. We were in the desert, after all, and it could've passed for the rocky terrain of a foreign planet. I had Mark deliver us some dynamite astronaut spacesuits from "Western costumes," and with only my half-baked idea to go on, we filmed a takeoff of *Planet of the Apes* called *Space Vixens*.

The story begins with a group of astronauts landing on another planet, or at least what they *think* is another planet. They take off their helmets and realize, "Wait a minute, we can breathe!" After exploring the planet, they stumble across a tribe of cavewomen, dressed in tiny loincloths and very little else. They have sex with the cavewomen, and eventually one of them figures it out.

"We're not on some strange, distant planet," the head astronaut tells the others. "We're back on Earth! We . . . we . . . *went back in time!*"

It was exactly as hilarious and corny as it sounds. And as if that wasn't enough, there were some truly spectacular astronaut/cavewoman sex scenes. Really, what more could you ask for?

Space Vixens is probably one of my most glorious moments in porn. It was cheap, it was easy, and it still stands up as one of the most intentionally and yet unintentionally funny comedies in the canon of adult cinema.

I never saw Sam Kinison laugh so hard as when I showed him *Space Vixens*. He was one of the first people to screen it, and his reaction was exactly what I was hoping for. He loved every last frame, every campy and overacted conceit. But Sam appreciated details that even I hadn't anticipated.

"You worked so hard to make it look authentic," Sam told me. "You had real costumes, and the actors weren't wearing jewelry or

high heels or anything else that might give them away. You never accidentally shot a car or a telephone pole in the distance. But Ronnie, the astronauts are using a fucking *clock radio* to check the atmosphere."

He paused on the scene to give me a closer look. And sure enough, there it was. The astronauts were using a device to calculate the planet's oxygen levels—sort of a hackneyed version of the *Star Trek* tricorder—and after a far-too-pregnant dramatic pause, they said, "The machine says that the atmosphere is . . . like Earth." But upon closer examination, it was clear that their seemingly intricate piece of astronaut technology was, in fact, just a standard clock radio. You could even see the clock's cord tucked into the actor's pants.

"Well, what do you want from me?" I yelled at Sam. "I'm not fucking Orson Welles."

"That," Sam said, wiping away his tears of laugher, "is painfully obvious."

I don't think I understand," I said. "Are you telling me that you don't want to see *me* anymore or you don't want to do *porn*?"

Tanya shrugged. "I guess it's a little of both."

I was sitting on our bed, watching Tanya pack the last of her clothes into an overstuffed suitcase. The bedroom was the only room left that hadn't already been stripped clean. There were a few boxes left, piled in otherwise empty corners, waiting to be carted away. Her Brooklyn apartment had the eerie echo of a warehouse.

Actually, it *was* our apartment. It had been our apartment for two years, until today. We had both decided that the time was right to move out to Los Angeles for good. And we were going together, or at least that had been the plan. But somewhere along the way, Tanya had apparently changed her mind. About something. I still wasn't quite sure what she was telling me.

"So you want to quit porn," I said cheerfully. "That's no big deal. I'm fine with that."

She threw a shirt onto the mound of clothes and scowled at me. "But *you're* not going to quit, are you?"

"Well, no, of course not. Why would I?"

Tanya shook her head reproachfully, like I was missing some obvious connection between the two things.

"You see, that's why it'll never work between us," she muttered. "I can't be with anyone who's involved in this business. It's time to grow and move on. You've won plenty of awards already. We should both get out."

The porn lifestyle can be a tough one. When you're in what you think is a committed relationship, the last thing you want to hear your partner say in the morning is, "Okay, honey, I'm off to have sex with Seka. I'll see you around five for dinner, okay?"

But with Tanya, I had found somebody who lived a life as unconventional as my own. She above anybody would understand that monogamy had nothing to do with my feelings for her. I could go to work and have sex with countless beautiful women, and at the end of the day I'd come home to her and be as devoted as ever. And when she made porn films, it worked the same way. I would call it emotional monogamy . . . physical nonmonogamy.

"So what exactly is it about porn that you have a problem with?" I asked her.

"It uses people and then spits them out the other side," she growled.

"Since when did porn 'use' you?" I asked. She had hit a nerve with me. "Please tell me that you're not becoming one of those women who blame the industry for everything they don't like about their life."

There were very few things that made my blood boil like a porn star playing the victim. If it was coming from some innocent Catholic high school girl, I might've been able to partially accept it. But Tanya was by no means innocent. Porn had not corrupted her. Even before she got into the business, she had been stripping for bachelor parties and doing things that were too wild even for me. And now here she

was, pointing a critical finger at porn as if it had somehow robbed her of her sexual virtue.

The truth is, *she* had approached *me* about getting into adult films. We had met at a party in New York. She originally asked Mark "Ten and a Half Inches" Stevens about the business, and he recommended that she talk to me. Her first sex scene was with me, in Gerard Damiano's *Whose Fantasy Is It Anyway?* And she was very, very good. She didn't need me to hold her hand. She was a sexual dynamo, and when we did scenes together, it was a wonder our genitals didn't spark a small fire.

And she was rewarded for her efforts. She was making upward of a thousand dollars a day, which was a huge sum even for name performers. After only a year in the biz, she was nominated for a FOXE (Fans of X-rated Entertainment) Award for best new starlet. For somebody who seemingly loved sex so much, and was paid so handsomely for doing films, she had absolutely nothing to complain about.

"So you're just going to throw it all away?" I asked.

"This was never going to be forever," she said, finally getting her suitcase closed. "I was only ever going to do this for a few years, just long enough to get some money saved away."

"That's right," I said. "How can you say porn is bad when it's done so much for you? It paid for your education. It allowed you to travel and take flute lessons in Florence, Italy. You were able to do a small part in *9 1/2 Weeks.** It gave you the freedom to do whatever you want to do."

That might have been one of the reasons I had fallen in love with Tanya. She had so many interests and talents outside of porn. She played classical flute, and she was probably the best musician I'd ever known. I went to her concerts and met the other members of

* I was a consultant on the film, and I helped her get a role as Porn Show Girl. She received $3,000 for the job and a SAG card.

her chamber ensemble. When she went to Italy to study flute with the masters, I flew over to see her and to take her sightseeing. She couldn't have asked for a more supportive and enthusiastic boyfriend.

Was that what I was? Her boyfriend? I suppose so, though we never really defined ourselves in that way. We didn't introduce each other as "boyfriend and girlfriend." We were just roommates or, better still, "friends with benefits." It didn't have the same possessive connotations that came with being a couple.

I did love Tanya, however, and I had told her as much many times. I don't know if she realized just what a scary leap that was for me. I've always had a rule in relationships: never be the first one to say those words. Because once you say "I love you," you become a slave. But with Tanya, I didn't need to think about it. I didn't tell her because I thought it was something she wanted to hear. I told her because I meant it, with every last cell in my body.

"So what do you want to do?" I finally asked her. Her bags were packed. The apartment was empty. All that remained was for one of us to make the first move and leave.

"I don't know," she said weakly. "Meet a nice guy. Maybe get married."

"So marry me," I offered, kind of half seriously.

She tried to laugh, but it sounded more like a hiccup. "No offense, Ron, but you're not the marrying type."

That wasn't true. I wasn't the *monogamous* type, I'd give her that. But I wasn't totally opposed to the idea of marriage.

"Can we talk about it?" I asked. "This doesn't have to be over."

She looked at me with so much tenderness I wanted to pull her onto the bed with me and just kiss her. But it wouldn't have made a difference. Somewhere in her head, she had already left me.

"**R**onnie, what's wrong?" Mimi asked, gazing down at me with her toothy smile. "You're turning blue."

When Como and Navarro walked into the bedroom, knocking so casually you'd think we'd been expecting them, I just about had an aneurysm. I was cuddling with a lady friend named Mimi, and the moment I saw them standing in the doorway, I threw Mimi to the side and pulled the blanket over me. Como walked over to the bed and sat on the edge, patting the mattress like he was testing its buoyancy.

"I'm a little surprised," he said, winking at the cameraman who was cowering in the corner. "This seems like a small-time operation for a star of your stature. What, you couldn't afford a full crew?"

"What are you doing here?" I grumbled at him. "Didn't we win?"

It was true. Both of the pandering charges against me had been dropped. And it was all thanks to Hal Freeman.

Hal had taken his case to the California Supreme Court, and in late August 1988, his conviction was overturned in a 7-0 decision.

"In order to constitute prostitution," the court had decided, "the money or other consideration must be paid for the purpose of sexual arousal or gratification." Using this logic, the payments that Hal had made to his performers for the film *Caught from Behind 2* were nothing more than "acting fees," and the director did not "engage in either the requisite conduct nor did he have the requisite [intent] or purpose to establish procurement for purposes of prostitution."

In a single morning, pornography had become legal in California.

It had a domino effect on the rest of the industry. Every other porn director like myself, who had seen his sets raided by vice cops and been slapped with pandering charges, were suddenly in the clear. Our cases were dropped; there was no longer a legal precedent for convicting us. Freeman had cleared the way for hundreds of adult filmmakers, making the world safe for porn again.

So what the heck were Como and Navarro doing in Mimi's bedroom?

"Relax," Como said. "We're not here to bust anybody. Now that you guys are all legal and everything, we're just checking in to make sure you have the right permits."

Como put his arm around me and gave my shoulder a tug. "You're with the big boys now, Ronnie."

Navarro took some of the porn stars aside and asked to see their IDs, just to make sure they were over eighteen. But as he was checking, he noticed me slipping something under the mattress.

"By the way," Navarro said. "You wouldn't happen to have your address book on you, would you?"

"Very funny," I snarled.

"Is that what you're hiding under there?" he said, lifting the mattress and peering underneath. "You worried that we're gonna confiscate it again?"

I gave them the permits, but I wasn't happy about it. Though I was thrilled to be legal finally, I thought it was unfair that we were treated like a big-budget Hollywood production. If you had money to burn, as many of the Hollywood studios did, you could afford a few extra thousand dollars for permits and insurance. But for a porno shoot, which usually operated on a shoestring budget, it was enough to break the bank.

The vice cops weren't harassing nonunion indie films, demanding to see permits. I believe that they singled us out because we were doing *porn*, and they were just annoyed that we'd beaten them. If they couldn't bust us for pandering anymore, they'd use any loophole they could find to hassle us and make our jobs more difficult.

And they weren't just nailing us for permits. In the hills of Laurel Canyon, which is considered a fire zone area, a film production was required to have a fire marshal on set at all times.* We had to pay a fire marshal $600 a day. Six hundred goddamn dollars! Back then, the girl doing anal wasn't getting $600.

Before long, the administrative vice unit in California closed its porn doors for good, I believe. Without the big, bad porn industry to pick on anymore, the cops were forced to chase street prostitutes,

* For the record, the fire marshals *loved* these jobs.

gangsters, and drug dealers (which should have been their focus in the first place).

I saw Como a few years later, outside a Hollywood nightclub.

"Tell me the truth," I asked him. "How much did you really know?"

"You mean about Hawaii?" he said. "We knew everything."

My jaw dropped as he told me about our every secret location, every backwoods home and remote beach that we'd ever used for that shoot. We'd found places that weren't on any map, so secluded and inaccessible that even a Navy SEAL wouldn't have been able to track us down. We scaled dangerous hills, traveled through forests, swam into underwater caves. But Como knew about it all, every twist and turn, every descent into deep valleys and shadowy crevices, right down to our last carefully guarded step.

"How come we never saw you?" I asked.

"Oh, Ronnie," he said, shaking his head in disbelief. "We didn't *want* you to see us."

Of all the cops in the world to be chasing us, it was just our luck that the man on our trail was a surveillance genius. He even taught surveillance at the police academy.

In fact, years later through him I was invited to Officer Don Smith's retirement party. I was out of town, but I believe I signed a card.

It was the least I could do for a friend.

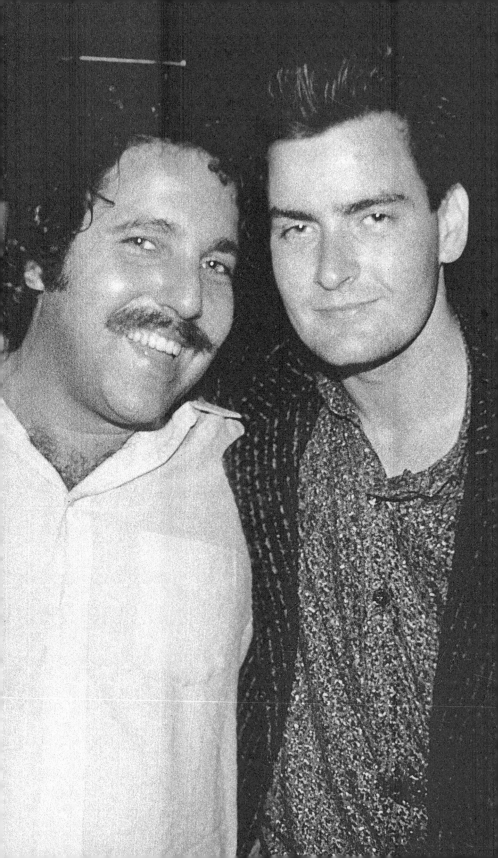

HOLLYWOOD NIGHTS

I have paid for sex only once in my life, and it was all Charlie Sheen's fault.

During one balmy summer night—I believe the year was 1989—Charlie invited me to a party at his Hollywood Hills home. I arrived with two of my roommates, Heather Hart and Devon Shire, who both wanted to meet Charlie. Charlie—who, I'd like to add, was single at the time—had also invited over a few friends, most of them young and attractive and with stomachs so tight you could bounce a quarter off them. We nibbled on snacks and watched some television, and soon people were pairing off and disappearing into any spare bedroom they could find.

My lady friends didn't waste any time making friends. I caught one of them in the Jacuzzi with a guy, and the other somehow ended up making whoopee in a utility closet. Before long, a hot blonde number sat next to me on the couch and started kissing my neck, which seemed as good an indication as any that she was looking for more than casual conversation. I took her by the hand and led her to the nearest bedroom, and we spent the next few hours playing Naked Twister.

With a young Charlie Sheen.

By four A.M., the party was finally beginning to wind down. I walked my new blonde friend to the door, where Charlie was waiting to say good-bye. As I stood there and watched, Charlie kissed her on the cheek, thanked her for coming, and slipped a wad of bills into her hand.

I wanted to kill myself.

Charlie closed the door and turned back to me. I must have gone pale because he grabbed my shoulders like he thought I might keel over at any moment.

"What's wrong, buddy?" he asked. "You don't look so good."

"I-I don't understand," I said, shaking my head.

"You had fun with her, didn't you?"

"Well, yeah, but . . ."

I'll admit it; it was a blow to my ego. I'd never paid for sex before, much less had a friend pay on my behalf. Besides, Heather Hart and Devon Shire weren't there for business. They were just having fun.

"I thought you were having a good time," Charlie said, still stunned by the disappointment in my face. "We could all hear the two of you going at it back there. What's the problem?"

I could barely find the words. "Was . . . was she a . . . a *working* girl?"

Charlie smiled, finally understanding. He put an arm around me and patted my cheek.

"Aw Ronnie," he said. "You thought she *liked* you."

oving to Hollywood was the best thing ever to happen to my social life. I wasn't what you'd call a couch potato when I lived in New York, but the Los Angeles nightlife was unlike anything I'd experienced before. During the late 1980s and early '90s, the Sunset Strip was a nonstop celebration, a Mardi Gras party that never ended. At legendary clubs like the Viper Room, the Rainbow, the Roxy, and Gazzarri's, you could catch the biggest names in rock performing every night, and flirt with big-haired beauties in spandex pants. If the

nightclubs weren't enough, there was sure to be a party happening somewhere, usually attended by enough celebrities to fill an entire season of *Love Boat* episodes.

It was an era of sex, drugs, and rock and roll, and I was a big fan of at least two of those things (no drugs).

I never turned down an invitation to a party in Hollywood. Some of them were amazing. They were bacchanalian revelries that lasted all night. And some of the parties were, sadly, duds. Over the years, I've developed a set of guidelines that I use to determine whether a party is worth my time or if I should make a mad dash for the exit. And, charitable fellow that I am, I'm going to share it with you.

REASONS TO STAY AT A PARTY
THE FIVE-POINT PROGRAM

1. Good food
2. Great entertainment
3. Women I could maybe have sex with
4. Directors or producers or agents who might be able to help my career
5. Celebrities, or anyone I can later brag about having met

This last point is particularly important. I've learned long ago that it never pays to be the most famous person in the room. If I'm at a party and I notice that everybody wants to pose for photos with me, and I'm the only one among them who has had an acting job that didn't involve hawking used cars on a local TV commercial, it's time to make up an excuse and get the hell out of there. "Oh, I forgot to feed my pet tortoise." Whatever. I'm out of there.

But even when I've been fortunate enough to stumble across a party filled with bona fide celebrities, that doesn't mean they've necessarily wanted to meet *me*. As you'll see by the pictures in this book, I've rubbed shoulders with hundreds of celebrities over the years. Some of them have even run across the room to shake my hand. I've met John Travolta, Keith Richards, Johnny Depp, Ice-T, Samuel L.

Jackson, Willem Dafoe, Nancy Sinatra, Billy Joel, and Tony Curtis,* to name just a few. But for every celebrity who got a kick out of meeting me, once in a rare while there have been a few who've treated me like a walking petri dish of disease.

I've experienced my fair share of disses. And, weirdly enough, they weren't always the most famous person at the party. I would expect somebody like Brad Pitt to ignore me, if only because he's such a big star and has better things to do.** No, the actors who've dissed me were usually the lesser knowns.

People like Katey Sagal.

David Faustino,*** an actor from the Fox sitcom *Married with Children*, invited me and my two roommates, Heather Hart and Devon Shire, to visit the set and meet the rest of his cast. He introduced me to Ed O'Neill, the show's star, and I helped myself to the complimentary wine-and-cheese buffet backstage. At one point, Dave pulled Ed aside and whispered, "Should we bring him over to Katey?"

Ed started giggling. "Yeah, yeah, do it," he said.

Katey played Peg Bundy, a white-trash housewife with a gravity-defying perm and leopard-skin tights. She seemed like a talented comedienne, and I always liked meeting good performers. But something about Ed and David's reaction should have warned me that the feeling would not be mutual.

David took me over to Katey, who was standing nearby with a group of her girlfriends. David introduced us, and I told her that I was

* Tony told me some amazing stories about Marilyn Monroe. He claimed that she had problems with drinking and pills for years, so it wasn't unusual for Marilyn to overdose and call for help. The person she usually called was Peter Lawford. On the night of her death Peter didn't get there in time, so he didn't believe that there was any conspiracy involved in her death.

** Coincidentally, I *have* met Brad Pitt, and he gave me a big hug.

*** I knew him from various clubs, and we'd both worked on Sam Kinison's *Under My Thumb* video.

a big fan of the show. "You're just terrific," I said. "A great actress." I held out my hand, hoping she might take the hint and shake it. But she just looked down at it like I was holding a steaming pile of dog crap, and turned back to her friends.

Devon Shire wanted to throw her drink at her, but I stopped it. "People have the right not to like me," I told her. I ran back to Ed and David, who were laughing in the corner like a couple of teenage pranksters.

"You bastards," I yelled at them. "You knew that was gonna happen, didn't you?"

David explained that Katey had a reputation for snubbing nude models and porn actors. When Traci Lords or Teri Weigel or Jessica Hahn did guest appearances on *Married with Children*, Katey was not too cordial with them. She had supposedly grown up in a religious household and didn't think too highly of the adult industry.* So I didn't let it bother me. I could certainly understand her attitude, even if I didn't completely agree.

Less than a year later, I was at Gene Simmons's birthday party at Jerry's Deli (and bowling alley) in Studio City. It was packed with celebrities, from Lita Ford to Roseanne and Tom Arnold. The minute I walked in, I saw Katey Sagal standing in the back, and I almost did a beeline toward the other end of the room. I was in no mood for another public rejection. But then I noticed something. Katey was talking with none other than Pamela Des Barres, the world's most famous groupie.

I walked over to Gene Simmons and asked him, "What the hell is Katey Sagal doing with Pam Des Barres?"

"They're best friends," he told me.

Now I was furious. *Now* I wished that I'd let Devon Shire throw her drink right in Katey's fucking face. I thought she disliked everyone associated with the sex trade. But here she was, chatting up a woman who was famous for *screwing*. Pamela had even written a book titled *I'm with the Band*, in which she revealed intimate details about her backstage sex antics

* She also, supposedly, sang gospel music with Bette Midler.

at rock shows. What right did Katey Sagal have to judge *me* when her best friend was selling books about her tales of screwing rock stars?*

I've also been snubbed by Lisa Marie Presley and Christina Aguilera (prompting Ashton Kutcher, who was standing nearby, to mutter, "What a bitch"**). And Secret Service guys have prevented me from getting *too* close to the president. Charlie Sheen took me as his guest to the opening of the new Planet Hollywood in Las Vegas. Everyone was there and saying hello—from Whoopi Goldberg to Bruce Willis—and in the middle of it all was former President George H. W. Bush. Coincidentally, I had said hello to him and his wife, Barbara, a year earlier on a flight to Texas. Most likely he didn't remember. But the Secret Service certainly did—I could tell by their smiles. After I shook his hand and walked away, a photographer asked if he could get a shot of us. I walked right back and said, "Certainly!" Right as the photographer was about to take the shot, however, a very smooth Secret Service agent put his body in front of the camera. "Come on, Ron," he said with a smile. "You got a handshake." I should have known there was no way I was going to get a photo with the former leader of the free world! Then there was the snub by the brilliant actress Rosanna Arquette, which I actually didn't mind because it almost made me a richer man.

I was at a party hosted by Gregory Peck's daughter, Cecilia, at her Hollywood Hills home. It had all the ingredients of a stellar shindig: great food, great music, and more celebrities than you could shake a stick at. Rosanna Arquette was at the party, and she was one of the few people to whom Cecilia didn't introduce me. I wanted to say hello, if only because she had once dated Sam Kinison (according to Sam). But when I tried to wave at her, she looked right past me. My every attempt to get her attention was ignored. I was with Adam Rifkin, my

* I actually told this story to Katey's son (or it might have been her brother, I'm not sure). He thought it was kind of funny, although he understood how I felt.

** This took place at the premiere of the movie *Spun*, and Brittany Murphy, Ashton's girlfriend at the time, also seemed to side with me.

good buddy and a very successful movie director and writer, and he was convinced that Rosanna was purposely dissing me.

"I'll tell you what," he said. "I'll give you ten thousand dollars if you go over there and put your dick in her drink."

"What?" I said. "There's no way."

It wasn't the first time that Adam had tried to bribe me into doing something like this. When I was interviewed by Barbara Walters on *The View*, he offered me $25,000 to pull out my penis on the air and lay it on her shoulder. I didn't do it, of course. Live TV isn't exactly the best place to be using your schmeckel for a prop-comedy routine. But here, in a private party with a limited number of witnesses, I'd be lying if I didn't say I was tempted.

Steve Bing, a very wealthy film producer* who was standing nearby, turned around and said, "I'll double that offer!"

"That makes *twenty* thousand dollars," Adam said. "And all you have to do is take out your cock and stir her cocktail."

"It's not going to happen," I insisted.

"Just think about it. That's all I'm asking."

Word began to spread around the party, and all night I was approached by random celebrities, offering to put more money into the pot. By midnight, there was almost $50,000 on the line. I wasn't seriously considering it. I was annoyed that Rosanna wouldn't even acknowledge my presence. But did that really deserve having a porn star's schlong dunked into her drink like a party favor?

Still . . . it was a *lot* of money.

The clincher came when a bodyguard walked over to me and tapped my shoulder. "Mick Jagger just heard about the wager," he said. "He wants a piece of that action, too. He'll double whatever's on the table."**

"Okay, fine," I said, loosening my belt. "I'll do it."

* He produced two films that I was in.

** Now, Mick Jagger *was* at the party. We did say hello. But I'm not sure if the guy who told me this was really his bodyguard.

Oh, come on! Do you really think I'd be that stupid? Do you know what would have happened to me if word got out that I'd used my wang as a swizzle stick and publicly humiliated a major Hollywood actress? I'd be escorted across the California border by armed policemen. Of *course* I didn't do it.

Which isn't to say that my penis hasn't made the rounds in the home of a Hollywood actress or two. Like Lynn Redgrave.

Yes, *that* Lynn Redgrave. The celebrated British actress and staple of *Masterpiece Theater*. The 1966 Academy Award nominated actress for *Georgie Girl*. The Broadway legend and two-time Tony Award nominee. The sister of Vanessa Redgrave.

You may recall a minor scandal that surfaced during the late 1980s. Tabloids like the *National Enquirer* and *London People* were reporting that Lynn Redgrave and her husband, John Clark, were letting a group of porno actors into their Topanga Canyon house to make adult films. My name was bandied about as the main culprit, and it was insinuated that I was hosting nothing short of sex orgies in their home.

When John and Lynn were questioned by reporters, they of course denied everything. Lynn was a spokeswoman for Weight Watchers at the time, and it would not have looked good for her to be associated with such a nasty business like porn. I stood by their story, though I admitted to directing at least one porno movie at their home. But, I was careful to add, we had used only their backyard for some exterior shots. Lynn and John had not been involved in any way and were not present during the filming.

But I lied.

John and Lynn *did* know what we were doing. John had allowed us into their home with the specific intention of letting us shoot a film. And not just one film, mind you. *Two* films. John Clark even appeared in one of them. He played the father of Paul Thomas in *Sore Throat* (a takeoff of *Deep Throat*). We gave him a wig, and he

disguised his voice (using a southern twang rather than his usual British accent). He never performed any sex scenes—he was married to Lynn, after all—but he did have a speaking role.

As for Lynn, she never participated in any of the movies. During a good chunk of filming, she was in New York, appearing in a Broadway production of *Aren't We All?* She returned at the end of our shoot, so, in all fairness, she was never there during the actual filming.

The next afternoon, I walked into their kitchen and saw Lynn and John tying up some trash bags. It was a staggering amount of trash—at least four or five bags—and they were touching them like they thought they might contain medical waste.

"I really appreciate your keeping the place so clean," she said in her adorable English accent.

"My Lord, Ron," John added. "How many disposable douches do you people use in a day?"

Disposable douches are the *sine qua non* of the porn profession. No performer can work without them, so it was not uncommon for discarded douche boxes to litter the floors of an adult film set. But I had given my actors specific instructions that we were not to leave the Redgrave's house looking like a gynecologist's office.

"Well," I told John and Lynn, "at least they're putting them in the garbage."

"Yes," Lynn sighed. "I suppose I should be thankful for that much."

Lynn was, if nothing else, a good sport.*

As much as I adored the peaceful and breathtaking Topanga Canyon countryside, my heart still belonged to the dirt and

* Many years later, Lynn went on to appear in my music video *Freak of the Week*. As for John, he performed with me in two cute B movies, *Lords of Magick* and, more recently, *Charlie's Death Wish*. The latter also starred a handful of rock stars.

grime of Hollywood at night. I loved the rowdy parties that raged till dawn, and, most of all, I loved the rock and roll. Los Angeles during the late 1980s and early '90s was ground zero for the rock universe. Hair metal reigned supreme, and the Sunset Strip was home to all the great bands, from Mötley Crüe to Ratt, Poison to the L.A. Guns. I was happy just to be around the excitement, watching the bands from the audience like any other fan. But a porn star at a rock nightclub couldn't go unnoticed for long.

It's been argued that rock music and porn are two halves of the same bastard child. They're both embraced by outlaws and outsiders; they're both considered vulgar and uncouth by polite society; they've both helped thousands of ugly guys get laid. If you're not conventionally attractive and you're still getting more tail than a toilet seat, odds are you're either a porn star or rock musician.*

Whenever I'd show up for a concert, I'd invariably be taken backstage to meet the band members or, in some cases, even asked to introduce the show. I partied with CC DeVille and Sebastian Bach, and I got to meet Hole lead singer Courtney Love on several occasions. During one night at Ben Franks in Los Angeles, Courtney came over to my table and told me that her boyfriend wanted an autograph. Her boyfriend at the time was—you guessed it—none other than legendary Nirvana frontman Kurt Cobain. Kurt waved at me but was too shy to come over and say hello. I signed autographs for both of them, and Courtney still claims that I'm one of the few celebrities whom she's ever asked for an autograph.**

I had some memorable times hanging out with Lars Ulrich, the drummer from Metallica. On one night, I was driving around Holly-

* Kid Rock once said the same thing.

** Years later, I saw Courtney again at a Hole concert in L.A. Drew Barrymore, who was dating Hole guitarist Eric Erlandson at the time, was also at the show, and she interviewed me for a cable-access show. Drew asked me some questions, and her boyfriend kept walking by and teasing her about asking dirtier questions. "Come on," he said to her. "Ask him about anal sex."

wood with him, and he was messing around in the backseat with porn stars Heather Hart and Devon Shire.* I'm not sure exactly what was happening back there, but it was very sexual. When I dropped him off at his hotel, I realized that Lars had dropped his driver's license, credit card, and a bracelet. I called him the next morning and asked, "Lars, are you missing anything?"

"Oh dude, I don't have my bracelet," he said.

"Anything else?"

"No, that's it."

I gave him back his bracelet and decided to hold on to the rest of his stuff until he figured out it was gone. Over the next few days, I'd call him just to ask again if he was missing anything.

"No, everything's fine."

I didn't say a word. Finally, as he was getting ready to leave town to go on tour with Metallica, I called him and said, "Lars, I have your driver's license and credit card!"

"Oh no, really?" he said, laughing. "I didn't even realize."

Typical rock star behavior, huh? He loses one piece of jewelry and his world comes to an end. But his credit card disappears and he doesn't even notice. Amazing.

I also befriended a fledgling rock outfit called Guns N' Roses in the days before they became rock's newest superstars. During an evening at the Rainbow Room, lead singer Axl Rose told me stories about hanging out with video-store clerks. He would rent my videos almost every week, he told me, and even cheer along during my sex scenes, chanting, "Go Ron, go Ron, go Ron!" When he learned that I could play the piano, he insisted that I give him a private recital, and he was amazed that I could still perform an entire concerto from memory.**

* I'd like to stress that he was single at the time, so I'm not ratting on him.

** Many rock and rap stars have been impressed by my abilities on the piano and violin. I once serenaded Pam Anderson and Kid Rock backstage at a show and I played piano in the video *Cowboy* for MTV.

202 RON JEREMY: The Hardest (Working) Man in Showbiz

But it was Slash, the scruffy and top-hat-wearing lead guitarist from Guns N' Roses, who was probably the one I hung out with the most. We would cruise the Strip together, or hang out at his house in the Hollywood Hills. *Rolling Stone* and an episode of *Beavis & Butt-Head* both mentioned that rock stars liked to keep me around because I introduced them to women. Nothing could have been further from the truth. No rock star on the planet, much less somebody like Slash, needed my help getting laid, trust me. When a woman had sex with me, it was often for a paycheck. But they had sex with rock stars like Slash because they *wanted* to. If anything, I was getting his leftovers. I'd show up backstage with a date, and she'd jump into Slash's lap. I'd think, Well, I guess I've lost her for the night.

Sure, there were a few times when Slash and I would be with the same woman. And sure, I might have hooked him up with the occasional porn star. I introduced him to Savannah, the platinum-blonde queen of porn, at the Rainbow Bar & Grill. She probably would have found a way to meet him anyway, because she was hell-bent on screwing rock stars. But Slash always gave me credit for introducing them, and they managed to make quite a splash in the media. I still remember a *People* story about the two of them. They were apparently getting a little frisky outside of a New York nightclub called Scrap Bar, and the reporter called it "full-tilt whoopee." I love that expression: "full-tilt whoopee."

Slash eventually stopped seeing her, but their relationship became a part of rock mythology. Years later, Slash was being interviewed on Howard Stern's radio show, and once again he mentioned that I was the one who introduced him to Savannah. Now, I *believe* that his wife at the time was so upset that she revoked my backstage pass at all Guns N' Roses concerts. She didn't want me bringing around any more women for Slash to diddle.

Before Slash, Savannah had had a brief fling with Axl Rose, and then went on to mildly insult him in the tabloids. She reviewed every rock star she'd ever screwed, from Greg Allman to Billy Idol. "I love sex," she was quoted as saying in *London People* and *Spin*. "And I

love sex with rockers more than anything." But apparently she didn't give huge praises to Axl. You can insult a rock star's music or his talent, and that's fine, but if you insult his sexual prowess, you're begging for a fight.*

Slash wasn't the first musician whom Savannah got to know through me. I introduced her to Steve Percy (of Ratt), and I once brought Sebastian Bach to a casting call at World Modeling Agency. His band, Skid Row, was huge at the time, and when the girls saw him walk in, they were flipping out and calling their friends. But Jim South, who runs World Modeling, didn't have a clue who he was.

"So who's this skinny guy?" he asked. "Is he trying to break into porn or something?"

"Oh, yeah," I said, making a joke of it. "Think you can get him an audition?"

"I guess. He's attractive enough, so it shouldn't be too difficult. He needs a haircut, though."

Before long, Savannah walked into the office, took one look at Sebastian, and decided he would be her next rock conquest. She had sex only with lead singers. She never went for the drummers or anyone behind the scenes. Slash was the one exception to that rule. She had her friend and roommate Perry Rosen give me a note to give to Sebastian, which basically said, "I'd love to meet you, love and kisses, Savannah," and then it listed her phone number. Sebastian looked at Savannah, then back at the note, then back at Savannah. He couldn't quite place where he knew her.

"Savannah," he muttered to himself. "Where have I heard that name before?"

I could have left well enough alone, but I had to help out.

"Axl Rose," I whispered.

"Holy shit," he exclaimed. "*She's* the one who insulted Axl?"

* In all fairness to Axl, he didn't recall having slept with her, and I've known many women who were crazy about his abilities.

"Yeah."

He crumpled up the note and threw it across the room. "Tell her I'll be at the Nelson concert at the Universal Amphitheater. I'll meet her outside at the box office."

The Nelsons were a popular pair of pretty-boy rockers with bleached-blond hair and a fondness for saccharine ballads. Although I liked them and socialized with them now and again, they were not always appreciated by bands like Skid Row and Guns N' Roses. Axl once told me, "I have a problem with guys who are better looking than half the girls I date."

So Sebastian had no intention of going to the Nelson concert. It was just his humorous way of turning down Savannah.

I never performed with Savannah in an adult movie, but I did mess around with her off camera. Mötley Crüe frontman Vince Neil invited me to a party at his hotel room in Hollywood, and I arrived with Debi Diamond, another porn star. Vince was dating Savannah, but he wanted to give Debi a roll in the sack. So we arranged a switcheroo. He had sex with Debi while I took Savannah to the other bed.

Savannah preferred young, cute boys, which I was definitely not. So we didn't go much further than oral sex. I ate her out, and she had an orgasm in my face, which I always love. And she gave me a few strokes and a little bit of head, but not enough for me to cum. I could sense that she would rather be with Vince and Debi, so I told her to stop.

Savannah liked the freaky stuff, at least if the tabloid stories are to be believed. Billy Idol was up to the challenge. She wrote that he liked to wear high heels while they were having sex, and they once fucked six different times in a single evening. You have to respect a guy with that kinda stamina. He was no Larry Levenson, but still, my hat goes off to him.

I've run into Billy a few times over the years. He once invited me to a party at his Hollywood Hills home, and the moment I walked inside I realized that I'd been there before. Back in the early 1980s, long before Billy had purchased it, the house had been used for a porn film, which

starred me and a young starlet named Christy Canyon. I believe the film was a takeoff of the comic strip *Blondie*. Billy demanded that I tell him everything, and we took a tour of the grounds.

"You see that corner over there?" I said, pointing to his bedroom dresser.

Billy's eyes got as big as saucers. "No, you didn't!"

"Yep," I said. "I popped right there."

"Goddamnit, Jeremy," he said with his trademark snarl. "I don't know whether to bronze the place or hire a cleaning service."

Later that night, we got involved in a swinging situation. I had brought Heather Hart to the party, a porn actress who had always wanted very badly to be with Billy. After the other guests left for the night, it was just the four of us: Billy and his girlfriend and Heather and I. We broke off into pairs in the living room and started messing around. I remembered Savannah's stories about Billy's kinky side, so I was ready for anything.

As I was having sex with Billy's girlfriend, I glanced over at Heather just to see how she was doing. Billy was lying on the couch, his legs spread-eagled, and Heather was crouched below him, massaging his ass. We'd been going at it for almost an hour, and as far as I could tell, Billy had declined Heather's invitation for actual penetration. He just wanted . . . well, I guess you'd call it ass-cheek foreplay.

I felt bad for Heather. Here I was getting lucky with Billy's girl-friend, and Heather was stuck with butt masseuse duty. She wanted to feel his schmeckel inside her, but he wouldn't let her.

I smiled and waved at her, and Heather just flipped me off. I had to bite my tongue to keep from cracking up. There she was on the couch, one hand massaging Billy's butt, the other hand flipping me the bird.*

* When Heather told this story to Sam Kinison, he said, "I guess squeezing his butt helps him hit the high notes."

The Sunset Strip of the 1980s wouldn't have existed as long as it did without Bill Gazzarri, the "Godfather of Rock 'N' Roll."

Bill owned a nightclub on Sunset called Gazzarri's, and it was a hotspot for up-and-coming bands in L.A. Bill had an eye for talent, having actually discovered such future greats as the Doors and Warrant. But he was picky about which bands he'd allow on his stage. He only wanted acts that were "foxy." Those were his exact words. "If a band ain't foxy," he'd say, "I'm not interested." So the rockers who appeared at Gazzarri's always had the biggest hair, the most makeup, the wildest costumes. On some nights, it was like wandering into the circus.

With his white fedora and pinstripe suits, Bill looked like an aging mafioso. He was almost sixty years old when I met him, and he was already suffering from emphysema after a lifetime of chain-smoking Parliament cigarettes. Because of his humor and charisma, you'd see him flirting with girls barely old enough to be his granddaughter. And they flirted right back.

Bill treated me to countless dinners at the Rainbow Bar & Grill, the hair-metal eatery of choice. But while I never picked up a restaurant check when Bill was around, he always made me repay his hospitality in other ways. He was something of a practical joker, and I was usually the butt of his jokes. When I wasn't looking, he'd sneak a pepper shaker or ashtray into my pocket. And then, as we were leaving, he'd call over the waiter and accuse me of stealing.

"Check his pockets," Bill would say. "I've been watching him pinch stuff all night. There's probably some silverware stuffed in his jockstrap, too!"

Bill would also use my hand as an ashtray if I wasn't looking. But nothing would amuse him more than a good, long fart. He'd let one fly in the middle of dinner and then point a finger at me, blaming me for causing the foul stench. He'd walk by me or another guest on his way to the restroom and release a fart, once again blaming somebody else.

"Aw c'mon," he'd say, waving a hand in front of his face, "couldn't you hold it?"

He wouldn't usually do this if there were women present. But

Savannah once joined us for a late-night dinner and Bill didn't notice her. He ripped a fart that nearly lifted the table. Savannah was furious and told him, "You are a disgusting man." (It really was an accident.) We all laughed, but Bill never spoke to her again. There was no quicker way to lose favor with the Godfather of Rock 'N' Roll than admitting a lack of appreciation for flatulence.

I finally had a chance to pay Bill back for his generosity. When my father was visiting L.A., I took him and Bill to Ciro's Pizza Pomodora* and treated them to dinner.** Bill couldn't believe that the great tightwad Ron Jeremy was actually going to pick up a tab.

"Really?" he asked. "*You're* buying? Oh, this is too good. Give me a goddamn menu."

He then proceeded to buy three full-course meals; one to eat there, one for later, and one for his girlfriend, who was waiting for him back at his condo. My dad was a little curious, but I explained that Bill was just getting revenge for a decade's worth of mooching.

"It's not even a drop in the bucket compared to what he's spent on me," I said.

After Bill had gorged himself, he lifted a glass to toast my father. "Mr. Hyatt," he said, "there are people all over the world who object to what you did." He was referring, of course, to me. Or more specifically, my father having sex with my mom, which led to my birth. The entire table burst into laughter, but my dad didn't even flinch.

"Objection denied," he said.

Bill really showed his colors during our many trips to Las Vegas. He'd pick me up in his Cadillac and drive me for the weekend to Caesars Palace, where he'd always get free rooms and comped dinners. He had a passion for high-stakes gambling, especially blackjack, but little patience for losing. If the dealer gave him the wrong card, he'd flip it over and say, "I don't want this card. Give me another one." I once saw

* An Italian restaurant owned by my friend Ciro Orsini.

** I also invited six other friends, including Sally Marr, Lenny Bruce's mother.

him actually rip up a card in front of a dealer. The poor pit boss would just sigh and say, "It's okay; it's Bill." They loved him at Caesars. He'd practically built the hotel, so they let him get away with anything.

I preferred to stay at the $5 tables, but Bill would always drag me to the $100 tables. "I can't gamble here," I told him. "It's too rich for my blood."

"What? What's the problem? Are you worried about this stupid goddamn sign?"

He'd take the table's $100 MINIMUM sign and fling it across the casino like a Frisbee.

"There," he said, pulling up a seat for me. "Now the minimum is $5."

Bill was legendary for making a scene at the blackjack tables. During one ill-fated gambling spree many years before I knew Bill, he ran out of money and the pit boss refused to extend his credit. Bill was losing badly, and nobody at Caesars wanted him to lose his shirt.

"Bill, go home," the pit boss told him. "Come back in a week."

"You won't give me any more markers?" he barked back. "Okay, bet *this*!"

Bill dropped his trousers, pulled out his penis, and slapped it down on the table. The pit boss just stared, not sure how to respond.

"I'm sorry," Bill said. "Is this too small an ante?"*

Bill died in 1991. The emphysema he'd been fighting for so many years finally caught up with him. I heard rumors that he may have accidentally taken too much pain medication. He was in constant agony because of his lungs, and I guess he just wanted the pain to stop.

* This story is classic folklore that's still told by Bill's friends to this day. Supposedly, shortly after the incident, Jilly Rizzo and Frank Sinatra were woken up by the casino staff and told about Bill's antics. As the story goes, they both just laughed and went back to sleep.

I took my roommate Veronica—a striking brunette beauty—to Bill's funeral. Bill had introduced us, and within a few weeks we were living together. We became best friends, the closest I'd come to a relationship since Tanya. Veronica adored Bill as much as I did—she considered Bill and me to be her only family—and we were devastated by his death. The funeral was attended by rock royalty, with hundreds of the biggest names in music showing up to pay their last respects. Veronica and I brought Axl Rose, who kept handing us tissues because we were bawling so loudly.

After the service, Veronica and I went to McDonald's for a late-night snack. We glanced at the menu and saw a full-color ad for a new breakfast sandwich called the Sausage Biscuit. We just stared at it, not really comprehending what we were seeing. And then, our faces still soaked in tears, we burst into laughter.

It was stupid, really. In the circles we traveled in, sausage was slang for "penis" and biscuit meant "pussy." So to our eyes, the McDonald's menu might as well have read: "Penis-Pussy Sandwich." We were standing there in the middle of a nearly empty restaurant, laughing like idiots, so happy for even a brief reprieve from our sadness.

"Sausage Biscuits" soon became an inside joke between Veronica and me. Whenever I'd come across a newspaper ad for the sandwich, I'd cut it out, draw a heart around the words, and give it to Veronica. It never failed to make her laugh and, weirdly enough, think about Bill. And our pet name for each other was Biscuit, or just Bis.

It may not be the legacy that Bill would've wanted. I'm sure that he's looking down from heaven right now, thinking, *After all I've done for you, Jeremy, you reduce my memory to a goddamn McDonald's joke?* Then again, a man who got so much amusement from farting and dropping trou in a casino probably has just the sense of humor to appreciate something like that.

Veronica and I have been best friends for almost fifteen years. And it was in part because of a dead rock icon and a penis-pussy sandwich.

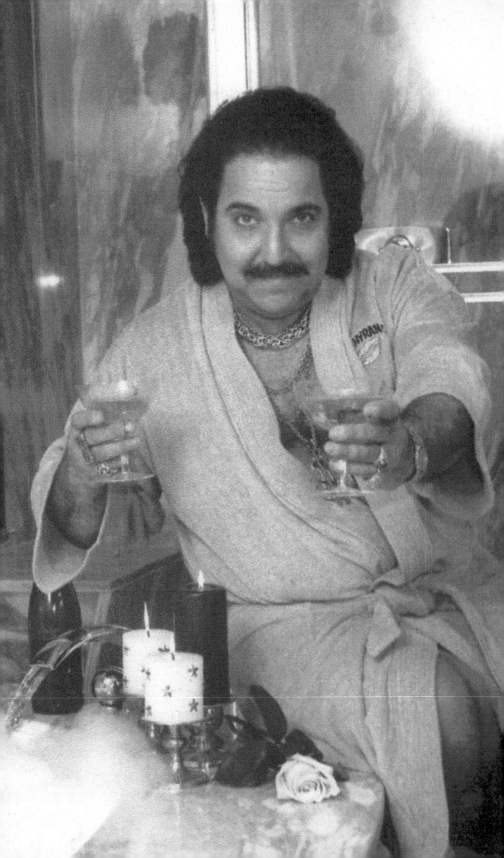

chapter 12
THE AMBASSADOR
OF PORN
(OR, A MIDSUMMER
BOOGIE NIGHT'S DREAM)

For an industry that's so universally misunderstood, there's an awful lot of people who are curious about what goes on behind the scenes on a porn set. It's not just the guys and girls who sneak into the back rooms of video stores to rent the occasional smut flick. The entire *world* is infatuated with porn, even if they've never watched so much as five minutes of a blue movie.

I can't tell you how many talk shows and TV interviews and college lectures I've done where audiences grill me about what *really* goes on during a porno shoot. We're all curious about sex, and a porn set is where sex is dragged out of the shadows and examined under bright lights. Everybody wants to visit a porn set because it's like taking a guided tour of your own id.

But as enticing as porn sets may be, not just anybody is welcome inside. You can't knock on the door and ask, "Do you mind if I poke around for a while and see what's going on in here?" (Unless you're a vice cop.) No, to scale the walls of a porn set, you need somebody on the other side willing to throw down a rope for you. You need a friend with connections.

(Courtesy of Metro)

Somebody like me.

My sets have been visited by more famous faces than have walked the red carpet at most award shows. I've invited actors, directors, musicians, comedians, writers, studio executives, and politicians. And with very rare exceptions, I won't reveal their names.

When you walk onto my set, you enter into a sacred bond. Your anonymity will be protected at all costs. Some, like Rodney Dangerfield and most of the rock stars, didn't care who knew they were there. Others have arrived in full costume, right down to the fake beard and oversize hats, and only I knew their real identities. You can stay as long as you want, watch as much as you can stomach, and leave without anybody being the wiser. In some ways, it's a lot like Las Vegas. What happens on my porn sets *stays* on my porn sets.

I do have rules, however. And here they are, in no particular order:

LAWS OF THE PORN SET

Law #1: You may not watch me have sex.

Law #2: No touching the performers unless a specific invitation is given, or you're Tommy Lee.

Law #3: Don't speak too loudly during a sound take.

Law #4: Ease up on the directing advice (unless you happen to be a famous director).

Law #5: If the performers want privacy during the hard core, the guests can watch only the kissing, petting, and foreplay, then retire to the monitor to see the rest of the action.

I'm particularly strict about law #1. I realize that this law may sound a little prudish, especially coming from a porn actor who gets *paid* to have sex in front of other people. But I've always been uncomfortable being naked around celebrities. I don't mind taking them to the set if I'm directing or writing or producing. But when I'm actually having sex in front of a camera, I just feel funny about it. I don't want

them to look at me in that way, especially if they're somebody who could potentially help my mainstream career. Because once somebody has seen you have sex on a porn set, they'll never look at you the same again. They'll forever think of you as that naked sex actor rather than an actor. I could have sex in front of a friend, like director Adam Rifkin, because he's a real buddy and it wouldn't matter.* (But he couldn't stomach that.) But a celebrity that I'm trying to impress is never going to watch me do a sex scene.

As nervous as I can be about having famous people on my sets, it doesn't begin to compare with the anxiety that inflicts many of my guests. Rock legend Stephen Stills was so tense during his visit to my set that he was barely able to sit still. It'd been years since porn sets had been raided by the cops, but he was acting like he was in a brothel, glancing over his shoulder as if he was certain that a vice squad was going to come running in at any moment. During the entire shoot, he was pacing back and forth and sweating a bit.

"Relax," I told him. "You're just watching. Nobody's going to jump on you or tell the press that you're here. We're not rats."

I'd heard that he'd recently given up smoking. But at one point, I looked over and Stephen was puffing away at a cigarette. He was sucking on it like he thought it might contain vitamins. So I guess I'm personally responsible for getting Stephen Stills back into smoking. I'm not proud of that. And in all fairness, he hardly watched any action. We just happened to be shooting a film near where he lives, so he came over mainly to see me.

After the shoot was over, he ran over and shook my hand. He was talking a mile a minute, not even pausing to take a breath. "Thanks Ron that was cool really cool I gotta go okay see ya later." And then he jumped into his car and drove away.

Over the years, I've learned little tricks to put my guests at ease.

* In fact, he hates seeing me have sex on screen. He describes it with that famous quote from *Apocalypse Now*. "The horror . . . the horror . . ."

When the Nelson brothers, the blond glam-rock duo, paid a visit to one of my sets, I tried to make them feel more comfortable by over-explaining exactly what they were seeing. I did it mostly to be funny, and maybe a little annoying.

"You see that, boys?" I whispered to them, pointing out a sexual position that was taking place just a few feet away. "In porn, we call that the *reverse cowgirl*."

"We *know*, Ron," they snapped, a little annoyed by me.

Later, when the actors switched positions, I pulled the Nelsons aside again for another porn primer.

"This is called *doggy-style*," I said. "And pretty soon, that naked guy over there will be doing something called the *pop . . . shot*. Do you want me to explain what that is in more detail?"

"Shut up, Ron," they yelled at me. "You're an asshole! We know what a fucking pop shot is, you jerk!"*

I was just trying to embarrass them in front of the crew. And it worked like a charm. By the end of the day, they were so relaxed and unfazed by all the sex happening all around them you'd think they were at a church social.

But it backfired on me. I was so worried about keeping the Nelson brothers happy that I didn't even think about what their presence would mean to the other actors. Buck Adams, the male star of my film, was having a slight difficulty keeping an erection. He did the scene just fine, just without his usual lightning-fast speed. And it was all because of the Nelsons.

"Thanks a lot, Ron," he complained. "The girls keep staring at these two beautiful blond boys. They all want to have sex with them, and they're being paid to be with me. How is a guy supposed to get wood with this kind of competition?"

* They got back at me for that. I watched them shoot a music video at an L.A. night-club, and in front of two thousand of their fans, they yelled out to me, "Hey, Ron, this is an amplifier. This is a microphone. This is a guitar. These are drumsticks." (And I wound up doing a cameo in the video, in the part of a security guard.)

He was right. It just wasn't fair. So I politely asked the Nelsons to retire to the monitor, in the other room.

"Why?" they asked. "What did we do?"

"No offense, boys," I told them, "but you're just too pretty."

N ot every visitor to a porn set comes to stare at the naked ladies. Some, like famed director John Frankenheimer, were there to do research.

Frankenheimer was a movie director whom I'd idolized since I was a kid, the man responsible for such classics of cinema as *Birdman of Alcatraz* and *The Manchurian Candidate.** When I got the call, John told me that he was working on a new film called *52 Pick-Up*, based on an Elmore Leonard novel of the same name. The story involved a businessman who was blackmailed by a sleazy porn king. Known for his stark realism, John didn't want to base his movie on conjecture alone. If he was going to accurately portray the gritty realities of the smut trade, he needed an "expert" to advise him, taking him deep into the belly of the beast for a firsthand look.

He came to a few sets with me before I invited him to sit in on one of my shoots in Laurel Canyon. John couldn't have cared less about the sex. He was more intrigued by the production end. When we'd finish a scene in one take, he'd shake his head in wonder.

"You don't need to do it again?" he asked. "What if the lighting was wrong? What if the continuity is screwed up? What if you don't have enough coverage?"

* I used to love talking to John about the Kennedys. He was a close friend of Robert Kennedy, and he was also the director of his campaign videos. Robert often stayed at John's place in Malibu, and John was actually with Robert when he was assassinated in Los Angeles in 1968. John told me that both of the Kennedy brothers had sexual appetites to match my own, and *one* of them had a larger penis than I do. He didn't say which one, but it could've been just a rumor that he heard.

I just shrugged. "Hey, it's porn. Our audience is *very* forgiving."

He couldn't resist interrupting me with the occasional comment, suggesting a different angle or changing a lighting gel in midscene.

"Hey," I teased him. "Did I tell you how to shoot *French Connection II*? Don't tell me how to shoot a porno."*

John spent most of the afternoon with us, and I hoped he was getting something useful from the experience. Compared to the danger and intrigue of his *52 Pick-Up* script, our set must've seemed monotonous. There were no mafia henchmen, no women tied to chairs, no sketchy characters delivering briefcases full of cash. It was just another movie, no more exciting or eventful than any other film set.

Until the cops showed up.

It was an unlucky coincidence. Had John visited me on any other day, he would've come and gone without incident as he had before. But he just so happened to be on my set during the very day that I was first raided by the L.A. vice squad. When John saw the cops come storming through the door, his face went as white as a sheet.

He was rounded up with the other actors. The cops recognized him but didn't let on. He asked for a moment alone with me, and we retreated to a corner to confer in private.

"You have to get me out of here," he whispered.

"I'll do what I can," I said. "I don't have too much pull with the LAPD."

I walked back over to Como and explained the situation to him. I didn't need to give him a list of Frankenheimer's credits.

"I know who he is," Como said. "He's the *Manchurian Candidate* director, right? What the hell is he doing on a porn set?"

"It's a long story," I said. "He's scouting locations and doing research for a new film. He isn't involved in any of this. Any chance you can cut him a break?"

Como sighed as he considered what to do. We both knew that

* Of course, I *did* take his advice. I was just teasing. Who wouldn't?

he could easily nail John just for being there. But it might also hurt the city's case against us. If word got out that a mainstream director was associating with a porno production, it would only legitimize us. We couldn't as easily be vilified as a criminal operation if we had too many famous friends.

"Okay, fine," Como said. "I'll let him go unnoticed. I can't get his name off the police report, but we won't make a big deal of it. Just get him out of here as fast as you can."

I escorted John to the back door, apologizing all the way.

"That was certainly an experience," he said, giving me a quick wave as his Ferrari sped away, kicking up a small cloud of dust.

After months passed and his name never appeared in the tabloids, John finally decided it was safe to contact me again. He wasn't brazen enough to visit any more porn sets, but he had other ideas about how I could contribute to *52 Pick-Up*.

He needed actors for a party sequence, and, because it required some nudity, he asked me to call in my industry friends.* I brought him porn stars like Amber Lynn, Jamie Gillis, Tom Byron, Amy White, Herschel Savage, Inez, Honey Wilder, Erica Boyer, Peter North, and, of course, myself. He also asked me to shoot a short, soft-core porn loop for a scene in which Roy Scheider goes to an X-rated theater and watches an adult movie. The video never made it into the final cut, but I was still given a "film clips courtesy of" credit. And John did use the audio portion. So the next time you rent *52 Pick-Up* and hear groans in the background, just remember that I created those groans. And John also gave me a small acting role, as a porn film director.

Often when mainstream directors have needed a brief snippet of porn for their movies, they'd come to me. Director Ron Howard asked my friend Bobby Gallagher and me to shoot some soft-core footage for *Parenthood*, for a scene in which Steve Martin's nephew watches

* John had to defend his reasons for using nonunion actors to the Screen Actors Guild and the film's producers. Even after he explained that porn actors were more comfortable with nudity, he was still fined by SAG.

a porno tape. It needed to be nonexplicit, as the studio wanted a PG rating. So we hired Janine Lindemulder, Veronica, Victoria Paris, Benet (and, of course, me) to do a little bumping and grinding for a short loop. Ron appreciated our efforts, but he opted instead to use a clip from a late 1970s porno called *Blonde Goddess*. My face never appeared in *Parenthood*, but listen closely during the scene and you can briefly hear the audio of me and a few other actors grunting and groaning.

I soon developed a reputation in Hollywood as the "go-to" guy for porn. If a director needed background on the history of adult films, he'd call me. If he needed a bunch of naked porn actresses to cavort in a hot tub, he'd call me. If an actor was cast as a porn sleaze-bag and needed coaching on his character, he'd call me. I even spoke on the phone with James Gandolfini to help him prepare for his role as a porn henchman in *8MM*, measured Jennifer Tilley's breasts (in a bra unfortunately) for a body double in *Fast Sofa*,* supplied porn footage for *American Psycho*, and consulted on the authenticity of the sex-club scenes in *9½ Weeks*. Any movie that so much as mentioned porn in passing has probably utilized my expertise in some way. And my name has almost always appeared in the credits.

It was only a matter of time before I was called upon to consult on a movie that not only dipped its toes into the shallow end of the porn pool but dove in headfirst. *Boogie Nights* was a comprehensive history of the adult-film industry, reaching back to the golden age of porn that I knew all too well. When director Paul Thomas Anderson called and told me he was working on an epic biopic about a porn actor with an unusually large schlong, I thought to myself, At last! Somebody has finally decided to document my life story!

* In this movie, I was cast as a diner owner who fired a waitress, who was originally to be played by Rose McGowan. But Salomé Breziner, the movie's director and writer, beat me to it. She fired Rose and gave her part to Natasha Lyonne instead. So Salomé got to fire Rose before *I* did. Strange but true. Backstage at the House of Blues in Vegas when I told this story to Marilyn Manson, he laughed his ass off (Rose was his ex).

"It's about John Holmes," he told me.

Crap.

Even in death, that skinny little bastard was still stealing my spotlight.

I came very close to blowing it with Paul before the *Boogie Nights* project even began.

He invited me to a private screening of his last movie, *Hard 8*, at the Hard Rock Cafe in Beverly Hills. Burt Reynolds and Drew Barrymore were also at the screening, because Paul was trying to woo them into accepting roles in *Boogie Nights*. Now, I don't know if any of you have ever been inside a private screening room, but it's not like the theaters at most multiplexes. You're not sitting in hard-backed seats designed to rupture your spine. You're reclining in huge, comfy sofa chairs, with cushions so soft and plushy that your ass just sinks into them. They're so cozy that even with the most captivating and well-crafted movie to hold his attention, a guy could feasibly drift off into a deep slumber.

My friends have accused me of having narcolepsy. While I'll admit to occasionally falling asleep in public places, I don't think a medical condition is to blame. If anything, it has more to do with my hectic schedule. I'm constantly on the move, whether it's shooting porn or hustling for mainstream work or flying across the country for another stand-up gig. If I slowed down long enough to get a proper six hours of sleep a night, I might not suffer from spontaneous napping. But as it stands, I have to make do with catching a few minutes of sleep wherever I can, whether it's in an airport terminal or on the set of a porn movie or, most disturbing to anybody who happens to be with me, while driving a car and stopped at a red light.

The last thing you want to do is throw me into a comfortable chair in a dark room. It's like slipping me sleeping pills. I'll be unconscious before the title credit hits the screen.

I don't know how long I was asleep before I felt a finger jabbing into my stomach. I jerked awake and saw a red-faced man glaring down at me.

It was Paul's agent from UTA (United Talent Agency). "You know, you're not making your friend look very good," he whispered angrily. "Paul's trying to show his movie to some major celebrities, and you're snoring through it and disturbing everybody."

Was I really snoring? I felt horrible. "I'm so sorry," I said, running a hand across my swollen eyes. "It won't happen again."

He walked back to his seat and within seconds I was asleep again. And this time I wasn't just snoring. My uvula was making guttural noises that sounded like a phlegmy wind tunnel. It was almost louder than the movie.

The agent ran back over and shook me until I stopped. "Maybe you should just leave," he growled at me. "If you can't stay awake for two goddamn hours, it might be better for everybody if you found someplace else to take a nap."

Not the best way to begin a professional relationship.*

Luckily, Paul never held it against me. I suppose that he realized I had too much to offer *Boogie Nights* to be put off by a little inappropriate snoring.

On most of my consulting gigs, I would show up for a day or two on the set and give the director a few notes. But for *Boogie Nights*, Paul and I got together often, discussing the adult industry and hammering out details. Paul didn't just want a casual tutoring in porn, he wanted to know *everything*. He came to several of my sets, watching my every move like an eager student. He interviewed the actresses, chatted with the crew, talked to anybody who had even the smallest

* Years later, I was backstage at the *Tonight Show with Jay Leno* and I bumped into Drew Barrymore (her boyfriend at the time, Tom Green, was a guest on the show). I asked her whether she or Burt knew that I was sleeping during Paul's screening. "Of course we did," she said, laughing. "We thought it was hysterical."

job on a porn shoot. I brought him to porn parties, introduced him to retired producers, and got him into the Hot D'Or Awards Show in Cannes, France. I took him and Mike De Luca, the head of New Line Entertainment, to an AVN awards ceremony. I even did some location scouting (the Gourmet studios were used in a few scenes) and I dug through dusty old warehouses, in search of reels of classic films (Paul didn't want videos or DVDs).

Paul wasn't the only one getting a behind-the-scenes education in porn aesthetics. Everyone in the cast was asked to attend at least one porno set. Mark Wahlberg went, as did William H. Macy and Philip Seymour Hoffman. Only Burt Reynolds managed to skip the field trips. As I believe he told Paul, "I know how these films are made. I don't need to see it."

During the *Boogie Nights* shoot, we were told not to discuss porn with Burt. The only acceptable topics were football or baseball. Burt loved anything athletic, and he could supposedly rattle off statistics or scores like an encyclopedia of sports minutiae. I don't know how he kept so many numbers in his head. I tried to be friendly and make conversation, but I wasn't the sports enthusiast he was. I could've told him how many pop shots there were in *The Opening of Misty Beethoven* but not who won the 1964 World Series. Somehow, I don't think he would've appreciated the similarities.

The female stars of *Boogie Nights*, Julianne Moore and Heather Graham, were a little more elusive when it came to visiting my sets. Not that they found it offensive or didn't want to be around porn actors, but their schedules were less predictable than those of the boys. I didn't get the call that Julianne Moore had a free afternoon until the last minute, and I had to scramble to find a porn shoot for her to watch. I was working on a new movie called *Three Foxes and a Dweeb*. It was a *Revenge of the Nerds* for the porn crowd; dorks with glasses having sex with women so far out of their league you couldn't help but cheer for them. Though we hadn't planned to film anything on the day Julianne was available, I begged my actors to come in on their day off for a quick scene.

We rented a hotel room in the Valley, and Julianne arrived just as we were getting started. I've got to hand it to Julianne, she was a consummate professional, because the shoot was hardly the most comfortable environment. It was a small room with a king-size bed, so there was barely enough space for the crew to move around unencumbered. Julianne was stuck in very close quarters with the other actors, and she probably got a better look at the sex than she really wanted.

What's more, Eric Monti, my lead performer, was not what you'd call the most handsome guy. He was cast specifically for that reason. This was a movie about dweebs, and he fit the bill perfectly: he wasn't somebody you'd necessarily want to see naked.

To make matters worse, we were shooting an anal scene, with all the lubes and oils necessary to make everything run smoothly, which made for a rather messy and less-than-visually-pleasing show. Plus, Eric sweats a lot. Paul actually told *The Globe* (or somebody did) that he worried about losing Julianne after the experience.

But Julianne, trooper that she was, took it all in stride. I wouldn't have blamed her if she had taken one look at my ragtag group of porn misfits and gone screaming for the hills. But she was nothing but cheerful and courteous, smiling at everybody and trying to stay out of the crew's way. She thanked me at the end as if I had just given her an early Christmas present. I don't think for a minute that she enjoyed any of it. I can only imagine that after she left, she took a Karen Silkwood shower, with guys in hazmat suits scrubbing her down with sponges. But she never complained, never made any of us feel like a carny sideshow attraction. She just sat and silently watched the scene and then got the hell out of there.

Heather Graham had an interesting experience. Actually, it was interesting for both of us. I was starring in a John T. Bone movie called *Sodomy Sodo-you*, and Paul asked if he could bring Heather by to check it out. I said it would be fine, as I assumed that I would be doing only dialogue during their visit. But then I looked at my schedule for the day and realized, "Aw shit, I'm booked to do a scene!"

Please take a moment to review my five laws for celebrities visiting a porn set. Take a good, close look at law #1. Ring any bells? *Nobody watches me have sex!* I had broken my most cardinal law, and it was too late to call Paul back and cancel. Besides, *Boogie Nights* would be going into production soon, and Paul was eager for Heather to sit in on at least one porno shoot before it was too late. Even if I wanted to, I couldn't get out of it.

Heather Graham was going to see me naked, and there wasn't a damn thing I could do to stop it.

The day's shoot was taking place at a mountain ranch in the Simi Valley, right down the block from Charles Manson's old farm on Santa Susanna Pass. It was a beautiful setting for a porn film, with rolling hills and picturesque views. But when Paul and Heather drove up, I knew there was going to be trouble.

Heather was wearing skates.

In *Boogie Nights*, she would be playing Roller Girl, a young porn starlet who never took off her roller skates. Heather was not the most skilled skater, so Paul had instructed her to practice at every opportunity. They both apparently decided that a porn set would be an excellent place for her to work on her balance. But what they didn't count on was the hilly and uneven terrain of the Simi Valley. The entire ranch was on a slant, which hardly made for the most forgiving skating rink. Paul had at least thought to give Heather some knee pads, but it still seemed like a tragedy waiting to happen.

But I had other things to worry about. I wasn't just doing a sex scene today; I was doing an *anal* scene. Well, if I was going to break my own law, I might as well go all the way and give Heather something she wouldn't soon forget.

My partner was a porn vet named Cortnee, and this was far from her first anal scene. I was thankful for at least that much. It would've been far worse if I'd been breaking in a new actress. A first-time anal is not pleasant for anyone. Tensions are high, and neither person enjoys the experience very much. But even so, I'm something of an anal sex aficionado—an analinguist, if you will—and I pride myself

on putting even the most inexperienced woman at ease.

Hey, you know what? This seems like a perfect excuse for yet another edition of . . .

Part 2:
ANAL SEX

The most common mistake made by women during anal sex is sucking in the muscles of their sphincter because they're afraid that it's going to hurt. But the thing is, that makes it only *more* painful. You have to push *out* like you're taking a crap. When you suck in, it tightens your muscles, and a guy's cock has to push through it, stretching the anal walls. But by pushing out, you're loosening those muscles and making entry less difficult.

When I tell this to girls, they never believe me. "If I push out, I'm going to take a shit on you." Well, possibly. But not if you're in the right position.

Doggy-style is the best position for inexperienced anal. A girl should be on her stomach, facing forward, with both of her elbows on the floor and her ass up in the air. This way it's less likely that she'll make a mess. I've seen some really stupid performers who never follow this rule. A girl will come in and say she just had a big Mexican dinner and she's a little nervous, and then she'll have anal sex on *top* of a guy. It's like she's sitting on a toilet, so of course she'll end up making a mess all over his goddamn balls. If a girl's concerned that she might be a little loose down there, or maybe she had a heavy dinner the night before, I'll say no problem, we'll just do doggy. Her chest and elbows are on the ground, with her ass at the highest point in the air, and she never has a problem.

Now, before you get started, it's important to do a little foreplay. Have some normal sex before you move on to anal.

Make sure that your partner is totally relaxed and aroused. Use a vibrator on her pussy or play with her clitoris. When she's ready for some anal play, use plenty of lubrication. Slather her asshole with K-Y jelly or Vaseline or Astroglide. I've even used Albolene (makeup remover) on occasion when nothing else was available.

When her sphincter is nice and moist, put one finger inside. Remember, she should be in the doggy position, elbows on the ground and ass in the air. Then put in two fingers. Two fingers is the width of most penises anyway, so you're already halfway there. It's important that your nails are very neat and trim. You don't want to be ripping anything in there. And don't just ram a finger inside. Gently rub around the outside of her asshole, lubricating the edges. When you do insert your fingers, do it slowly. Put just the tip of your finger inside, then a little more, and then a little more. Ideally, she should also be masturbating during this to further relax the muscles.

If you spread her cheeks, you'll notice that there's a little gape forming. A gape, for those of you who don't know, is when the anus is stretched open and a little black hole is visible. For some girls, this may be no larger than a pencil eraser. For others, their assholes could rival the Grand Canyon. We make a lot of jokes about the gape in porno, especially in the titles. There was *Planet of the Gapes* and *The Gapes of Wrath*. If the gape is wide, you know you're in great shape. That's what you want to see.

After a few minutes of this, you should be ready to begin. Stand up, spread her ass cheeks, and aim your cock toward her sphincter. It couldn't hurt to have something in her pussy while you're doing it. I've known some porno actresses who say they prefer double penetration to just straight anal. They need to have their pussy stimulated while there's a guy in their ass. If you don't have a second cock to work with, a vibrator

will usually do the trick, or she could always masturbate.

And here's the most important point: let *her* back her ass into *you*. A lot of guys think it's their responsibility to initiate the penetration, but that's just not true. You should remain almost completely stationary and let her slide her ass onto your cock. It's the psychological aspect of anal sex. It's more mental than physical. If she's the one in control and doing most of the work, it won't feel so much like an invasion.

Don't think that girls don't like nasty talk. When I'm having anal sex with a girl, I've found that a little dirty talk will go a long way. I'll say something like "I'm in your ass right now. That is so nasty. This is sodomy. This is the bad place. I'm on the Hershey Highway. This is filthy and disgusting. I am *ass*-fucking you." Sometimes they love that. It adds to the experience, and makes it seem more like a fun romp than a proctology exam. If they don't like dirty talk, then just shut up and screw. Whatever the case, if their head's not in it, their body won't be either.

So, to review, here are the six simple steps to achieving successful and pleasurable anal sex:

1. Elbows to the ground, ass up (the girl, not you)
2. Lubricate liberally
3. Insert one finger, then two
4. The sphincter pushes *out* rather than sucks *in*
5. Let *her* push back onto *you*
6. Keep stimulating her pussy and clitoris

If none of these tricks work, then you're outta luck. Give it up. You're not getting any anal. It happens. Not everybody is built for anal, and we all have very different physiologies. If you're lucky enough to find a girl whose ass has the elasticity of a rubber band, don't let her go . . .

Where was I?

Ah yes. I'm having anal sex in a movie called *Sodomy Sodo-you.* Heather Graham is watching while wearing roller skates. Paul was helping to hold her up, and even John T. Bone, the director, ran over to help her keep her balance a few times. As for me, I was too busy doing Cortnee in the keister to notice. Cort was a good sport, actually. She didn't mind performing in front of Paul and Heather, and she even commented on how young and attractive they both looked. When we finished the sex, Heather asked us a few questions about the scene and then left with Paul.

I saw Heather at a few SAG award shows, and while the entire cast of *Boogie Nights* was very warm and happy to see me (especially William Macy, a great guy), Heather would seem a little . . . well, standoffish. Not as friendly as she used to be.

Maybe law #1 is just silly. Maybe it's all in my head, and actors don't really care if they see me having sex on a porn set. I guess I'll never know for sure. . . .

I brought the well-known actress Fairuza Balk to the *Boogie Nights* premiere in Los Angeles.* After so many months of preparation, it was exciting finally to see the finished product. It was an epic, just as Paul had promised, lasting nearly three hours and never losing its momentum. I can't say that I (or most of the porn industry) could identify with any of the characters. I'd never been addicted to drugs, never robbed a crime kingpin at gunpoint, never coerced underage

* I'd taken her to a *Hustler* Christmas party before that, and she was always fun to hang out with.

kids into having sex. The characters were all based around the John Holmes crowd, but that was where the similarities between *Boogie Nights* and most of the porn industry ended. But even so, it was a major Hollywood movie! People all over the country would soon be watching it and talking about it, and I had played a small role in making it happen.

Well, not a *role* role. I didn't ever actually appear in the film. Paul had promised me at least a small walk-on part, but somehow it never happened. At first, he cast me as an audience member in a movie theater or nightclub, but he had to cut the scene for length. And then he put me in a prison scene toward the end, when Robert Ridgely's Colonel character is brutalized by a black inmate. First he made me a security guard, then a warden, and then a prisoner. I'm the Colonel's cell mate, and I was supposed to interrupt him from being attacked by another inmate. Paul had me ad-lib some dialogue, but none of it really worked. The scene didn't make a lot of sense. Why would I be talking so much? When you're in prison, you make a point of *not* speaking. But Paul wanted me to say a few lines to spice things up.

"Is there even any film in the camera?" I asked him.

"What?" Paul said, dumbfounded. "You're kidding, right?"

"This has happened to me before. Are you just throwing me a bone and pretending to shoot this scene?"

"Ronnie, I'd never do that to you. Why are you being so paranoid?"

I honestly didn't know. I was just jaded, I suppose. I'd been cut out of films before. The editors told me that my prison scene lasted until the final cut, so I appreciated Paul for the effort.

As I sat with Fairuza and watched the movie, I saw a lot of my friends in the porn business on-screen. Nina Hartley had a pretty big speaking role. Jane Hamilton, who had given the cast a backstage tour of her porn set, had a great part as a judge in Julianne Moore's child-custody case. Two big-boobed girls named Summer Cummings and Skye Blue had a lot of screen time in a Jacuzzi scene. Even Little Cinderella had a terrific bit as a party guest who overdoses on laced

cocaine. Every one of the porn stars whom I had recommended to Paul was used in the movie somewhere.

Except me.

As the closing credits began to roll, the hair stood up on my forearms. I watched the actors' names scroll by, and then the production crew, the cinematographer, the costume designer, the music supervisor. Just be patient, I told myself. The credits listed the extras, the set decorator, the first assistant editor, the boom operator, the chief lighting electrician.

The audience was getting to their feet, filing toward the exit. I held firmly to Fairuza's hand. "We're almost there," I whispered.

Set decorating buyer. The seamstress. The first assistant accountant. The office staff assistant.

Almost there.

The supervising sound editor. Special effects. Unit publicity.

Almost there.

Caterers, drivers, security, scoring mixers.

Where the hell was I?

And then I saw it: CONSULTANT: RON JEREMY. It was one of the last credits, just a few lines above the Panavision logo and copyright notice. I could have taken a walk, jogged around the block, had dinner, come back, and *still* not missed it.

Behind me, a few New Line executives were snickering. "Hey, Ron," they yelled. "*There's* your credit!" I was annoyed, but it *was* New Line, after all.

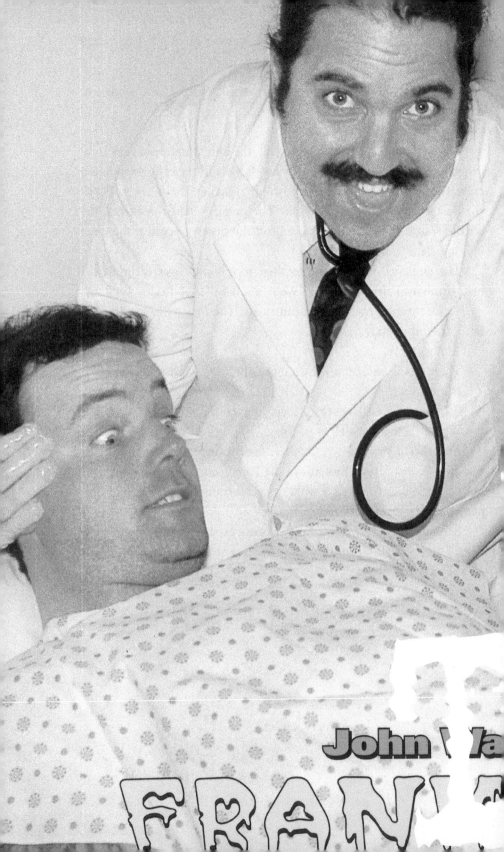

John Wa

FRAN

Love is the
answer, but while
you're waiting for
the answer, sex
raises some pretty
good questions.
--Woody Allen

★RON JEREMY FOR PRESIDENT★

chapter 13

GOIN' MAINSTREAM

I've been asked a lot of strange questions
over the years. Everything from "What do breast implants really feel like?" to "Who is your favorite sex partner?" My answer to this second question is always the same: your mom. After getting punched in the face, I'll explain that I'm only kidding, and then I'll ask if their mother still has that little birthmark on the back of her arm. After getting punched in the face yet *again*, I'll tell them the truth.*

But the question I'm asked most often is this: "Why do you care so much about becoming a mainstream actor? Isn't being a porn star enough?"

There really isn't an easy answer to that. A lot of people make fun of me because of my mainstream ambitions. They just don't understand why I can't leave well enough alone and be happy with what

* If you're curious, here are my eleven favorite performers, in no particular order: Tabitha Stevens, Christy Canyon, Teri Weigel, Taylor Wayne, Shayla Le Veaux, Jeanna Fine, Nina Hartley, Shanna McCullough, Vanessa Del Rio, Marilyn Chambers, and Jacklyn Lick.

(Courtesy Porn Star Clothing)

I've got. But the thing is, I've never thought of myself as a porn actor chasing after a mainstream career. I'm just an actor who *happened* to get into porn. When I was a kid and decided that acting was what I wanted to do with my life, I didn't think, Wow, this'll be my chance to show my schmeckel to the world! I *always* wanted a straight acting career. Porn was just the first opportunity that came along, but it was never supposed to be a permanent thing. I had dreams of breaking into big-budget Hollywood movies when I was a starving actor in New York, and just because I started doing porn doesn't mean that those dreams went away.

So why did I stay in porn for so long? If I was so damn determined to make it as a legitimate actor, why didn't I just quit porno once and for all and devote myself full time to pursuing mainstream acting jobs?

The answer is, I've learned to like porn. I may never quit, but at the same time I'll never stop sending out my résumé and checking the mainstream casting listings, just in case other things come along.

And over the years, they have.

When you're a porno actor looking for his shot at the mainstream, you have to try a little harder than everybody else. You can't just assume that because you have a little bit of fame, you're going to get every audition that comes along. It's unlikely, if not improbable, that a producer will call you and say, "Hey, Ronnie, I just saw you in *Big Boobs in Buttsville*. You were great! We're putting together a buddy-cop picture with Al Pacino, and we think you'd be great for the lead." If you want to talk to producers, *you're* the one who has to call *them*. And even then, you'll probably get a response like, "Who is this? How did you get this number? No, I never saw *Big Boobs in Buttsville*. If you ever call here again, I'll be notifying the police."

Porn may be enough to get your foot in the door, but it won't get you inside the white walls of Hollywood. If you want to break in, you some-

times have to be sneaky about it. You have to find a back door. (No, I'm not talking about anal sex. Didn't we cover that in the last chapter?)

I've been lucky enough to be approached by filmmakers who wanted my services in a capacity other than acting. Once I've developed a relationship with the director, I'll hit him up for a role. It almost worked for me on *Boogie Nights*. And it almost worked for me on my first consulting gig, on Adrian Lyne's 1986 erotic thriller *9½ Weeks*.

The movie, which starred Mickey Rourke and Kim Basinger, followed a steamy affair between an art-gallery dealer and a Wall Street executive. Adrian hired me to consult on the Show World scene, when Mickey and Kim visit the infamous Times Square sex club. I provided him with several porn actors to simulate sex during the scene. In return, he offered me a small, nonspeaking part as a swinger who kisses Kim Basinger.*

On the day of the shoot, Adrian took me aside and told me that Kim had requested another actor. She wanted somebody a little taller and somebody she knew better. I was certainly upset. I told Adrian that I'd wear platform shoes. But the role had already been given to David Everard, Mickey Rourke's personal assistant and somebody with whom Kim felt more comfortable. I was still in the scene as a silent bit player, but my face never made it into the final cut.

Mickey knew that I was depressed about losing the part, and he tried to console me. During a break in filming, we took a walk through Times Square to look at the sights. Mickey was not yet a major star. He had achieved some fame with *Diner*, but *The Pope of Greenwich Village* hadn't yet been released, and he was not yet a big player in Hollywood.** So he wasn't being recognized by the crowds out on the New York streets.

* The part was originally offered to John Leslie, but as he was already booked for another job, they gave it to me.

** I met Mickey in L.A., on the set of *City in Fear* (David Janssen's last film). It was Mickey's first break as an actor. I played a waiter. And just for the record, David Janssen, famous for the TV show *The Fugitive*, died shortly after this film.

But *I* was.

Remember, this was Times Square during the mid-1980s, when it was still the porn capital of the world. To the smut peddlers who called Forty-second Street home, I was a bona fide celebrity. We couldn't walk a few feet without somebody stopping us and asking for my autograph. Men would come running over with copies of my latest movie on VHS, and women would ask me to sign their boobs. But when they looked at Mickey, their expressions were blank.

"Why do you even care about losing the Basinger scene?" he said with a laugh. "You don't need it. You're already famous. These people think you're a god."

Finally, one of my fans—a hunched-over old man who looked like he had spent the night sleeping in a cardboard box—was curious enough to ask about Mickey's identity. "So who is this guy?" he said, eyeing Mickey suspiciously.

"Don't bother," Mickey whispered to me. "It's not important."

"Oh, him?" I said, nodding toward Mickey. "This, my friend, is none other than John Holmes."

The old man nearly did a cartwheel. He grabbed back his pen and paper and threw it at Mickey. "Can I have your autograph?" he asked, his voice trembling with glee.

Mickey signed it, all the while muttering, "Ronnie, you're an asshole." The irony was not lost on either of us. Here was an actor who made millions signing an autograph for an actor who made thousands.

I glanced at the autograph, and Mickey had indeed signed John's name. The old man thanked him, mumbled something about John's (or Mickey's) remarkable penis, and slithered away.

"So how does it feel to be John Holmes?" I asked him. "I bet you grew a couple inches down there, huh?"

He just smiled. "I shrank," he said.

And for the record, if anyone ever finds this autograph, it'll probably be worth lots on eBay.

Like anyone looking to break into Hollywood, it helps to have friends in high places.

I've been fortunate enough to know many directors and actors who believed in me and even fought to include me in their movies when everyone in the business thought they were crazy. Mickey Rourke helped me get parts in *Spun* and *Domino*. Don Johnson used his clout at CBS to get me a small role on his show *Nash Bridges*.* And John Frankenheimer was probably one of my most devoted allies. Even after the Laurel Canyon fiasco, he always tried to find parts for me in his movies. He put me in *52 Pick-Up*, and then again in *Dead Bang*, and then again in the TV miniseries *George Wallace*. When he was casting *Ronin*, he gave me a small role as a fishmonger and flew me to France for the shoot. He didn't care that I was a porn actor. As he told me once, "You're much more talented than people give you credit for. If I could help your career, I'd work for scale."

But his loyalty to me sometimes came at a price. He once came under fire in the media because of our friendship. At a press screening for *Dead Bang*, a reporter confronted him about it. "Why do you feel the need to use porn stars in your movies?" the reporter asked with a knowing smirk.

John was irked and a little embarrassed by the question. "I assume you're referring to Ron Jeremy," he responded. "I'm not sure why you think I put porn stars in my movies. I haven't. I've used Ron

* To show my appreciation, I presented Don with a bottle of Dom Perignon. But on the card, I called it "Don" Perignon. I'd met Don years earlier, on the set of Frankenheimer's film *Dead Bank*, where I had a cameo as Biker Three. John was a little nervous about what Don would think and introduced me as "Ron Hyatt" (my real name). "C'mon, John, that's Ron Jeremy," Don said. "I saw him a few weeks ago on late-night TV." We shook hands, and John and the rest of the crew broke out laughing.

Jeremy in a few, but not because he's in porn. I use him because I think he's a good actor."

Even John's producing partner at United Artists, Frank Mancuso, was befuddled by John's insistence that I be treated like a real actor and not just a porn oddity. During a test screening for *Ronin*, the audience cheered when my face appeared on-screen. One might assume that this was a good thing—a cheering audience is a happy audience—but Mancuso was just annoyed by it. When he met with John later to discuss edits, Mancuso argued that I should be cut from the film entirely. He felt that the chase scene, in which I made an appearance, slowed down the movie because of my recognizable face, but John knew what he *really* meant.

"It's because of porn, isn't it?" I asked John when he told me the news.

John just sighed. "I can't be sure, Ron. I think it was. I'm so sorry."

Well, at least he was honest. And I did receive an acting screen credit and residual payments.*

Director Adam Rifkin often sparred with producers who wanted to keep me out of his films. He used me in his 1994 feature *The Chase* and was asked by the studio, 20th Century Fox, to cut my scene. Adam fought for me, and my cameo remained in the final cut.

A few years later, he created a children's horror series for ABC called *Bone Chillers*. He wanted to offer me a role, but because the show was being produced by the family-friendly Disney Corporation and Hyperion, he knew that it wasn't even worth proposing. But that didn't stop him from hiring me anyway.

For one episode, Adam cast me as Blisterface, a pimply-faced monster who attacks the young stars. I was a little hesitant when he gave me the script. It was a show for kids, after all, and if Disney should find out that a porn star was on their payroll, it could mean

* I went on to have a cameo in *George Wallace*, and I wasn't cut from that one. *Time* called it "creative casting." In any case, the film won an Emmy.

trouble. But Adam told me not to worry. My character was a *monster*, he reminded me, and it required an extensive amount of makeup. My face would be covered with pockmarks and open wounds, rendering me utterly unrecognizable. Aside from the makeup artist, who had already been sworn to secrecy, the entire cast and crew wouldn't be the wiser.

And somehow we pulled it off. I arrived to the set hours before call time, and when the rest of the cast and crew showed up, I was already in full makeup. Nobody had any clue who I really was, and when asked, Adam just referred to me by my real name, Ron Hyatt. For my scene, I lunged after the teen star Linda Cardellini* and threw her over my shoulder. And you'll be happy to know that I was nothing but polite and courteous. I even pulled down Linda's dress when it started to ride up her legs.

"Oh my," Linda remarked when she noticed this, "what a gentleman."

I could hear Adam on the sidelines, snickering to himself. "He certainly is, isn't he? What a nice monster. What a lovely, kindhearted, upstanding monster."

"Shut up, Adam." I'd scowl at him.

"What's the matter, monster? Don't you like teenage girls, monster?"

"Shut *up*, Adam!"

Our on-set joking might've been a little too conspicuous, because somehow a Hyperion executive did find out about our ruse.

"This better not be leaked to the press," he told Adam.

The media never did find out, and *Bone Chillers* had a successful run on ABC. My lovable monster was seen by delighted kids across the country, and parents had no idea that the man entertaining their sons and daughters had, just weeks previously, starred in a film called *Backdoor Babysitters*.

* Who went on to star in *Scooby-Doo*.

But porn didn't always hurt my chances of being cast in a mainstream movie. In some cases, it's even helped.

When Adam directed *Detroit Rock City*, he gave me a small but funny part as an emcee at a strip club. At the test screening—just as with *Ronin*—the audience cheered whenever my face appeared on-screen. Mike De Luca, the head of New Line Entertainment, was watching from the back of the theater, and he admitted to Adam that he was surprised by the reaction.

"Those kids really like Ron Jeremy, don't they?" he remarked.

"Yes, they do," Adam said.

Mike thought about it for a minute, and then said, "Keep him in." He also allowed my cartoon likeness to remain on the poster.

It wasn't just the mainstream Hollywood studios that were discovering my appeal among younger college audiences. Indie filmmakers were seeking me out specifically *because* of my porn-star status. I starred in a slew of B movies during the late 1990s, from trash-horror classics like *They Bite* and *Hell's Highway* to Troma cult favorites like *Tales from the Crapper, Terror Firmer, Class of Nuke 'Em High III* and *Toxic Avenger IV.*

I was happy to be working in movies so regularly, but I started noticing a disturbing trend among the roles I was getting. In many of the films, I was murdered in some horrible, violent way. I was shot, stabbed, decapitated, bludgeoned, burned alive, strangled, run over by cars, drowned, poisoned, and smashed into walls. It didn't matter if it was a B film or a major Hollywood feature, the director always found some excuse to kill me in the most unpleasant manner possible (which of course means I can't be in the sequel). And here, for you film buffs, is an introduction to some of my best on-screen fatalities:

Ron Jeremy's Top Five Death Scenes*

1. **KILLING ZOE** (1994) In Roger Avary's cult hit of ultraviolence, I played a bank security guard who was shot in the chest during a robbery. I was on-screen for less than a few seconds. The robber kicks open the door, points a gun at me, and blows me away. I didn't even get to utter a single line before my chest exploded in blood.** But come on, can you blame me for wanting to do it? This is *Roger Avary* we're talking about, the Oscar-winning screenwriter of *Pulp Fiction.**** Getting riddled with bullets in a Roger Avary film is an honor. When a director like Avary puts you in a film, you don't haggle over dialogue. You say, "Which way do you want me to fall?"

2. **THE BOONDOCK SAINTS** (1999) I had a pretty decent part in this one before the guns came out. I played Vincenzo Lipazzi, a mafia boss and strip club owner. The film starred Willem Dafoe, and the first thing I said to him on the set was, "I heard a rumor that you were well hung. Is that true?" He almost did a double take. He couldn't believe that I had the balls to ask him a question like that after just meeting him. But he didn't deny it. He just told me, "Not a bad rumor to have, is it?" Anyway, in this one, my character was

* The death scenes listed here (and a few others) were compiled into a ten-minute tape by Al Goldstein, which was screened at an AVN awards show in Las Vegas. When Al introduced the montage, he said, "Here's Ron Jeremy as you can really enjoy seeing him."

** I originally had a little more to do (like pressing the alarm to alert the police) that didn't make it into the final edit. And I wrote a line that Roger used for one of the characters. I got a special kick out of that. I wrote a line of dialogue for a guy who got an Academy Award for screenwriting!

*** Quentin Tarantino was also a producer on *Killing Zoe*.

gunned down in a peep-show booth, which I guess is the most poetic way for a porn star to die. *Boondock Saints* was dropped by Miramax, but according to *Variety*, it was the number-one "straight-to-video" film in Blockbuster's history. Whenever I do public appearances, there'll always be a few fans asking me to sign their VHS and DVD copies.*

3. **CITIZEN TOXIE: THE TOXIC AVENGER IV** (2000) A classic horror film and hands down my most bloody death. I played Mayor Goldberg, a religious zealot who assembles a team of superheroes to battle the evil Noxious Offender. I'm killed with a metal crucifix, which is slammed into my mouth like I was a human shish kebab. There was blood everywhere, spurting out of my head like a lawn sprinkler. Some of the crew asked me, "Hey, aren't you Jewish? Maybe we should use a Star of David instead." "Hell, no!" I said. "It has too many sharp edges."

4. **WITCH'S SABBATH** (2004) It wasn't the first time I've been beheaded in a movie, but it's definitely the most controversial. I play a Bible salesman named Craven Moorehead who has his head chopped off by a coven of witches. That alone wouldn't make this movie death worthy of note. But things got a little messy when some of the producers were inundated with angry letters and phone calls, decrying their supposed mockery of the recent Taliban executions. We explained that it was just a joke and we had shot the scenes long before those horrible Taliban beheadings.

5. **ORGAZMO** (1997) This is probably my most famous death scene. My head literally explodes after I'm kicked in the face by Trey Parker. It just shatters into a million pieces like an old ceramic pot. This is one of the few times that I've ever challenged a director.

* It got picked up recently by 20th Century Fox, due to its cult status. And received nice comments on *Ebert & Roeper*.

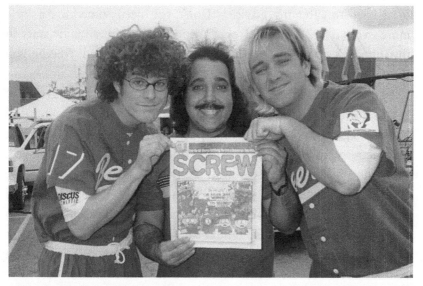

With Matt Stone and Trey Parker.

I knew it was supposed to be a comedy, but it just seemed a little too illogical and unrealistic.

From the moment Trey Parker asked me to be in *Orgazmo*, I was dubious. It sounded like a cute concept—a Mormon gets lured into making adult films—but I wasn't sure if he'd be able to pull it off. This was before he and Matt Stone started doing the *South Park* cartoon on Comedy Central, so they were not yet the poster children of shock comedy.

I was cast as a porn actor/henchman named Clark, who used the porn stage name Jizz Master Zero. The script was funny, but Trey was doing things that just made no sense to me. He had actual female porn stars in the cast, like Chasey Lain and Juli Ashton, but he never let them show their bodies. During a sex scene, the girls would begin to lower their bras, but just as they were about to expose their boobies, some naked guy would step into the frame and block them with his big, hairy ass. It was confusing to me. Trey had specifically hired porno actresses, and yet he wasn't allowing any of them to be naked on-screen.

I tried to offer my advice. "Don't you need something a little more exploitive?" I asked Trey. "You don't have any major stars in this film. It's not going to play to the art-house crowd. Maybe you should think about showing a little more skin?"

Trey laughed at me. "Ronnie," he said, "you just don't get it."

Though he wasn't interested in T&A, he was willing to jeopardize his R rating because of a single line of dialogue. In one of the scenes, a porn actress explains just how far she'll go to stay gainfully employed. "I'm the only one in town who'll do a double anal and double vaginal at the same time," she says. "You know, DVDA. It's how I still manage to get work." He refused to cut it, and, as a result, *Orgazmo* was slapped with an NC-17 rating. An NC-17 rating is the equivalent of an X. Most of the theaters in Middle America won't pick up an NC-17 movie because it cuts down on their potential audience.

I begged with Trey to reconsider. "Please," I said, "just cut the line, and everybody will be happy. Is it really worth having a limited release just so you can save one lousy gag?"

"Ron," he said, "I don't like succumbing to pressure."

"Can't you just compromise this one time?"

"Let me tell you a little story," he said. "When some of the backers at October Films heard that you were in this movie, they tried to get me to fire you or give you a much smaller role. But I told them no. I wouldn't even discuss it. Ron Jeremy stays in. If I had let them bully me, the first thing we would've lost is you."

I thought about it and said, "Y'know, you're right. You have to put your foot down. Don't let those bastards push you around!"

But not all of Trey's choices were so easy to get behind. The film had its own internal logic that just baffled me. In one scene, a black guy was brought in as a stunt cock for a white guy's sex scene. Aside from the naked male asses, the only real nudity was a morbidly obese woman dressed in a skimpy bikini. After my character was killed, he reappeared a few minutes later, his head fully intact.

"What a minute," I asked Trey. "Didn't I die? How did I come back to life? What happened?"

"Ronnie," he said. "You just don't get it."

I finally saw the complete film at a screening in Beverly Hills.* Trey had kept in all of my scenes, including the martial-arts kicks (which I'd done without a stuntman). There was a method to Trey's madness that I never noticed before. The comedic special effects, the plot inconsistencies, the absurd overacting, it was all played with a wink to the audience.

As the credits rolled, I turned to Trey, who was staring at me with a shit-eating grin.

"Well?" he asked.

"Trey," I said slowly, "I *get* it."

Trey stood up and waved to the crowd. "Ladies and gentlemen," he announced. "Ron Jeremy *gets* it!"

Over the years, I've been fairly lucky when it's come to film-makers. Every director who promised me a role—or even an audition—has usually come through. There's been only one notable exception:

Alex.**

Alex worked for a major production company in L.A. When he and his assistant asked to visit a few of my porn sets, I was happy to accommodate them. On one occasion, they even asked to bring along the head of their studio—let's call him Mr. Big—who was a major player in Hollywood. But in a strange twist of fate, the sprinkler system at our location accidentally went off, dousing the furniture and most of the lighting equipment. We had to cancel the shoot at the last minute, and Alex and Mr. Big were unable to reschedule.

* The star-studded after party was held at the Playboy Mansion, with live music provided by, believe it or not, Metallica.

** To protect his identity, "Alex" isn't his real name.

In exchange for my hospitality, Alex and his assistant promised to get me an audition for at least one of the films they were developing. Months went by, and I didn't get so much as a phone call. Alex eventually became a major executive at his studio, with enough power and influence to green-light projects on his own. But still, I heard nothing from him. Several of his movies went into production, and I never got anywhere near a film set, much less an audition.

I got my revenge sooner than I expected (and totally by accident). When the Heidi Fleiss prostitution scandal broke in 1993, the tabloids reported that Alex *may* have been one of Heidi's regular clients. It was just speculation, but nobody in Hollywood was surprised by the stories. The real shocker came (at least for me) when I learned that *I* was at least partially responsible.

Years earlier, I had introduced Alex to a few of my lady friends (including porn star Taylor Wayne). When he asked for a girl to entertain at a bachelor party, I suggested that he contact Veronica, my roommate and a college student majoring in physics. I knew that she danced occasionally for extra dough, but I had no clue that she was also doing escort work for Heidi Fleiss.

Veronica told me everything. After the bachelor party, she and Alex had some form of sex at the Bel Age Hotel in West Hollywood. (I'm not sure if money was exchanged, and I never asked.) They hung out a few times after that, and he met her friends, including—and here's the kicker—*Heidi Fleiss*! Alex ended up hiring some of Heidi's escorts,* and the rest, as they say, is tabloid history.

I was stunned that I'd been so naïve. Not just because I had played an innocent, unsuspecting role in introducing Alex to Heidi Fleiss, but because my roommate had been an escort and I'd never had any idea.

"I can't believe this," I told her. "You really have sex for money?"

"Yes." She grinned at me. "So do *you*, y'know."

* Either for himself or some of his executive friends, I'm not sure which.

She had a point. But the fact that we both made our living in sex was where the similarities between our two professions ended. I had fought hard to prove as much after my pandering arrests. What I did involved cameras and photography and stills and video. It was intended for entertainment, which separated us from prostitution.

But this was the real deal. This *was* prostitution. Whatever my personal feelings about the morality of escort services, it was still against the law.

I asked Veronica politely to move out of our apartment. I couldn't risk being linked to prostitution. There were too many ways it could blow up in my face. She was a sweetheart about it, and she agreed that it would be for the best if she found her own place. So she moved next door, and as I said earlier . . . still best friends fifteen years and counting.

As for Alex, he was never charged with soliciting a prostitute, but the public scrutiny and tabloid headlines were punishment enough. I felt strangely vindicated by it all. He had used me and ignored me, and as penance he was thrust into a scandal that just so happened to involve my roommate.

Well, that's karma for you.

I'm sometimes asked if I have any advice for young actors looking to break into Hollywood. Here's what I tell them. Bend down and take a fifty-yard dash into a brick wall. You'll be knocked unconscious, and when you wake up you'll realize it was a mistake and you'll find something better to do with your life.

That's it. That's my advice. To be an actor in Hollywood, you have to be the world's biggest idiot.

Just this morning, a producer for VH1's *Pop-Up Video* called me with a pitch.

"Okay, Ron, hear me out," he said. "I'm working on a show that I think you'd be perfect for."

"Great," I said. "I'll do it."

"You—you'll do it? But . . . you don't even know what the idea is yet."

"Doesn't matter. The answer's yes. You have the interest of a studio or network?"

"Uh . . . we're hoping."

"You have the funds to shoot it?"

"I think so."

"Then I don't give a fuck what the idea is. I love it. Count me in. You can tell them that Ron Jeremy said yes. Put it in writing. Fax me something to sign, and I'll fax it back. Just tell me when you want me on the set."

"But I didn't—"

I hung up on him. There was nothing else to discuss. I don't want to waste time going over details. If a studio or network wants it, I'm happy to do whatever it is. You want to do a reality series about Ron Jeremy cleaning his shoes? Great. Put me on a farm and have me shovel horse manure? I'll do it. Cruise around Sunset with some half-naked girls? Fine. Whatever. I don't care. I'm not that picky. I'm a performer. That's what I do, I *entertain.*

I've gotten too excited about too many film or TV projects that have gone nowhere. My apartment is piled high with nonfinanced scripts that were rejected by the studios. I don't even bother to read them anymore. It's too heartbreaking. You have a concept? The answer is yes, I'll do it. When you have a studio or network behind it, *then* I'll meet with you.

"No, no," the producers will say. "We have a great track record with the studios. They really want to work with us."

"Oh," I'll say, "then the answer is *definitely* yes."

"But I haven't told you the idea."

"I *love* your idea."

Twenty years ago, I would have gladly jumped through hoops if I thought it might get me an acting job. But I just don't have the energy for the game anymore. Some days, I'll wake up and think,

That's it. I'm done. I don't want any more disappointment. If it's not a real offer, I'd rather skip lunch, stay home, and play with my pet tortoise.

But then, just like that, everything changes.

As I was writing this chapter, I got a call from my friend Ben. I'm up for a small role in a new George Clooney–produced movie. I'm being considered for the part of a Russian spy. It's a long shot, but they want to give me a reading.

So, if you'll excuse me, I have to go practice my Russian accent.

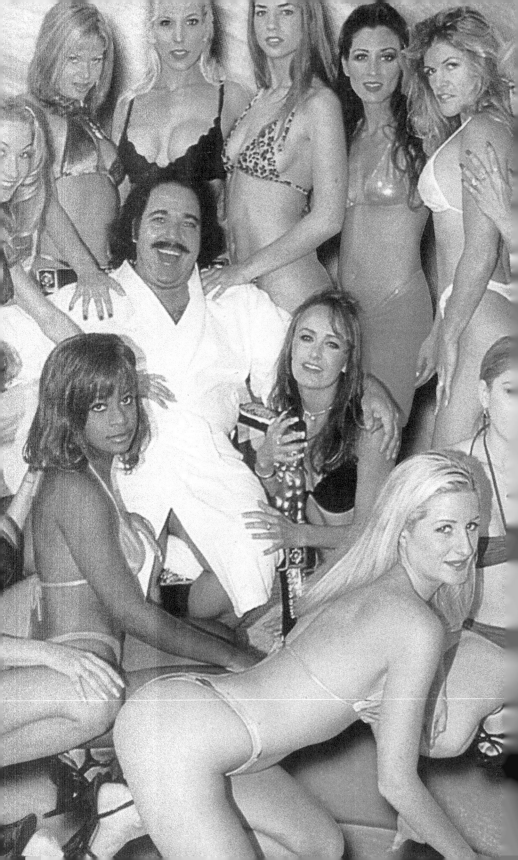

IT'S GOOD TO BE THE KING

It's a defining moment in a guy's life when he realizes that his penis is more famous than he is.

I've always known that my large endowment was responsible for at least some of my popularity. You can't get very far in porn if you're hung like a mosquito bite.

I once did a funny little skit about the notoriety of my penis for a porn film called *WPINK-TV 2*. Do you remember those American Express commercials from the 1980s? Karl Malden flashes his credit card and says, "Don't leave home without it." Well, we did a parody of that commercial, with me substituting for Karl Malden. "People don't always recognize me," I said to the camera. "And my credit card doesn't help one bit. That's why I carry"—and the camera panned down to my crotch—"my *penis*. Don't leave home without it."

Wherever I go, there's always a chance that some stranger will ask to "see it." I'm at a party in Hollywood. "Hey, show us your cock." I'm shopping at the grocery store. "Hey, show us your cock." I'm visiting with my rabbi at the local synagogue. "Hey, show us your cock." They're around every corner, just waiting for me to drop my pants and wave my penis at them like I'm a Macy's Thanksgiving Day Parade float.

On the set of Put It in Reverse. *(Courtesy Zane Entertainment)*

But that doesn't mean I keep the ol' fella completely under wraps. If somebody asks nicely, and that somebody's a woman, and especially if she's famous, I might just give her a quick peek. But I expect something in return. Remember that old game from grade school, "You show me yours and I'll show you mine?" Well, let's just say that adults like playing that game, too. Hey, fair is fair. If a woman wants to see my pecker in the flesh, without paying the rental charge at her local video store, then the least she can do is flash me her boobies.

Paris Hilton once took me up on that offer.* I was at a premiere party for the movie *Wonderland*, hosted by Val Kilmer at the Chateau Marmont. I was just minding my own business, chatting with Laurie Holmes and playing a Bach tune or two with Sean Lennon at the piano. All of a sudden, Paris came strolling over with her girlfriend, Bijou Phillips, and asked if they could see it. I agreed, but only on the condition that they flash their tops. I expected at least one of them to storm off in a huff. Bijou was dating Sean Lennon, who just so happened to be standing a few feet away. But without batting an eyelash, they both said yes and took me directly to the nearest women's bathroom along with another female friend.

After making sure that the coast was clear, we squeezed into an empty stall. They pulled up their shirts. I unbuckled my pants, and, after seeing my schmeckel, Bijou turned to Paris and wondered aloud, "Could this be considered cheating?"**

I may not be able to go to each of your homes and give you a personal look at my goodies, but I can answer your questions. And I may be overassuming that you have questions, but in any case . . .

* This was about six months before her sex tape was released.

** Being a true gentleman, I never confirmed or denied this story when it was reported in the *New York Post*. Later, at a party in Las Vegas, I overheard Paris loudly exclaiming to Limp Bizkit singer Fred Durst that she had seen my penis. So now I feel comfortable telling the story and confirming it.

Frequently Asked Questions About Ron Jeremy's Penis

How big are you, really?

I always say that I'm two inches . . . *from the floor*. Seriously, folks, I'm nine and three-quarters inches. The media sometimes rounds it up to ten, which is fine by me. If they want to give me an extra quarter-inch free of charge, I'm certainly not going to complain. Sometimes I feel like Christopher Guest in *This Is Spinal Tap*. "It goes to eleven." Yeah, right.

Do you have the biggest penis in the history of adult films?

I wish. No, that honor belongs to John Holmes. John liked to brag that he had well over fourteen inches, but it was actually closer to eleven. That's still pretty massive, though. The truth is, a lot of porn stars exaggerate their size. They use "porn inches," which are substantially different than real inches. Gay porn star Jeff Stryker swore that he was eleven inches, but the gay press has since reported that it's a bit smaller. Long Dong Silver was reportedly a staggering eighteen inches, but most people know it was just a prosthetic.* *Nobody* is eighteen inches. I've met very few porn actors who weren't somewhere between eight and ten inches. So no, I'm not the biggest in the biz, but I'm big enough to put me ahead of the competition.

And to paraphrase the late, great Milton Berle, "If somebody wants to compete, I'll just pull out enough to win."

* As you may remember, Long Dong Silver was a favorite of Supreme Court Justice Clarence Thomas. During his confirmation hearings in 1991, Anita Hill claimed that while working for Thomas, he asked her to watch porn videos and look at the male actors. "Which actors?" Ted Kennedy asked. Every other porn actor—myself included—on the planet ran to our TVs and screamed, "Say my name! Say my name!" Who wouldn't want that kind of free publicity? I was crushed when she said Long Dong Silver.

So how does that happen anyway? Is it genetic? What is your family like? Are all the men in your family hung like grizzlies, too?

First of all, *yuck*. Do you really think that my dad and I have compared penises? That is disgusting. I have no idea how big my dad's cock is, and I have no interest in finding out. What I *do* know is that all the men in my family (and the women, too, for that matter) are very intelligent, and some are even geniuses. We're all college educated, all with at least a master's degree or higher. My dad is a retired physicist and the smartest man I've ever met. He knows everything about history, language, science, medicine, and literature. I've never seen him without his nose buried in a book. My brother majored in economics at Williams College and then got his master's from Harvard. I remember coming home from school and catching him reading *The Economics of Traffic Control*. Just for *fun*. Is there some connection between book smarts and genital size? Could be. It'd make a great public service announcement, don't you think? "Hey, kids. Ron Jeremy here. If you want to have a big dick just like me, stay in school! Oh, and don't do drugs."

What's the deal with that Ron Jeremy dildo we've seen in sex novelty stores? Is that really molded after your own penis?

You're damn right it is, and it's very popular. When I was shooting the movie *Boondock Saints*, Sean Patrick Flanery came to the set with a box full of my dildos and asked me to autograph them. I have no idea what he was doing with a box full of dildos, but I was too flattered to tease him about it.

Has a mold of your penis ever been used in an art exhibit?

Believe it or not, the answer is yes. I visited an art gallery in Amsterdam, and the curators asked me to dip my penis into cement, which they then used to make an exact replica. You want to talk about pressure. It's one thing if somebody is just going to see my

cock, but this would be *forever*. Future generations would be looking at this mold and judging me long after I'd passed on.

The curators were kind enough to leave me alone with one of their salesgirls. She was hugging and kissing me while I jerked myself and tried to get the circulation moving in the right direction. I was getting closer, but then I started to hear voices coming from upstairs. The gallery was still open for business, and one of the patrons was carrying around a very upset baby. It was crying so loudly that the shrieks were echoing throughout the gallery. Unless you're a bit weird, this isn't the sort of thing to put you in a sexual mood.

I tried to block out the baby's bawling, but it was ruining my concentration. So even though I usually love kids, I yelled out, "Would somebody please tell that baby to shut the hell up?! *Some* of us are trying to get an erection down here!"

The mother took the hint and left the gallery. My boner returned, I dunked it into cement, and everybody was happy.

As your penis is so valuable, have you ever considered taking out an insurance policy on it?

You mean like with Lloyd's of London? It's not a bad idea, actually. Performing in porn can be a precarious profession. I was once observing a scene with Samantha Fox and Bobby Astyr on a porn set in Hollywood. They aimed the lights under Bobby's legs for what's called an "Australian down under" angle, which is where the camera gets a shot of the penetration from beneath the guy's legs. I was standing above them, watching while Bobby was banging away from behind, and out of nowhere, we caught a whiff of this weird odor. None of us had any idea what it could be. But then Bobby looked down and saw that the lights had moved in a little too close and were burning the hairs on his balls. He screamed and did a double-flip somersault with a half gainer right into the pool. It was like somebody had pressed a hot iron to his testicles. I think he broke an Olympic diving record. I'm not sure if he ever fully

recovered, and since then I've been *extremely* conscious of where the lights are at all times.

When you die, are you going to donate your penis to science?

Not a chance. But I have been asked. When I was in Reykjavík, the capital of Iceland, I visited the Phallological Museum. It's a museum devoted to penises, and there are well over a hundred cocks on display, with specimens from the entire animal kingdom. They have reindeer penises, walrus penises, skunk penises, whale penises, everything. The cocks were mounted on walls, stuffed in jars, and embalmed in formaldehyde. I believe it's the only museum in the world like this.

I spoke with Sigurdur Hjartarson, the owner and head "phallologist," and he asked if I'd be willing to donate my penis to the museum after I died. I told him, "Hell, no! I'm an American. When I croak, my cock stays on American soil." Maybe I'll bequeath it to the Smithsonian if they want it. Or to one of my ex-girlfriends. But otherwise, it goes right in the ground with the rest of me.

While my penis was always my most famous appendage, there was another part of me that threatened to overshadow it, taking over as my most defining characteristic.

My belly.

As you'll no doubt notice from my pictures during the 1970s and early '80s, I wasn't always fat. There was a time when you could have even called me skinny. I had a trim belly and washboard abs, and I was in the best shape of my life. But something happened during the last few decades. I started snacking and haven't stopped. And I packed on the pounds like I was expecting to be stranded on a deserted island. I don't know what I was thinking. Maybe I thought that the metabolism of my youth would keep up with me. But appar-

ently it decided to give up the fight and let the calories take over, and I puffed up faster than a balloon filled with helium. As I've said before, I went from the gym to the buffet. I went from posing in *Playgirl* to *Field & Stream*.

It never stopped me from getting work in porn. If anything, I was getting *more* jobs now that I was on the beefy side. Porn directors couldn't get enough of me, and apparently audiences shared their enthusiasm. How could this be, you ask? How could such a flabby guy, who couldn't even look down and see his own dick if he'd eaten too large a meal, continue to be a performer in adult films?

Well, as I've said many times in my stand-up routines, I am living proof that anybody can get laid. When you watch a porno with somebody like Peter North or TT Boy—both hunky, muscular guys—it's what you expect. Of *course* they're getting plenty of sex. Where's the surprise in that? But when people see me in a porno, they think, If *this* guy is getting lucky in the sack, maybe there's hope for me!

Audiences identify with me because I'm just like them. I'm not a statuesque physical specimen, and, let's be honest, very few guys are. I'm just a normal schlub who happens to have the kind of sex life that most men can only dream about. And there's something inspirational in that. I like to think that I've given confidence to millions of men across the world. They look at themselves in the mirror and think, Y'know, compared to Ron Jeremy, I'm not that bad looking at all. Then they go out and, with their faith restored in their own sexual allure, actually muster the courage to talk to that hottie at the other end of the bar.

If you think of it that way, you might even say that I'm the defender of all men who think that only the pretty boys are allowed to get nookie. Or at least that's what I tell myself whenever I go back to the buffet for seconds. Good rationale, huh?

My peers in the porn community haven't been quite so generous. Once I started to let myself go, it was open season on Ron Jeremy jokes. When Bill Margold first called me "The Hedgehog" during the late 1970s, I was still skinny enough to dismiss it. But as I got older

and fatter and my already hirsute body sprouted hair like a Chia Pet, it wasn't so easy to escape Bill's increasingly accurate nickname. I did look like a hedgehog. I was short and chunky and undeniably furry. I couldn't very well refute my eerie physical similarities with the pilose rodent.*

Screw magazine publisher Al Goldstein wasn't satisfied with that less-than-flattering moniker. He once lobbied to have my nickname officially changed to "The Manatee." During a visit to his Florida mansion, I was swimming in the pool, doing flips and somersaults through the water and off the diving board, and he took one look at me and said, "You're not a hedgehog. You're a big, fat underwater creature." He wrote an article in *Screw* and again in *Penthouse* saying I should file for tax-exempt status because I'm an endangered species.

Mark Carriere, my friend and boss at Leisure Time, wanted to take it even further. He decided that I more closely resembled a chupacabra, the mythical South American beast that sucks the blood out of goats. It's half man, half beast, and all stomach. The nickname caught on, and now even my closest friends call me "Chup."

So now you have a choice. I'm a Hedgehog, a Manatee, or a Chupacabra, depending on who you want to believe.

I never took any of it personally, because I knew that it was all meant in jest. The worst slurs usually came from my friends, and if you're too thin skinned to endure a little mockery from your friends, you're probably taking yourself *way* too seriously.

Hustler publisher Larry Flynt hated when I would flirt with his daughter, Theresa Flynt. Whenever I'd stop by the Rainbow Bar & Grill or the Hustler Store not even to see her, she'd grab her cell phone and say, "I'm calling Daddy." She'd put me on the phone with Larry and he'd say (half in jest), "What the hell are you doing with my daughter?"

* But c'mon, hedgehogs *are* kinda cute. And since I've started body shaving before all of my sex scenes, my similarities to a hedgehog aren't quite so obvious. . . .

"Nothing, nothing," I'd say. "I swear!"

"You keep your hands off of her, Jeremy. I don't want your filthy DNA anywhere near her."

During one of my visits to Larry's office, he told me, "There's only one thing that would make me want to kill myself. And that's if my daughter ever left her husband to be with you."

"Wait a minute," I'd say. "What about Dennis Hof?" Dennis was the proprietor of the Bunny Ranch, and a close friend of both Larry and me. "He's a fucking pimp. He owns a brothel. Why isn't he on the list?"

Larry just looked at me and said, in a completely deadpan voice, "Kill myself."

"I'm a nice Jewish boy. I have some money in the bank. I'm a former schoolteacher with six years of college. Your daughter could do worse than me."

"Kill myself."

"And you didn't even mention Al Goldstein. He's a fat, obnoxious old man. He can't even wipe his own ass without an intern. Why does he get a free pass?"

"Kill myself."

"What if she asked to marry me? What if we were in love and there wasn't anything you could do to stop it?"

"Kill myself."

Mark Carriere had the most fun finding new ways to make a mockery of me. He took some of my old movies and gave them new titles that were designed to emphasize my Falstaff-like qualities. He retitled one of them *The Humpster* and gave it the tagline: "He's fat, he's hairy, he's ugly, he's the Humpster." He called another film *Ugly Fuckers*, which later became *Fuckin' Ugly*.

I let most of it roll off my back. Try as he might, Mark could never come up with a title that crossed the line. That honor belonged to Adam Rifkin.

My first mistake was introducing Adam to Mark at all. I thought they might get along since they seemed to share a similar sense of

humor. But I was really pushing my luck when I invited them both out to dinner. Putting them in the same room was a recipe for tragedy. Mark decided that it was an excellent opportunity to brainstorm porn title ideas; the more deprecating to me, the better. Vivid had recently released a film starring one man and lots of women titled *The World's Luckiest Man*. Mark owned a film with *me* and lots of women, so Adam suggested, "How about *The World's Unluckiest Women*."

Mark laughed so hard I thought he was having a stroke. I could have killed them both.

It wasn't enough for me to be the biggest porn star on the planet. I needed a challenge, to prove once and for all to the industry that I wasn't just a one-trick pony. I wanted to show them that I was more than a fat man with a big dick. I looked for anything to justify my fame. If there was a first happening in porn, I wanted to be a part of it. A director needed an actor to have sex with lifelike, synthetic dolls? I'd do it. They were shooting a five-hundred-man gang bang and needed an emcee? I'd step up to the plate. They wanted someone to bone an elderly woman for a fetish video? I was their man.

It's all true, I'm afraid. Even the part about sex with an elderly woman.

It was for a movie called *87 and Still Bangin'*, and, just as the title indicated, I did indeed have sexual relations with an eighty-seven-year-old woman. But in my defense, the film had socially redeeming value. I wanted to prove to the world that you're never too old to have sex.

My costar was a lovely widow named Rosie who had been trying for years to find a lover, mostly by taking out personals ad in national newspapers. When the producers at Heatwave Video learned about her, they called and offered to put her in an adult film. And then they hired me because, well, I suppose because I said yes.

The sex lasted only a few minutes, and I'll say this much for Rosie,

she was astonishingly agile for her age. The best part of the film was that we played off of each other like a veteran comedy duo.

"So what made you decide to do an adult film?" I asked.

"Well," she said, "I haven't been able to find many men my own age who are able to keep an erection."

"Uh, Rosie, most of the men your age have been dead for ten years."*

I was breaking sexual records left and right. I had supposedly already surpassed Tom Byron for the most adult films.** We were neck and neck for many years, but I finally beat him (I think) with more than eighteen hundred titles to my credit. But there was one hurdle that I'd yet to jump. I had never, in my twenty-five years in the adult business, had sex in front of a live audience.

During the 1970s, most of my porn peers were doing live sex shows. Actors like Joey Silvera and Jamie Gillis would have sex onstage at Show World in Times Square, and they were making incredible money. But I never even considered it. I was making a good living in porn films, and I didn't need the extra income. And besides, I always felt like doing live shows was giving away too much. If my fans (all three of them) wanted to see Ron Jeremy have sex, they had to go to a theater and buy a ticket like everybody else.

But as I approached my fiftieth birthday, I felt like the time was right to make the plunge. I wanted to try it at least once, just to see if I could do it. I was invited to the 2000 Internext Convention in Las Vegas, which hosted "live content" evenings. Basically, the creators of Internet sex sites would pay a hefty fee to attend a live sex show. They would photograph all of the action and then use the photos on their Web sites.

* Howard Stern had me on his radio show for almost a half hour talking about that scene. I defended myself by saying, "Didn't Anna Nicole Smith mess around with a guy in his nineties?" "Yeah, Ron," Howard shot back. "But not on *film!*"

** Depending on which porn historian you talk to.

I agreed to do it. What the hell, it'd be fun. It would be like any other porn set, I told myself. Except that instead of a single cameraman, there would be more than three hundred.

It was a little disconcerting at first. I was used to having sex in front of other people, but this was something altogether different. In porn I had more control. I always knew where the camera was pointed, and I could manipulate what they were seeing. I could suck in my gut or cheat the angles. I knew how to lean back so that my cock looked as big as possible. But with so many cameras in the room, aimed at me from every corner and vantage point, I was completely at their mercy. While I was focused on one cameraman sitting near the front, somebody behind me could have snapped a few photos of my flab. Or worse still, a wide shot of my ass, which is the last thing I wanted anyone to see.

And then there was the matter of my erection. On a porn set, I could always ask the crew to leave so that I could focus on my boner. But what was I going to do with three hundred guys staring at me? "Hey, would you mind leaving the room for a few minutes? Thanks." Once I was hard, I didn't care. The Mormon Tabernacle Choir could be watching. It was *getting* hard that made me nervous. I didn't like people watching me while I jerked off. I needed privacy to concentrate on what I was doing. If somebody was watching, I'd be worried that they'd be thinking, What's the matter, Ron? You getting old?

People have misconceptions about porn stars. They think we're all monsters, like we just have to look at a girl and *boing*, it gets hard. The schlong just comes flying out of the pants like a Scud missile. But it doesn't work that way.

Luckily, I had a very cute girl, so it didn't take much to get aroused. Even with cameras flashing all around me like paparazzi on the red carpet, we did a great scene, and I walked away feeling like I could have sex in front of a Republican Convention without losing wood.

A few years later, I was asked to appear at the Melbourne Sexpo in Australia. It would mostly involve meeting the fans and signing a

few thousand autographs. But the Sexpo also featured live sex shows at a club a few miles away, and they wanted me as a headliner. I was still riding high from the confidence of my first attempt at live sex, so I didn't give it a second thought.

My scene was scheduled as part of a late-night sexual variety show at Maxine's, a popular Australian strip club and sometime brothel. Besides me, the other performers included dancers, comedians, magicians, and a sixty-year-old stripper who pissed into beer bottles and masturbated with a traffic cone. I wasn't sure how I could follow an act like that, but I was willing to give it a shot. I had every reason to be hopeful, as this time I wouldn't be stuck with just one partner. I was doing a threeway with Jacklyn Lick and Serenity, two very sexy female porn stars.

What could possibly go wrong?

I arrived at the theater at midnight, exhausted from a long day of signing autographs. My hands were so badly cramped that I could barely make a fist. I was tired, I was ornery, and I just wanted to go back to my hotel room and crawl into bed.

I peeked out at the audience from the backstage curtain. They were mostly young men, clean-cut and harmless, but they appeared to be in a rowdy mood. They were hollering and stamping their feet, like bikers looking for a bar fight. Maxine Fensom, the host and emcee, wasn't doing anything to calm them down. If anything, she was just throwing fuel on the fire.

"So who here thinks they're as big as Ron Jeremy?" she asked the frenzied crowd.

Dozens of hands shot up. "Okay, big boys," she said. "Let's see what you've got."

The guys began unzipping their pants and pulling out their dicks. And there were not too many limp ones in the bunch. Some of them looked like they had sequoias growing out of their crotches. You could tell how old they were by counting the rings. I don't know what they're feeding them in Australia, but whatever it is, they should bottle it and sell it to the rest of the world.

But Maxine was unimpressed. "You call *that* a cock?" she cackled. "That's nothing. Just wait until you see Ron Jeremy."

This was not good. This was not good at all.

I certainly don't have a problem with somebody complimenting my penis size. But she was building me up to an unrealistic standard. The more she insulted these big-dicked men, the more they'd expect me to walk out with a fire-breathing hydra hanging between my legs. If it didn't have horns and snapping jaws, they'd boo me off the stage.

"Shut up, shut up," I whispered to her from backstage. "Please shut up."

"When Ron Jeremy comes out here," she told the crowd, "then you'll see what a big cock *really* looks like."

They screamed and hooted, waving their penises at her like conductors.

I was dead.

I went into Jacklyn and Serenity's dressing room to discuss the specifics of our scene. They would take to the stage first for a lesbian tryst, and after they'd warmed up the crowd I'd join them for some hard-core sex.

"Are you okay, Ron?" Jacklyn asked, eyeing me with a concerned expression.

I was pacing the room, nervously running a hand through my hair. "Yeah, yeah, I'm cool," I said. "Just make sure I get a good look at what you're doing out there. I need to be *really* turned on before I come out, okay?"

"Calm down, sweetie. You'll be fine."

Jacklyn and Serenity walked onto the stage, and the audience went into hysterics. They danced around for a bit, doing a hurried striptease, teasing the crowd with a few playful licks of each other's breasts. I watched from behind the curtain, frantically jerking my cock and praying for a monster erection. I tried to focus on what Jacklyn and Serenity were doing, blocking out the hundreds of faces that were staring from the darkened theater like unblinking owl eyes.

The girls jumped into bed and began eating each other out in a 69 position. I felt something stir down below. *Now* we were getting somewhere.*

"Just look at the pussy," I muttered to myself like a mantra. "Look at the pussy, look at the pussy, look at the pussy being eaten."

Jacklyn flipped over and lowered her face into Serenity's snatch. The crowd had a perfect view, but from my vantage point in the sidelines I couldn't see a damn thing.

"Goddamnit," I grumbled and ran toward the other end of the stage. When I stuck my head out of the curtains, they had switched positions yet again, and all I could see were a few intertwined legs. The crowd seemed to be in a trance, so whatever I was missing was probably very hot.

I ran back to the other side of the stage. But because it was pitch-black, I couldn't see where I was going and plowed into a costume rack, knocking it over with a crash. Clothes scattered across the backstage floor. I picked myself up, hoping that nobody had heard me, and continued running.

I peered from behind the curtains and caught a brief glimpse of Jacklyn's face. She was shoving her entire tongue inside Serenity. I tried once more to jerk at my unhelpful genitals. But just as I was making progress, the girls tumbled across the bed again, shifting into a position just out of my sight line.

I was starting to think they were doing this on purpose. Their moans had reached a fever pitch, but I swore I heard one of them giggle. They could certainly hear me running around backstage, crashing into things.

I raced back to the other side. I tried to negotiate a path around the overturned costume rack and ended up tripping over some stage lights, falling through a piece of scenery, and landing headfirst into a

* By the way, for you math nuts out there, here's a true fact: the square root of 69 is . . . 8 something. Get it? Ate something?

box full of props and instruments. It was like a pratfall out of vaude-ville. From the stage, it must've sounded like an earthquake was rat-tling the theater from its rafters.

I lifted myself off the floor and limped back toward the curtains. I stuck just a nose outside and saw Jacklyn staring back at me. She mouthed, "Are you ready?"

I looked down at my sad excuse for a penis, which looked demor-alized and frightened. I had a better chance of growing a vestigial tail than getting an erection.

"No," I mouthed back, holding out my hand. "Five more min-utes."

I paced backstage and gave my shriveled manhood a pep talk. "Just do this one thing for me," I pleaded with it. "And I'll never ask anything of you ever again. Please, I'm begging you here. Don't make me go out there alone. This crowd is going to eat me alive."

"Do you need some help?"

I turned and saw a vision of loveliness standing in front of me. She was dressed like a Las Vegas showgirl, with sequins and peacock feathers and a brassiere that appeared to double as an automatic weapon. I didn't know who she was or what she was doing there, but she might as well have been a guardian angel, sent from the heavens by some divine, sympathetic creator.

"Please," I whimpered.

She took me to a bathroom and shut the door. She wiggled out of her costume and posed for me like my own personal *Playboy* centerfold. Without the cheers and blinding lights to distract me, my stage fright was gone. It was a relief just to be able to look at a naked woman without cricking my neck for a fleeting glimpse.

I jerked and jerked, trying to lose myself in the girl's succulent body and peaches-and-cream complexion, certain that the worst was behind me. My penis was starting to grow.

I heard a knock at the door. "Ron, we're waiting." It was Jacklyn.

"I'm not ready, goddamnit! It's getting there, but not yet!"

"Well what's the holdup? The crowd's getting restless."

I could hear them in the distance, banging their fists against the chairs, chanting my name. My penis recoiled at the sound, trying to burrow back into its cave of pubic hair.

The door swung open and Jacklyn waltzed inside. Her naked body was glistening with sweat. "Anything I can do to move this along?"

So now I had two girls posing for me. If this didn't inspire an erection, I'd need to call for paramedics and have them check for a pulse.

"I have to go," the showgirl said. "My boyfriend's picking me up soon and I can't, you know—"

"That's okay," I said, hugging her with my free hand. "Thanks so much, you're a doll!"

She threw on her costume and left. Now that we were alone, Jacklyn sat on the bathroom's sink and spread her legs. "Maybe this will do the trick," she said, forcing my head toward her pussy. She knew that giving a woman head has always been one of my favorite things.

"Are you almost ready?"

I came flying out of the curtains, my boner waving in front of me like a fleshy sundial. The audience leapt to their feet and gave me a round of applause, and somewhere in my head, the thunderous bass drums of *Sprach Zarathustra* were booming. Jacklyn and Serenity went to the bed, clapping along with the crowd.

After making them wait for so long, I wanted to give the onlookers something special. I kicked at the stage floor like a bull preparing to charge a matador. My nostrils were flaring, and I placed two fingers on either side of my head as makeshift horns. Jacklyn turned over, perching on the bed in a doggy position, her ass poised in the air like a target. The crowd stomped their feet in unison, awaiting the imminent stampede. I gave a few warning snorts and scraped my hooves, my eyes red with fury.

And then, with one last mighty bellow, I took off, kicking up a cloud of smoke as I charged toward Jacklyn.

"Olé!" the crowd roared. "*Olé!*"

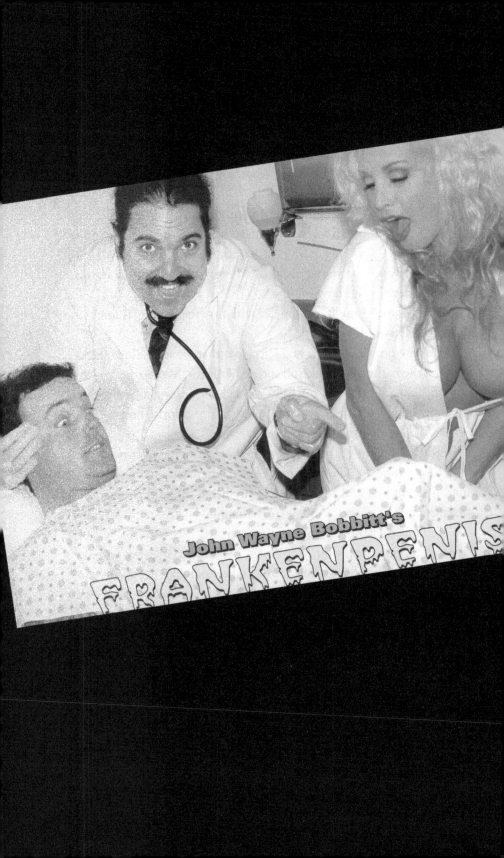

John Wayne Bobbitt's

FRANKENPENIS

chapter 15
DUDE, WHERE'S YOUR PENIS? (OR, "JOHN WAYNE BOBBITT, SUPERSTAR")

"So listen, is there any chance you'd want to be in a porno movie?"

John Bobbitt raised an eyebrow, perhaps trying to determine if I was serious. I knew it was a gamble, but it couldn't hurt to ask.

"You mean like have sex?" His voice was confident, almost daring me to come right out and say it.

"No, no, no," I said. "Just a walk-on part. You'd come out, say a few lines, and leave. It'll be easy, I promise."

I met Bobbitt at a Playboy Wet 'N' Wild party in Las Vegas with my friend and producer Greg Watkins. It was hard to miss him. Though there were dozens of celebrities in attendance, Bobbitt was clearly the man of the hour. From the moment he walked in, all eyes were on him, staring at the infamous bulge in his pants and wondering, "What the *hell* does that thing look like?"

Just a year earlier, Bobbitt—or rather, Bobbitt's penis—had made headline news across the country. While he slept, Bobbitt's wife, Lorena, had sliced off his manhood with an eight-inch carving knife and then thrown the shriveled remains from her car window. Miraculously, the severed penis was discovered in a nearby pasture and doctors were able to reattach it to Bobbitt's body.

(Courtesy Leisure Time Entertainment)

And now the entire world wanted to see it. Was it covered in stitches and scar tissue? Did it even *look* like a penis anymore? And, more important, did it still work? Would an erection cause his stitches to come popping off and his penis to shoot across the room like a balloon pricked with a needle?

But thus far, nobody had gotten a glimpse of it. The tabloids were drooling for just one picture, but Bobbitt wouldn't allow it. During Howard Stern's 1994 New Year's Rotten Eve Special, Bobbitt was offered $15,000 to flash his mangled dick for the cameras, but he refused. It only heightened the national fervor, and every day there were new rumors circulating about Bobbitt's now notorious cock.

I wasn't vain enough to think that I would be the one to unveil his penis to the world. If he wouldn't show his dick to Howard Stern, he sure as hell wouldn't show it to me, much less allow me to photograph him having sex with a porn actress. All I wanted was a nonsex dialogue cameo to make the video more interesting and newsworthy.

"Sure," he told me. "That sounds like fun. I'll do it."

The next morning, I received a call from Bobbitt's managers, Jack* and Aaron Gordon. They weren't the most traditional management team in Hollywood. They were scandal chasers. They worked primarily with B-list stars and scandal celebrities. Aside from Bobbitt, their clients included Paula Jones, Divine Brown, and a lounge singer who claimed to be Elvis Presley's illegitimate son. They even represented Bobbitt's wife, Lorena, which was nothing if not a conflict of interest.

"Ronnie, baby," Jack's smarmy voice echoed into the phone. "Looks like we're gonna be doing business together."

"So I hear," I said.

"We've had a long talk with Bobbitt about this movie of yours, and the way we figure it, why stop at a little dialogue? If he's gonna do a porno, we might as well go all the way. The whole nine yards!"

* La Toya Jackson's husband.

I checked the phone's receiver to make sure I didn't have a bad connection. "Excuse me?" I asked.

"Johnny wants to do *it*."

"Do . . . *it?*"

"Sex. He wants to have sex. On camera. For you."

I must've been hearing things. I roughly jabbed at my ears with a finger.

"Are you fucking with me?" I asked.

"I'm not fucking with you, Ron," he said. "He's serious about this."

"And he'll do it for the same price as a dialogue cameo?"

A raspy chuckle escaped Jack's throat. "No, smart-ass. It's gonna cost you a *lot* more."

When I hung up the phone, I had to take a moment to catch my breath. I couldn't believe what was happening to me. Not *only* was I getting Bobbitt for a film, not *only* would he be showing his schmeckel, but he was going to *use* it. He was going to *fuck!* Or at least *try* to fuck. I still wasn't sure if his penis worked. It didn't matter, limp or hard, he was going to do it all for the camera. I felt as if I had just won the lottery.

I knew exactly who to call.

Many of the adult companies were furious with me for bringing Bobbitt to Mark Carriere and Leisure Time Entertainment. "He's already a multimillionaire," they told me. "You're making a rich man even richer." While this was true, Mark was also my friend, and he'd been loyal to me for years. If I'd taken the deal to another major company like Vivid, VCA, or Wicked, they would've thrown me a few grand as a finder's fee and passed it along to one of their in-house directors.

Another reason to bring it to Mark was the production costs. It wouldn't be cheap to get Bobbitt out of his pants. He wanted thousands up front and a hefty percentage of the profits. Overall, he stood to make at least $500,000 for the entire thing if it all went well. It wasn't chump change, and Mark was the only man I knew whose pockets were that deep.

I called Mark immediately. Just days later, Mark and I met with Bobbitt at a restaurant at Caesars Palace in Las Vegas. From the moment we stepped inside, we were the center of attention. Waiters did double takes, diners paused in midbite as we walked past. They were staring at Bobbitt, pointing at him and whispering to one another. "Is that the guy who got his dick chopped off?"

After we had signed the contracts and sealed the deal with a handshake, we decided to take some comical pictures to commemorate the occasion. John and I posed with steak knifes, aiming the sharp edges toward each other's crotch like we intended to carve out our initials.

"Be careful with that thing," Bobbitt said to me, eyeing my knife nervously.

"Oh, relax," I told him. "It isn't anything you haven't felt before."

You know, John, we could've made this movie without you. I was going to get Robert De Niro to play you and Danny DeVito was going to play your penis."

The crew laughed, but Bobbitt didn't seem to notice. He had other things on his mind besides my crappy jokes.

Bobbitt arrived for his first day on the set looking uneasy. I wasn't sure if he was having second thoughts or if he was just worried about whether he'd be able to perform. He had a daunting task in front of him. A first experience in porno can be frightening enough, but when your cock is tied together with sutures and it's *literally* hanging by a string, a guy can be excused for a little performance anxiety.

I thought some humor might lighten the mood. I just wanted to remind him that we were all friends and we were all here with a single purpose: to make fun of his crooked, misshapen, gargoylish penis.

To be fair, it didn't look *that* bad. The stitches were hardly noticeable. It had a slight curve in the middle like someone had tried to snap it in half. But otherwise, it looked like any other penile shaft.

The million-dollar question was whether it could get hard.

"You know what really makes me think?" I told John. "Your penis stayed in the park for around *three* hours before the cops found it. A hot dog can't be left outside for that long without getting a little funky. You throw a knockwurst into the park and a squirrel is gonna steal it. A dog will take it away. A stray cat is going to bite into it. John, all kidding aside, how disgusting is your dick that not even a *cockroach* crawled through it? Not one squirrel looked at it and said, 'Hey, that could be lunch?' How does that happen, John? How repulsive is your penis that not one animal would so much as give it a sniff?"

Bobbitt smiled at me, but my teasing clearly wasn't putting him at ease.

"Hey," I added. "I forgot to mention. We invited Lorena to be in the movie, but she got into a car accident on the way to the set. Apparently some prick cut her off."

The crew howled in laughter, but Bobbitt's face was a blank slate. Not even a glimmer of outrage or bemusement.

Bobbitt's first few scenes were less than successful. He tried to get an erection on his own, but it was clearly a losing battle. I had prepared for just such a difficulty. This was in the age before Viagra, so it wasn't as simple as having him pop a few blue pills and waiting for wood. But if you had contacts with a few helpful doctors, it was possible to get your hands on some Caverject.

Caverject, for you nonmedical types, contains something called prostaglandin, a lipid hormone that causes the muscles to relax and stimulates the flow of blood. You just insert it directly into the spongy tissue of the penis and, five minutes later, *blamo*, instant hard-on. The only problem is, it needs to be injected with a huge and menacing-looking needle. The thought of having your arm punctured with a needle the size of a fencing sword is enough to make most people a little light-headed. But imagine taking that same needle and jabbing it into your *penis*.

I wasn't about to give Bobbitt the injections, so I gave the job to Adam, Mark's assistant. Before every scene, he would take Bobbitt

into the bathroom and demonstrate how the Caverject shots were used. It was supposed to be a temporary thing, as we assumed that Bobbitt would eventually be able to do it himself. But Bobbitt didn't have the nerve to ram his own penis with a needle, so Adam became his permanent medical liaison.

I loved watching Adam on the set. He'd stand on the sidelines with his fingers crossed, waiting to find out if Bobbitt would be able to perform without the injections. "Oh please, please, please," I heard him muttering. But invariably Bobbitt would go limp, and, with a heavy sigh, Adam would grab his arm and bring him back into the bathroom.

"Now, don't get too carried away," I'd tell him. "I need Bobbitt excited, but not *too* excited."

"Fuck you, Jeremy," Adam would grumble before slamming the door.

Bobbitt's costars knew about the Caverject, but they weren't entirely clear on why Adam was helping him. "What's going on in there?" they asked me after Adam and Bobbitt disappeared into the bathroom.

"Well," I said, "Adam takes Bobbitt's cock in his hand and gives it a few jerks. And then when it's nice and hard, he puts the needle in. If that doesn't work, he blows him."

And the girls believed me!

When Adam found out about the rumors I'd been spreading, he went ballistic. "I do *not* do that!" he screamed at me in front of the cast and crew. "I do *not* jerk that man's penis. Nor do I blow him. That is a filthy, rotten lie."

"None of us think any less of you," I teased him. "You're a valuable part of the production team. Just because you have your hands all over another guy's cock doesn't mean you're gay."

"I'm going to kill you, you motherfucker!" he snarled, storming off. Everybody was laughing except him (the cast and crew soon figured out I was just kidding).

Eventually Bobbitt learned how to do the injections himself. But he

wasn't very good at it. Before one of his scenes, he walked out of the bathroom clutching his penis like he'd just been kicked in the balls.

"I think I put it in wrong," he said, grimacing. "It hurts."

I felt sorry for the poor guy. It was heartbreaking to watch him cowering in the corner, tending his wounded penis, thoroughly humiliated. The rest of the crew was just annoyed by the delay, but I almost felt fatherly toward him. He looked so helpless and scared, and nobody deserved that, even if there *was* a fat payday at stake.

"It's okay, John," I told him, joining him on the floor. "Put some ice on it and take a break. This isn't worth torturing yourself over."

Bobbitt faced some extra intimidation when he found out that he was doing a scene alongside of me. Mark wanted another dick in the movie, just in case audiences got bored watching Bobbitt's contorted cock in action. So we arranged for a mini-orgy, with Bobbitt and me each tackling a different girl in separate corners of the room.* It was a risky proposition for Bobbitt, as it meant being unfairly compared with a porn pro. He handled it well, though, and he even let me share a few tips on giving a better performance. I demonstrated "The Grip" to him, one of my most time-honored techniques.

Never heard of it, you say? Well, sounds to me like it's time for more . . .

SEX
Advice from DR. RON JEREMY

Part 3:
THE GRIP

First, give your penis a few jerks, just enough to get a semierection. Then grip your penis by its base, using two fingers and a thumb, and squeeze. Don't use your entire fist, just the fingers and thumb. You're not trying to double the size of your schlong. Rather, you're creating a cock ring, vise-

* Vince Neil of Mötley Crüe played a bartender in this scene.

like effect. You're forcing whatever blood is already in there toward the front of your shaft and giving it some leverage so that it actually sticks forward.

Now jump on the bed and waddle toward your lady's "business." As long as you're gripping tightly at the base, your penis won't lose any of its rigidity. And you'll have enough of an erection to make an actual insertion. Once you're inside, it'll feel so damn good that a real erection will form on its own. In just a matter of minutes, you'll be able to release your grip, and say, "Look, Ma, no hands!"

Trust in "The Grip." If it worked for Bobbitt, it can work for you.

You're welcome.

Making *John Wayne Bobbitt Uncut*—yes, that was the title—was, to say the least, surreal. I knew what it was like to have the vice cops kick down my door. I knew what it was like to fear that somebody was lurking outside, just waiting to catch you in the act. But this was scrutiny of a very different sort.

We'd arrive on the set each morning, and the front lawn would already be besieged by news crews. The streets were lined with vans, satellite dishes mounted on their hoods like doomsday devices. Helicopters hovered over the house constantly, and photographers skulked in the bushes, waiting for any sign of movement inside. Our set was quite literally a compound. We couldn't even open a window without attracting reporters, who'd come running like mosquitoes to a sweaty neck.

Aaron Gordon, our public relations director, had his hands full keeping the media juggernaut at bay. Our production was under tight security, so nobody—much less a reporter—was allowed on the set

during the shoot.* But right under our noses, our so-called "closed set" was infiltrated by a spy.

We caught the little bugger red-handed. He was an extra, hired for a boat party scene during the production's final days. He'd hidden a tiny camera in his sleeve and was taking photos all day before a crew member nabbed him. His name was Steve Duran, and he admitted to working for *Current Affair* and gladly gave up the name of his accomplice: my friend and roommate porn star Devon Shire. I confronted her and tried to play the stern disciplinarian, but I was too impressed with her ruse to give her any grief.

"*Please* tell me you got paid for sneaking him onto my set," I said.

"Of course," Devon said with a smug smile. "You think I'd sell you out for free?"

"I can't believe you pulled that off," I chuckled. "Well done."

We agreed to let the rogue photographer keep his pictures, and even shoot some B-roll video, but only on the condition that he give *Hard Copy* (to which Aaron had given an exclusive) a two-day lead. And because I'm such a good sport, I even paid him his full wage as an extra. So he got a $30 check *and* a scoop on the Bobbitt set. Not bad for a day's work.

The real challenge came after the shoot was finished and I had to edit the mountain of footage into an actual movie. I had put a lot of effort into writing the script, basing much of it on the court transcripts and witness testimony. One of my favorite gags happened in the film's opening minutes. According to police accounts, when Lorena threw Bobbitt's penis out of her car it hit the window of a passing vehicle before falling into a nearby grassy field. I just had to re-create that scenario for the movie.

> *Two women are driving at night. A dismembered penis smacks into their windshield and then just as quickly disappears.*

* We did do interviews off set, however.

> **WOMAN 1**
>
> Was that a fly?
>
> **WOMAN 2**
>
> If it was, it had the biggest penis I've ever seen.*

But as much as I wanted to fill the movie with dick jokes and a dense "ripped from the headlines" story line, I had to remember that I was, in the end, making a porno. You don't want your audience to start wondering, "When the hell are people going to shut up and start *fucking*?" So I cut out huge chunks of dialogue and concocted a flashback to explain much of the backstory.

All of my frustration disappeared when I saw the final cut on the big screen. It was probably one of the best films I'd ever directed. The story was butchered, but still . . . *it had a story*. It felt like a return to the old days of adult films, when plot (such that it was) carried an equal weight to sex. It couldn't compete with classics like *Insatiable* and *Behind the Green Door*, but I was proud to have my name on it.

Mark pulled out all the stops for the world premiere. We screened *Uncut* in Beverly Hills, at the Motion Picture Academy of Arts and Science. And the after-party was held at the Steven Spielberg Pavilion.** It had all the glitz and glamour of a real Hollywood premiere. We even had a few unintentional celebrity guests. There were rumors that actor Eric Roberts arrived at the theater, mistakenly thinking it was a screening of *Shawshank Redemption*. When he found out that he was actually at a premiere for a porn film, he got a little upset and even pushed a photographer while trying to make a hasty retreat. That was what I heard.

When *Uncut* hit video stores, it sold better than we could have

* Okay, so maybe I made that part up. But I did use legendary Motorhead frontman Lemmy to play a bum in the park who sees the flying penis land at his feet, then checks himself to make sure it's not his, then runs off.

** Or at least I believe it was. My memory is fuzzy.

hoped. The average porn release moves between two and three thousand copies. But *Uncut* sold more than *eighty* thousand tapes in the first few weeks. The porn world wasn't sure whether to shun us or shower us with praise. *Uncut* received a rave review in *The Adult Video News*, but the X-Rated Critics Association awarded *Uncut* the dubious honor of "Worst Film of the Year." I attended the XRCO award ceremony at the Belage Hotel in L.A. and cheerfully accepted the trophy—a bronze roll of toilet paper—on behalf of the entire cast and crew.

"It's an honor to win Worst Film of the Year," I said during my acceptance speech. "Especially considering that *Uncut* outsold every other adult film out there. We had bigger sales than all of you *combined*. If that's what it means to be the worst film, I couldn't be happier."

There's a time and place to get bad news. And live TV is not one of them.

I was asked to appear on Geraldo Rivera's daytime talk show to discuss *Uncut*. I was joined by Tiffany Lords, a buxom, blonde porn actress and one of Bobbitt's costars. Tiffany and I were seated onstage, fielding questions from Geraldo. Out of nowhere, she had started mumbling about skeletons in her closet, alluding to secrets that she had been hiding for too long.

"I'm not going to tell him about this," Tiffany said, more to herself than anybody else.

When Geraldo asked her to elaborate, she looked surprised, as if she hadn't meant to say any of it out loud.

"I really shouldn't say anything," she told him.

"Come on, Tiffany," Geraldo persisted, "you obviously want to get it off your chest."

I narrowed my eyes at Tiffany. I was as confused as anyone in the studio audience. I had no idea what she was talking about.

"I'm pregnant," she said.

What?

The hair stood up on the back of my neck. This was a bombshell. And I was caught completely by surprise. I could see Geraldo smiling underneath his massive mustache.

"And you have reason to believe that Bobbitt is the father?" he asked.

"He is," Tiffany declared. "He's the only one I've had sex with in the last three months. I'm sure it happened on the set. We fooled around a few times off camera, in the shower between scenes."

I knew that Tiffany and Bobbitt had taken a liking to each other. His scene with Tiffany was the only time he was able to perform without the needle. But as for these off-screen encounters, it was news to me.

Geraldo turned to me for a comment. I swallowed hard and tried to think of the most diplomatic response. "This doesn't usually happen," I said, my voice wavering. "We don't . . . I'm not sure how . . ."

It was, for me, especially embarrassing. I had just finished ranting about sexual diseases and HIV. I insisted that we practiced fairly safe sex on porn sets. There were no condoms, but the ejaculations were all external, which lessens the chances of pregnancy. And now I was being outed on national TV, unprepared to defend myself.

"Why didn't you tell me?" I muttered angrily to Tiffany, not caring that the entire world was watching. "You should have said something before now. This isn't the most appropriate place to bring this up."

"Sorry, Ron," she said, her eyes welling with tears.

During a commercial, I stormed backstage to find Eric Barzoom, Leisure Time's marketing director. He was standing with Bobbitt's manager, and they were both smiling broadly, as if they couldn't have been happier with Tiffany's shocking announcement.

"Will somebody please tell me what the fuck is going on out there?" I hissed.

Eric peered over my shoulder, making sure there weren't any nosy stagehands nearby, and pulled me closer. "Ron," he whispered, "she's not really pregnant."

"She's *not?*"

Eric put a finger to my lips. "This is just between you and me, okay?"

"Well, why would she say that? Do you realize how this is going to play in the media? They're going to have a field day with this. Tomorrow morning, it's going to be in every newspaper and news show and tabloid in the . . . in the . . ."

I was starting to catch on.

"And that's exactly what you want, isn't it?"

"Bingo," Eric said, tapping his nose.

I just shook my head. "That is disgusting and devious and dishonest, and I'm annoyed that I didn't think of it first."

Geraldo ate it up. He even aired a second "special edition" show later that night, recounting the scandal for his prime-time audience. Well, I'd like to personally apologize to Geraldo. Yes, you were duped. Bobbitt did not get anyone pregnant on my set. They were just trying to generate a little extra hype, and you just happened to be the best media outlet. But it wasn't my idea, I swear.

As long as I'm making amends, I should probably also apologize to Jerry Springer.

A few weeks after the Geraldo fiasco, the cast flew to Chicago to appear on Jerry Springer's talk show. With no prior warning, Bobbitt told Jerry that he had "a very special announcement." I had no idea what he was talking about—once again, I had been kept in the dark—but I expected the worst. Bobbitt kneeled in front of Tiffany, kissed her hand, and said, "I want to keep the baby."

The crowd jumped to their feet and gave Bobbitt a round of applause. I couldn't believe they were buying it.

"John, do you really feel this way?" Jerry asked.

"Yes," Bobbitt said, cozying up to Tiffany on the couch. "We're in love with each other, and I want to do the right thing."

It was one of the few times that Bobbitt gave a decent delivery. He's a terrible actor, but he was so sincere and doe-eyed that I almost believed it myself. Never mind that the baby didn't exist. The audience wanted this soap opera to have a happy ending.

The next day, the announcement made national headlines yet again. From New York to Los Angeles, Bobbitt's imminent father-

hood was treated like hard news. And with all the free advertising, *Uncut* continued to fly off the shelves.

Months passed, and the story moved to the back pages. Nobody noticed when Tiffany didn't bloat with pregnancy. Neither Springer nor Geraldo followed up when the make-believe baby never materialized. It was just another forgotten scandal, one that could have easily been debunked if anybody had bothered to pay attention.

I should feel bad about all this.

I don't like deceiving the media or using them as pawns in the porn promotional machine. I know Springer and Geraldo personally, and I like them both. The last thing I want is to con a friend, but come on, guys, had you been in my shoes . . .

There was a sequel, of course. With the kind of money involved, why wouldn't there be?

But we needed to do something different. Nobody was going to buy another video just to see Bobbitt's mutilated cock in action yet again. It was just our good fortune that Bobbitt came up with a reason on his own. He decided to get a penis enlargement, and he allowed us to film the entire operation for the movie. The surgery involved removing fatty tissue from his ass and inserting it into his penis, stretching the ligaments nearly to the breaking point.

Bobbitt not only fully recovered, but his penis actually looked bigger. A little misshapen, maybe, but definitely bigger. It looked like a snail that had gorged on something a bit too large for its digestive tract. It was skinny on top, wider in the middle, and then skinny again at the bottom. It was less a penis than a haggis-filled tamale.

We had everything we needed for a sequel. And we called it, of course, *Frankenpenis*.*

* We shot the film in a gorgeous mansion (owned by the heirs to the car air-bag inventors) that was also used for the movie *Casino*.

I played the title role of Dr. Frankenpenis, the power-crazed doctor who operates on Bobbitt and gives him his remarkable penile extensions. The story followed Bobbitt as he travels to Las Vegas to recuperate and have sex with naughty nurses and health-care professionals. Bobbitt was able to do all of his sex scenes unassisted, which came as a great disappointment to Adam.

"I've got some bad news for you," I told him. "We don't need you to hold Bobbitt's cock and jerk it off this time. He doesn't need the shots anymore."

"*I don't jerk it!*" Adam screamed. "I've never jerked it! Why do you keep telling people that?"

Frankenpenis did not do as well as the original, but it still did better than most films, and it featured a cameo by famed rapper Ice-T. The Bobbitt well was clearly running dry, and I met with Mark Carriere to discuss our next move.

"Nobody wants to see Bobbitt anymore," Mark told me. "I'm cutting him loose."

"It's a shame." I sighed. "I really thought we were on to something."

Mark's eyes lit up. "What makes you think we aren't?"

"What do you mean?"

Mark slapped an open fist against a newspaper on his desk. "The world is filled with B-list celebrities looking to cash in on their fifteen minutes of fame. And we're just the guys to help them do it."

That's what I loved about Mark. It wasn't enough for him to spot a trend. He had to create his *own* trends.

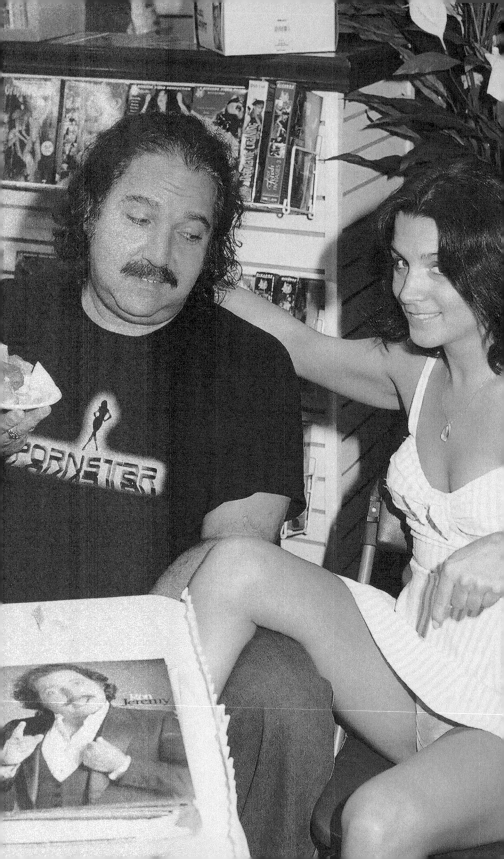

Divine Brown had toweled herself off and slipped back into her clothes so quickly that nobody in the crew had noticed. She'd just finished her first sex scene for the day, and apparently she thought that nothing else was required of her. I had to chase her before she finally stopped.

"I'm sorry," I said. "There seems to be some misunderstanding here. You're not done."

Divine looked at me with a blank expression. "Whaddayamean?" She pointed with her head toward her naked costar, who was lying on the bed and watching his erection disappear like the Eiffel Tower being demolished in slow motion. "He came, didn't he?"

"Well, yes. But that doesn't mean we're finished."

Divine paused, contemplating what I meant by this. I could see the wheels turning behind her eyes as she replayed the events of the last five minutes and tried to determine if there was some step she'd missed. It was like she was trying to do the math in a complicated physics problem.

"I don't get it," she finally said.

With Laurie Holmes, John Holmes's widow. (Courtesy "Dirty Bob" Krotts)

"We still have to shoot the soft-core footage. And we need to get some reaction shots and different angles. There's still a lot more to do."

Still nothing. I might as well have been speaking in Yiddish. I gently took her arm and led her back toward the set. "Just one more hour, and we'll be finished," I said. "Don't worry, I'll walk you through everything."

I should have seen this coming. I just assumed that Divine would know the difference between an adult movie and her regular line of work, prostitution. For her, a job ended when the guy popped. She just collected her money and stumbled out of the car. But porn was a bit more complicated. Sure, it was still essentially about having sex. But I'd hoped that the crew, the cameras, the lights, and, well, the fact that she was having sex indoors would clue her in that this wasn't the same ol' "wham-bam, thank-you-sir."

Her most infamous trick, Hugh Grant, was also an actor. But I suppose that just blowing an actor doesn't automatically instill a person with a working knowledge of film production. It's a shame, really, because if she'd had any idea of what that blow job would lead to, she would've asked Hugh for a few acting tips rather than her usual cash compensation.

Mark happened to be on the prowl for our Bobbitt follow-up when the scandal broke, and Aaron Gordon and a fellow named David Hanz Schmidt approached Divine about starring in her own adult movie. The three of us quickly threw together a script, which we called *Sunset & Divine: A Doc-HUGH-Drama*. As with *Uncut*, I based much of the story on actual events. I included the infamous blow job in the front seat of Hugh Grant's car, of course. But that alone wouldn't have been enough to substantiate a full movie, even a plot-deficient adult movie. So I added some filler to flesh it out to a full two hours. A lesbian threeway in a prison here, a sexual rendezvous with a randy lawyer there, and *voilà*! We had a porno.

I found a British actor named Mark Davis to play Hugh Grant. Aside from the obvious similarities in their accents, Mark also bore a

slight physical resemblance to Hugh. Well, except for the uncircumcised penis. As far as that went, we were just guessing.

I took over the role of Divine's lawyer. The actor I originally hired failed to show up for the shoot, and, with no time to recast, it was down to either me or the on-set caterer.

As for Divine, once she stopped fumbling for a door handle the moment she finished a scene, she was actually quite good. She had an innate sense of how to perform on film. She knew to tilt her legs to the side so that the camera had a better shot of the insertion. She knew to pull back her hair during a blow job, how far to arch her ass while doing doggy, and even how to aim a guy's cock for the most photogenic pop shot. All in all, she was a pro, and I'd happily hire her again if given the chance.

Mark rushed *Sunset & Divine* into video stores, and it did a modest business. It didn't do Bobbitt numbers, but with roughly forty thousand copies sold, it still performed well above the industry norm.

With *Uncut* and *Sunset & Divine*, Mark and I were two for two. We'd made porn superstars (however temporary) out of an ex-Marine who'd lost his penis and a street hooker. In our self-made genre of quasi-reality, semicelebrity, scandal porn, we were (at the time) the uncontested leaders. It seemed like nothing could stop us from churning out an endless string of hit adult titles.

Assuming, of course, that we could find another willing participant.

I've been very fortunate when it's come to casting star talent in adult films. When celebrities have wanted to try their hand at porn, more often than not they've come to me. I've directed everyone from football players (a former Miami Dolphin) to horror scream queens (Linnea Quigley) to cult-film actresses (*Beyond the Valley of the Dolls* star Edy Williams). Some did soft core, some did hard core.

But for every legitimate star who has wanted to appear in my films, there've been a few who came close but ultimately changed

their mind. Here's a short list of my most heartbreaking near-misses and almost-rans in celebrity porn.

1. Heidi Fleiss

In 1997, the Hollywood Madam was busted for operating one of the biggest prostitution rings in Los Angeles. Soon after the arrest, her ex-boyfriend and business partner, Ivan Nagy, showed us a sex tape that featured him and Heidi in action.

Mark and I agreed to take a look at the video, and it was surprisingly good. Heidi even brought a little humor to her scenes. During the tape's first few minutes, she pretended to be annoyed with Ivan. She looked up and said, "Get that fucking camera out of my face." When he wouldn't stop, she looked back at his crotch and narrowed her eyes. "What's that dripping out of your penis? It's green. Do you have gonorrhea?" Ivan quickly turned off the camera. It was all in good fun.

We met privately with Heidi to negotiate a possible deal. We assured her that we wouldn't distribute Ivan's video without her consent, and Mark even tried to persuade her to star in a professionally made flick, which I would direct. Heidi thought about it, but she ended up turning us down. She was still arguing her case in court, and she worried that doing an adult film wouldn't win her any sympathy with a jury. We were disappointed, but we realized that she was probably right.*

2. Pamela Anderson Lee

Okay, fine, Pamela never technically approached me about doing porn. But Mark and I were given first dibs on her sex tape with

* In an amazing coincidental turn of events, about a year later, Mark met with Heidi's father, Dr. Paul Fleiss, at the exact same meeting spot, for totally different reasons. They were planning their trips to Cabo San Lucas, along with other doctors, to administer health care to the poor. Mark was providing his private plane. The Mexican people called them "Doctors of Charity."

then-hubby Tommy Lee. I was friends with Milton Ingley, a porn actor from the mid-1980s and the director of such flicks as 1994's *Deep Space 69*. One of his employees had supposedly done some electrician work at Tommy's estate and somehow stumbled upon his private video collection. Mark and I were intrigued, but we decided to pass because there was no chance we'd get any kind of releases from Tommy and Pam. They might not have even been aware that the tape had been stolen. And it wouldn't have been fair to Tom and Pam (whom I'd met on many occasions) who hadn't consented to releasing the tape. It just seemed like a legal nightmare waiting to happen.

And we were right. The tape got into the hands of Seth Warshavsky, who sold the illegal video on his Web site before being sued by Tommy and Pam for close to $80 million dollars. They eventually signed some kind of a deal with Seth and the video went on to beat *Uncut*'s record as the bestselling adult movie of all time (with close to three hundred thousand copies sold). But even if I had the chance to do it over again, I still wouldn't want any part of a video that'd been hijacked from an unsuspecting celebrity.

I will say this: the Pam and Tommy tape was one of the best amateur sex videos ever made. I've screened a few—including Pam's sex tape with Poison front man Bret Michaels*—and none of them compare with Tommy and Pam. They had the most clearly shot positions (they passed the camera back and forth), a lot of exotic locations (including a boat trip to my old porn stomping grounds on Lake Mead), and a clearly visible pop shot.

I was talking about her tapes to actor Scott Baio, another one of Pam's exes, and he said, "Well, I have news for you."

"You're kidding me?" I said.

"Yeah, we did a tape a long time ago. But I was smart. I have that thing stashed away where nobody can find it."

* In spite of an offer, for lots of money, Bret requested that Mark and I never release it, so we didn't. It's a shame, because it was a good tape, and so far it has never been released.

Don't be so sure, Scott. You never know when a nosy electrician is going to snoop around and uncover your dirty secrets.

3. Joey Buttafuoco

Joey and I met, curiously enough, because of a tabloid TV show called *Current Affair.* The producers brought us both to New York to identify a porn actress who looked eerily similar to Amy Fisher, Joey's one-time girlfriend. As it turned out, the porn starlet in question wasn't Amy Fisher at all but Kim Angeli, an Amy Fisher look-alike who had appeared with me in *Maddams's Family* and *Debbie Does Dallas 4.*

Thanks to *A Current Affair,* Joey and I became friends. He invited me out to Long Island to meet his family and tour his auto-body shop. He soon became a regular addition to my social clique, which included Al Goldstein and Dennis Hof. The media called the four of us the "Slime Pack,"* which seemed like the most appropriate moniker.**

Buttafuoco and I often discussed casting him in an adult movie. He had loaned out his home as a location for several pornos, so he was no stranger to the industry. But his agent, Sherri Spillane, put the kibosh on it. It's a shame, really. Joey's porn debut could've been huge.***

4. Tonya Harding

The bad girl of Olympic figure skating, whose ex-husband once hired a thug to break the shins of competitor Nancy Kerrigan,

* I gave them the name.

** Larry Flynt occasionally joined us for brunches, but he thought we were giving him a bad name by calling ourselves the "Slime Pack."

*** I did help him get a job at the Rainbow Bar & Grill. And to his credit, he has had a few parts in mainstream films.

made a brief splash in the porn world with her amateur sex tape in 1994. Mark and I were intrigued enough to consider signing her, and we even took a few meetings with her publicist, David Hans Schmidt. David explained that Tonya was only willing to be nude. She would discuss her skating techniques while doing a mild striptease on ice, but that was as far as she would go.

Needless to say, Mark and I passed. With her amateur hard-core tape already in circulation, we couldn't imagine that an audience would pay to watch Tonya Harding flash her boobies. And for the salary she was demanding, it would've required at least a double anal.

5. La Toya Jackson

Every porn director has the one big fish that got away. Their proverbial white whale, if you will. For me, it was La Toya Jackson.

Around the same time as Bobbitt entered the picture, plans were already under way for La Toya's porn debut. Mark agreed to pay La Toya around $500,000 up front—the largest payday ever for an adult star—and promised her even more on the back end. (Remember, La Toya's husband, Jack Gordon, was Bobbitt's manager.) Rather than toss off a quickie script, Mark hired a professional. I only skimmed the first draft, but I was impressed with its ambitious production values. It had an elaborate story line, taking place mostly on a train. We even discussed bringing in a second director to assist me. We took meetings with mainstream filmmakers like Salomé Breziner and Adam Rifkin, who considered directing the dialogue scenes while I directed the sex.

As we worked on the production end, La Toya continued her national tour of strip clubs, doing live appearances to promote her *Playboy Celebrity Centerfold* video. I soon heard about a disturbing rumor about her visit to Al's Diamond Cabaret in Reading, Pennsylvania.

My friend, stripper Adara Michaels, was at the club with La Toya, and she told me what happened. When La Toya arrived for her show, she announced that she had no intention of getting naked. "It was bizarre," Adara said. "She wouldn't even consider going topless. She

thought she could just dance around the stage fully clothed and get the same paycheck." The capacity crowd was not amused. They had paid big bucks to see a nude Jackson. They demanded their money back, and when the club owners refused, they went on a rampage, throwing chairs and overturning tables. The police had to be called in to bring the riot under control.

I explained my concerns to Mark, and he agreed to talk with La Toya. Much to our surprise, she feigned ignorance.

"You mean I'm going to have *real* sex?" she asked. "I thought I'd have a stand-in or something."

If we had to, we could have found a stunt double to do her sex scenes. I knew a few black actresses who could match La Toya's pussy beautifully. But even so, the public isn't stupid. Even with the best morphing techniques, they would know that something was up. If every genital shot was a close-up and we never panned up to reveal La Toya's face, most audiences would realize that they weren't getting the full show.

Mark agreed to compromise, but as he reminded La Toya's husband and manager, it would mean renegotiating her contract. "La Toya needs to understand that she'll get a *lot* less money," he said.

There were a few hopeful phone calls, but in the end the deal fell apart. La Toya didn't want to do any nudity whatsoever. If we had accepted her terms, it would have required superimposing La Toya's head on another actress's body. Even if we had had access to George Lucas's editing facilities, we wouldn't have been able to pull off those kinds of special effects. And even if we did, word would get out that we cheated.

ark and I had a pretty good run in the celebrity porn racket. We lost a few big names, but we also signed more famous faces than any other adult company at the time. I thought about doing another big movie, but I couldn't imagine who I or Aaron Gordon could get who would be worth the time and trouble.

And then I got a call from Howard Stern.

Actually, that isn't entirely true. I didn't get a call *directly* from Howard, but rather from somebody claiming to be Crazy Cabbie's partner. I was told that Crazy Cabbie, one of Howard's sidekicks on his morning radio show, wanted to star in a porno, and he wanted to shoot it at Howard's studio, among other places. Not only had Howard approved the idea, they said, but he was willing to promote the movie on his radio show.

I was happy and surprised that they'd come to me to direct and act in the film. I knew that Howard was a fan of adult films. He was constantly interviewing porn starlets like Jenna Jameson and Tabitha Stevens, who, in some ways, owed their careers to his support. But he couldn't have cared less about most male stars. To him, we were just props, and our lack of titties made us less than appealing to his mostly male listeners. I was one of the few male stars who'd been invited on his show, for various skits and interviews many times, but he'd always vow never to have me back.*

Whatever their reasons for choosing me, I was thrilled. A porno film that came with Howard's blessing would be huge. And what's more, we would be shooting in his studio, where Howard and Robin Quivers and the whole radio gang recorded their show every morning. It would've been better if Howard himself was more actively involved in the shoot, but allowing us to use his studio was close enough.

I quickly rounded up a cast of actors, which took all of five minutes. Including myself, I hired Taylor Wayne, Tabitha Stevens, Christi Lake, and some new actress out of New Jersey who came highly recommended. I couldn't offer any of them a big salary; I was given a budget that barely covered the bare minimum of expenses. None of us would be paid a normal salary until the movie was sold to a distributor. But given Howard's reputation, it seemed like a foregone conclusion. Any publicity from Howard Stern was reason enough to fly across the country and perform in a movie for less than full pay.

* He always eventually invited me back.

On a cold winter night in late 2000, we arrived at Howard's studio at WXRK-FM in New York and were escorted upstairs by a nervous staffer. He seemed awfully jumpy about a porno shoot that was, to the best of my knowledge, completely sanctioned. But I dismissed it as porno jitters, a typical reaction among visitors to my sets.

We went straight into the recording studio and set up the cameras. We had only a few hours to shoot before Howard showed up for his morning broadcast, and we were given strict orders to be long gone by the time he arrived. So we didn't waste a moment. After Crazy Cabbie did a brief scripted introduction—"Oh, what do we have here? Somebody's in Howard's studio! And . . . and . . . they're *naked!*"—I had sex with Taylor Wayne right on Howard's chair.

A few of the staffers were milling about, watching the action. Someone on the crew made a joke about using Howard's microphone somewhere in the scene. I was well aware of Howard's germaphobia, so I declined. But I did grab the O.J. Simpson mask off the wall and put it on while Taylor gave me head.

Though I wasn't about to befoul any of Howard's personal effects, I did make a few jokes about the possibility. As I was about to climax, I yelled out, "Oh God, here we go! I'm going to cum! Right . . . on . . . *the chair!*"

Taylor jumped out of the way and I started jerking myself, aiming my cock right at the chair's cushions. "Uggghhh . . . ," I moaned. And then, just as I was about to explode, I stopped and smiled at the camera. "Just kidding!"*

When we finished, we moved to the green room for the next scene. This time, I had sex with Tabitha Stevens on the couch, and I wore a Gene Simmons mask. I put my tongue through the mouth hole and flicked it at Tabitha, doing my best impression of Gene's onstage KISS persona. Weeks later, I met with Gene at a coffee shop in Los

* For the record, I can say with complete honesty that no sperm or even much sweat was *ever* left in the studio area.

Angeles and told him about the scene. He gave me written permission to use his mask in the movie. I never did track down O.J. Simpson, but I doubt if he would've given me permission anyway.

I was in the studio only for those two scenes, though Crazy Cabbie's partner returned on other nights to shoot more sex on Howard's chair. We shot the rest of the movie at a porn set in Manhattan, decorated to resemble the hallway outside of Howard's studio. We filmed an orgy scene where Crazy Cabbie and I teamed up with Taylor Wayne and Christi Lake. We had a large crew, and Cabbie had a little trouble performing with so many people watching. He wanted to be with Taylor away from prying eyes, so he and his partner Brett reshot their scene at a hotel room downtown, and he did a fine job. After he climaxed, he pointed at his erection, pounded a fist in the air, and screamed, "Hey, Howard, this is for the fans! Look at this! All right!!"

Cabbie and his partner also shot some additional scenes with the rock band Alien Ant Farm, who had a Billboard hit at the time with "Smooth Criminal." I wasn't present at the shoot, so I'm not positive who was involved. It may have been an actual band member, or it could've been their tour manager. Whoever it was, he was wearing a mask and having sex with a groupie while "Smooth Criminal" played in the background.*

I took the footage back to Los Angeles and gave it to my editor Jake. A few weeks later, we had our finished movie, which clocked in at over two hours and featured seven or eight sex scenes. We titled it *The Crazy Cabbie Movie.* The plot (such as it was) followed Cabbie during a "typical day," as he and his friends had sex in a variety of locales, exchanging bodily fluids in the WXRK office.

As I waited to hear back from Brett and Cabbie, I happened to catch one of Howard's morning broadcasts. He was scolding Elephant

* Brett later admitted that we were smart not to include it, as it would've been impossible to get licensing permission from the record labels, ASCAP, and BMI.

Boy, another of his comedy sidekicks, for purportedly having sex in the studio's green room.

"You *cannot* mess around in my green room!" Howard admonished him. "Do you know what kind of scolding I'd get from Infinity Broadcasting for something like that? If you want to have sex, do it someplace else, but don't bring it to my studio."

Hmm, I thought. That doesn't sound right. How could he lash out at an employee for messing around in his studio when he had just allowed a porno to be filmed in the very same location? That seemed awfully hypocritical. It didn't make much sense at all. Unless . . .

Uh-oh . . .

I called Brett immediately and demanded answers. "Are you sure Howard's in on this?"

"Relax, he knows all about it," Brett said.

"And he's okay with it, right? He knows what we did in his studio and he doesn't have a problem?"

"Will you stop worrying? Howard said on the air that he's okay with it. You think we're going to go behind Howard's back to shoot a porno without his consent? You think I *want* to get Cabbie in trouble?"

Like a putz, I believed him.

I sent Brett the edited film and all of the masters and waited for him to contact me with news of a release date. A month later, Brett called me in a panic.

"We've got to reedit the film!" he said.

Crazy Cabbie had been offered a full-time gig as a deejay, and he feared that he could lose the job if they found out about the movie. He didn't mind being in a porno, but he couldn't be shown participating in any of the sex scenes at Howard's studio.

"I don't understand," I said. "What's the big deal?"

"He just doesn't want it to appear like he's sneaking into a radio station and letting porno actors have sex on the company's property."

"What do you mean 'sneaking'? Didn't Howard give the green light for us to be there?"

"W-well," Brett stammered. "I think so. I'm pretty sure."

"You're pretty sure?"

Because I'm a director who follows orders, Jake and I made a second edit, which created two films. We called them *Scenes from a Shock Jock Studio* and *The Crazy Cabbie Movie*. In the second film Cabbie appeared only in scenes that were clearly shot outside of the studio. In the other, the scenes were *in* the studio, but not with Cabbie.

Months later, I began getting phone calls from Melrose Larry Green on behalf of Stuttering John. They'd gotten wind of the movie and were *not* happy. I felt like I was being backed into a corner, and I wasn't sure if I should confess to everything or keep my mouth shut and hope that Cabbie wouldn't get in trouble. When in doubt, don't rat. That's how I was raised.

"I cannot confirm or deny that such a film even exists," I told them. "But I will say that if it does exist, there are no plans as yet to release it."

"All we want to know is if you did anything sexual with his microphone."

"Absolutely not. If this alleged porn film was indeed shot in Howard's studio and I played some role in it, I can promise you that his microphone was not anywhere near a vagina. I would never do that."

"We're more worried about whether a penis was anywhere near it," said Melrose Larry.

"No, of course not. My penis did not, at any time in this hypothetical porno, make any contact with his microphone. That's just wrong."

Cabbie was rattled enough to pull the plug completely. He stopped returning my calls, and Brett informed me that the movie was being shelved indefinitely. As Cabbie was making a *lot* of money for his upcoming Atlantic City boxing match against Stuttering John, he certainly didn't need the proceeds from the film's sale. I wanted to strangle them both. I had devoted months of work to this project, flying across the country and working for no pay, and it had come to nothing. Brett still owed money to my editor for the extra edits,

and he should have at least thrown a few grand to my actors for their trouble. But he just wanted to sweep the movie under the rug and forget that any of it happened.

I called Brett and threatened to release the movie anyway. He had the only copy of the master tapes, as well as all the releases and receipts, but I had a few VHS dubs and I was prepared to use them. I couldn't legally distribute it to video stores, but I could release it for free on the Internet, as a newsworthy documentary, just to spite Brett and Cabbie. Brett finally came up with the money for my editor. As a courtesy, I let the matter drop,* but I was still furious that my performers got a raw deal.

For all I know, Cabbie destroyed every last copy of the movie. But somewhere in some warehouse, I still have unlabeled VHS dubs of the original footage. I told Brett that I had disposed of the tapes, but it wasn't true. One of these days, I may show it to Howard's staff, if they ever ask to see it. Howard has moved on to satellite radio, so he may not care about the sexual high jinks that took place at his old station.

And as for Crazy Cabbie, well, it's all water under the bridge between us. Maybe someday he'll actually want to see the video again. He actually looks pretty good in it, and he did a fine job. One of these days, when he's old and gray, he might get a kick out of seeing himself as a young whippersnapper, during his very brief career as a porn stud.**

* It was a mostly hollow threat. I never would have released the movie.

** It means a lot to me that Cabbie and Brett understand that I never ratted them out until this book. And now it doesn't matter. To this very day, I'll never reveal which staffer let us into the building. Many have asked, and I've never answered. In addition, Brett tried to sell the film to Jill Kelly's company for distribution. It didn't work out, but he himself thereby revealed the existence of the tape, so he kind of ratted himself out.

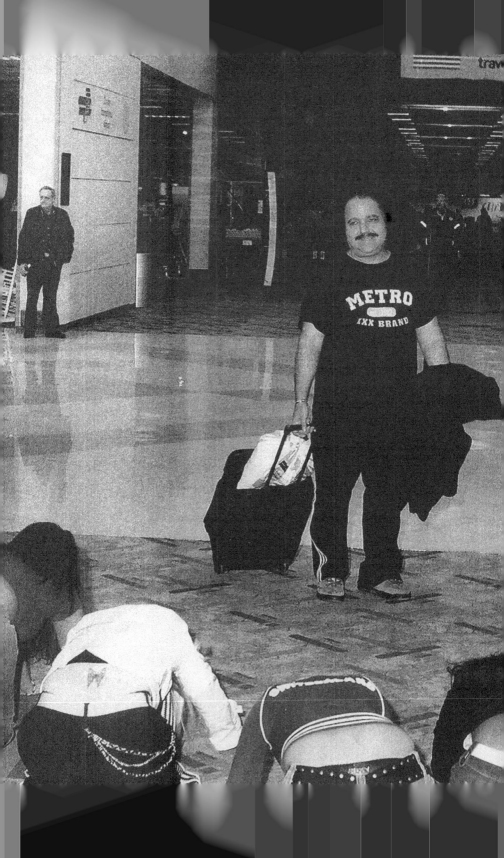

chapter 17

THE RON JEREMY SHOW, STARRING RON JEREMY

Over the past few years, I've worked more consistently than at any other point during my career. I've done a few porno films for a company called Metro, with which I'm contracted, and I'll almost always take a mainstream movie or TV role when it's offered to me. But more often than not, when I'm hired for a live appearance, they don't want me to portray a character or pretend to be somebody else.

They want Ron Jeremy.

If Ron Jeremy is a commodity, then I've been my most enthusiastic salesman. I'll go almost anywhere, do almost anything, generally when I have something to promote other than myself. I've hosted S&M shows in urban nightclubs and judged spring break wet T-shirt contests in the Caribbean. I've lectured on college campuses including Oxford in England and signed autographs at Internet conventions. I've done posters for PETA, had couches dropped on me at Xtreme Pro Wrestling shows, and sang "I Got You, Babe" with the defense minister of Northern Ireland on British television. I've been interviewed for countless TV shows, from VH1's *I Love the 80s* to *E! True Hollywood Stories* to CNN. I've served as the emcee at the Ponderosa Nudes-A-Poppin' Festival for the past two decades. And if there's a rock concert happening somewhere, the odds are good that I'll get to introduce the band.

I've introduced acts as diverse as Blues Traveler, Peaches, Poison,

Sublime, Korn, Sum 41, the B52's, Mötley Crüe, Snoop Dogg, and Digital Underground. I've rapped with Kid Rock onstage in Las Vegas and in Louisville. I've performed with 2 Live Crew and the Wu-Tang Clan at the Luke Campbell Club in Miami. When gunfire erupted and I found myself on the floor (to avoid being shot), I actually *enjoyed* the experience.*

"This is so exciting," I chuckled as DJ Polo almost smothered me with his body.

I've appeared in more than fourteen music videos for MTV or VH1, more than any other actor. I've done cameos in videos for Moby, Mercury Rev, the Mieces, Sam Kinison, Guns N' Roses, Kid Rock (twice), Nelson, Everclear, Pauly Shore, and Cool G & Polo, to name just a few. I had a decent speaking role in Alanis Morissette's Comedy Central TV show. I was even asked by the band Sublime to help direct and produce one of their videos. I was approached by Brad Nowell, Sublime's lead singer, at a 1995 AVN Award Show in Las Vegas. I'd never heard of the band, but my friends told me that they were getting heavy radio airplay, so I agreed to give it a shot.

"What's the song called?" I asked Brad.

"'Date Rape.'"

I thought he was just having me on. "No, seriously, what's the name of the song?"

"'Date Rape,'" he repeated, unblinking.

"Are you fucking *nuts*? How the hell am I going to make a video with a title like that? The feminists are going to have a field day with this. If you make it serious, you'll depress everyone, and if you don't take it seriously, you'll be accused of making light of a serious situation! You're damned either way!"

Somehow, though, I managed to pull it off.* The song didn't glor-

* I was amazed at how many shoes were left on the floor. When the gunfire went off, people actually jumped out of their shoes to try to get away.

** With the help of my roommate Bobby Gallagher, and the head of Skunk Records.

ify date rape, and it ended with a bit of a moral message. "I can't take pity on men of his kind," Brad sings. "Now he takes it in the behind!" To re-create these lyrics, I cast myself as the inmate who exacts anal revenge on the convicted date rapist. We had to be very careful with how much we revealed. MTV was not about to let us show an actual *Deliverance*-style man rape, so we had to imply what was about to happen. In my scene, I embraced the convict from behind and pulled back his hair, giving the camera a leering smile. It was suggestive but not so suggestive to catch the attention of the MTV censors.*

A lot of musicians have used my name in their lyrics. In the Sublime song "Caress Me Down," Brad claimed that he was "hornier than Ron Jeremy." A tall order, but I gave Brad the benefit of the doubt. In the hit single "Let's Get Naked," Tommy Lee bragged, "Rockin' my porno tape / bigger than Ron Jeremy." He's not, but it's cute that he would think so. And LL Cool J mentioned me on the *Walking with a Panther* album, in whose lyrics he said, "J stands for Jeremy." Then he sang "sucker MCs really make me sick. I'm so bad, I can suck my own dick."

It's nice to know that I have a following among metal bands and rappers, but some of my musical admirers haven't been quite so obvious. In 1999, I flew to Canada to do a comedy show at the Thunderdome in Edmonton. I checked into a local Westin Inn and learned that members of the boy band *NSYNC were staying at the same hotel (they were performing at a nearby stadium). Over the weekend, I began getting phone calls from underage girls who were convinced that I was actually *NSYNC singer Joey Fatone.

"Hey, Joey," the girls cooed. "We love you."

"Uh, actually, this is Ron Jeremy," I told them.

"Yeah, yeah, we know. So listen, Joey, are you gonna sing 'Tearin' Up My Heart' tonight?"

* The video was introduced on MTV's *Headbanger's Ball*, and it had a decent rotation. (I also played the judge in this video.)

"How should I know? Seriously, I'm not Joey."

"C'mon, Joey, stop playing hard to get."

"Do I *sound* like him?"

After fending off dozens of calls from breathless teenage girls, I finally went down to the front desk to find out what was happening. It turned out that there were *two* Ron Jeremys registered at the hotel. The other Ron Jeremy was actually Joey Fatone, who had been using my name on the *NSYNC tour to disguise his identity. His fans had somehow cracked the code, and if it wasn't for the unfortunate coincidence that I was staying at the same hotel, they might very well have tracked him down.

They wanted to talk to a young, handsome pop star. But instead they got me, a chubby porn actor. To make matters funnier, Joey had been getting some of my phone calls.

I left a note and photo for Joey at the front desk. "Dear Joey," I wrote. "I love the attention I've been getting from these young women over the phone. Hope to meet you someday. You guys are a great act. Love and kisses, the *real* Ron Jeremy. P.S. Please call Michelle in Alberta. It sounded important."

Though I meant it as a private message to Joey, the letter was somehow leaked to MTV, and Kurt Loder recited it verbatim during an on-air special report. It soon became international news, and the letter was mentioned on VH1, E!, and Howard Stern, as well as in the *National Enquirer* and the back page of *Time*'s 2000 millennium issue.

I ran into Joey a few months later at a party in L.A., and he greeted me with a big hug.

"Thanks for the publicity," I told him.

"Thank *you* for the letter," he said, laughing. "And just so you know, I'm not using your name anymore."

"Well," I said, "It wasn't working anyway."*

* One of Alanis Morissette's band members *still* uses my name.

Hollywood was a very different place in the new millennium. Back in the 1980s and '90s, it was not too common for a porn star to be welcome on prime-time television. But audience tastes were changing. They were bored by the same old sitcoms and dramas. They wanted to watch *real* people doing *real* things that were unexpected and always unscripted. So by the late 1990s, TV networks across the world responded by filling their schedules with reality shows, making overnight celebrities out of regular Joes. But the reality phenomenon was also a boon to guys like me. I had just enough fame—or maybe infamy—to appeal to an audience's voyeuristic curiosity. Even the most porn-loathing families in Middle America might want to know what I was *really* like.

In 2001, I was invited to be a contestant on the Newsmakers edition of the NBC hit game show *The Weakest Link*. I competed against reality-TV actors and former child stars like Gary Coleman and Corey Feldman. The host, Ann Robinson, was a redheaded Englishwoman who delighted in making a mockery of her guests. I knew that she'd make no exception with me, and I was not disappointed.

Playing coy, she asked what exactly I did in my movies. "In the regular features, I act," I told her. "In the adult features, I act and do other things."

"What other things?" Robinson demanded.

Gary Coleman, who had recently admitted to being a virgin, said, "He does what I haven't done."

Robinson wasn't about to let me off the hook so easily. "Then what happens?" she persisted.

"We make a very funny noise, get our paycheck, and leave."

The audience laughed, but Robinson wanted the nasty details. "Tell me the noise you make," she said.

"Well, the ending noise sounds a little like this: *uuugh*."*

I did pretty well in the game itself. I lasted down to the final

* An orgasmic noise.

minutes before missing a question about Natalie Portman and getting voted out. Robinson usually dismissed the losing contestants by saying, "You are the weakest link. Good-bye." But with me, she added a groan. "Uuugh . . . good-bye"

My appearance was so well received that other reality-show offers came pouring in. I flew to Britain for Channel Five's *The Farm*, where I lived on a meat farm with celebrities like Flava Flav, model Emma B, actress Charlene Tilton, Prime Minister John Majors's daughter-in-law Emma Noble, and others. In 2003, I joined the cast of the WB's *The Surreal Life*,* which included former *CHIPs* star Erik Estrada, televangelist Tammy Faye Messner, rapper Rob Van Winkle (better known as Vanilla Ice), the *Real World*'s Trishelle Canatella, *Baywatch* star Traci Bingham, and my tortoise, Cherry.**

For two weeks, *The Surreal Life* cast lived together in a Hollywood Hills house*** and had our lives recorded. We were allowed some privacy in the bathroom but only if we ventured in alone. Any time two or more people were present in the same room together, a camera would be right there, watching our every move.

Because I was the first porn star many of them had ever met in the flesh, my female castmates—with the exception of Tammy Faye—were curious to see the penis. *Baywatch* babe Traci Bingham was especially curious about getting a look at my appendage. She'd occasionally follow me around the house and tug at my pants, or wake me early in the morning to try to yank off my blanket.

I wasn't completely opposed to giving Traci a peek. I gave her my standard deal: "If you show me your boobies, I'll show you my penis." She never agreed. Apparently she thought that she could get

* According to *Variety*, that season of *The Surreal Life* was the highest rated show for that time slot in the WB's ten-year history.

** Tammy Faye said prayers for Cherry. As she told me, "Turtles have souls, too, Ron." Cherry has been healthy ever since.

*** Formerly owned by Glenn Campbell.

a free show without giving anything in return. Well, tough luck! "If I don't see the boobies," I told her, "you don't see the schlong."

Trishelle was the first cast member brave enough to strip. During a cast field trip to a nudist resort, she came out for dinner with a towel wrapped tightly around her chest, and while we ate she slowly found the courage to let it fall to her waist. When the towel was cast aside, she quickly grabbed for a napkin, using it to cover her crotch. We all stared, of course, if only because a naked pair of breasts is the last thing you expect to see while dining on lobster. She was so embarrassed it was adorable. She kept yelling at us, "Quit looking! God, you fucking pervs!"

A deal was a deal. I promised the cast that I would get naked if one of them did it first, and I'm a man of my word. I went back to a dressing room to disrobe. I took a deep breath, threw open the door, and walked outside.

Trishelle took one look at me and shrugged. "I had a boyfriend who was as big."*

After dinner, we lounged in the Desert Shadows Jacuzzi. Trishelle was still topless, but she'd slipped into a G-string when nobody was looking. Traci finally agreed to join her and strip down to her birthday suit. But she was shifty about it. She decided to go bottomless, because once she was in the water the Jacuzzi's bubbles would conceal her goodies. She wiggled out of her bikini bottom and dived in, and nobody was the wiser. I thought this was a brilliant idea, so I threw off my towel and jumped in next to her. Below the waist, we were both naked as jaybirds, but the the *Surreal Life* cameras weren't able to catch any of it.

Not that it stopped the show's editors from implying that something naughty was happening. When I gave Traci a quick peck on the lips in the Jacuzzi, the editors played back the footage in slow motion and freeze-framed it, so that it *appeared* as if I was giving her a long, passionate kiss. Even her fiancé was a little jealous about this.

But it wasn't all innocent fun. I suppose it's time to spill a few beans.

* Yeah, but I wasn't *hard*, for gosh sakes!

A few weeks earlier, Mark Cronin, the executive producer, asked me to host a barbecue at the house. The rest of the cast would be down in the city, attending Tammy Faye's book signing, so I could have the entire place to myself.

"Just bring over a few of your friends," Mark told me. "It'll be fun."

A few of my "friends"? Yeah, I knew *exactly* what he was driving at.

"Oh sure," I said. "I'll invite over some guys I know from Harvard and Stanford. We'll sit around the pool and sip on tea with our pinkies in the air and discuss Shakespeare and Nietzsche and world politics and Steven Hawking's theories on the expanding universe."

Mark's face went pale. "Uh, actually, those aren't the kind of friends I'm talking about."

"Oh, you mean *porn stars*? Wow, I don't know. I can make some calls, but I don't really know many porn stars who are available."

"Just shut up and do it, okay?"

How could I blame him? Mark wanted ratings, and naked women were a surefire way to get huge ratings. So I called Tabitha Stevens and Jacklyn Lick and Lisa Sparks and a few other porn starlets whom I knew from L.A. Dennis Hof flew in from Nevada with a posse of girls from the Bunny Ranch.* I also invited Andy Dick and members of the band Digital Underground. By the next night, the the *Surreal Life* house looked as if it had been overtaken by an AVN convention. We cooked some food and skinny-dipped in the pool and gave Mark more long, lingering shots of naked flesh than he could possibly use.

And you'll never guess what happened next. The cast came back *early* from Tammy Faye's book signing. What a shocker! It was almost as if the producers had *planned* it. But no, they wouldn't be that devious and cunning, would they? They wouldn't want Tammy and company to stumble across a porn-star pool party right in full swing, would they?

* He would've had more, but some of the girls (including Sunset Thomas) had delayed flights due to the fires in the Burbank hills. It was just dumb luck that it happened on that day.

It wasn't nearly as scandalous as it appeared on TV. Tammy ran back inside when she realized that some of my friends were naked, but the rest of the cast was happy to join the party. They didn't jump out of their clothes, but they weren't shy about socializing with my guests. Erik later bragged that one of the women offered him an "oral compliment." And Traci almost joined us in the Jacuzzi until her fiancé showed up and ruined the mood. How dare he?

The next day, rumors started circulating that I had sex in the Jacuzzi. Rob Van Winkle saw Tabitha sitting on my lap, and he was convinced that we were doing something more under the cloud of Jacuzzi bubbles than just a friendly snuggle.

"That is *not* true," I told him. "Did you see her bopping up and down on me?"

"Well, no," Rob admitted.

I stuck to my story to the very end. I knew that if the cast believed that my DNA had been floating around in the pool, they would've been too squeamish to swim in it again. Even during the final episode, as the cast said their good-byes and left the house for the last time, I said, "This was the longest I've ever gone without sex in my entire life."

Well . . . that wasn't entirely true.

Okay, fine, it wasn't true at *all*. I was lying. I *did* have sex in the Jacuzzi.

I didn't mean for it to happen. Tabitha and I were just cuddling at first. But she was naked, and I was desperate. It'd been at least six days since I'd had any nookie, and I had already forgotten what the inside of a vagina felt like. I wasn't going to try anything with Tabitha because the cameras were pointed at us, and Rob was sitting just a few feet away. But Tabitha took pity on me. She could feel my growing erection and with just a flick of her wrist she pushed my bathing suit to the side and wiggled down on top of me.

We tried to be surreptitious. And I *did not* climax in the Jacuzzi, so at least when it came to that, I never lied to the cast. My "kids," as Erik so callously called them, did not get any free swimming lessons that night. But as for the sex part, well, I like to think of it as a white

lie. I only had a tiny bit of sex, just enough to get a taste. It was like a conjugal visit.

Of all the friends I made on *The Surreal Life*, I probably had the best connection with Tammy Faye.* Which was ironic, because we were the two people nobody expected to get along. She was an evangelist preacher and orthodox Christian, and I was a porn star. Not exactly a match made in heaven. But Tammy and I bonded. She recognized that I wasn't such a bad guy after all, and though she never approved of my line of work, she respected me and always treated me fairly. She even told Larry King and other interviewers how much she liked me (and my pet turtle). When I brought Rick James on the show (one of his last public appearances before his untimely death), it was as a gift to Rob, who was a longtime fan. What TV viewers never got to see was Rick singing and playing the acoustic guitar. For some reason, WB never used this footage. He sounded so good, Tammy Faye got out of bed (it was late at night), and joined the rest of the cast on the couch, to hear him sing. I think she even sang with him. A really great moment. **

Tammy and I kept in contact after *The Surreal Life* ended. I even arranged for a reconciliatory phone call between her and her one-time nemesis, Jessica Hahn. Jessica, as you may remember, was the one-time church secretary who slept with Tammy's former husband, PTL televangelist Jimmy Bakker. For years, Tammy partially blamed

* In *TV Guide*'s "100 Most Unexpected TV Moments" (December 5, 2005), the friendship between Tammy and me on *The Surreal Life* was listed at number 83. Why did Tammy and I get along so well? According to the *TV Guide* writers, "Only God knows."

** Rick James's funeral provided for an interesting afternoon at Forest Lawn Cemetery. Stevie Wonder sang and Louis Farrakhan made a speech. Jamie Foxx invited some of Rick's family and friends to his home afterward, where the two of us talked about Tom Cruise. I asked Jamie about Cruise's infamous stare—you know, the one where he kind of stares at you for a second before answering a question— and Jamie said that whenever he noticed Tom doing it, he'd give him a hard stare right back and think to himself, "Right back atcha, Tom." Jamie told me, "I'm a Baptist boy! I was practically raised in a church. I don't quite get that stuff."

Jessica for destroying her marriage, and they had a feud in the media. But the dust had settled, and both women were ready to speak to each other at last.

All they needed was a push in the right direction from a friend.*

And this, folks, is verbatim:

Tuesday, August 2, 2005

Early afternoon

Three-party phone call between Jessica Hahn, Tammy Faye, and myself.

RON JEREMY: Without further ado, allow me to introduce you to Jessica Hahn. Jessica, say hello.

TAMMY FAYE: Hello, Jessica.

JESSICA HAHN: (Bursts into tears) I am so sorry for all the pain that you've been caused.

TAMMY FAYE: Oh honey, it wasn't your fault, and I will never, ever, ever believe it was your fault. It takes two, Jessica, and I never blamed you, honey, I really never did.

JESSICA HAHN: I've been crying for days, Tammy. You've ministered to so many people, and everybody thinks you're just a ball of energy.

TAMMY FAYE: Oh my goodness, you're just like my little girl.

JESSICA HAHN: I am, I am. I always wanted to be a part of your family.

TAMMY FAYE: I kinda feel like you are. You'll

* Jessica made the suggestion, as she was concerned about Tammy's health. Jessica and I had met years earlier through Sam Kinison, and we'd been friendly ever since. She knew that I knew Tammy, and so I became the liaison to a historical event.

always be a part of our family. Just know that I love you and that everybody asks me, What would you do if you see Jessica? And I say, I'd put my arms around her and we'd both say thanks to Christ.

JESSICA HAHN: I just want to see you, so I can hold you and let you know . . .

TAMMY FAYE: We'll do that one day, baby.* Maybe you and Ron, we can meet somewhere.

JESSICA HAHN: Please, just know that everyone is on your side and I love you so much. Please stay healthy.** There's so much more for you to do. You must stay healthy.

TAMMY FAYE: I will, sweetheart. Thank you for wanting to talk to me. It means more to me than you'll ever know.

JESSICA HAHN: I love you very much, Tammy.

TAMMY FAYE: I love you, too, Jessica, and you're a beautiful girl.

When you've made a career of fucking for the cameras, people just naturally assume that you know a thing or two about sex. And I guess they're right. Most people average maybe a dozen or so partners in a lifetime, but I've slept with more than four thousand

* They eventually discussed the possibilities of a face-to-face meeting on Rita Cosby's *Live & Direct* TV Show for MSNBC. But plans are on hold until Tammy's health improves. As of this writing, they haven't done it yet, so, therefore, there's a chance that the only communication between these two ever presented to the public will be in this book.

** I'm happy to report that Tammy has survived cancer for the third time. I guess she has connections upstairs after all.

women. So I suppose you could call me something of an expert. In my own mind, I'm a professor in sexology but without the PhD.

I've always been happy to share my knowledge with the world. I've been a guest on hundreds of talk shows and radio broadcasts, where I've given sex advice alongside Dr. Ruth Westheimer,* Dr. Tony Grant, and Dr. Drew Pinsky. I've even had famous friends approach me in private, asking for my guidance on sexual health and STDs., or asking for a referrel to a good, closed mouthed doctor. There were a few celebrity actors and directors—none of whom I'll name—who've dropped their pants in front of me and asked me to examine a mysterious-looking pimple on their genitals.

"Is this anything to worry about?" they'd ask. "Could it be herpes or genital warts?"

"No," I'd say, calmly giving their schlong a quick inspection. "It's probably an infected hair follicle. You're fine."** (Sometimes, I can actually see the ingrown hair.)

I've had only one friend who was wary of letting me see him naked. And it was the last man in the world who should've had anything to hide. I'm talking about Dennis Hof, the owner, proprietor, and "Pimpmaster General" of the Bunny Ranch in Nevada (not to mention one of my best friends).

There were many times when we'd be on a double date and the girls wanted to have sex with each other (and us), but Dennis always found an excuse not to do it. He'd say something like, "Oh, it's kinda late and we're tired. Maybe next time." And he and his date would retire.

"Dennis, why are you blowing this?" I'd ask him. "These girls want to party. Why are you being such a wuss?"

"I'm just not in the mood for this," he explained.

"Not in the mood? I know the real reason. You're just afraid of letting me see your dick."

———————

* For a TV show in Australia.

** I always advise them to see a doctor, just to be totally sure.

"That's not why, Ronnie."

"Yes, it is! Listen, I don't care about seeing your dick. I just want to have a little fun. Why won't you trust me?"

I knew that if I was ever going to convince Dennis to relax and be part of a foursome, and stop being so needlessly intimidated by me, I'd have to find a way to break down his defenses.

I found my opportunity in Las Vegas during the summer of 2001. Dennis and I were visiting for a weekend retreat, and he was staying at a private suite at the Rio Hotel and Casino. While cruising the Vegas Strip without him, I ran into an old friend, a dancer named Fire Ann Steele. She lived in Vegas with her husband, and they were both swingers who liked a good party. I told her about Dennis, and she admitted that she was a big fan.

Lightbulbs flashed in my head. "Well," I said, "we should pay him a visit."

As her husband and I hid behind a maid-service cart, Ann knocked on his hotel-room door. It was approaching four A.M., and Dennis was already asleep, but Ann kept pounding until he stumbled out of bed and opened the door.

"Yes?" he said, looking at her groggily.

"Hi," she said in her most seductive voice. "You don't know me, but I think you're the sexiest thing."

He just stared at her for a minute, not sure if he should believe what was happening. And then he took her by the hand and said, "Come with me, young lady."

They disappeared into the room, and in his haste Dennis forgot to make sure the door locked behind them. He let it swing shut, and I ran over and blocked it with my foot. Ann's husband and I crept inside, slowly feeling our way through the pitch-black suite. We could just make out the shadowy figures of Dennis and Ann in the distance, and we crawled toward them, huddling on the floor just below the bed. We listened to everything: the slurping and groaning and moans of pleasure. Dennis was giving her head for the longest time, like a man who hadn't eaten in years. Though I couldn't see much from the

darkness, judging from the violent creaking of the bed, which seemed ready to collapse on itself, it was clear she was enjoying herself.

Hours passed, and the night was fast becoming morning. Rays of yellow sunlight were streaming across the room from an open window. They finally started to screw, and Dennis was too engrossed with Ann to notice that we were just a few feet below him, admiring his feats of carnal gymnastics. The four of us were like a symphony of sounds, matching each other in perfect syncopation.

"Ugh," Ann cried.

"Ugh," Dennis grunted.

"Shh," I whispered to the husband.

"Okay," he whispered back.

We went back and forth like that as if somebody was conducting us. "Ugh." "Ugh." "Shh." "Okay." "Ugh." "Ugh." "Shh." "Okay." "Ugh." "Ugh." "Shh." "Okay."

Dennis finally had an orgasm and collapsed on the bed. While he was still heaving from exhaustion, Ann's husband and I jumped to our feet and gave them both a standing ovation.

"It's about damn time," I said, glancing at my watch. "We've got things to fucking do, Dennis. How long does it take for you to fuck a girl anyway?"

Dennis's face went ashen. "Who the hell is that?" he asked, pointing at the man standing next to me.

"It's her husband," I announced.

"*What?*"

"It's okay," the husband said with a laugh. "We're big fans. I get a kick out of sharing my wife with somebody like you. And she does the same with me."

"Do you realize what just happened here?" I told Dennis. "I saw your dick! I saw you give her head, I saw you fuck her. And you know what? It's no big deal!"

"You're an asshole," Dennis growled at me.

He pretended to be angry, but I knew that everything had changed between us. He didn't even bother to reach for his robe to cover him-

self. A few minutes later, he and Ann were sitting on the couch together, messing around while her husband and I watched. Whatever nervousness he once had about having sex in front of me was gone.

"We're finally bonding, Dennis," I said with a laugh, as Ann dropped to her knees and gulped down his penis. "Isn't this nice? Isn't this what friendship is *supposed* to be about?"

"Will you shut up?" he grumbled, combing back Ann's hair for a better look. "I'm trying to concentrate here."*

Here's a short quiz for you. What do three U.S. presidents, two prime ministers, Winston Churchill, Mother Teresa, the Dalai Lama, and I have in common? Well, if you read the Reuters news services, or the AP wire, you'd know that we've all lectured at Oxford University.

When I called myself a professor in sexology, did you think I was just pulling your leg? In May 2005, I was invited to Britain to do a lecture and participate in a debate on pornography at the esteemed Oxford Union, the 183-year-old institution of higher learning.

It wasn't my first time speaking to an academic crowd. I've been a regular on the college-lecture circuit for close to a decade. I've traveled to renowned universities around the world, speaking on topics like the ethics of pornography, and sex and the law. Sometimes I've lectured alone and sometimes I've toured with feminist author Susan Cole or *Porn Nation* spokesman Michael Lahey. Both are staunch critics of adult films, but we've actually become friends over the years.

* As our friendship solidified, Dennis invited me to be a guest (during a party scene) on his reality series *Cathouse* for HBO (or, as Dennis calls it, "HB-Ho"). The show is in its fourth season and has great ratings.

I know that's not something most people want to hear. A feminist like Susan should be the sworn enemy of a pornographer. When the college kids come out to our debates, they want us to be like Mike Tyson and Lennox Lewis. They want to see pure, unadulterated hatred between us. They expect smoke to come out of our noses. When they see Susan and me socializing together before a show, sharing a dinner at a nearby restaurant, they feel betrayed.

"Relax," I tell them, "when we hit the podium, the gloves will come off."

Though Susan and I are firm in our convictions, we both know that it's still entertainment. She truly does dislike the adult industry, and I think her arguments against porn are a little misguided and inherently flawed. But offstage, away from the howling crowds, we're able to separate business from pleasure. We treat each other with mutual respect even if we don't always agree with the other's personal philosophies. Aw, heck, she graduated Harvard for gosh sakes.

When we sign autographs after the debates, I'm careful not to do anything that might inadvertently offend Susan. During one of our college visits, we went to a bar after the debate, and, as usual, I was surrounded by girls asking for autographs. One of them asked me to sign her boob, and, as I usually do, I turned to Susan for approval.* She just rolled her eyes, which is her way of saying, "Fine, do whatever you want." The girl pulled down her blouse, and, as I was signing her left boob, I noticed that there was already a signature on the right one. I inspected it more closely.

I would recognize that handwriting anywhere.

It was Susan's signature!

I pulled Susan over and pointed to the evidence. "Did you do this?" I said. "You, the champion of women's rights, the adversary of pornography? *You* signed a boob?"

* Since Michael Lahey is a recovered porn addict, I never sign a boob in front of him, and he's always appreciated that.

"So what if I did?" Susan said. "Don't make such a big deal of it. You do it every day. Besides, she asked."*

In every city I visit, I'm faced with a new group of young people who ask more or less the same questions. They want to know, "What's it *really* like to be a porn actor? Is it as much fun as it looks in the videos? And what can we do to make our sex lives as exciting and visually electrifying as what we see in a porno?"

Okay, kids, it's time that I gave you the brutal truth once and for all. Grab a seat and get ready for the final installment of . . .

Part 4:
HOW TO MAKE LOVE LIKE A PORN STAR

I remember when Jenna Jameson's autobiography came out, and I first saw the title.

Now, I really like Jenna. We've done projects together (mostly mainstream) and I'm proud of her success, but I got a big kick out of the title of her book. *How to Make Love Like a Porn Star?* There's so much wrong with that phrase I don't even know where to begin.

First of all, porn stars don't make love. We make like. What we do is just sex. I'm sure it looks pleasurable. Every-

* I continue to tour the United States and Canada, either alone or with Mike, Sue, or recently with Craig Gross from Triple X Church. The colleges are always sold out. I've done Trinity College in Dublin, Ireland, and I'm in my twelfth year as a guest lecturer for Professor W. Garrett Capune's criminology class at Cal State Fullerton. Even Bill O'Reilly has made a comment about my college appearances on his A.M. radio show.

body in a porno movie appears to be moaning and sweating, and sometimes we're having a swell time. But I've got a little secret for you. More often than not, it's difficult work, and anybody who tells you differently is a liar.

The next time you rent a porno, take a long, hard look at what we're actually doing. Do you see those positions? Notice how the woman's legs are being thrust into the air at odd angles, how the guy's torso is twisted around like a pretzel, how our bodies seem to be levitating in the air with only a trembling shinbone to support our weight. Does it *look* like we're having fun? Do you think we're doing those positions because it's more stimulating than anything you have the courage or physical dexterity to try at home? The answer is no. We're doing it because it's *required* of us. We need to give you, the audience, the best possible view of what's happening. If you can't see the penetration, then a porno flick isn't doing its job. It's not for our pleasure, it's for *yours*.

We like to think of ourselves as marital aids. We want to inspire you to try as many different positions as possible, and to make an effort to satisfy *both* partners. We advocate communication and sometimes a little dirty talk to spice things up. But remember, what *feels* good doesn't always *look* good, and what *looks* good doesn't always *feel* good.

You want further proof? Consider the porn blow job. When an actress is fellating somebody in an adult film, her cheeks often need to stick out. It doesn't hurt to have visual evidence that a cock is in her mouth. And for the guys, this means ramming your cock straight into her cheekbones. You're not really fucking her mouth, you're going through two rows of her *teeth*. Yes, let's all say "ouch" together, shall we? It looks great on camera, but for the people doing it, it doesn't feel that exciting.

In your private life, when a girl is giving you head, what

feels the best? You want your cock to be deep inside her mouth, right down to the tonsils, while she's creating a sucking, vacuumlike effect and swirling around it with her tongue. But we can't show that in a porn film. Unless we had miniature cameramen out of *Fantastic Voyage* who could travel inside a girl's mouth and catch all the action, it's not going to work. In a porn film, we spend more time with our cocks *outside* of a girl's mouth than in it. And even then, she can't give it too much attention without ruining the shot. I've been on too many sets when directors have shouted, "Honey, your hands are blocking the balls! Back it up a little, please."

Making love like a porn star means enduring all sorts of uncomfortable and occasionally downright nasty things. Take a double-penetration scene, for instance. Two guys are riding a girl at the same time, one in her pussy and one in her ass. As a visual spectacle, it makes for great eye candy. And sometimes it feels great. But once in a while, you feel some guy's balls knocking against your balls. Perhaps it's the size of the girl's taint,* or maybe the guy just has balls that hang a little lower than usual. But whatever the reason, it can take every last ounce of strength not to lose your wood completely.

Sometimes if you're on bottom and the guy on top pops first, his cum will end up missing her completely and dripping down your leg. When it's happened to me, I just take one look at the guy and say, "You better get a towel and get your kids off my leg, or I'm gonna put them through college. Now *I* have to see *your* blood test."

* Taint: n., (tănt): The perineum—the area between the genitals and anus, male or female, although the term is said to originate from the saying "It ain't pussy and t'aint ass . . ."

Still want to make love like a porn star?

"But what about those amazing cumshots?" you're probably asking. "How do you make your sperm fly over a girl's head and hit a wall twenty feet away? I've heard that some actors drink raw egg whites before a scene. Is that true?"

Whoa, whoa, slow down, Tex! You're right, porn stars do shoot some pretty massive loads. But you're an idiot if you think there's a secret to it. You can suck back as many egg whites and Asian mushroom extracts as you want, and you still won't cum like a sperm geyser. If you really want to have a better orgasm, here's my advice. Two words: *hold back!* The longer you can abstain from having sex or having an orgasm, the better it'll feel when you finally do it.*

I pretty much guarantee that you'll have a slightly more liquidy cumshot with this method, but why does that matter? In a visual medium like porn, sure, a big cumshot is important. But in the privacy of your bedroom, when nobody is watching, you shouldn't care if you're cumming buckets or thimbles. The only thing you should be concerned with is how it feels. Does it feel good? If it does, then you're doing something right. Do you actually think that women pay attention to the amount of gook? What's your girlfriend going to say? "Oh, very nice. You drenched me. Now bring me a towel, you pig."

As long as we're on the subject of cumshots, there are a lot of you out there who seem to think that we porn stars have some kind of superhuman control over our own orgasms. Okay, sure, I've bragged in this book that I can time my ejaculations down to the second. And yes, it *is* true. But as remarkable as this skill may be, it took a little trial and

* This works for women, too.

error before I got it right. And even then, I'm only human.

Here's a little tip for you guys out there. If you think you're going to cum and you're not ready, just take your cock out and give it a rest. You have a luxury that we don't have on a porn set. You can stop whenever you want. This doesn't mean that sex has to end completely. You can still play with your partner with your fingers or your tongue. Trust me, she won't mind. Alternate between your dick and other parts of your body. Dick-tongue-dick-tongue-finger-tongue-dick. If you're so turned on that even touching her will make you pop, take a break and go make a sandwich. If you need to, run your pecker under cold water. It's okay, you're allowed.

For every cumshot that I got right, there were a few times when I came too soon and almost ruined a scene. You want an example? Fine. Here's one:

A few years ago, I did a porno called *The Adult Apprentice*, a parody of Donald Trump's TV show *The Apprentice*. I had a scene with Vicki Vette, an incredible blonde bombshell who gives absolutely amazing head. Every time I've been with her, it's been a struggle not to climax too soon. We were doing a position called the pile driver, which is very physically difficult. The woman is basically turned upside down. Her head is on the floor and her legs are sticking straight up in the air, and the guy is standing over her and penetrating her by putting his legs on either side of her. In a way, it's like you're trying to simulate human scissors.

So Vicki and I were doing the pile driver, and even though it's a taxing position, she was getting me really excited. Vicki knows how to do things with her body that are probably illegal in forty-eight of the fifty states. I got the horrible feeling that I was going to pop too soon, so I did what I always

do in that situation. I started thinking of disgusting things: war casualties, deceased relatives, etc.* To my amazement, it wasn't working. So I pulled it out just long enough to regain control. Normally, this wouldn't be a problem, but I had forgotten that I was doing the pile driver. I was standing on a bed, perched precariously over Vicki with nothing but her legs to hold on to for support. The moment I backed up to pull out my penis, I realized that I was losing my balance.

And if that wasn't bad enough, I was cumming.

I fell over backward, tumbling off the bed and onto the floor, my sperm trailing behind me like the burning smoke from a crashing plane. The director adjusted the camera in time to capture my orgasmic plummet, so at least it wasn't a complete waste.

And that, in a nutshell, is the main difference between sex at home and sex on a porn set. When one of you suffers from premature ejaculation, the most that gets hurt is your pride (and maybe that of your wife or girlfriend). But when we do it, we can end up with a broken back and a face full of our own jism, and the entire cast and crew gets to witness it.

At least I'm getting paid to put myself through the abuse. What's *your* excuse?

* Some guys will think of another man's hairy ass to keep from cuming too soon. I warn them that that's dangerous, because if they cum anyway, it can change their entire way of life. As we learned from the scientific research of the Skinner Box or Pavlov's dogs, what can happen now, is that every time they see a man's behind, they'd go, "ugggh!" and not know why.

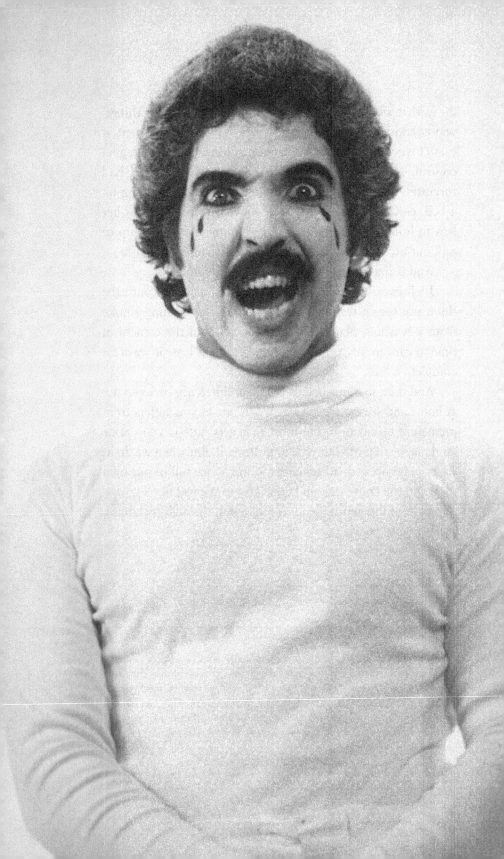

EPILOGUE

**It is very difficult to
fail at pornography.**

—Michael Chabon

In 2004, Slash invited me backstage to hang out with his new band, Velvet Revolver, at the Roxy in Los Angeles. Slash was an old buddy, and I couldn't have been happier that he was making a triumphant return to music after the nasty breakup of Guns N' Roses and the semisuccesses of his new bands, the Snake Pit and Slash's Blues Ball. I watched as he tuned his guitar while his wife, Perla Ferrer, sat by his side.

I knew Scott Weiland (Velvet's lead singer, former front man for Stone Temple Pilots) and the other band members, but I felt a special kinship to Perla and Slash. After all, I had introduced them to each other.

You see? I haven't always introduced musicians to porn stars. Sometimes when I play Cupid, I can actually get it right.

It all happened just five years earlier, as I was on my way to Slash's hotel room in Las Vegas for a late-night party. I bumped into Perla in the lobby, and she asked me to bring her upstairs to introduce her to Slash.

"I'm going to marry that man someday," she told me. She didn't say

On the set of Scoundrels. *(Photograph by Cecil Howard/Command Cinema)*

it hopefully; she spoke with a confidence that I'd never seen in the group-ies who usually chased after Slash. She knew in her heart that she was destined to be with him, and nothing could convince her otherwise.

So I brought her up to meet Slash, and they hit it off almost immediately. A short time later, just as Perla had predicted, they were married. It'd been a few years since I'd seen either of them, and I was happily amazed that they were still a couple. Relationships in rock tend to be short-lived, but Slash couldn't have been happier. He loved his new domestic life and raising a family with Perla. They had two kids already, and Slash told me there were plans to have another.

The other members of Velvet Revolver had undergone similar transformations. Scott had spent the last decade battling his substance-abuse problems, an addiction that he had finally been able to kick. He was also married with a kid, and his rowdy past seemed to be com-pletely behind him. The rest of the band was no different. They were all clean and sober, and to watch them lounging together backstage you would never guess that these four guys were once the hard-partying, booze-swilling, drug-taking, sexed-up wild boys of L.A.'s rock scene.

I glanced around the backstage dressing room. There were no empty bottles of beer or Jack Daniel's, no blonde groupies, no panties draped across lamps or overturned furniture that had recently been set on fire. It was just a small group of friends and their wives, a social gathering no different from what you'd find at any suburban dinner party. I pretended to be horrified.

"This is absolutely appalling," I barked at them, breaking the silence. "You should all be ashamed of yourselves!"

The band looked up at me, stunned by my outburst. I walked around the room, surveying the shameful display of rock impotence.

"You call yourself rock stars?" I continued. "What the hell is this? There's not one bottle of hard liquor in the place. Not even a beer. You've got bottled water and sodas, PowerBars and granola. What kind of rock star drinks fruit juice? I mean seriously, *fruit juice*? Are you worried about your prostates or something?"

Slash began to giggle. He knew that I was just having some fun with them, mocking how radically their lives had changed since the glory days of the 1980s and early '90s. I stormed over to the buffet table, on which the usual amenities had been replaced with something far more sinister.

"And what do we have here?" I asked, my voice shaking with rage. "Antibacterial Handi Wipes? Baby powder? Pacifiers? Rattler toys? *Diapers*? I remember a time when this table would've been covered with unconscious groupies. And now it's been replaced with boxes of *diapers*? I'm telling you, if word gets out that the Velvet Revolver touring machine is moonlighting as a day-care facility, your careers are finished. You think your teenage fans want to know about this? It's an affront to rock and roll!"

I collapsed next to Slash, and we both burst into laughter. "Seriously though," I said. "I'm proud of you guys. This is the best it can be. And I'm one to talk. I don't touch drugs, and I barely drink."

"That's right!" Slash exclaimed. "Where do you get off scolding us?"

"Well," I said with a wide grin, "I do enjoy the occasional groupie."

"Oh, sure," he agreed. "There's that."

Slash gave me a consolatory hug. "It's okay, Ronnie," he said. "I'm sure you'll catch up with us eventually."

I just found out that my ex-girlfriend Juniper is moving to Florida.

To be honest, Juniper hasn't technically been my girlfriend for two years. I mean, we had been living together, and we were what you'd call "romantically involved." But now we're friends, first and foremost. We enjoy each other's company, and Juniper always tells me that I'm the best friend she has in the world. But whatever we were—or are—was never clearly defined. I was in love with her and

wanted to be with her, and that's all I needed to know. We were just taking our relationship day by day, without any expectations of what tomorrow would bring.

But then Juniper announced that she was fed up. She didn't think I'd ever be ready to settle down and commit to her. She wanted me to quit the swinging lifestyle. She didn't want to share me with other women, and if I couldn't devote more one-on-one time to her, mind and body, then she didn't want to waste any more time on me.*

The monogamy thing is difficult for me. I have no problem with emotional monogamy, but physical monogamy is different. I've sometimes asked my dad, "How did you do it, Pop? How did you stay married to the same woman for so many years?" He knew what I was really asking. It wasn't marriage itself that confused me. It was monogamy. It was the idea that anybody could ever limit himself to just one sexual partner.

"Well," my father said cautiously, "you just find ways to keep it fresh. You think of new things to do."

"Like what?" I asked. "After thirty-some years, what is there left to do that you haven't already tried? Do you hang from the chandelier, or hang glide into it?"

My hat goes off to anyone who can make monogamy work. I've known very few people who could pull it off (especially men). Even if they stay in the marriage, they'll eventually give in to the temptation to cheat. If a guy is approached by a beautiful woman and she offers to massage his ball sack, no strings attached, he's often going to say yes. I don't care who he is. Most men cannot turn down free sex, and it has nothing to do with our emotions.**

* Smart married men have told me that no matter how busy you get in your professional life, a relationship won't work if you don't devote time at least a few days every week to your lady when nobody else is around, whether it's a dinner or a show or just one-on-one time.

** Comics like Chris Rock and Eddie Murphy had done hilarious routines about this, and they all admit it's true.

In most cases, the thing that bothers women about cheating isn't the sex but the deception. It's not cheating if you're truthful about it and you're willing to let your partner do the same thing. I've known some actors and rock stars who couldn't grasp that concept. They'd go on tour and have sex with a different woman every night. But when they came home and their girlfriends so much as looked at another guy, they'd freak out.

When Juniper was breaking up our romantic relationship, I tried to explain this to her. I told her that the world is filled with men who consider swinging a one-way street. They're too insecure or chauvinistic to realize that it's something that can be shared. Most guys are going to cheat, and the best you can hope for is to end up with somebody who's *honest* about it.

"Maybe," she said. "But that doesn't change anything."

"Why can't you give us another chance?" I asked her.

"Because you're never going to change. Isn't there a small part of you that's tired of this swinging nonsense? It isn't normal to be so obsessed with this."

"I wouldn't say I'm obsessed. I'm more like a bonobo monkey."

"A what?"

"A bonobo monkey. They don't just have sex for procreation, or when they're in heat. They do it every day with a variety of partners. They're one of the few animals that practice fellatio and group sex. And because of it, they're very nonaggressive and peaceful. They're the happiest, healthiest monkeys in the jungle because they're too busy screwing. So I'm pretty sure that I evolved from a bonobo."

"Yeah, well, I guess I'm more like a tamarin monkey," she said, "or like most birds."

"You mate for life?"

"Exactly."

And that, in the end, is why Juniper and I decided to break up. I'm a bonobo and she's a tamarin. As much as we loved and respected each other, we're two very different monkeys.

I can pinpoint the exact night that everything almost changed between Juniper and me. It was the moment when my feelings for her changed from like to love.

It was years ago, when Juniper and I were still a couple. She was sleeping at the time, which is usually when I feel the most affection for her. For as long as we'd been together, watching her sleep had been one of my favorite things. She doesn't just lie there and breathe deeply. Her arms are outstretched, and she purrs like a kitten. And she has this adorable smile that just kills me. She looks so innocent and sweet and harmless. Sometimes when I come home late at night, I'll just sit on the edge of the bed and watch her sleep.

She hates it when I do that. And she hates it even more when I bring friends to watch her. But I just can't help myself. On some nights, I've invited porn stars like Taylor Wayne and Jacklyn Lick over to our apartment, and I'll bring them into the bedroom just to look at Juniper.

"Have you ever seen anything so cute in your whole goddamn life?" I'll whisper.

"Ronnie, why don't you just give it up and marry that girl?" Jacklyn asked me. "It's so obvious you're in love with her."

I guess it was.

As I already mentioned, she was sleeping.

And holding a bald, partially blind rat named Fetus.

As a kid, I once had a pet turtle named Timothy. But as an adult who travels constantly, it didn't make much sense to leave an animal alone in an empty apartment. But Juniper is a veterinarian's assistant, and she doesn't think clearly when it comes to adopting pets. And big softie that I am, I've never been able to say no. It started with Cherry, a tortoise who hasn't left my side since Juniper brought her home. That would've been enough for me, but Juniper pushed for more. A few years later, she adopted a rat. A skinny, hairless, partially blind, adorable rat.

"Are you out of your mind?" I asked when she walked into our apartment with the bald bundle of joy.

"What?" she said, clutching the naked beast to her chest. "I love rats. I had lots of rats as pets when I was growing up."

"It's a rodent. And they only live for maybe two or three years. You're just setting yourself up for unnecessary heartbreak."

Juniper fought for the rat, and it stayed. She named it Fetus because of its resemblance to a misshapen embryo that was all but begging to be aborted. And like a sucker, I ended up falling in love with the weird-looking thing. I told Juniper that I hated it, but she'd catch me sharing a meal with Fetus or spooning with it on the couch.

"You're in loooooove," she'd tease me.

"Okay, fine. You were right. Don't rub it in, okay?"

We found out later that Fetus once belonged to the comic Howie Mandel. He'd given it up after his daughter went to college,* and it somehow got passed along to Juniper's clinic. During a visit to Las Vegas, I learned that Howie was performing at the MGM, and I immediately called him to share the news that his onetime pet was alive and well.

"Oh my God!" Howie laughed. "What the hell is Ron Jeremy doing with little Chemo?"

"You called her *Chemo*?" I asked. "You are a sick, sick man."

"Oh come on, you're telling me she doesn't look like a chemo patient? I'm just amazed that she's still alive."** He was so excited, he thanked Juniper on my cell phone. The MGM staff and Howie's manager were in shock, and I didn't know why. They explained to me that Howie is a germophobe. He won't even shake hands with someone, let alone use their cell phone. I figured, heck,

* On the condition that it be given to a happy home and not used as snake food.

** He asked that I e-mail him a few photos of Fetus, which I did. He loved them and shared the pictures with his daughter.

since he knows I'm in porn, maybe he knows I'm blood tested every month.

A year and a half later, Fetus was diagnosed with cancer. It was ironic, really, given her former name. Juniper and I spared no expense in treating her, but despite a successful surgery, the doctors couldn't bring her out of anesthesia. The brave little rat fought for hours to stay alive but didn't make it. And so, on a rainy summer afternoon in L.A., we drove to the hospital to have our beloved Fetus cremated and her remains placed in an urn that we could keep.

And that's when I realized that I wanted to have children with Juniper.

I can't really put my finger on what it was about that particular day. Maybe it was just the sadness of losing something that we both cared for. I don't want to sound overly corny, but maybe it was the Celtic music playing on the radio as the rain battered against the car's windows. But as I glanced over at Juniper and saw her sleeping, her tiny hands outstretched, I felt such a wave of love wash over me. I knew then and there that I wanted to be with Juniper for the rest of my life. And I wanted us to be something more to each other than just two friends who occasionally had sex.

"Hey," I whispered, giving her shoulder a tender nudge. "Wake up. I need to tell you something."

"No' now, le' me alone," she said in that drowsy voice that just makes my heart ache.

"I think it's time," I said, surprised by my own certainty. "I think we should be parents."

She shot upright in her seat. "What did you just say?" she asked, now very much awake.

"I want to have a baby," I said. "I want to have a baby with *you*."

We were mostly silent for the rest of the trip. Juniper didn't say yes, at least not right away. She just wanted to sit with it for a while, maybe to wait to make sure that I wasn't going to back down over time.

But I wouldn't. I was serious. Over the past few months, I'd been having dreams about being a father. I dreamed that Juniper and I had an actual baby. And stranger still, when I woke up, I was sad to discover that it had been just a dream. I told my dad about these dreams, and he said, "Ronnie boy, that *means* something."*

Fathering instincts have a way of revealing themselves slowly. It may have continued a few years later, when I was on the British reality show *The Farm.*** Part of our duties involved attending to the ranch animals—milking and feeding them. During one of my first days at the farm, I helped deliver a baby lamb. She was born deformed, and even her own mother rejected her. Because I have a thing for outcasts, she became my favorite. I nursed her and took care of her for sixteen days until she was healthy enough to feed from her mommy. On some mornings, I'd jump out of bed and be in the barn before any of the other cast members were awake. I took to the role of nurturer like it was the most natural thing in the world for me.

At one point, Flava Flav—one of the other celebrity cast members—walked by and saw me sitting in the hay, coddling the baby lamb and feeding her from a milk bottle. He just shook his head and laughed.

"Dude," he said, "you need kids."***

Juniper and I tried to get pregnant for almost six months, but it never worked, and we eventually gave up. Now, years later, I'd prob-

* I received a totally different attitude when I told popular KLSX radio personality Tom Leykus. He said, "I don't want to lose my best student. Come back to Professor Leykus 101."

** At this point, Juniper and I were best friends and living near each other in Hollywood.

*** When I left the farm, the now-healthy baby lamb kissed me good-bye on the nose.

ably still want to give it a shot. But Juniper and I are best friends, not lovers, and I may have missed my chance.*

For now.

Where the hell am I?"

I rub a hand across my swollen eyes. I must have drifted off again. I haven't slept in days, so it's no wonder. I squint into the fluorescent lighting and try to get my bearings. It looks as if I'm in another airport, but which airport is hard to say. It could be Chicago, or New York, or even Miami. It's difficult to tell anymore. If you travel as much as I do, all airports start to look pretty much the same.

I reach into the old plastic grocery bag that passes for my luggage and pull out my trusty binder. If there's any hope of figuring out where I'm flying today, the answers will be there. I flip through the yellowing pages until I find today's date.

Ah yes, I'm going to Florida to see Juniper.

I gave up on trying to convince her to stay. If she needed to get out of L.A. to be happy, I wasn't going to stand in her way. But in the weeks after she left, we still talked almost every day, spending hours on the phone like two teenagers. Sometimes we had nothing of any importance to say, we just needed to hear each other's voice. Other than the fact that we no longer lived in the same town, it was like nothing had changed between us.

* We still have joint custody of Cherry the tortoise, although she lives with me now. Cherry, by the way, was part of the cast of the WB's *The Surreal Life*. And you can see her in the film *Pornstar Pets*, produced by my friend Danny Vinik (who also produced *Spun*). She accompanied me during the photo shoot for my poster for PETA (one of my favorite organizations). You can also check her out at Peta.org or Helpinganimals.com. If Juniper and I play our cards right, Cherry can live up to one hundred sixty years! (She's about sixteen years old now.) As for Fetus, she's smiling down from rodent heaven with her two good eyes.

A tinny voice over the airport PA system announces that my flight is boarding. I gather together my bags and head toward the gate. I feel naked, like I'm forgetting something. And I probably have, as I've packed unusually light for this trip. Juniper had only one request of me. She wanted me to come to Florida without any of the accessories that I cart around with me everywhere. No scripts, no magazine clippings in which I'm quoted, no souvenir T-shirts to sell to fans, not even a Polaroid camera for photos. She just wanted me, unencumbered by the weight of my incessant ambition.

We weren't going to discuss weighty matters like "us" or "how can we make this work?" We were just going to forget about it all and act, well, for lack of a better word, like a "normal" couple. A couple of best friends.

I can be in Florida only for the weekend. After that, I have to be back in L.A. to shoot a scene for *Domino*, Mickey Rourke's next film. And then I'll be attending the premiere of *The Aristocrats*. I was sliced out of the final cut, but I'm given an "extra special thanks" in the closing credits, and I'll be included in the DVD release. And then I'll be starring in a new porno flick called *Very, Very Bad Santa* for Metro Interactive, promoting my line of Ron Jeremy rolling papers and my new line of toys for Pipedream Productions, meeting with Adam Rifkin to discuss his new movie, and—

What, you really didn't think I was just going to forget about work completely, did you?

I'd give it
all up for one
more erection.
—Grocho Marx

EPILOGUE: THE SEQUEL

When I learned that HarperCollins was putting out the paperback edition of this book, I immediately called my ghostwriter, Eric Spitznagel, and told him we needed another chapter. I didn't want to ask people to buy the same book twice without giving them something extra for their hard-earned cash.

"Maybe we should put in a few more sex stories," Spitznagel suggested. "How about something from the early 1980s, when you were doing porn flicks with that guy Phil Prince, the cross-dressing director who may or may not have killed his wife?"

"No, no, no," I told him. "I want something more uplifting."

"Okay, then how about that actor you were telling me about—I think his name was Spike—who used to smash his testicles with a hammer and piss in his own mouth? That'd make a great chapter."

"You must be joking," I laughed. "You think I wanna end my book writing about a piss-drinking, ball-abuser that I hardly knew? Nobody wants to read that."

I'll admit it, I was disappointed in him. I like to believe that some of you were surprised by what you learned about me.

Need proof? Not long after my book was published, I went to Toronto for a bookstore signing and to do promotional appearances

338 RON JEREMY: The Hardest (Working) Man in Showbiz

for Virgin Mobile, who hired me for a rejection hotline called Dial-A-Dis. You've heard of it, I assume? It's a phone number that Virgin customers can give to unwanted suitors. Somebody calls it expecting to reach the hot young stud or lady they met at the club last night, and instead they're greeted with a recorded message by none other than me.

"I've got good news and bad news," I said in one of my messages. "The bad news is she doesn't want to see you. You're aced out, finished, kaput, gone. But here's the good news. *I'm* gonna do her."

Well, because I was working for Virgin Mobile, it meant I was an employee of Sir Richard Branson, the multi-billionaire and CEO of the Virgin media empire. As luck would have it, Branson just so happened to be hosting a party for his staff while I was visiting Toronto. I got invited to the shindig and wasted no time in tracking down Branson. He's exactly what you'd expect of him: charming, handsome, filthy rich, and not a pretentious bone in his body. My kinda guy.

He was happy to meet me, though he wasn't thrilled when I handed him a copy of my book and tried to show him the photos.

"Ron, I appreciate it," he laughed, trying to push the book away. "But I don't need to look at pictures of naked women."

Oh, really? You mean a man who makes more money in a single afternoon than most of us earn in an entire year *isn't* hard up for sex? How shocking! (Yes, smart guy, I'm being sarcastic.)

"I *know* that," I told him with a smile. "That's not what I wanted to show you. I thought you might like to see a picture of me hang gliding."

That got his attention. "You were a hang glider?" He said, scarcely able to hide the shock in his eyes. It's not the first time I've gotten this reaction. Not many people look at a chunky guy like me and think, "He's probably spent a lot of time practicing a recreational sport that involves a lot of upper body strength." But it's true.

So there you have it. That's at least one person who was more impressed with a Ron Jeremy story that *doesn't* involve sex. Y'know, now that Richard Branson is aware of my windsport experience,

With British Billionaire Richard Branson. (Courtesy of the author)

maybe he'll invite me to join him the next time he tries to circumnavigate the globe in a hot-air balloon. You think he might?

Yeah, yeah, I know. Probably shouldn't hold my breath, huh?

You've already read about some of the celebrities who've dissed me over the years. But even today, when porn actors have become more accepted in the mainstream than ever before, it still happens from time to time. Not long ago, I was acting in director-writer Adam Rifkin's new film, *Homo Erectus*. As you know by now, Adam has been one of my biggest supporters. He's cast me in many of his films, from *Detroit Rock City* to *Night at the Golden Eagle*. He also likes to make a lot of jokes at my expense, although it's always in good fun. He put me in his film *Look*—which, by the way, won the Grand Jury prize at the 2007 CineVegas Film Festival—and then listed me in the credits as "Fat Man on Computer." He did *not* have to do that. You don't even see my stomach in that scene.

Adam also cast me in *Denial* with Patrick Dempsey, and I had a great dialogue scene with Patrick in a jacuzzi. But in the credits, I'm listed as "Hairy Man in Jacuzzi." Again, he did *not* have to do

With the lovely Spiderman *star Kirsten Dunst.* (Courtesy of the author)

that. But I never get offended by Adam's digs. That's just his sense of humor. As long as he keeps putting me in his movies, he can call me whatever he wants, including a taxi.

Anyway, where was I? Ah yes, *Homo Erectus*. So I had a nice role in this movie as a caveman named Oog. I got along great with most of the cast, like Tom Arnold and Dave Carradine. But Talia Shire, a terrific actress whom I've always admired, seemed a little uncomfortable with me. She didn't come right out and say anything, but I could tell by the way she looked at me that she'd be much happier if I wasn't there. I asked Adam about it later and he insisted that I was just being paranoid. But then after the shoot, Adam admitted that Talia had told him, in a very gentle way, that she "didn't approve" of my work.

I suppose it's not a strong diss, but it still irritated me.

But for every person who's dismissed me as another schlub in the porn racket, I've met dozens who aren't so quick to judge. I was at an advance screening of *Marie Antoinette*, partly because the Screen Actors Guild asked me to be one of their voters—I had to turn them

down because I just didn't have enough time to see all the films—and partly to see a fellow I knew, Jason Schwartzman, one of the film's stars and, ironically enough, Talia Shire's son. I told him about my experience with his mom on the set of *Homo Erectus*, and he just smiled and shrugged and said, "What can you do?"

Jason was kind enough to introduce me to Kirsten Dunst, his co-star in *Marie Antoinette*, and I was worried that she wouldn't be thrilled to meet me. But she lit up when she saw me and said—and these are her exact words—"Ron Jeremy doesn't need any introduction. I know *exactly* who he is." She went on to tell me that I have the funniest movie titles on the Internet Movie Database.

It always makes me laugh the way some people react to me. When I met Sarah Silverman—who, as you may recall, made a hilarious joke about me that she used in her concert film *Jesus Is Magic*—I told her that my brother had helped her sister get a job. Well, Sarah's face went ashen and her jaw nearly dropped to the floor and she said, "What?!" God only knows what she must've been thinking. But then I explained that my brother is a CFO of several different East Coast

With comedy's leading lady Sarah Silverman in my arms. (Courtesy of the author)

companies, and he had helped Sarah's sister, who's a rabbi, get a job at a synagogue on the East Coast.

"What did you think?" I wanted to tell her. "That *everybody* in my family is involved in the adult film business?"

Sometimes even actors with the best of intentions can't get beyond my porn credentials. Richard Dreyfuss, the Oscar-winning star of dozens of cinema classics, gave me a private performance that's probably the finest acting of his career.

Allow me to explain . . .

Richard and I grew up in the same neighborhood—Bayside, a largely Jewish neighborhood in Queens, New York. We never knew each other as kids, but we eventually met as adults and reminisced about our youth in Bayside. I took him to porn star karaoke at Sardo's Restaurant in Burbank, and we became fast friends. He invited me to the set of *Poseidon*, the update of *The Poseidon Adventure*, and I watched his scenes and spent time with him in his trailer. He told me about meeting Harry Reems in the 1970s, and lecturing him about how difficult it is to make the transition from porn to mainstream acting. I understood his point, but told him that I'm probably a better actor than Harry, and I hustle a little harder.

He knew about my porn career, of course, but he wasn't aware of my mainstream credits. I mentioned *Boondock Saints* and he had no clue what I was talking about. He thought I was kidding when I told him it had a huge cult following, but then he asked his son about it, who told him "*Boondock Saints* is my favorite movie."

A few months later, Richard invited me to the wrap party for *Poseidon*. But then, the night before the festivities, he called me and left a long, rambling message on my voicemail, explaining that he had a limited number of tickets to the party and he had to uninvite a bunch of his closest friends and he felt so embarrassed and blah, blah, blah. I didn't believe a word of it. I knew what was really going on. I could read between the lines. It wasn't a matter of bringing too many people. This is *Richard Dreyfuss*, for fuck's sake. You don't limit an Oscar winner's guest list for a stupid wrap party. But *Poseidon* was

a family-oriented movie. The studio must've heard that Richard was bringing a porn star and they immediately nixed it.

So I called Richard back and told him he was full of crap. "I know you've got an Oscar for *The Goodbye Girl*," I told him, "but if the Academy heard that message you left for me, you'd have another statue for your mantel, no problem. Seriously, Richard, that is the best acting you've ever done. Forget *Mr. Holland's Opus*, forget *Close Encounters of the Third Kind*. This is the performance they're gonna remember you by. Believe me, I'm going to save that voicemail message. It's gonna be worth something someday."

Richard laughed his ass off, and though he never admitted it, he at least hinted that I was correct. It was nice to have proof that I shouldn't take it personally; that at least some of my acting friends realize the absurdity of shunning a guy just because his acting past wouldn't nominate him to become a Disney character.

As long as we're talking about friends who understand the difference between Ron Jeremy the porn star and Ron Jeremy the person, I'd be remiss if I didn't mention Tammy Faye. Tammy and I worked together many times, including a highly rated season of *The Surreal Life*, and we remained close friends even after the cameras were turned off. She was such a little honey, and it hurt me when she died. I really wanted to be at her burial, but very few people knew about it when it happened. In fact, by the time the world learned that Tammy had passed away, she had already been cremated and buried in a forest near her husband's family. The only people at the burial were her husband, Roe Messner, the immediate family, and the woman that was taking care of her in her final years. When the news broke, the mourners were already flying home from the funeral. That's kinda sneaky, but it's exactly what Tammy and her family wanted, to pay their last respects without any of the media hoopla.

Although I'm sad that she's gone, I'm proud of her for leaving on her own terms. She decided to give up on chemotherapy and put the remainder of her life, as she put it, "in God's hands." And she wanted to be cremated, as she explained on her last Larry King

interview, because she didn't want bugs eating her. My feelings about cremation are totally different. I don't want to be cremated, and not for religious reasons, but because I'm happiest when I'm being eaten. Let the bugs make a meal of me, I say. As long as *somebody* is eating me, I'm happy.

I think what I loved most about Tammy was her tolerance for ideas different from her own. She really cared about people, and she was never phony, fraudulent, or fake. Tammy was one of the few religious leaders who spoke openly of her support for gay people, which is probably why she had such a loyal and humongous gay following. And though her friendship with me, an infamous porn star, may not have won her any popularity contests among the religious right, she never wavered in sticking by me and calling me her friend.

I visited her and Roe as often as I could in North Carolina, and we had some great times together. Roe is one of the nicest guys in the world, and he put up with a lot of my humor. I remember one night in particular, when we were out at a local restaurant and attracting a lot of attention from the other diners, as you might imagine. The dinner arrived and Tammy turned to Roe and said, "Would you lead us in prayer?"

"Tammy, would you mind if I did the prayer this time?" I asked.

Tammy peered at me uncertainly. She wasn't sure if she could trust me. "Okay, Ron, but be serious, okay? This is the *Lord* we're talking to."

I clasped my hands and said, "Good food, good meat, good lord, let's eat."

Tammy rolled her eyes and wagged a disapproving finger at me. "Roooon!"

"Okay, okay, how about this? Rub-a-dub-dub, thanks for the grub. Yaaaah, God!"

"Roooon! I knew you couldn't do this." She turned to her husband, who was struggling not to laugh. "Roe, would you please?"

"Wait, give me one more chance?" I pleaded.

"Okay, just *one*," she insisted. "Please get it right this time."

I cleared my throat and paused for dramatic effect. And then I delivered my last attempt at a proper prayer:

"I thank thee
For the milk from cow
I thank thee
For the cheese
Now I'm in my lonely room
With Mad Cow Disease."

"Rooon!" Roe started laughing out loud, which only frustrated Tammy further. "Roe, it's not funny," she scolded him. "Don't encourage him." But I know that Tammy was enjoying it as much as we were.

That's a very sweet story," my ghostwriter just told me. "But at any point in this dinner with Tammy Faye did you put your penis in the food?"

What? No, why would I do that? I swear to God, I'm gonna fire this guy if he keeps pushing me to spice up my stories with unnecessary sex. Isn't it enough that the stories in this book are funny and real and tell you something true and unexpected about me?

You want another surprising tale? Okay, here's a story that we had to leave out of the hardcover edition, probably because it didn't have enough titties.

Phoebe Dollar, who received a special thanks in my book, has been a loyal friend to me for many years. She's written and starred in a lot of great B movies and horror films, and you might even call her a scream queen. She's been kind enough to put me in a few films, like *Hell's Highway*, where she stabs me and I bleed all over the windshield, and *Charlie's Death Wish*, which also stars Dizzy Reed of Guns N' Roses, Lemmy from Motorhead, and Tracii Guns from LA Guns.

She and her dad, Kenny, are fascinating and quirky people. I enjoy nothing more than spending an evening with them, if only because it's guaranteed to be hilarious and full of wacky antics. A few years ago, we were having dinner at the Gladstones Restaurant in the Pacific Palisades, right next to the water. As we walked towards our table, we passed the lobster tank and Phoebe's heart began to melt. She looked at these poor little crabs, all of them so sad and frightened, and I half-expected her to break down in tears.

When the waiter arrived to take our order, Phoebe and Kenny both asked for the same crab—a miserable-looking creature that seemed more fragile and depressed than his lobster cell mates. But, they said, they didn't want the chef to cook it. "Just put it in a bag and give it to us," she told him. Their plan was to bring him down to the ocean after our meal and liberate him, sending him back to his watery home.

I tried to tell them that this wasn't the best idea. If this crab was from a part of the ocean with different enzymes, it would die very quickly. You can't just throw a crab into any old body of water and expect it to survive. But then the waiter informed us that this particular crab was from Santa Barbara, just a few miles to the north of us.

"He should be fine," the waiter assured us. "The water is actually a little warmer here." "Yeah, but not as warm as the water he was *going* to end up in," Kenny said with a smile. So we finished our dinner and ran down to the shore for the crab's homecoming. As Phoebe was bending over and trying to gently place the crab into the ocean, her cell phone fell out of her pocket and splashed into the water. And then the crab—I couldn't believe my eyes—somehow seemed to grab her cell phone and hold onto it as he washed away into the sea.

And ever since, the crab won't stop calling her and thanking her.

Obviously, that last part isn't true. But it's been a recurring joke between Phoebe and me. Every time we go out, either to a club or a restaurant or a party of any sort, I'll pull the same scam on her. I'll ask a waiter or a bouncer to walk over to her and say, "Ms. Dollar, you have an important call."

"Who is it?" she'll ask innocently.

"It's a Mr. Crab, he wants to thank you for saving his life."

And with that, she'll turn to me and laugh. "Goddammit, Ron! You got me again!"

The key to a gag like this is patience. I've done it to her enough times that she's beginning to expect it. But if I let enough time go by, she'll forget about the crab and I can still catch her by surprise. And of course, it helps to have some willing accomplices. My best experience was at the Polo Lounge in the Beverly Hills Hotel, where the maître d'—a great guy with a fantastic sense of humor named Waleed—actually added some props. Phoebe and I were having lunch with a large group of people, and he walked over with the house phone on a silver tray. He looked so official and Phoebe never realized what was happening until it was too late.

And surprisingly enough, months later we actually saw a commercial on TV featuring a crab holding a cell phone.

I like where you're going with these stories about practical jokes," my ghostwriter, Eric Spitznagel, just told me, "but I think it would behoove you to drop a few more celebrity names. And maybe dish a little dirt on them. You've gotta have dozens of stories about your famous friends doing terribly scandalous, incredibly filthy, borderline illegal things, don't you?"

I do. But I'm not going to share any of it. I've been involved in a *lot* of extracurricular sexual activities with a *lot* of Hollywood celebrities, and if any of it got out, it would lead to a *lot* of divorces. But I'm gonna carry these stories with me to my grave. My ghostwriter has heard some of them, and even if he was beaten and water-tortured at Guantanamo Bay, he still wouldn't confess everything he knows.

"I wouldn't?" Spitznagel asks.

That's right, I tell him. And don't you forget it. Unless you don't care if that check clears.

It's funny, sometimes I feel like nobody appreciates my reasons for being so protective of my friends. I have a conscience. I am not a rat, and I think that's the reason I've survived. Look at somebody like Linda Tripp. The nation is never going to forgive a woman who wore a wire to rat out a friend. How many celebrities have been caught in sex scandals? Dozens, maybe hundreds. But they're all eventually forgiven if they just apologize and seem honestly remorseful. But a rat will *never* be forgiven.

Okay, here's a funny story about one of my famous friends in which nobody gets hurt. When my book first came out, I flew to New York to promote it, doing interviews for CNN Showbiz and a few other shows. Just days after I arrived, I got a call from Dennis Hoff, the proprietor of the world-famous Bunny Ranch in Nevada. He told me that he was also coming to New York, to plug the next season of his *Cathouse* reality show on HBO.

In the worst case of timing ever, as soon as Dennis showed up—on his own dime, by the way, and with a gaggle of girls from the Bunny Ranch—word began to spread that Anna Nicole Smith had overdosed on prescription pills and died. Because the Anna Nicole story was such a hot topic, all of Dennis' interviews ended up getting cancelled. I was laughing at him, only because I was lucky enough to show up a few days earlier. But then I learned that I'd been bumped from the *Geraldo* show, and as with Dennis, Anna Nicole was to blame.

So both of us were in the same boat, and we were both pissed about it. We finally decided to release a statement to the press, announcing that Dennis or I (and possibly both of us) may've been the biological father of Anna Nicole's child. Why is that, you ask? Well, because we got screwed by her . . . *after* death.

We meant it all in good fun, of course. I have no disrespect for Anna Nicole. I met her on a couple of occasions—once at the Larry Flynt Roast at the Friar's Club, and once at the Rainbow Bar and Grill—and she was always very friendly and sweet to me. But I will admit that at the Rainbow, she seemed a bit tipsy, and she was only wearing one shoe. I asked her about it, and she just smiled and said

she must've lost it at a disco. It struck me as a little weird at the time, but I guess that's what made Anna Nicole so unique.

It's probably not in the best taste to talk about somebody who can't defend themselves. But I will say this: when I die, I hope that people are making *millions* of jokes about me. Seriously. When I croak, I want Jay Leno to come out on *The Tonight Show* and say, "Ron Jeremy died today. Well, he's *really* a stiff now, isn't he?"

Now we're talking!" My ghostwriter is jumping around the room, laughing like a drunken hyena. "We need more bawdy one-liners like that! More references to the size of your angry Samoan! C'mon, Ron, stop holding out on me!"

I don't know about this.

"Just one story, Ron. One story about your penis is all I'm asking for. It can be like the end of *Animal House*. You know, the 'Where Are They Now' part, where they tell us what happened to Bluto and Otter and the whole gang. I think I speak for all of your readers when I ask, 'Since the book ended, what's happened to your penis?'"

Okay, okay, fine. *One* story.

There's a filmmaking team called the Fields Brothers—Adam, Scott, and Jordan Fields—and they asked me to be in a movie called *One-Eyed Monster*. It isn't a porn flick, but it's still got plenty of raunchy scenes, and it's very, very funny. The film stars Charles Napier, who is very well known, and the redhead girl from *Buffy the Vampire Slayer*, Amber Benson. And it also stars a couple of porn stars like Veronica Hart, and yours truly. But I guess the *real* star of *One-Eyed Monster* is . . . well, my one-eyed monster.

The premise is pretty simple: aliens are monitoring the earth, and one of the first things they pick up is satellite signals, and one of the biggest things on satellite is porn, and one of the biggest things in porn is me. So they try to infiltrate the earth by disguising themselves as my penis. It's like a cross between *Friday the 13th* and *Aliens*.

Except the alien is a liiiiiiittle more phallic than in the Ridley Scott movie. Oh wait, I just thought of the perfect tagline. "In Space, Nobody Can Hear You Cream." I gotta call the Fields Brothers and tell them about it. Remember, you read it here first, folks.

There's actually a funny backstory here. I loaned the filmmakers a mold of my penis, which was originally taken by Pipedream Products for a sex toy. And the director asked me, "Are you sure we have the rights to use this?"

"What do you mean?" I said. "Of *course* you have the right! It's my dick!"

"Yeah," he said, "but isn't the mold owned by a company?"

"Well sure, the *mold* is. But the mold is based on *my* penis, and I own my penis. At least I think I do. Oh god, I haven't signed away the rights to my penis, have I? I've got to call my lawyer."

I was kidding, clearly. But it was just to point out how absurd it was. You can sell a mold of my penis as a sex toy, but you can't ever own my penis. Even when I die, I'm gonna hire a security force to guard my grave 24-7. Nobody is gonna dig up my corpse and sell my schmeckle on the black market if *I* have anything to say about it!

Yeah, yeah, I know, all this talk about wanting to be taken seriously as an actor, and it still comes back to my penis in the end. But, as I've said before and I'll say again, I'm not ashamed of what I've done, or what I do, or what I'm planning to do tomorrow. One of my good friends, Moss Krivin, summed it up perfectly. We'll go out on the town together and meet some girls, and almost always I'll get lucky and he won't. He's better looking than I am and younger, but I'm kinda famous, so I always end up going home with one of the girls.

"I'll buy the dinner and drinks and then *you* take her home and have sex," he's told me. "So I pop in one of your videos, and in your own strange way, you manage to get *both* of us off."

Maybe that's part of the reason why I still do porn films whenever my schedule permits. I don't want porn to be my main source of income anymore, but I know that my reputation was built on adult movies and I don't want to snub my nose at the industry that gave

me my first break. And sometimes—yeah, this isn't going to shock anyone—sometimes making porn is a lot of fun.

Teri Weigel, who is among the porn actresses I've most enjoyed working with, called me up not long ago and asked if I wanted to be in a video for PlayTime Inc. It's run by a guy named Gary Spencer (slobabes.com), who's well known for taking care of his talent and showing them a good time. This particular shoot was happening in Paso Robles, also known as San Luis Obispo, so I guess it made sense why he'd try a little harder to make his actors feel appreciated. To convince a porn star to get on a plane and leave Los Angeles, when most of the work is right in town, just to shoot a few lousy sex scenes, you've got to go the extra yard to make it seem worth the effort.

Well, when I showed up in Paso Robles and was taken to a mansion in a beautiful vineyard, I knew right away that this was going to be something special. My scene wasn't scheduled until later that night, but I showed up in the morning and was instantly surrounded with temptations.

I have three rules about doing a sex scene. At least twenty-four hours before my performance, I can't eat a big meal, I can't drink, and I can't have sex.

My reasons for not eating are pretty obvious. I have no willpower, so the moment I start shoving things into my gullet, I can't stop. And then by the time I'm ready for my sex scene, I'm bloated and looking chunkier than usual, and in some cases my penis will look dwarfed when compared to my bulbous stomach. But Teri, because she's such a sweetheart, must've given this guy a list of all my favorite foods, because there was a buffet waiting for me, filled with shrimp and lobster and clams and everything I crave. So, rational thinking be damned, I stuffed my big fat face with as much seafood as I could cram in there.

As most of you know, I'm not a drinking man, but every once in a while I'll sip on Baileys Original Irish Cream liquor. So of course, the mansion was equipped with several bars, where sexy lady bartenders were pouring Baileys on ice for me. And then, being satiated with food and a little goofy from the liquor, I was lured into the bathroom

by hot young women. Some of them were actresses on the shoot and some were just friends of the cast, but they were all breathtakingly gorgeous and they were all feeling a little playful.

Now, I'm not saying I'm God's gift to women, because I'm certainly not. But these women, all of them staggeringly beautiful, were just curious about what my schmeckle looked like. You know, the usual routine: "Is it as big as everybody says it is?" Well, there's only one way to find out, isn't there? But as soon as I'd get them into a bathroom stall with me—and at some point there were six of them, which is just a ridiculous number, even for me—things started to get a little frisky. They didn't just want to look. They were grabbing at it, giving it a kiss hello, putting in just the tip. I was trying to be a good boy and control myself. Thank God I didn't have an orgasm, because then I would've been finished. My sex scene—the reason they were *paying* me to be there—would've been abysmal.

Your body changes when you hit forty. Before that, I could cum thirty, forty times a day. (Calm down, I'm just kidding.) But after forty—and I'm long past that age by now—you have to be careful not to climax too soon. Because after the first one, you're going to have a noticeably weaker scene. You're gonna have to squeeze the base to make your erection look bigger, and the pop at the end will have a lot less volume. You'll start hearing crew members whisper things like, "What happened to Ron?" I can't take that chance, because I'm a professional.

But you know what? I pulled it off. Even with all the food and the booze and having sex with six girls in a bathroom stall, I still showed up for the shoot and did a good scene. As further thanks for doing a good scene, Gary got me front row center tickets for Aerosmith and Stevie Nicks at the California Mid-State Fair. Even though I broke all of my cardinal rules and wasn't going to eat, drink, or have sex before doing a scene, I ate, drank, and had sex before doing a scene. But, it still worked.

AVN magazine, listing top adult porn stars, made me number one, Jenna number two, and John Holmes number three. But, it still takes a lot of work to stay in the game . . . along with a lot of hustle, good people, and dumb luck.

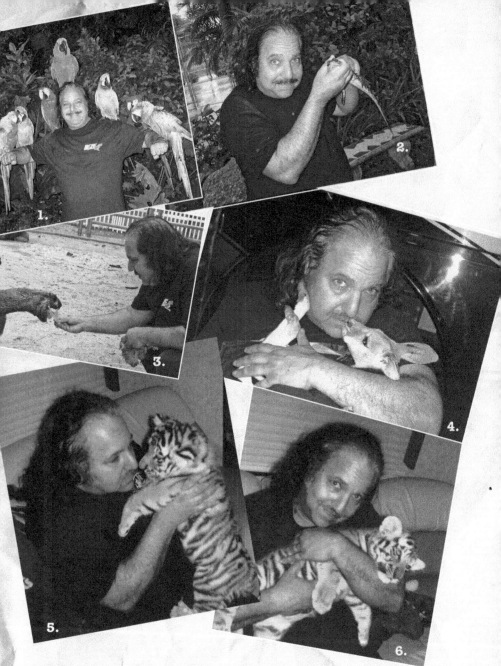

1. Surrounded by some feathered friends. (*Courtesy of Larry Wallach and Summer Haze*) **2.** Much friendlier than he looks! (*Courtesy of Larry Wallach and Summer Haze*) **3.** An over fifty-pound turtle eating right out of my hand. (*Courtesy of Larry Wallach and Summer Haze*) **4.** Smooching a baby kangaroo. (*Courtesy of Larry Wallach and Summer Haze*) **5.** I'm doing a nosey with a tiger! (*Courtesy of Larry Wallach and Summer Haze*) **6.** She's practically asleep in my arms. (*Courtesy of Larry Wallach and Summer Haze*)

ACKNOWLEDGMENTS

In lieu of thanking those people who helped me with this book (we'll get to that in a few pages), I'd like to take this opportunity to share something with you that I find important.

The fight against world hunger. Don't laugh, I'm being serious.

The idea hit me while I was on the television show in England called *The Farm*. Now hear me out. I know that you probably didn't pick up this book expecting to read about my humanitarian efforts. You wanted tales of porn and Hollywood gossip. And I hope that I gave you just that. But if there's a chance that I can also use this book to make a difference, well, what sort of guy would I be if I didn't try?

Below is a sample of a letter that I sent to the representatives of various celebrities who had publicly expressed interest in this subject. I'm not aware of their interest in *my* idea, but a few of their agents and managers have been very encouraging and enthusiastic. It's my hope that by reprinting this letter in my book, it will get to people whom I couldn't reach, and go places where I couldn't go. If you want to take part, I encourage you to contact your congressperson and tell him or her about this idea.

TO: Ben Cosgrove
Kristin/Plan B
Brad Pitt

This proposal is my small contribution in the ongoing fight against world hunger. In addition to you, I have also brought this concept to the attention of Paul McGuinness, Bono, Oprah Winfrey, and Bob Geldof, among others.

I lived on a farm as part of a British television show called *The Farm*. (Many celebrities, high ratings.) I learned a disturbing fact. A tremendous amount of meat is wasted. If a cow, pig, or lamb, etc., doesn't meet the high-quality standards and perfect meat consistency to compete in the world market, the humane farm will let the animal graze until death. Some factory farms will just kill them even though this meat would achieve FDA standards. They are just too old or not good enough to compete with farms in Morocco, the U.K., Australia, etc. As the farmers told me, the profit margins are so slim and the competition so fierce, it does not pay to house, clean, or even feed them. (Almost all farms compete for the top-paying buyers; anything else is not worth it.)

So basically, this meat isn't good enough for Spago's in Beverly Hills, but it certainly is good enough for third-world countries. (This is the meat that is often used for stews, hot dogs, and hamburgers.)

Just to give examples: There are many animals used for procreation (bulls for their semen, sows who produce piglets, ewes who produce lambs, etc.). Their offspring are eaten in a year or two. When the parents are no longer valuable to produce offspring, dairy cows that no longer can produce milk, or even certain calves that have too much fat and not enough muscles, all these animals are to graze and die. Some of them have a massive build.

The farmer and I approximated 800 to 1,000 mouths could be fed per animal. At least 1,000 animals are wasted each day in the world pool. That could be 1 million mouths fed per day.

The farmer I spoke to in England and a few in the United States and Australia all agreed that if the governments would give them a tax deduction per animal, it would then behoove them to deliver these animals to the docks for delivery to the third-world countries. I'm assuming the receiving countries would cover the shipping. The money raised per various charities could be used to build humane slaughterhouses, and the Africans could be trained to operate them. Or if this is too

impractical, the animals could be slaughtered first and then the preserved meat sent over.

This is a win-win situation because our governments wouldn't be paying, just offering tax incentives. The farmers, being private businessmen, can always benefit from a tax write-off. (Some of this goes on already in other farming areas.)

HIV medication is a perfect example. Africans couldn't afford it. Various governments offered tax incentives. Drug companies lowered the prices. Africans received their medications. This could work for the animals that are basically being discarded.

If this process has started and others have thought of this, I applaud that. I'm not in this for any kind of publicity or attention. If it hasn't, someone of Brad Pitt's clout could ask some of the political powers that be to offer these tax incentives to meat farmers. It could start in one country and blossom.

I'm sure you're aware that money raised and awareness go only so far. (A good portion of money goes toward clerical fees, administration, commercial spots, etc.) This idea specifically feeds the people.

> Thank you for your time.
> Sincerely, *Ron Jeremy*

SPECIAL THANKS

This book wouldn't have been possible without my friends and family. So I'd like to send a big thank-you to Mickey, Adam, Ben, John, Roger, Troy, Greg, Gary, Dennis, Al, Mark, Bobby, Venice, Natalie, Phoebe, Ken, Lois, bro Larry, sis Susie, Allen, Moss Krivin, Metro Interactive, Stu, Josh, Eric, Mauro, Joelle, and especially anyone I forgot.

Appendix A:
RON JEREMY FUN FACTS

BIRTHDAY: March 12, 1953

REAL NAME: Ron Jeremy Hyatt

NICKNAMES: The Hedgehog, The Manatee, The Chupacabra

DIRECTING PORN ALIASES: Ron Hedge, Nicholas Pera,
Hiramus Smurkin, Ron Prestissimo, Lolita Brooklyn,
Bill Blackman, Lululatush

NUMBER OF SEX PARTNERS: more than 4,000

NUMBER OF PORN FILMS: At least 1,750 (a world record)

NUMBER OF PORN FILMS IN WHICH RON HAD SEX
WITH A SYNTHETIC DUMMY: 1 (*Real Doll: The Movie*)

NUMBER OF PORN FILMS FOR WHICH RON
HAS SHAVED HIS MUSTACHE: 2

NUMBER OF PORN FILMS FOR WHICH RON
HAS SHAVED HIS BACK: 1,500

YEAR IN WHICH RON BECAME THE FIRST
MALE PORN STAR TO TRIM HIS PUBIC
HAIR (to exaggerate his penis size): 1980

AGE AT WHICH RON BEGAN TAKING PIANO LESSONS: 8

AGE AT WHICH RON PLAYED THE PIANO WITH A PENIS MASK
ON HIS HEAD IN THE MOVIE *RULES OF ATTRACTION*: 49

RON'S PENIS SIZE: 9¾ inches

AVERAGE PENIS SIZE OF A HEDGEHOG: 9 centimeters

AMOUNT RON WAS OFFERED BY DIRECTOR
ADAM RIFKIN TO PUT HIS PENIS ON BARBARA
WALTERS'S SHOULDER ON *THE VIEW*: $25,000

AGE OF RON'S YOUNGEST
SEX PARTNER: 17 (Traci Lords, in *Sex Fifth Avenue*.
She had fake ID and looked 21.)

AGE OF RON'S OLDEST
SEX PARTNER: 87 (Rosie, in *87 and Still Bangin'*)

WEIGHT OF RON'S FATTEST
SEX PARTNER: 300 pounds (Sindee, in *Fatliners*)

NUMBER OF RON'S PORNO FILMS WITH
THE WORD *FAT* IN THE TITLE: 8

RON'S RANKING IN *ADULT VIDEO NEWS*
TOP 50 PORN STARS OF ALL TIME: 1

COMICS WHO HAVE IMPERSONATED RON ON
SATURDAY NIGHT LIVE: 2 (Jon Lovitz and Horatio Sanz)

YEAR IN WHICH RON PUBLICLY ANNOUNCED
THAT HE WOULD NO LONGER PERFORM IN
PORN FILMS ON YOM KIPPUR: 2001

AGE AT WHICH RON RECEIVED AN ADULT
FILM LIFETIME ACHIEVEMENT AWARD: 50

AVERAGE AGE AT WHICH MOST PORN STARS RETIRE: 36

NUMBER OF FAKE OBITUARIES FOR RON IN *SCREW*: 1

Appendix B:
KING OF DVDS
(or, "If I'm a Cheesy Actor, Who Cut the Cheese?")

I've appeared in dozens of mainstream films, but I've also been sliced out of a few. Here's a partial list of my movie roles that never made it into the final cut (and many of these aren't listed on IMDB).

RONIN I was cut from the film, but I did receive a screen credit, as Ron Hiatt, which they obviously spelled wrong.

REINDEER GAMES Although my scene never appeared in the movie, I also received a screen credit for this one, as Ron Hyatt, spelled correctly this time . . .

PATH TO WAR John Frankenheimer hired me to do narration for this film about Vietnam and President Lyndon B. Johnson, but I was cut after John passed away. John loved my reading, and his only correction was my pronunciation of "Vietnam." John had every intention of giving me a small role (as the German soldier, possibly) in his new film *Exorcist: The Prequel*. He even called me while scouting locations overseas. Again, his untimely passing ended all that. And I still have the original script, which changed when the new directors took over.

CONFIDENCE In this 2003 film starring Dustin Hoffman, I played the nonspeaking role of a bar owner. I was cut and didn't receive a screen credit, but you do see me clearly in the deleted scenes of the DVD, *with* Dustin Hoffman.

PAULY SHORE IS DEAD I played a patient in a mental hospital. I was cut from the theatrical release, but my scene is in the DVD's deleted scenes. (Britney Spears and rapper Eminem introduce the deleted scenes.)

ARISTOCRATS I did a poem that's included on the DVD. I'm also given a special thanks in the movie credits.

DOMINO I had a nice part that was cut from this Mickey Rourke feature. I'm given a special thanks in the credits, and I was supposed to be included in the DVD's deleted scenes. Last I heard, I "might" be in a special-edition release of the DVD.

BOOGIE NIGHTS and **9 1/2 WEEKS** I have a consulting credit on both of these films, but my scenes—as you already know—were cut.

ODD JOBS This was a TV pilot for NBC, produced by Aaron Spelling and Roger Avary and directed by Peter O'Fallon. I would've played the sleazy bathroom guy, who was supposed to be a recurring character, but the pilot wasn't accepted by NBC.

I'M WITH THE BAND I had a major role in this Alanis Morissette TV pilot before Comedy Central pulled the plug.

RED LINE I got a screen credit *and* you see me on-screen, but my additional scenes were cut. This movie was memorable for me because I got to meet Michael Madsen. He's a very hospitable guy, and I was at his oceanfront home, on a July Fourth barbecue a few years ago. He published a book of poetry, and when I visited him at a book signing, I asked him, "Do I want to see Shakespeare shoot somebody? Do I want to see Edgar Allan Poe pistol-whip someone? No, of course not. So why would I want to read Michael Madsen's poetry?" Michael gave me a dirty look, but he knew I was kidding. "Okay, I'll buy it," I said. "But I want you to sign something that's from the heart." He took my copy of the book and wrote: "Ron Jeremy, go fuck yourself." Very funny. "Okay," I said. "*That's* from the heart."